MICHELANGELO

MICHELANGELO

A TORMENTED LIFE

ANTONIO FORCELLINO

TRANSLATED BY ALLAN CAMERON

polity

First published in Italian as *Michelangelo: Una vita inquieta* © Gius. Laterza & Figli, 2005

Polity Press
65 Bridge Street
Cambridge CB2 1UR, UK.

Polity Press
350 Main Street
Malden, MA 02148, USA

ISBN-13: 978-0-7456-4005-1

A catalogue record for this book is available from the British Library.

Typeset in 10.75 on 14 pt Adobe Janson
by Servis Filmsetting Ltd, Stockport, Cheshire
Printed and bound by MPG Books Group, UK

With the support of the Italian Ministry of Foreign Affairs.

The translation of this work has been funded by SEPS
SEGRETARIATO EUROPEO PER LA PUBBLICAZIONI SCIENTIFICHE

Via Val d'Aposa 7 – 40123 Bologna – Italy
seps@alma.unibo.it – www.seps.it

CONTENTS

List of Illustrations

LIST OF FIGURES

LIST OF PLATES

INTRODUCTION

On Friday 18 February 1564, Michelangelo Buonarroti, Florentine patrician and 'divine' sculptor, painter and architect, lay dying in Rome in a part of the city called Macello dei Corvi. It was a small house with a few of the ground-floor rooms converted into workshops, a forge for making tools and a kitchen. The bedrooms were on the first floor.

Five days earlier on Carnival Monday, someone had seen the little old man, hatless and dressed in black, walking in the rain that chilled the city. They had recognized him, but did not have the courage to approach him. They notified Tiberio Calcagni, a pupil who looked after him like a son, but he too did not find it easy to persuade the famous artist to return home. He would not hear of taking a rest: his aches and pains, he said, gave him no respite. He attempted to ride his black pony, as he always did when the weather permitted, and he started to panic when he realized that he couldn't manage it and would never be able to ride again. Although he had been expecting death for decades, now that it had arrived with that cold rain, he was frightened just as we all are – even those of us who, like him, have lived far into old age. He slowly yielded to death in the care of another pupil, Daniele da Volterra. For two days he waited in an armchair by the fire, and then in his bed for three more. As the angelus rang out on Friday morning,

a still alert Michelangelo died in the care of Tommaso de'Cavalieri, Diomede Leoni and Daniele da Volterra.

Macello dei Corvi was a part of Rome close to the Foro Romano, the Foro Imperiale and the slopes of the Quirinale. Drawings of antiquities by travellers and scholars provide us with a very clear idea of the area the artist's house overlooked at the time: it was an uncultivated countryside from which the skeletons of antiquity's greatest monuments emerged. The greatest of all these was the Coliseum, that mountain made of travertine stone and riddled with holes, whose base was still buried and whose arches and vaults had turned into caves that were home to a great variety of precarious lives. Then there were the great triumphal arches, which were also half submerged in the ground, and on cold days like the ones that brought Michelangelo's life to an end, the sheep and cows huddled around them to shelter from the rain, and pressed against the marble reliefs sculpted to commemorate the eternal glory of the emperors. The huge columns of the Temple of Saturn rose above the ruins and the ancient trees that grew there, and were crowned by the white marble of the entablatures miraculously suspended in the sky.

The neighbourhood in which Michelangelo lived bordered the level area of the *Fori* to the north and marked the beginning of the medieval and Renaissance city. It was hardly one of the elegant sites of the new Rome. It was almost countryside, with vegetable gardens and vineyards that found their way in amongst the ruins of the ancient city – the same ruins that Michelangelo had studied and drawn on his arrival from Florence sixty years earlier, under the careful tutelage of the venerable Sangallo. For at least a century, the papal strategy had been to concentrate the 'rebirth' of the city of Rome on its other side, where the Tiber forms a tight bend between Castel Sant'Angelo and Tiberine Island. Since the final years of the fifteenth century, Italy's best architects had been attempting to revive ancient architecture. Of course, they had to make do with resources that were infinitely more restricted than those of the ancient Romans, but their ingenuity had overcome this obstacle, which in many ways had encouraged creativity. Raphael, Bramante, Peruzzi and the Sangallo family were all excellent artists whom Michelangelo had known and who had since died, and they had built *palazzi* in that area which looked as if they had been there since antiquity. These white buildings decorated with columns and

rustication were impressive additions to the wide and straight avenues that open a breach in the maze of insalubrious alleys which Romans crowded into throughout the Middle Ages, like a shipwrecked people who had adapted themselves to life in the wreckage of a vast ship.

None of these new buildings could be found on the streets around Michelangelo's house. The only town-planning measures that had been taken were those of Paul III, who demolished the shacks that clustered around Trajan's Column, the giant trunk of marble on which bas-reliefs depicted the deeds of the Roman emperor. He did this to impress another emperor, Charles V, who came in 1536 to stage a triumphal ride into Rome following a victory over the Turkish admiral at Tunis. With a very modern sense of theatricality, Paul III decided to free the city's ancient monuments of the clutter that surrounded them, in the certain knowledge that this would have made a strong impression on the visitor who was susceptible to the power of ceremony.

Otherwise Macello dei Corvi was an unassuming part of Rome, to say the least. The houses were mainly on two floors, and pressed together so that there was no room for courtyards. They were built from the debris lying in the corpse of the ancient city: badly cut tufa rock from the Viterbo area was mounted on lines of Roman bricks taken from the old walls, and sculpted blocks of peperino or travertine were cemented and used as cornerstones, thresholds and lintels for doors and windows, without a care for the sophisticated bas-reliefs on their surfaces. Occasionally this dubious hotchpotch of building materials had the protection of a plaster made from volcanic ash, which was livid red or purple depending on the quarry it came from – almost always a vineyard just inside the Aurelian Walls.

Michelangelo came to live in this poor area of Rome around 1510, when Julius II or his heirs had provided him with that house and workshop so that he could work on the sculptures for the planned tomb of the great Della Rovere pope. He left Rome in 1517, only to return there in 1533 as a now world-famous artist. During the years that followed, his financial and social advancement never ceased, and yet he never left that squalid house so distant from the centre of the papal court. His continued presence in that district on the then outskirts of Rome demonstrates how he never wanted to integrate into a city where, for thirty years, he essentially felt himself to be a Florentine exile.

Even the circumstances of his death were typical of an exile, in spite of his undoubted fame. The short illness that broke him came without warning. One morning at the beginning of the previous October, he turned up at the church square of Santa Maria sopra Minerva in excellent health and in the company of his faithful servants, Antonio del Francese and Pier Luigi da Gaeta. He may have gone to attend mass, but was certainly interested in taking another look at his beloved Pantheon, the best preserved building from antiquity, which alone, in his opinion, demonstrated the unattainable beauty of which Roman builders had been capable. In the square in front of the church he was recognized and greeted reverentially by another Florentine, Miniato Pitti, who later described the old artist as a man who 'goes around with a stoop and can hardly lift his head, and yet he stays at home and continuously works away on his sculpting'.[1] Almost ninety years old, Michelangelo was still working. And he was not working with his pencil, but with his chisel.

The vigorous old man who came to that meeting in the church square of Santa Maria sopra Minerva on horseback would die four months later in his miserable home in Macello dei Corvi. He died alone, without the presence of a single one of his relations for whom he had worked and saved all his life – not his nephew Leonardo, whom he had loved but kept at a distance, in Florence, because he hated the idea of his nephew awaiting his death to take possession of his wealth. And yet Leonardo could count upon that wealth, as one of the principal aims of Michelangelo's had been to make the Buonarroti line rich and respected.

Although historians would attempt to transform Michelangelo Buonarroti into a mythical figure much accustomed to the luxury of the princes he served, the circumstances of his death, so carefully chronicled by the witnesses to it, tell of a fierce and irredeemable conflict between the artist and the rest of the world. The only exceptions were a few simple people who he allowed to look after him and Tommaso de' Cavalieri, a Roman nobleman that Michelangelo had loved too much to refuse his presence during the last days of his life. The account provided by these people detailed his agony hour by hour, and this made it difficult to create romantic interpretations that could shroud him in the mystery and greatness of which legends are made.

For Michelangelo, as is often the case, the circumstances of his death were extremely revealing. Like everyone facing death, he was not prepared for it and begged like a child never to be left on his own, even for a second. But as soon as it arrived in his extremely modest home, death discovered another weakness in this man: the avarice that afflicted him all his life. A chest full of gold, sufficient to buy the whole of Palazzo Pitti, was hidden under his bed. He trusted no one, not even the banks. He always feared deceit, persecution and fraud. He lived like a wretch, while accumulating money in a wooden chest under his bed. The man who was the object of veneration during his life should have provided his public with another death – one that did not involve a frightened and suffering old man slowly fading while he desperately struggled to cling onto life right up to the last second.

That death was soon to be remodelled by the commemorative works of two of the most brilliant Florentine intellectuals and members of the Academy, Giorgio Vasari and Vincenzio Borghini, who were committed to enhancing the public image of Duke Cosimo I de' Medici of Florence. As soon as they heard of the great artist's death, they immediately set about transforming and cleansing it of every defect and affliction to use the old master as an initial step in the creation of a new narrative for Florence – all part of a far-reaching and wide-ranging political project. The weakness of the state Cosimo I inherited after the assassination of his savage cousin Alessandro convinced him that one of the ways to make the duchy more secure and, above all, to reach a peace agreement with the republican exiles whose wealth and intelligence he badly needed, was to exalt the social and cultural identity of the Florentine nation. Michelangelo was destined to play a key role within this strategy, because he was the very symbol of Florence's talent and its most loved and famous son, in spite of attempts by bankers and aspiring princes to link their names to the city.

During his life Michelangelo, always a resolute republican, would never have wanted to support such a project. He never wanted to return to Florence, in spite of the duke's requests, nor was he generous to Florence with his works. Until the death of the French king, Francis I, in 1547, he harboured vain hopes of seeing the city freed of Medici rule. After that he resigned himself to a more respectful attitude as befitted his own dignity, and which was just sufficient to avoid

problems for his heirs and for the wealth he had accumulated in the city and its surrounding countryside. Vasari expended a great deal of energy on this project, possibly because he felt sincere admiration for the quintessentially Tuscan artist, but undoubtedly to please his duke. He had constantly enticed Michelangelo with all kinds of proposals, always pointing out the advantages for his descendants, as he knew the ageing artist was sensitive to this argument. But it had all been in vain. Michelangelo's excuse was always the need to finish the work on St Peter's, an undertaking that genuinely was for him a votive offering made directly to God. He didn't want to move from Rome even when the election of Pope Paul IV (Gian Pietro Carafa) meant that his life was no longer safe. His unswerving hatred of the duke and the pope was demonstrated by the destruction of his own drawings and cartoons, which he ordered as death approached. He had them burnt, even though Cosimo I would have paid him any price for them. Indeed, the duke put aside his usual princely reticence and expressed his exasperation with the stubborn artist: 'We regret this vexation of his not having left any of his drawings: it was not an act worthy of him to have thrown them on the fire.'[2]

But now that the stubborn old artist was dead, no one could hold back the demands and plans of the powerful to whom he had not submitted throughout his life. Power now had a free hand to manipulate his mortal remains and his myth. It was the moment everyone had been waiting for. On hearing that he was dying, cynical Don Vincenzio Borghini immediately understood that Michelangelo's death would provide an excellent opportunity to improve what we now call the 'image' of the Florentine Academy and its patron, Cosimo I. 'Consider what I have to tell you; on occasions the malevolence of those envious of other people's virtues provides the opportunity to do things that enhance the reputation of the person who does them rather than that of the person for whom they are done. Now, as I have said, you will think about this; all I have to do is to get things moving, and you will bring them to completion.'[3] Borghini was all too aware of the advantages of a state funeral: Cosimo, the enlightened monarch, would reward virtue, make it more fruitful with his generosity and acknowledge the great worth of one of his sons. How could anyone accuse such a man of tyranny? How could you challenge the virtuous foundation of the Tuscan state

that was now identified with the Medici? The exiles were completely outflanked by a propaganda campaign that used one of the most revered symbols of the entire century. To make this operation even more effective, the funeral oration was entrusted to Benedetto Varchi, a highly respected republican exile who had returned to Florence twenty years earlier at Cosimo's insistence – the initial stage of the prince's policy of winning over and seeking reconciliation with his republican opponents (at least those he did not have murdered by his hired assassins).

However, they had to move quickly and adeptly. Other powers were claiming the right to bury the famous corpse so as to bathe in the artist's reflected glory. The strongest of these contenders was the papacy, which had incessantly provided Michelangelo with work for the previous thirty years. A commission set up by the governor of Rome rushed to the house in Macello dei Corvi as soon as they heard of the artist's death on Saturday, and Alessandro Pallantieri, the governor himself, followed shortly afterwards. As in the case of a pope or a king, they had to draw up an inventory of all the assets contained within the house. But their real intentions soon became very clear, when the artist's nephew and legitimate heir arrived in Rome. Leonardo, whom Michelangelo had so dearly loved, was threatened and they told him sharply that he was lucky to have the money they were leaving behind or, in other words, the chest with the ten thousand ducats the old man foolishly kept in his home. There was no trace of the works, some drawings and three unfinished statues. That was the real treasure – one of inestimable worth – but the guards had been ordered to take everything away.

Leonardo understood that the best service he could do for his prince, Cosimo I, was to bring back his uncle's dead body to Florence. Fortunately it was a very cold winter, and the corpse was well preserved. The body was stolen at dawn from the Church of the Santi Apostoli, where it had been temporarily placed, and loaded on a cart for transporting goods. When it arrived in Florence three days later, Cosimo, Vasari and Borghini sought to keep this a secret in order to stage-manage the event better. Besides, Michelangelo was still the most important symbol of republican beliefs, and in Florence you could never be absolutely sure that the republican opposition had been entirely defeated. Yet rumours of what had actually occurred were soon

circulating the city. First the artists and then the people, or certainly the republicans amongst them, held a procession through the night to revere the artist's remains like those of a saint. Thousands of men in tears marched in silence, and they were dressed in the same worn black smocks and 'shabby' jackets that the meticulous author of the inventory had discovered in Michelangelo's wardrobe. By embracing him in this spontaneous manner – an honour no one else had ever been accorded – the Florentines repaid the artist's immense love for his native city that had never dimmed, and which he had paid for with his exile.

Then it was time for the state funeral in San Lorenzo, the family church of the Medici, on which they could finally bestow the glory of Michelangelo, just as they had taken possession of the statues he had never wanted to give them while he was alive: his unfinished *Prisoners* and *Victory* for the tomb of Julius II had been left in his house in Florence. The most obvious thing would have been to put those sculptures on the artist's tomb, but Vasari immediately found a way to replace them with the *Pietà* which Michelangelo had defaced and given to Francesco Bandini. In this way, the sculptures could become Duke Cosimo's personal possessions. The plan was suggested to the compliant nephew Leonardo a few days after the artist's death, and not even the refusal by Bandini's son to hand over the *Pietà* was enough to deter the single-minded Vasari from his plan. It was easier to betray Michelangelo than to disappoint Cosimo I. It was decided that the tomb should go without, and the young sculptors of the Academy were given the task of making alternative statues, which to this day offend the artist's memory with their ugliness. In the end, the Duchy of Florence had its champion of virtue, and the duke had his sculptures.

In Rome they also breathed a sigh of relief. Carlo Borromeo immediately gave orders to cover the nudes of *The Last Judgement* with those ghastly underpants and the work was completed by 1565. Michelangelo's death meant the loss of one of the last remaining exponents of the *Spirituali*, a group that had engaged in the risky business of promoting reconciliation with the Protestant Reformation over the previous thirty years. At the heart of the Catholic world, Michelangelo had 'illustrated' this shared and effusive heretical faith using marble and paint, but now he was dead, the official Church could cleverly reintegrate him and his works. Daniele da Volterra was given the task

of covering up the more 'obscene' nudes of *The Last Judgement*. Other works, such as the frescoes in the Pauline Chapel, could be assimilated with more sophisticated methods: they placed alongside his paintings, which were pervaded by a faith entirely different to the now dominant one that had triumphed at the Council of Trent, other didactic paintings that directed the onlooker towards more orthodox interpretations.

The myth of Michelangelo was destined to grow and to be manipulated in the years and centuries to come. His nephew Leonardo's son, Michelangelo the younger (1568–1647), took the trouble to change the relevant endings from masculine to feminine when he came to publishing his great-uncle's sonnets, in order to remove the unsettling shadow of their author's homosexual passion. Nor could Hollywood, that great, modern factory of myths, refrain from exploiting Charlton Heston's irresistible attraction to provide the mass market with a Michelangelo in love with a woman he actually never met.

The historical figure that has come down to us is difficult to make out precisely because of the excessive light that has been shone on him. That light has obscured the man and even his work. It was felt that his *Moses*, which is his most viewed statue, needed to be analysed and restored in order to discover what should have been obvious to an eye less blinded by prejudice and indeed what an important document also made clear: namely that Michelangelo had changed it completely when the work was already at an advanced stage and late in the artist's life. However, the opening of the Vatican archives and the historical research of Adriano Prosperi and Massimo Firpo have finally clarified the ambiguous circumstances in which Michelangelo worked towards the end of his life. Restorations, particularly the masterly ones carried out under the direction of Gianluigi Colalucci in the Sistine Chapel, have made it possible to rediscover a craftsman who mixed plaster and colour, sculpted marble and scribbled ceaselessly on sheets of paper, and thus in part to separate him from the myth in which he has become entangled. The enormous quantity of documents that have been amassed since the mid-nineteenth century have been ordered philologically by Giovanni Poggi and subsequently by Paola Barocchi. This has recently been enlarged upon by Rab Hatfield's indispensable work on the artist's current accounts, which produced an often extremely harsh assessment of Michelangelo's many vicissitudes, which he made every

effort to varnish over in the versions he dictated to his biographers. Just as Charles de Tolnay edited a catalogue of Michelangelo's works in the mid-twentieth century, Michael Hirst has more recently edited one of his drawings, and every year a myriad of specialist studies produce new and adventurous dissections of single works and single moments in the artist's life.

The unequalled scale of this intense study of documentary sources is proof in itself of the fascination with Michelangelo and of the enormous volume of contemporary accounts about him. The most recent works produced in the last century are essential to any study of the artist, as they provide new interpretations founded on the endless quantity of documents, but they also make it increasingly difficult and daunting for the non-specialist to approach his works. By combining this careful academic study of the written sources with that of the material sources and his methods of painting and sculpting, this book attempts to relate the two different spheres to each other, and to interpret the artwork not simply as images but also as specific financial and technological undertakings in which the artist used up all his physical resources and to which he contributed all his human passion.

Following the important restorations of the Sistine Chapel and Julius II's tomb, we now have new information that can be used for the first time in understanding Michelangelo in his totality: this knowledge can help us to neutralize the myth and get closer to the divine artist and the suffering man Michelangelo comprised. The results are stunning. On the one hand, the artist himself belies the myth, and on the other, his art becomes even more sublime, because it proves to be rooted in the miseries, conflicts and sufferings of a life that was ordinary in its grimness. Past centuries could not accept this apparent paradox, but modernity knows it only too well. This is undoubtedly the reason why Michelangelo continues to fascinate us as the most modern of all the artists who have ever lived.

1

CHILDHOOD

1 THE BACK OF BEYOND

Four long hours remained until daybreak. The small house was at the top of a cliff overlooking a forest in the grip of a winter freeze. On the northern side, where the walls followed the edge of the cliff, the windows did not open because the wind from that direction was unremitting. However, the side that looked onto the village's little square, had three windows on the first floor, which corresponded to three minuscule rooms where the maids bustled around and where the householder Ludovico was trying to find escape from his increasing anxiety.

The thick walls of the house, made of grey, clayey rock quarried from the mountainside, were not thick enough to muffle the screams of the woman about to give birth to her second child. It was not only the isolation of their home that worried Ludovico, who had already been through this torment, nor was it the fear that assistance would never reach a mountain top in Casentino. At that particular moment he could only think of his wife's fall from a horse six months earlier, while they were moving to this godforsaken spot. Even though she was three months pregnant, the journey was hard and giving birth promised to be risky in a place perhaps never before visited by a doctor, he had had to

accept the post of the governor [*podestà*] of Florence's most insignificant possession to save himself from financial ruin. The salary was derisory, a mere 500 liras for six months, out of which he had to pay for two notaries, three servants and a stable boy. But he had no choice; they were certainly not going to offer him the governorship [*podesteria*] of one of the wealthier Florentine possessions, which came with salaries of 2,600 or 3,000 liras. He had now slipped far down the social scale, to the point of compromising the financial security and dignity of his own family. He was even close to losing his privileges as a citizen, and such a loss would have made him indistinguishable from the socially insignificant mass of craftsmen, salaried workers and artists.

Gone were the days when the family could boast a leading position amongst Florentine patricians. Two centuries earlier, Ludovico's ancestor Simone di Buonarrota had been in the Council of the Hundred Wise Men. His grandfather, Buonarrota di Simone, wool merchant and moneychanger, had lent a large sum of money to the Florentine government [*Comune*] and had been elected to the most prominent public offices. Unfortunately he died too young, at just fifty, in 1405, and when he went to his grave, he also took the family's rising star. The decline started with Ludovico's father, Leonardo, and resulted from expensive dowries for his daughters, unpaid taxes and increasingly miserable postings. He too accepted that insignificant governorship twenty years earlier, and took his children with him. Perhaps this explains why Ludovico accepted. That dismal village must have appeared familiar and preferable to an equally desolate castle in a place he did not know. Nonetheless his wife was pregnant, the journey had been long, and she had fallen from her horse with unknown consequences for the unborn baby. And now there were still four hours to go before daybreak.

The screams suddenly became more desperate and equally suddenly they ceased, to give way to the triumphant crying of a baby who had made it into the world. He had managed to be born above that inhospitable ravine and seemed to be a healthy baby. The village in which he had chosen to make his appearance in the world was called Caprese, and from that morning it would start to occupy an increasingly respectable place in the world's historical memory. The child would be called Michelangelo, and would become a painter, sculptor, architect and

eventually the most famous artist of his time. Of the places that would form the backdrop to his long life – the greatest and most magnificent of these being Florence and Rome – that desolate land overhanging a deep Apennine valley and only fit for goats has the most to say about his savage and unsociable character, even though he left only a few months after his birth.

The day that finally put an end to Ludovico's anxieties was 6 March 1475, but for the Florentines who followed a calendar in which the year began with the Incarnation, which according to tradition was 25 March, that date corresponded to 6 March 1474. Ludovico diligently recorded the difference between these dates in his memoirs:

> Today I put on record that on this date of 6 March 1474, a male child was born to me. I gave him the name Michelagnolo, and he was born on Monday, four or five hours before morning. . . . Note that the date 6 March 1474 is from the Incarnation in the Florentine mode, and from Christmas in the Roman mode, it is 1475.[1]

The night that greeted Michelangelo into the world had stars that fortunately were unconcerned about the different dating system which, like so many other things, divided the statelets of Italy. In Rome it was 6 March 1475, in Florence it was 6 March 1474, but in the heavens Mercury and Venus were entering the second house of Jupiter and determining a destiny strongly influenced by sensuality, albeit a sensuality depicted in every way and hardly ever experienced.

Two days later on 8 March, Michelangelo was baptized in the small church of San Giovanni, a saint who was dear to the Florentines, in the presence of the church's rector, a notary and a few of the townspeople from Caprese. Ludovico's term of office ended on the 29th of that month and, as soon as they were ready to travel, the family left for Florence. Michelangelo, however, did not, as he was handed over to a wet-nurse in the small town of Settignano, some three miles from the city, where the Buonarroti owned a small property: 'A farm . . . with a house for a gentleman and a labourer, and cultivated fields and vines and olive trees,'[2] which produced an income of only 32 florins, but later Michelangelo would transform it through subsequent purchases into a substantial estate.

The use of a wet-nurse was customary in Florence, where scholars unsuccessfully attempted to argue the importance of the bond created between mother and son during breastfeeding. Anyone who wished to demonstrate their affluence was required to hand over their children to wet-nurses, leaving the natural mother with the only task of any importance to the husband, that of fertile producer of an unending succession of children. In Florence, the family was essentially a male preserve, just like business and the affairs of state. The custody of new-born babies was personally arranged by the father, who signed a contract with the wet-nurse's husband or father. Women were simply chattels, and never took part in this trade between families. The mother was very quickly excluded from the education of her children, who almost immediately after their return home were subjected to a family ethos that was exclusively male. Women were held to have such an inessential role in this transmission of the family's ethos and bloodline that, in the event of widowhood, they were compelled to abandon their children and their dead husband's home, taking their dowry in the hope of finding a new home in which to use their reproductive apparatus in the service of another man.

Children were entrusted to a wet-nurse for a period of about two years, until they were weaned. Generally the original family supervised the child's development from a distance. Only a few families could afford to keep a wet-nurse under their own roof or even in Florence. More usually, they entrusted the babies to young women in the Florentine countryside, as these were less expensive than wet-nurses in the city.

Settignano looked over Florence and the Arno Valley. Then, as now, olive groves and vineyards flourished there. It was the area in which they quarried the *pietra serena*, a grey clayey rock that was easy to work and had been used for centuries for the most important buildings in the city. Brunelleschi had used it to make perfectly geometrical columns and arches. The quarries of *pietra serena* had developed into a highly profitable industry, and everyone in Settignano worked the stone in some way: they quarried it, they cut it and they shaped it. When they became particularly skilled, they moved down to Florence and opened a sculptor's workshop. Occasionally they specialized, as did Desiderio with his melancholic madonnas. In other words, it was a town of stonemasons, and the wet-nurse who took in the little Buonarroti was a stonemason's daughter and a stonemason's wife. Michelangelo

would later say that the decision to hand him over to that home deter-
mined his fate to be a sculptor, given that the first sounds he heard
were undoubtedly those of the chisel on stone and the milk he drank
was mixed with marble dust. But the coldness of the marble in whose
company the baby grew could be seen as a symbol of another dramatic
feature of his destiny: the coldness of family emotions that would cause
him much suffering throughout his life.

2 MAGNIFICENT AND HEARTLESS FLORENCE

The Florence that greeted little Michelangelo is much easier to visual-
ize than to understand. Its image is preserved with the clarity of a spring
day in Francesco Rosselli's *Veduta della catena*, which he drew in 1472
with the analytical technique that suddenly brought Florentine artists
to the cutting edge of figurative representation. It is much more diffi-
cult to penetrate the complex mechanisms of government of a city-state
which formally had all the appearance of a republic, but in reality was
using highly sophisticated and modern methods of control to become a
secular principality under the dominion of a family of bankers. Even in
the twenty-first century, historians are excited by and divided over the
forms of powers developed at that time.

The population of Florence, which had reached 80,000 in the period
immediately preceding the Black Death in 1348, was struggling to get
back to 40,000 at the end of the fifteenth century, and the city was fight-
ing with all its prodigious energies to maintain a leading role amongst
the Italian states, whose balance of power was always precarious: the
Church, the Kingdom of Naples, Venice and the Duchy of Milan were
being fought over by foreign powers. Florence's particular strengths
were the wealth of its trade and the rationalism of its political organiza-
tion, which explained the intelligence of its alliances with other states,
which in turn were essential to its domestic autonomy.

Francesco Rosselli's view of the city shows how this organization
was translated into town-planning (Fig. 1.1). The city was a discrete
and fully formed entity. The districts, which brought together and
organized the population, acted as intermediaries between the family
clan – the true political unit of the city – and the municipal authority.
Each one was gathered around one of the churches built in the previous

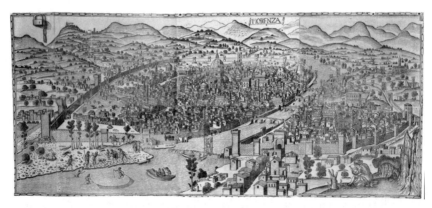

*Figure 1.1 Francesco Rosselli, Veduta della catena [View of the Mountain Chain].
Detail of Francesco Rosselli's view of Florence. Vatican Apostolic Library,
Vatican City
bpK/Kupferstichkabinett, Staatliche Museen zu Berlin Photo: Jörg P. Anders*

century, Florence's golden age: Santa Croce, Santa Maria Novella, Santa Trinità and Badia, which all still had gothic forms, and San Lorenzo and Santo Spirito, which had an apparently very new design but actually one that went many centuries back in Italian history. Only a class fixated on the singularity of its own destiny could have accepted such a stunning and creative rigour.

Clear straight roads linked the strategic points of the city, and passed the seats of the many powers that challenged each other. Above all, there was the cathedral, around which the entire view and the city itself appear to have been built. The Florentines had wanted it to be vast and covered by Brunelleschi's miraculous dome to celebrate the faith of their citizens, which was quite distinct from the authority of Rome – something they had never held in awe. During that very period, they had hanged a bishop from a window of the *palazzo comunale* for having meddled a little too much in local politics. In order to make absolutely clear the extent to which Florentines were attached to their independence, the bishop was hanged in the company of other condemned men and left there for a few days. Even the children could understand the lesson.

Just as imposing as the cathedral and piercing the skyline with the most famous crenellated tower in Italy, Palazzo della Signoria was the government's military garrison and located close to the Arno. It

was supported by Palazzo del Bargello (then Palazzo del Podestà). In Rosselli's drawing, it is possible to make out other places, no less representative of the city's life, around these strongholds of power. These are the *palazzi* of the aristocracy, not knights or feudal nobles but patricians of wealth, mainly merchants and bankers, who had acquired the right to govern one of Europe's richest cities by themselves. Because of its elevated position, Palazzo Pitti stands out and dominates the district of San Felice along Via Romana on the other side of the Arno. Others, however, can be confused with the surrounding buildings: so the Palazzo dei Rucellai, the Palazzo Spini Ferroni at the entrance to Holy Trinity Bridge, and the Palazzo dei Medici, which was built by Michelozzo in the north of Florence in a district which, even by the time of Rosselli's drawing, had become a little family enclave, a city within the city with its own church (San Lorenzo), its own monastery (San Marco) and numerous other annexes, gardens and houses to suit the social and military needs of the rich family that held Florence's destiny in its hands.

Rosselli's drawing also shows extensive empty areas, and these were used for vegetable gardens on the precious land within the city walls. It had been the hope of the Florentine government that these areas would be filled with the houses of new citizens, but the demographic growth was not keeping up with that of the previous century. Another significant reality that is clearly shown in the drawing is the huddle of several buildings, connected in various ways to create a kind of *insula* within the district. Each of these groups of houses belong to a family clan, the nuclei that reflected the basic form of the city's social structure. Governed by one or more men, the clan found that this spatial aggregate could interact with the city as a political unit with a strength that could not have been attained by any individual or householder. It was the simplest and crudest form of the Florentine *consorteria*, an association that bound together its members and would mark all the subsequent history of the city. Above the family *consorteria* there was the district *consorteria* and then the city *consorteria*: the three most significant administrative layers in republican Florence.

Finally, in the bottom-right corner of the drawing, in the vicinity of Porta Romana, we can see some condemned men who have been hanged from delicate little trees and left to rot in the air for all to see.

It was a clear warning that the city, whose order and prosperity was reflected in its many *palazzi*, could display in a manner that no other city could. Not even Rome, for all its princes and cardinals, was founded on such severe and brutal social relations and laws. Florence was not a merciful city, but rather a practical city – practical to the point of cynicism. While Rosselli was carefully capturing this architectural marvel in a drawing to be left to posterity, another Florentine, who was no less intelligent and no less passionate about his native city, started writing a simple but unfaltering diary, which guilelessly tells of the everyday life within those elegant walls and on those proud streets. This memoir helps us to imagine what little Michelangelo felt and saw on return from exile in Settignano:

> And around 8 o'clock in the evening of 17 May 1478, young lads disinterred him again, and with a piece of noose that was still around his neck they dragged him around the whole of Florence. And when they were outside the door of his house, they put the noose through the ring-shaped knocker and pulled him up, saying 'knock at the door', and then around the city they did many other acts of derision. And when they were tired and didn't know what to do with him, they went to the Rubaconte Bridge and threw him in the Arno. And they made up a song that contained worthless little ditties, one of which went as follows: Messer Jacopo went on his way down the Arno . . . And seeing him floating down under Florence and seeing him always on the surface of the water, were the banks and the bridges watching him go by.[3]

This is Luca Landucci's description of how they tormented the corpse of Jacopo de' Pazzi, one of the authors of the plot against the Medici family on 26 April 1478. Lorenzo de' Medici had more than seventy men slaughtered in a few days, in part to punish the conspirators but principally to free himself once and for all of his political opposition in the city. He had them hanged at the windows of the *palazzo comunale*, and every now and then one of them was dropped to the ground so that the poor could steal their stockings and clothes. One of the plotters, a priest, met with an even more horrific fate: he was quartered in the square, and then his head was removed, placed on a

pike and carried around for a whole day. Little Michelangelo had just arrived in Florence, and they were still carrying him on their shoulders. These scenes made such an impression on him that he retained a vivid memory of them until the day he died.

3 A RESTIVE APPRENTICE

In Francesco Rosselli's drawing, you can see the great bare facade of the church of Santa Croce just behind the *palazzo comunale*. The church is wedged between houses of the district which bears the same name. The houses of the Buonarroti are amongst them. On several occasions during the fifteenth century, before the family went into decline, some of its leading members were put forward to represent the district in the election of the Dodici Buonomini, one of the most important bodies in the city's government.

As a small child, Michelangelo would certainly have found his family's city home unfamiliar. He must have had similar feelings about Francesca, his mother, who by 1477 had already given birth to another of Michelangelo's brothers, Buonarroto, and then gave birth to Giovan Simone in 1479. She still had enough time in this world to bring Sigismondo into it in 1481, before dying that same year, probably from childbirth. During the six years in which Michelangelo had a mother, everything conspired to prevent her from looking after him: the lack of maternal warmth left the child with the emptiness that was responsible for all the pain of his future life. Typically for a Florentine of the period, Ludovico lost no time in finding another wife and in 1485 he married Lucrezia degli Ubaldini. But he was no more fortunate on this occasion, because he was a widower once more in 1497 and had five children to look after. Before getting a position of some importance within the administrative system, he would have to wait until 1510, when he obtained the governorship of San Casciano.

In accordance with the family tradition, Michelangelo should have received a classical education, a respectable beginning for a career as a merchant, banker or money-changer. Unfortunately financial difficulties drove Ludovico to put the young Michelangelo into an artisans' workshop. According to Vasari, this occurred in 1488, but documents show that it must have been much earlier, given that

the child was already collecting a payment from the Ghirlandaio brothers on 28 June 1487, when he was twelve years old. The trust the employers were putting in the small boy suggests that he had been working for them for some time: 'Domenico di Tomaso del Ghirlandaio must pay on 28 June 1487, three florins [*fiorini larghi*], which Michelagnolo di Lodovico changed to 17 liras [pounds], 8 soldi [shillings] . . .'.[4] Whilst still a child, Michelangelo started off on a life of hard work, as was the custom for those who were to take up the trade of artist in Florence at the time. This was perhaps the only moment when his life was similar to that of other artists about whom we have information.

Ludovico's decision was undoubtedly a hard one, because it signalled the family's inexorable decline. Michelangelo's patrician origins were thus renounced by his embarking on a career as a craftsman, which was foreign to the moneyed classes of Florence. The public records in Florence remove any lingering romantic illusions about the role played in the Renaissance city by the men we think of as leading players of the time. In reality, they had little access to the city's political life because their status was considered too lowly. There is almost no trace of artists being involved in the government of republican Florence, even in some modest position. In the elections carried out between 1378 and 1532, when the Medici definitively put an end to constitutional government, there were about 23,100 ballots for positions on the *Tre Maggiori*, the three most important administrative bodies. Names of known artists only appear on five occasions. These were almost always figures with important social functions, such as the master builders working on the cathedral and baptistery, Lorenzo Ghiberti and Filippo Brunelleschi. Generally those who managed to break through the social barriers and enter the governing class attempted to change their professional profiles. This is what the heirs to Giotto and Taddeo Gaddi did, as did the heirs to many other successful artists.

Michelangelo was undergoing the painful business of slipping down in the opposite direction, from the aristocracy to the artisanal class, and had to face up to all the consequences that went with this fall. His prodigious talent would reverse this decline and shatter all the social and cultural barriers of his time. It comes as no surprise that, when he snatched the seat next to the pope from the cardinals and the

seat next to the king from the ambassadors, the artist would attempt to hide his early career as an unremarkable apprentice and replace it with an ineluctable calling of the spirit which his father Ludovico is supposed to have unsuccessfully obstructed. The truth is that if the family had not needed the apprentice's money, Michelangelo would have started his education at the age of six, and that education would have included Latin. But the artist never learnt that language, because he received only a very modest education, even before commencing his apprenticeship.

The Ghirlandaio brothers' workshop was considered to be one of the most important at the time, and not only because of the 1,100 florins they manage to get for the frescoes in the chapel of Santa Maria Novella on which the young apprentice is supposed to have worked, according to tradition. The Ghirlandaio brothers appear to have been amongst the artists with the highest social status. They had a family name, which in itself was a mark of distinction, and they were one of the very few artist families who appeared in the ballots of important public office (Ridolfo Ghirlandaio in 1518 for the Council of the Twelve). Thus even the choice of workshop demonstrates the lengths to which Ludovico would go in order not to stray too far from his social origins.

The apprenticeship in the workshop was very hard work and started with the most humble tasks. First of all, the apprentice had to learn to look after the tools of the trade and keep them in complete working order. Then he had to become familiar with the materials, from the simpler ones, such as lime mortar, to the more complex ones, such as the primers used to prepare surfaces for painting and milling to make colours. This servitude to adults did not leave a great deal of time for learning to paint and draw. The apprenticeship was a slow process and the time spent in service was supposed to pay for access to the secrets of the trade. Only when an apprentice was completely expert with every material and its use, could he start to work as a genuine assistant to his more senior colleagues: preparing the surfaces for painting, spreading the glue and chalk primer over wooden surfaces in order to have a clear and smooth base on which to paint tempera colours much later, and painting in small portions of the background for more senior artists.

During their brief periods of rest, the boys were permitted to prac-
tise their drawing skills. However, they had to do so sparingly, as paper
was very expensive and could not be wasted. One of the greatest privi-
leges was that of being allowed access to the models belonging to the
master of the workshop, which were indispensable to learning the art
of drawing. Copying the workshop's models was then supplemented
by the study of works carried out by other artists in the churches and
palazzi open to the public. In this field, Florence could boast the rich-
est display in the whole of Europe. Michelangelo, like the other young
apprentices, copied the models in the workshop and the works of great
artists of the past, particularly Giotto and Masaccio, whose realistic
depiction of the body and natural plausibility he valued a great deal
even then. He was already attempting to improve on them and showing
himself to have supreme critical abilities.

The workshop was governed by a strict hierarchy. But the young
Michelangelo, perhaps already painfully aware of his own social decline,
committed the most serious transgression possible for an apprentice: he
competed with his own master and humiliated him. According to his
most reliable biographer, Ascanio Condivi, Michelangelo went so far as
to improve upon a model prepared for him by Domenico Ghirlandaio
and, even worse, he laughed about it with another lad in the workshop.[5]
This apparently innocuous episode not only revealed the artist's arro-
gance, which kinder critics have defined as his daunting talent, but also
the enormity of the master's defeat, and indeed Ghirlandaio took the
boy's insolence very badly. Apart from boasting an unparalleled techni-
cal excellence in its frescoes and panels painted in tempera, Domenico's
workshop was known for being at the forefront in drawing and for
the naturalness of its invention, and this was due to Domenico's own
talent, which ensured his dominant position in the Italian market. The
existing drawings by Domenico are striking for their refinement, the
sureness of his hand, the believability of the anatomic proportions, the
decorous, almost classical moderation of the expressions and the nar-
rative richness in the detail of the clothing and pleats. This great store
of excellence built up by a small industry was reduced to nothing by a
teenager, who was moreover in the workshop's pay and there to learn
the 'trade' he ridiculed. It is easy to imagine that the master's reaction
was not a mild one, and it triggered contempt in his young and arrogant

pupil, which over time would become ingratitude and a denial of the contribution that the highly skilled brothers gave to the apprenticeship of a genius.

Both the master and the pupil must have realized that the apprenticeship would not end as it did for all other apprentices. Shortly afterwards, we find that Michelangelo had been freed from the workshop and was dealing with a family group of an entirely different rank: the one gathered around the effective ruler of Florence, Lorenzo the Magnificent.

4 THE GARDEN OF WONDERS

As with many ancient heroes, there had to be a garden in the destiny of a man whose life already tended towards the legendary.

The garden that opened new horizons to the adolescent apprentice painter and closed the door forever on his possible life as an artisan, ran alongside Via Larga, between the monastery of San Marco and the Medicis' new *palazzo*, and was separated from San Marco Square by a wall slightly higher than a man. Its perimeter measured a few hundred metres and was closed off on two sides by an arched loggia. Its plan was unremarkable, as were the trees it contained, probably bays and lemons, and certainly a line of cypress trees which could be seen on every side of the square and which identify the garden in the few existing pictures of it from that time.[6] It was not yet customary to have recreational gardens in Florence, as its rich patricians were in the habit of moving to their country mansions when spring came, where they enjoyed the delights of nature to the full. The renowned and very remarkable garden, which somehow escaped the pressure for building plots in the city centre, owed its status to the collection of ancient and modern statues Lorenzo de' Medici was collecting and keeping there. There were whole statues and fragments, which were precious for their antiquity. Perhaps the cypress trees, which protected them with their shade, made them feel a little more at home in that northern city. The statues certainly helped the young students of antiquity who came to study them, to imagine that Homer's sparkling sea lay behind the dark green of the trees, and that the dazzling rocks from which their stone was extracted came from the sun-drenched islands of the Aegean.

In 1471, Lorenzo visited Rome in the company of the greatest counsellor on cultural issues in Italy at the time, Leon Battista Alberti. He witnessed the frenzied manner in which princes and cardinals were collecting the sculptures dug up every day from the generous earth of the Eternal City. These marvellous relics were put on display in the gardens of the *palazzi* and began to form the early versions of the collections that were to grow in centuries to come and would so enhance the majesty of modern Rome. In the meantime these astonishing 'antiquities' conferred a new nobility on their owners, one based on good taste and culture, and not just wealth. Latin and Greek inscriptions, fragments of sculptures and architecture were amassed amongst the fountains and porticoes which attempted to imitate those very decorations that had survived on ancient marble. Ownership of these ancient relics conferred a social distinction that no longer feared comparison with the well-born, or rather it increased the prestige of the well-born.

This fashion could not go unnoticed by Lorenzo, who was struggling to build the legitimacy of his prince-like status and that of his family. His grandfather Cosimo had brought the Medici to a position of pre-eminence amongst Florentine patricians, by using an intelligent and prudent policy of obtaining consent from the social and constitutional structures of the Florentine Republic. Without any apparent changes to the constitutional forms of government, Cosimo and his allies had taken over the most significant posts within the city's administration. By exploiting his considerable wealth (which was not, however, one of the greatest in Florence), he was able to buy control of the government. From this dominant position, he embarked upon a deadly campaign to destroy his political adversaries. He reduced the wealth of those families who could oppose him, by exacting exorbitant taxation from them, while at the same time bolstering the fortunes of men and family groups of more modest means in order to obtain eternal gratitude and the certainty of never being challenged in his position of control. The city exiled those leading citizens who could have competed in excellence with the Medici. The Strozzi were condemned to this fate, in spite of their enormous wealth. Thus the government of Florence was firmly in the hands of the Medici and lost any democratic content, even though formally the Republic continued to exist.

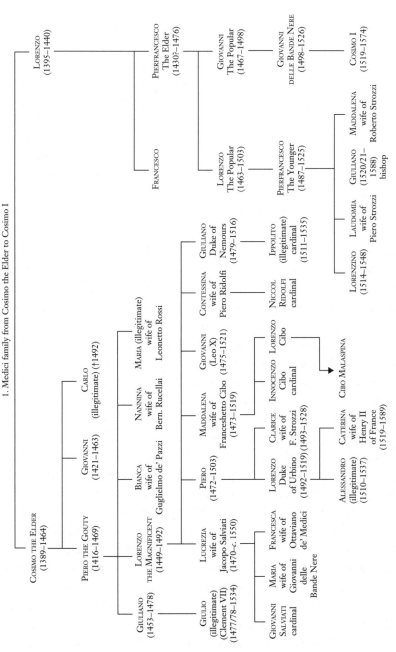

1. Medici family from Cosimo the Elder to Cosimo I

Figure 1.2 The Medici family, from Cosimo the Elder to Cosimo I

Cosimo's grandson, Lorenzo, had to take over the business of defending the family's interests from his father when he was still very young, and by then those interests were identical to those of 'their' Florence. At the time the family's fortunes had started to wane considerably. Many of his opponents were convinced that he would not survive the financial crisis afflicting the family, in spite of its shameful abuse of power. But it was precisely the foolishness of the opposition that allowed him to re-establish the firm legitimacy of his rule. The Pazzi family, which was wealthier and more ancient than the Medici one, had been terribly mistreated by Lorenzo, who was fearful of its greatness. Some of its members were unwilling to wait for the crisis in the Medici camp to take its natural course and organized a plot against Lorenzo and his brother Giuliano, with the support of Gerolamo and Raffaele Riario, relations of Sixtus IV. On 26 April 1478, while the city notables were taking mass to celebrate the Resurrection, the plotters suddenly appeared from behind the high altar and attacked Lorenzo and Giuliano. The latter was immediately killed, but Lorenzo managed to defend himself and he and his most loyal followers barricaded themselves in the sacristy.[7] The city rose up against the plotters and not against the Medici, as Jacopo de' Pazzi had mistakenly expected. Lorenzo's skilful plan of seeking support amongst the lower classes was bearing fruit, and now they were defending him against attack from the highest ranks of the aristocracy.

Having survived the plot, Lorenzo immediately understood that he would never have a better opportunity to consolidate his rule. The repression was brutal and motivated by the need to destroy political opposition in its entirety, irrespective of its role in the plot. There were dozens of fatalities, and Lorenzo managed to introduce constitutional reforms that assured the stability of his government, which from then on was clearly tyrannical, although mitigated by the civility of his manners. He had his own armed guard and powers to exile his enemies, which gave him complete control over the city, even though republican procedures formally remained in place. Very soon, rulers and ambassadors abandoned the habit of engaging in talks with the priors in the Palazzo della Signoria and went straight to the *palazzo* in Via Larga where Lorenzo lived, as he was now the true prince of the city, although officially he had no role in government at all.

This very singular form of tyranny, which was exercised by an ordinary citizen without any royal or divine investiture, needed a very shrewd policy of social control, which above all respected the city's traditions and 'civilization'. This civilization was a very difficult value to define, but for Lorenzo's contemporaries it was a very clear reality to which they continually referred in their sophisticated political analyses. It mainly consisted of observing public virtues and ensuring that the state was governed in a manner that brought honour to the city's entire community and cultivated the basic principles on which it had built up its power. The most important of those principles was the impartial administration of justice and the dignity of individuals. In this, Lorenzo was outstanding, and his wisdom gave his government a rather discreet nature, which did not flaunt his personal power and appeared to permeate the city as a whole. His greatest political asset was his skill in governing and subjugating the city's magistratures without ever challenging their independence publicly.

Art and the promotion of art would play a central role in this strategy of consent. Florence's founding myth was undoubtedly the resourcefulness of its citizens, but art as a means of representing this attribute was cultivated to such a degree that it turned the entire city into a community of critics and admirers who participated in various ways in the production of art, which was already famous throughout Europe. Although it never went so far as to confuse art with the nobility of the liberal professions, Florence had occasionally shown itself capable of broadening its political network to include in government those who, by their art, had contributed to the city's good name, although this was only for appointments of lesser importance. The public recognition conceded to Giotto, Brunelleschi and Ghiberti is evidence of this.

Lorenzo had no intention of passing up this traditional mechanism. He gave a great deal of space to the arts and he co-opted intellectual energies capable of celebrating his own greatness. But he always gave the impression of celebrating the greatness of the city. The magnificent *palazzo* that he had Michelozzo construct in a district of little importance before the Medici claimed it as their own, was touted as a new jewel that increased the esteem in which Florence was held, rather than that of its owners. In reality, that *palazzo* was the kind of fortified citadel that in other cities would have been home to the prince's court, but in

Florence this would have clashed with republican sentiments and the competitive spirit of other rich families who were not yet resigned to the idea of Medicean supremacy.

The forms thought up by Michelozzo were powerful but graceful, and evoked the elegance of classical architecture. He brought a new design into the city, which made the Palazzo della Signoria look like a gigantic stable in the country. The interior decorations did the rest of the work, and enchanted the Florentines who, because of Benozzo Gozzoli's frescoes, got into the habit of perceiving the Medici as the new Magi and were no longer surprised when Lorenzo showed off in processions through the city that gave life to the figures in gold and lapis lazuli painted on the walls of his own *palazzo*.

The San Marco garden, adjacent to the Dominican monastery and not far from the Medici *palazzo*, was little more than one of the more sophisticated manifestations of this strategy of political seduction through a series of images. Lorenzo had brought the idea back from Rome. But he needed something more: he was the prince of a city and could not just content himself with the collection of works of art that expressed his good taste and sophistication, as in the case of the nobles and cardinals who lived in the Eternal City. He needed, albeit discreetly, to create a court around himself and make the city aware of the presence of a cultural focal point that was substantially different from the artisans' workshops that had characterized mercantile Florence and belonged to the city's industrial make-up, and whose precise rules were comparable with those of the other productive 'arts'. His garden had to evoke the munificence of the ancient princes and academies, whose knowledge was perpetuated outside the rigid straitjacket of medieval guilds.

He gave responsibility for the garden to Bertoldo, a sculptor who had studied under Donatello, the unchallenged master of the previous generation who more than any other artist personified the city's artistic talent. His professional competence was much in need, as the garden had been created around a collection of ancient and modern statues, and therefore required an expert sculptor. Centuries ahead of his time and before the introduction of artistic academies, Lorenzo was getting young men to study the models of perfection which the artistic technique and culture of central Italy had been striving to revive for at

least a hundred years. His control of the entire city made it easier for him to concentrate in that garden not just artists, poets and thinkers, but also scholars of every discipline who commented upon the works in accordance with a tradition that went back to the classical age and was recorded in ancient books, whose collection, translation and propagation was another element within his cultural strategy. Anyone with talent and discernment was drawn into a network of relations that was controlled discreetly and increased the prestige of the Medici family in direct proportion to the fame of its courtiers.

5 THE FINAL SALUTE TO DONATELLO

Lorenzo had cleverly organized a princely court within a stubbornly republican city. The plan was so successful that the banal epithet 'magnificent', which was used for other leading citizens as well, was transformed by his biographers into an integral part of his name, which has forever ensured him an important place in history.

The subtlety with which he constructed and maintained his governmental strategy appears to have been imprinted on the cunning and somewhat shifty features we find in his portraits and on his coins. Not a tall man, he was slightly stooped because he suffered from gout. With his straight hair and jutting chin under a round and broken nose, he would undoubtedly have been considered ugly if it weren't for his highly intelligent and inscrutable eyes, like those of a fox with whom it seemed natural to compare him. Those dark and gentle eyes betrayed the extreme sentimentalism that surprised his contemporaries and which bound him for many years to a woman who was neither young nor beautiful, at a time when men of his rank did not think twice about using violence and rape against girls and young men, as occurred in the cases of Galeazzo Visconti and Cesare Borgia.

Those who knew him well and were immune to his insidious seductiveness have left us a portrait that is highly unflattering and could assist our understanding of why he was so friendly to the young Michelangelo and immediately recognized the latter's enormous talent. In his treatise on the government of Florence, which was written immediately after Lorenzo's death, Girolamo Savonarola warned the Florentines against the dangers of tyrannical government and, in particular, a tyrant who

had neither royal nor divine right, as in the case of Lorenzo. He spoke of Lorenzo's cynicism and cruelty, and of the violence with which he destroyed the just and the courageous to prevent them from taking on a role in government of the state, while unscrupulously favouring mediocrities to the detriment of Florence. Savonarola denounced the greed with which Lorenzo emptied the city's coffers and the vanity with which he wanted at all costs to impose himself on others by exploiting art and grandiose ceremonies. The preacher also criticized the resulting licence to unbridled vice in which the Medicean ruler sought consolation, the solitude into which he was forced by his own tyranny, and the lack of rules applied to his own behaviour.[8]

The tyrannical Lorenzo certainly had all these defects, but he was not lacking in intelligence, good taste and emotion. He immediately understood that the ambitious teenager of noble birth, Michelangelo dei Buonarroti, had a great future ahead of him. He therefore wanted him in his San Marco garden and in his home, the very *palazzo* that, forty years later, the artist would actually attempt to demolish, the pinnacle of his extreme ingratitude.

On moving from the Ghirlandaio workshop to the San Marco garden and the *palazzo* in Via Larga, Michelangelo found in Lorenzo the first critic of his sculptures: this was the means for the greatness of the prince to herald the future greatness of the young artist, and with smoke and mirrors to consolidate the perceived sophistication of the patron and the perceived talent of his protégé. When he was just fifteen, Michelangelo was busying himself with the mask of a faun copied or inspired by ancient models, which sadly has not survived. He had abandoned the paintbrush for the chisel, which he knew how to use with a skill poor Bertoldo lacked. The latter had become the guardian of a tradition that the young man already found insufferable. Lorenzo was pleased with the faun's head and, aware that its creator was a boy, made fun of him and reminded him that the old, even if they are fauns, cannot have so many teeth, as the boy had sculpted them. Not wishing to offend either nature or Lorenzo, Michelangelo lost no time in breaking the faun's teeth: 'he removed one of the upper teeth from the old faun by drilling the gum, as though it had come out with the root, and the next day was desperate to see the Magnificent.'[9] This pleased and greatly amused his illustrious host.

However, Lorenzo and the ageing Bertoldo, now close to death, were not the only people he had to deal with in the garden. There were also less talented but no less ambitious young men. One of them, Pietro Torrigiani, who came from a family of high social status, had been introduced to sculpture by Bertoldo and was gifted with undoubted talent and, unlike the young Michelangelo, a startling beauty. It is easy to imagine that his arrogance in that ambivalent context of social transition was a match for Michelangelo's, given that conflict between the two very soon produced violent results. Michelangelo got the worst of it, and the other boy's fist broke his nose and disfigured his profile, which had never been handsome, for the rest of his life. Even as boys, Michelangelo and Pietro experienced the bitterness and violence of competition for success.

At the court of Lorenzo the Magnificent, where he remained until 1492, the year of Lorenzo's death, Michelangelo also met Angelo Poliziano, who persuaded him to depict one of the most beautiful of Ovid's fables: the abduction of Hippodamia and the resulting battle between the Centaurs and the Lapiths. The legend tells of how the Lapiths and the Centaurs, who were half man and half horse, lived together in close friendship in the shady mountains of Greece. The latter were invited to Hippodamia's wedding by the king of the Lapiths, but unfortunately they very soon lost control under the influence of the alcoholic drinks served at the banquet, and attempted to abduct the bride. This triggered a brawl from which the Lapiths emerged victorious. The legend was part of the mythology surrounding the founding of Greek culture and later the Roman one, because it recalled the times of uncouth human prehistory, symbolized by the Centaurs who were still half beast, and the final affirmation of civilization through control of one's own instincts and through the spirit of reason, which made mankind superior to the natural world from which it came. This rich allegory on how progress flowered was clearly attractive to the humanistic culture of the time, particularly in Florence, which was proudly projecting itself as the heir to the virtues of republican Rome. By identifying itself with a mythical age, the city felt it was responsible for a rebirth of civilization. As never before or after, a whole tribe of Centaurs populated Florentine paintings and filled the ranks of the city's marble and bronze statues, particularly amongst the artists who gravitated around the Medicean court of the time.

Michelangelo's interpretation of the theme suggested by Poliziano seems rather uninterested in the story's allegorical meaning, and thus Vasari incorrectly thought it was 'Hercules' battle against the Centaurs', while the more reliable Condivi describes it as the 'Abduction of Deianeira and the Fight with the Centaurs' (see Plate I.1).[10] But this in no way lessened the great satisfaction of his patrons. Although it doesn't narrate the sequence of events described by Ovid, the marble perfectly restores the 'ancient' nature of the fable, and indeed the relief does initially have all the appearance of being from the side of a Hellenistic sarcophagus. The sculptor concentrated all his interest on the bodies galvanized by fighting and the tensed muscles of the limbs that are so intertwined that it is difficult to distinguish to whom they belong: men or Centaurs. Michelangelo's youthful candour can clearly be detected in the ambiguity of this tangle of muscles, and the work's innovativeness is to be found in his ability to transform all the marble into relief and create levels of representation that shift only very gradually from the surface to the deepest relief with a harmoniousness that had previously only been seen in the very best ancient sculpture.

Instead of setting out the figures on parallel planes that were clearly separated from the deepest level, as had been done up till then and with great skill by Ghiberti and Donatello, Michelangelo created a seamless continuity of an infinity of levels that without any appearance of artifice appear to merge into each other. He felt no need to plan a series of abstract levels in order to organize the transformation from drawing to sculpture. Roman sculptors of the first and second centuries AD had achieved similar effects in their panels as the result of a centuries-long development of their customs and skills, but they retained a certain rigidity in the sequence of parallel levels of separation. This resulted in the representation not of a real space in which the figures could be formed, but rather of a hierarchical space in which each figure was set in a plane which was parallel to and clearly distinct from the others. Michelangelo proclaimed his own personal revolution when he sculpted the *Battle of the Centaurs*. At the same time, he managed to restore harmony to the perspective of the individual body; in other words, he was able to posit in space a body that was no longer static but in movement, with limbs that gradually extended themselves and no longer belonged to different planes. A body's joints or *appiccature*, as they were called in

the Italian of the time, were perfectly articulated, in spite of the fact that wrists, shoulders, elbows and knees had always been a torment for sculptors. They now joined other limbs without appearing to be locked, as can be seen in the twisting figure on the left of the relief, which is something of an artistic manifesto.

The other innovation introduced by the teenager (for he was still a teenager) was that he managed to perceive the potential within each single portion of marble, without reference to the preparatory drawing, and could thus transform the undercut of a body into the body immediately behind it, until it all merged into the final plane as in a liquid from which the other bodies emerge only through subtle gradations. The result must have stunned even his admirers, and the unfinished state in which he left the relief could only have underscored its value as an artistic manifesto. Many of the bodies are still marked by the gradines that Michelangelo used to sculpt the details of the relief after a rough cast with a chisel and after his bold use of drills to produce undercuts that were then joined and deepened with a chisel. This too demonstrated the highly precocious nature of Michelangelo's revolutionary technique: not simply an ability to see the marble in its three dimensions independently from the drawing that could be traced on its surface, but also an ability to use a gradine or chisel right down to final surface, when other artists would more prudently want to use a file. The risk in Michelangelo's technique was to ruin the statue's final surface by hitting the chisel too hard and causing it to dig deeper than intended. As far as we know, this never happened to him in his long career. We are, however, aware of the advantage of this extremely risky technique: it made it possible to create sudden changes and a rapid shift from concave to convex, whereas the file used by previous artists stiffened the figures and inhibited the composition, by precluding the kind of vitality that pulsates in Michelangelo's marble.

The youthful nature of the work emerges from some incongruence in the form, which was caused by the difficulty in fully connecting three-dimensional bodies in such a crowded space. The centaur who has been prostrated in the foreground displays an excessive and not very convincing separation of his human back from his horse-body, just as the figure falling on top of him cannot find sufficient space between the wounded centaur and the man seen from behind, who is grasping

a reclining figure by the hair. Equally the artist failed to resolve the contact between the buttocks of the reclining figure and the right leg of the man whose neck is being squeezed by an adversary. However, the relief is entirely credible and skilfully depicts the fury of battle and the muscular force of those engaged in it.

The extent of this revolution can be fully understood by comparing *The Battle of the Centaurs* with another of his reliefs from more or less the same period, which displays an expressive style still very much tied to contemporary, late fifteenth-century models: the *Madonna della Scala* (Plate I.2).[11] It is a fairly typical example of a Florentine votive relief, as skilfully developed by Donatello. Bertoldo would certainly have been attempting to teach this style to the young men who frequented the San Marco Garden. The *Madonna della Scala* still applied Donatello's technique, which was founded on several well integrated and yet parallel planes on which the foreshortened figures were spread, as though separated by an invisible but impenetrable obstacle. Michelangelo raised this technique to its highest degree of perfection, but at the same time he revealed its technological limitations.

The first and most noticeable incongruence appears in the Madonna's arm, which is almost separated from the hand that holds the child. He completely fails to deal with the problem of the perspective of the right foot and the steep steps on which a *putto* displays an excessively high relief in his shoulder and a very low relief in his legs and body. This all suggests a young artist still coming to terms with a very rigid method of working marble. He sketched the profile of the figures on the most external plane of the block, and struggled to shape them on their parallel planes. Only afterwards, did he attempt to hollow out, create the relief and give expression to muscles and folds of cloth within these planes from whose limitations it is impossible to escape.

We can perceive the talented youth's ambition in this desire to provide the relief with greater force and majesty. The monumental nature of the figure trapped within the marble block heralded all the later developments. It is clear in the first, or one of the first, of his works in marble, that the marble block would never be able to satisfy him: the Madonna could shatter the boundaries just by slightly straightening her neck. Even the compactness of the baby's body proclaims the vigorous anatomies of subsequent works. Another factor that influenced the

young Michelangelo was his fascination with the ancient. While the *Madonna della Scala* is a descendant of Donatello's reliefs, it is also true that the composure of the movement and the abstraction of the physiognomies and expressions remind us of ancient funereal reliefs.

Finally, the steps that have more depth than height are a promise of spatiality within the form, which will be fully achieved in the *Battle of the Centaurs*. The *Madonna della Scala* appears for these reasons to be a typical exercise in the tradition of Donatello, encouraged by the diligent custodian of the garden, the ageing Bertoldo. Only with the *Battle of the Centaurs* does Michelangelo break free of the limitations imposed by the tradition of Donatello and his city, by building a bridge back to antiquity. And in the works that immediately followed he would go even further.

2

YOUTHFUL GENIUS

1 PANIC ATTACKS

On the evening of 5 April 1492, while a terrifying tempest pounded the skies above Florence, lightning struck the lantern on top of the Santa Maria del Fiore and hurled a good part of it down to the ground beneath. At his Careggi home just outside the city, Lorenzo the Magnificent observed the tempest in a state of considerable anguish, and was overcome by dark forebodings. For many months a persistent illness had confined him to his bed, although initially it had appeared to be a minor disorder and his doctors had underestimated the threat. His life had been so extraordinary that Lorenzo was convinced that his death would be equally exceptional and heralded by premonitory signs to the entire world.[1] When they told him that the lightning had shattered the lantern on the cathedral dome, he immediately asked which side the rubble had fallen on. Once he discovered that it had fallen on the same side as his home, he had no doubt that it was a premonition of his own death. His prescience was clearly well founded, as three days after the lightning strike, on 8 April 1492, he died in his sickbed and left his family and city in the hands of his son Piero, who was too young and too empty-headed to govern.

Twenty-year-old Piero lost no time in demonstrating that he was

not up to the task fate had assigned him and revealing something his father had carefully dissembled: the arrogance and the illegality of the Medicis' tyrannical rule of the city. The chronicles portray him as corrupt and dissolute, but it is not easy to identify the vices he indulged in, because for the next two centuries the official history of Florence would be written by the same family that destroyed the Republic. He was certainly domineering in a manner that few have equalled, he had men assassinated on a whim in the cowardly manner of striking during the night, and he had the effrontery to play football in the streets in full view of the city entrusted to his rule, while it was going through its most terrible crisis.

Michelangelo was so closely associated with him during the years immediately following Lorenzo's death that when Piero's position became uncertain, he seriously considered fleeing the city before his protector's final fall from power, as though he were one of Piero's ministers and not simply a young artist who frequented his court. As with many relationships in his life, Michelangelo would seek to hide the genuine depth of his feelings and of that betrayal. However, significant traces of that relationship have survived.

On 20 January 1494, the feast of Saint Sebastian the Martyr, it started to snow in Florence towards the evening. An unremitting wind pushed the snow into every hole and crevice, and after twenty-four hours of uninterrupted torment the city was submerged under a very deep blanket of snow, and many of its inhabitants had difficulty in opening up their snowed-in houses. The streets were empty of people and animals, and the shops could not open their doors. No one had encountered such a snowstorm in living memory, and the children used the snow to make statues in the form of lions, in accordance with the fashions and traditions of the time.

Piero de' Medici could not have been content with lions made of snow: he wanted an exceptional statue in snow that was worthy of his princely status. He summoned Michelangelo, who following Lorenzo's death had returned home to his father Ludovico, to whom Lorenzo had given a minor position in customs as a result of his fondness for Michelangelo. The young artist presented himself to his new ruler and was ready to follow his instructions. He produced a Hercules that was as masterful as it was ephemeral, to the joy of

Piero's little court. Fortunately, contemporary accounts assure us that
the sculpture lasted a little time and the snow in the city did not thaw
for at least eight days: thus there was time enough for all Florence
to admire Michelangelo's new work.[2] Once again Piero's frivolous
mind was incapable of conceiving anything more lasting than a snow
sculpture, and it says much about the young tyrant that he wanted the
commitment of one of his best servants for such a foible. From that
time on, Michelangelo once more frequented the Medici home and
the San Marco Garden. During this period, Florentines called him the
'sculptor from the garden'.

This companionship lasted at least until October 1494, when
Michelangelo panicked and left Florence without telling Piero and
headed for cities that seemed more secure: Bologna which was under
the Bentivoglio family, who had long been friends of the Medici, and
Venice which was an aristocratic republic. This was perhaps the artist's
first panic attack, and it struck at the youthful age of nineteen.

Two and a half years after Lorenzo's death, that flight marked the
end of the most obscure period of Michelangelo's life, not just because
of the scarcity of extant documents relating to it, but also because of his
links with a circle that everyone at the time and since has considered
immoral and dissolute. Lorenzo's death had left the city on the brink
of an extremely difficult crisis, which threatened to become even more
serious as Florence became involved in the conflict between the pope
and the king of France. Piero, who was young and overly concerned
with satisfying his own contemptible desires, was unable to deal with
the situation and soon incurred the hostility even of his father's friends,
who in vain attempted to assist him in the government of the city. In
the summer of 1494, the city, like many other Italian states, was faced
with the difficult choices imposed by the presence of the French king
in Italy and his expansionist ambitions. It was then that Piero refused
the assistance and advice that many offered him for the good of his
dynasty and his city. Blinded by his own arrogance, Piero foolishly left
to negotiate with the French king without even informing the govern-
ment of his decision, and thus destroyed the doubtful appearance of
the Florentine citizens' ownership of their own state, about which they
had been able to deceive themselves under the tyranny of his father
Lorenzo. The gravity of this act and the resulting situation in Florence

produced a popular uprising that on 9 November 1494 forced Piero and those close to him to flee the city.

But Michelangelo had not waited for things to develop to this stage. Before the city rebelled, he had secretly abandoned Piero's court and fled as far as he could from his friend and master. The flight, which was public knowledge, was recorded in a letter of 14 October 1494, and was perhaps the first blow to the young tyrant's pride.[3] It was very unusual that an artist, who was not even twenty years old, felt so involved with the tyrant that he feared the consequences should the government fall, and this can only imply that Piero's court, which was mainly made up of very young men, had been transformed into an arrogant and debauched clique which made use of an unnatural power and incalculable financial resources. This dubious youthful delirium, which was soon to end in tragedy, left some documentary evidence of Piero's excessive benevolence towards an extremely handsome Spanish footman who, apart from his good looks, could only boast a prodigious athleticism when it came to running. This community of eccentrics, which gathered around the dissolute tyrant, undid the carefully constructed legacy of Lorenzo, who had opened universities, had books of philosophy translated from the Greek, and funded the works of the most subtle minds in Italy at the time. However, Michelangelo had been very much at home in this grotesque court and forged a strong friendship with Piero, which drove him to flight when the government started to falter.

The disorders that accompanied Piero's expulsion from Florence risked turning into a bloodbath between opposing factions, which had been contained but not removed by the long rule of the Medici. The dangerous slide towards civil war was avoided through the skilful manoeuvres of Girolamo Savonarola, a Dominican friar who had been preaching in Florence since 1484 and had become an unchallenged authority partly because he had been supported by Lorenzo and his most trusted advisers. Shortly after Lorenzo's death, the pulpits from which Girolamo delivered his fiery sermons became the most significant places in the civil and political life of the city. The cathedral itself was not large enough to contain his audience who listened terrified and spellbound to his promises of either punishment or triumph. The lucky coincidence of some of his prophecies with events that actually

occurred during those years turned him into a supernatural authority. Very soon the city was in his power, particularly after Lorenzo left its government to his son Piero.

Originally from Ferrara, the friar, whose enormous nose resembled a vulture's beak, preached a powerful faith based on religious renewal and reform of the Church, and this very soon brought him into conflict with the authorities in Rome. According to his prophetic vision, the rectitude of government reflects the sanctity of Christian behaviour, and he attempted to persuade Florentines that their city had been chosen to demonstrate to the world how the Kingdom of God could rise up on earth. Good political government, which in Florence meant the republican tradition and not Medicean tyranny, was the best way to develop a true Christian life. The preaching of this religious zeal coincided with a period of profound crisis for the city and its foreign relations, and the friar developed such an influence over the government that he was sent to represent the city in a meeting with the French king during the difficult months in the autumn of 1494.

However the ability and forcefulness with which Fra Girolamo took control of a city terrified by events, was accompanied by the crazed intransigence with which he demanded the renunciation of what he considered vanities but many citizens considered essential expressions of a noble mind and things they were not willing to forego. The violent accusations he made against the vanities and luxuries in which Florentines indulged could not fail to terrify the young Michelangelo, who was no doubt present at many of his sermons, while tearful women screamed in desperation and children cried in terror. Perhaps he too felt that he was being personally censured by the powerful prophet, who had works of art burnt in the public square – works of art that for Michelangelo were the hope for the future. The young artist must have found Savonarola's threats all the more dispiriting because he was engaged in anatomical dissections with the complicity of the prior of the Church of Santo Spirito, who undoubtedly must have given his support because of Michelangelo's friendly relations with the Medici. Both the authorities and public opinion were deeply suspicious of dissections of human bodies, but the sculptor's desperate search for perfection meant he could not back away from such practices, whatever the risk. One risk was to his health, and by his own admission, the dissections

which were so useful to his art, made such a powerful impression on him that they ruined his appetite forever; and yet the dissections benefited his art enormously. To compensate the prior for his complicity, Michelangelo sculpted a crucifixion for the church of Santo Spirito which unfortunately has been lost.

The friar's tirades against any acceptance of the vice of sodomy must have been even more direct and painful. Savonarola fought his campaign with an obsessive violence that was quite unknown in Florence, where sodomy was widespread and tolerated without a great deal of scandal, in spite of the formal prohibitions. In the fifteenth century, Florentine men would get married at around the age of thirty, when their youthful passion was in decline, and they started to seek out other outlets which must have surprised no one. A few years later, Niccolò Machiavelli would speak of it as something entirely natural in his correspondence with Francesco Vettori, and this also appears to have been the attitude adopted by Francesco Guicciardini in his memoirs, when he commented on the sexual tastes of his ancestors.[4] But Savonarola unleashed such violence against sodomites that he demanded that they be burnt at the stake (paradoxically he too would meet this end, and it appears that the fire was lit by one of those 'sodomites' who would happily survive him in Florence and in the rest of Christian Italy).

Homosexuals were not alone in paying the price of the moral rectitude demanded by the prophet from Ferrara. The entire city changed, under his influence, into a cheerless community of penitents, in part because of the serious political crisis that afflicted it.

> There were no more games in public, and even at home they were played in an atmosphere of fear. The taverns, which had been the meeting-places for all the unmannerly youth who practise every vice, were all closed up. Sodomy was stamped out and considerably humbled. Most women abandoned dishonest and lascivious clothing, and young men, almost all of whom abstained from many forms of dishonesty and resolved to live in a saintly and civilized manner, . . . [and] went to church regularly, wore their hair short and persecuted with stones and cross words dishonest men, card-players and women who dressed in a lewd manner. They went to the carnival and collected all the dice, cards, *lisci*, paintings and dishonest books, and burnt them

publicly in Piazza della Signoria, and thus on that day which had been one of countless iniquities, they held a procession with much saintliness and devotion. . . . He brought succour every day to men who had abandoned pomp and vanities, and restricted themselves to the simplicity of a religious and Christian life.[5]

Savonarola made use of the weakest elements in the community: children. An army of fifteen thousand 'lads' between six and sixteen years of age oversaw the morality of their Florentine elders with the blind fanaticism of their age. They broke into houses where people were gambling, they tore at women's hairstyles or headgear in the street, when they found these too showy, and they indulged in extreme behaviour during colossal processions, the intention of which was to impress a city that owed its wealth to its pragmatism.

No artist would have wanted or indeed been able to live in such a city, and Michelangelo decided that a change of scenery was in order, at least until Florence could promise something better. He could not have been the only one who could not suffer the Black Friar's sermons, because many more people came to watch Savonarola burn at the stake on 23 May 1498 than had ever rushed to hear his moralistic sermons. It matters little whether the young artist in the dissolute palace environment of Piero and his handsome footman actively engaged in homosexuality – something that troubled him throughout his life – or even then abstained, in spite of the physical promiscuity of a young set that was constantly in search of pleasure. He certainly must have experienced an extreme discomfort in the face of the hysterical accusation that Savonarola directed at large congregations on a daily basis. He felt that he was being picked out for criticism, along with Piero and his court, and when he saw his protector's power wane, he imagined he would fall prey to some terrible torment inflicted by the mob the friar presided over with crazed moralizing zeal.

The hysterical climate of those days left a profound impression on Michelangelo, who more than fifty years later told his compliant biographer Ascanio Condivi of the obsessive visions that troubled him and his friend, a gentle and candid musician who worked as a carder in the wool industry. The latter was tormented by the evil omen of a repeated dream in which the afflicted Lorenzo wore 'a black and completely torn

garment over his bare corpse',[6] and announced to his son that very soon he would be banished from Florence. The dream manifested the sense of guilt experienced by these aimless youths, but Piero was not one to be intimidated by such facile premonitions: indeed they only excited his hubris to even greater heights. He was only irritated by the fact that his father had decided to send such important messages to him through a humble servant rather than making it known to his own son without the use of an intermediary.

Michelangelo's flight could not have gone unnoticed, if an influential citizen referred to it in his correspondence that same day, while rightly emphasizing its political significance: 'You should know that Michelangelo, the sculptor from the garden, has left for Venice without saying a word to Piero, in whose house he lived: I suspect that Piero has taken this very badly.' This is a precious piece of evidence, as it reveals many things at the same time: that at the time Michelangelo was already considered a sculptor, that he was still closely linked to Piero and the San Marco Garden and that his flight was sudden and without Piero's permission. According to the legend he would later pass on to his biographer, he fled in the company of two equally frightened young men, and they would have met the inglorious end of being imprisoned in Bologna for vagrancy, had it not been for Francesco Aldrovandi. Both closely linked to the Bentivoglio family that ruled Bologna at the time and a close friend of the Medici, Aldrovandi took Michelangelo into his home, the same home that would provide asylum to Piero a few days later as he fled along the same route.

Michelangelo stayed in Bologna long enough for the political turmoil in Florence to calm down and for a new government to establish itself after the expulsion of the Medici. Aldrovandi provided him with a home, treated him as a gentleman and arranged for him to obtain the prestigious commission to complete the monument in the church of San Domenico that Niccolò dell'Arca had been unable to finish. Michelangelo sculpted a stunning angel-candleholder (Plate I.3), which looks more like an Olympic athlete than one of heaven's inhabitants, and a statue of Saint Proculus dressed as a warrior. He also sculpted a statue of Saint Petronius, the city's patron saint, which still displayed the sudden nervous movements typical of fifteenth-century art in the pinched facial expression and particularly in the over-elaborate folds

of the clothing, possibly in order to harmonize them with Niccolò dell'Arca's sculptures (however, the heavy cloak is draped around its wearer with a softness that fully reveals the technical virtuosity of the twenty-year-old sculptor). Aldrovandi's protection and the commission to produce a work that was so important to the city demonstrate the high esteem in which Michelangelo was held in Bologna. His talents were already considered entirely out of the ordinary. At that time, there was only one work of some standing which he had completed on his own initiative, possibly dating from 1493. It was a 'Hercules, which was four *braccia* high [approx. 240 cm] and kept for many years in Palazzo Strozzi'.[7] The statue was sold without difficulty and we know that it was in Palazzo Strozzi until 1529, when Giovanbattista della Palla purchased it and dispatched it to France. This debut work was clearly valued by the Strozzi, who were important customers, but it would not have been sufficient on its own to guarantee access to such an important commission as the completion of Dell'Arca's Saint Petronius. Although he had sculpted very few statues, the restless young sculptor was already innovating artistic production. Nevertheless, the ambiguity of his social condition also came up as an issue in Bologna, where he lived in Aldrovandi's home and read him Dante and Petrarch, poets they both had a great passion for. Michelangelo's role was closer to that of courtier than that of sculptor. The art market in Bologna could not even be compared with the one in Florence, and the artist left as soon as he could return to his native city, showing little interest in the attractive commissions Bologna could offer. Although any other Italian sculptor of the time would have jumped at the opportunity, he felt they were not worthy of him, and his colleagues in Bologna do not appear to have appreciated the arrival of this presumptuous youth in their city. Bologna could not boast the wealth and good taste that at the time could only be found in three places: Venice, Rome and of course Florence.

2 THE STORY OF A COUNTERFEIT THAT ENDS WELL

After Piero was driven from the city, Florence received Savonarola's support in establishing a republican government that was very close to the section of the middle class to which the Buonarroti had belonged

to in happier times. This social group would soon benefit from the new government's more democratic approach, and Michelangelo was to forge a lasting friendship with this government. The Florence to which the artist returned for Christmas in 1495 was still undergoing a period of extreme political instability, which was exacerbated by Savonarola's increasingly influential sermons and inability to relax his intransigence towards people's weaknesses. The friar used his bizarre army of children to control every aspect of the city's life. His sermons became so political that he often ordered that only men should be present, as he did not believe that women carried much social weight.[8]

Florence was therefore unable to welcome an ambitious young man who had a profound fascination for the art that the Dominican friar persisted in denigrating in his sermons, which increasingly took on the appearance of a collective psychodrama. Savonarola's hatred of non-devotional art was such that he rejected the large sum offered by a Venetian merchant in exchange for all the works that were to be burnt in the square. According to his way of thinking, only fire could definitively purify the disgraceful vanities of man. The gloomy tone of his sermons gradually changed the popular mindset and undermined the people's pride in the way the city had contributed to the development of art and civilization.

But Michelangelo was not discouraged and took up his work exactly where he had left off. He continued to compete with classical sculpture, which was so fiercely detested by the man who dominated the city. He produced a *Sleeping Cupid*, a subject that had been much frequented by Greek and Roman artists. The sculpture was so successful that it resembled ancient ones in every way. Michelangelo or someone who was very close to him came up with the idea of organizing a fraud against the wealthy collectors of antiquities, who were often blinded by their mania for acquisitions. The sculpture was buried and treated in order to make it look as though it has been underground for centuries. The intention was to sell it as an antiquarian work of art. Of course, the sale of the forgery was not to take place in Florence, which with its climate of rigour and abstinence had now become a city of *piagnoni* or 'snivellers', as Savonarola's followers were called. The fraud was to take place in Rome, where *anticaglie* or 'old curiosities' had become the object of a compulsive mania at the rich papal court, whose dissoluteness had also

become one of Savonarola's targets, as the friar liked to contrast the pope's city with the Florence full of virtue and moral necessity that he was building.

The skilfully smoked cupid covered with clayey earth was then dispatched to Rome and offered to one of the wealthiest Italian collectors, the Cardinal of San Giorgio Raffaele Riario. The agreed sum for the transaction was huge: two hundred ducats as against a typical figure of fifteen ducats for a modern statue. Michelangelo had been paid eighteen in Bologna for his *Saint Petronius*, and this was the actual figure paid by the fraudster to Michelangelo. The success was such, however, that the artist decided to reveal his role and demand a greater part of the profit. The indignant cardinal demanded his money back,[9] but he was a man of the world and understood that the shameful intrigue of which he had been victim also revealed the exceptional talent of the young artist.

Once he had recovered his money, Riario immediately invited Michelangelo to Rome and his sumptuous court. This was exactly what the artist had been waiting for. The meeting was encouraged by Lorenzo di Pierfrancesco, a member of a cadet branch of the Medici family who had been exiled by the Medici themselves during their rule and who could now return to Florence to claim a leading role in the new anti-Medicean government without arousing suspicions. This was also a means to turn his back on his previous backers, as Raffaele Riario had been involved in the Pazzi Conspiracy and had been taken prisoner by the Medici, who had held him in Florence from 26 April to 12 June 1478, while they hanged many members of his retinue from the windows of Palazzo Vecchio, left like rags put out to dry in the sun. Michelangelo, who was impatient and ambitious, had been prevented by his irregular life from obtaining the fruits of a talent about which no one now had any doubts. Once again politics and influential friendships came to his rescue, and while still young and open to all kinds of influence, Michelangelo was thus discovered and championed by the man who, more than any other Italian of the time, was the perfect example of a rich and cultured patron – a man who cared little for the religious and moral prejudice that still prevented many influential European citizens from taking an interest in ancient culture.

Once he had been appointed Cardinal of San Giorgio by his uncle Pope Sixtus IV Della Rovere, Raffaele Riario embarked on the construction of the largest fifteenth-century *palazzo* in Rome with the proceeds of the city's most famous win from gambling at dice, which became a local legend. This episode says everything that is to be said about the cultural outlook of this self-assured and sophisticated figure. Riario was cynical and held in contempt the bonds and social conventions of his time, but held art in even greater esteem than princes and popes, who until then had been its most munificent patrons. The combination of culture and wealth was typical of Renaissance patronage. When it came to building his Palazzo della Cancelleria, the cardinal did not restrict himself to commissioning a palace of fabulous wealth: he wanted to create a building *all'antica*, that was capable of reviving and even surpassing the splendours of the palaces built by the ancient Romans, whose colossal fragments were uncovered every day to widespread admiration. To achieve this, he engaged architects with the most up-to-date knowledge of ancient composition, and he did not hesitate to demolish the venerable old church of San Lorenzo in Damaso so that he could use the columns of its nave for a classical-style courtyard large enough to be a municipal square. Like some mythical animal, Rome was achieving its rebirth by devouring its own limbs: the columns which dated from the Augustan era had been used by Christians to build the church of San Lorenzo, and now they returned to decorating a palace built to pay homage to beauty, the only true value to have survived the millennia of the Eternal City.

Indeed, there was no limit to Cardinal Riario's architectural ambitions: he even modified the production methods used in the city's dismal building industry, which could not even contemplate the possibility of such a building. He opened brick kilns, summoned Florentine stonemasons who were more skilled than the Romans in tempering iron, and had travertine transported down tributaries of the Tiber for facing his palace with an elaborate ashlar-work in the ancient tradition. Most importantly, he had built up a collection of Greek and Roman statues which alone could have changed the direction in which Michelangelo's art would develop. Riario's passion for his collection was so intense that when, on the morning 25 June 1496, the impudent twenty-year-old who had dared to ridicule his connoisseur's intuition turned up at his

door just after arriving from Florence, he immediately took the young man to see his collection without even giving him time to show the letters of recommendation which Lorenzo di Pierfrancesco de' Medici had obtained for him. The cardinal wanted Michelangelo to view his precious sculptures immediately, and the youth, who wanted nothing else, spent the whole day examining them. He must have been no less excited than the cardinal, given that he had promptly left for Rome on the eve of 24 June, the feast of Saint John, which for every Florentine was the happiest and most significant day of the year on account of its exquisite festivities, which were held throughout the whole city and reaffirmed the bonds of family, clan and district.

The following day, 26 June, the cardinal summoned him once again. He wanted to know what he thought of the sculptures and if he would like to do something that resembled them. Under the burning sun of ancient art, Michelangelo was affected by modesty for the first time in his life and gave the reply Riario would have expected: 'I replied that I could not do such great works, but I would see what I could do.'[10] The morning of the following day, Michelangelo was already wandering around Rome looking for a piece of marble large enough for a life-size figure. The subject was immediately decided upon: the life-size figure would be the one that had been at the core of classic poetics and would immediately become central to the poetics of this new Michelangelo. On Monday, 4 July, Michelangelo started to sculpt a life-size *Bacchus* at the home of a gentleman who was one of Riario's friends and lived close to Campo de' Fiori, in what was becoming the new centre of the revitalized city. He had seen everything he needed to see in Rome: Raffaele Riario's collection of sculptures. The commission had been agreed at a feverish pace.

The cardinal promptly paid up ten ducats on 18 July and then fifty florins [*fiorini larghi*] on 23 August. This was followed by two other payments of fifty florins each, on 8 April and 3 July of the following year. If the first ten ducats were for the purchase of the marble, then Michelangelo earned 150 florins in a year for his *Bacchus*, and this was an astronomic sum for a sculptor. New to the city and only twenty-one years old, he was nominated the leading artist of Rome by the cardinal, who with good taste guided him through his discovery of ancient sculpture of the kind he could only have glimpsed in Florence.

The statue was a spectacular success (Plate I.4). The god of wine is portrayed in a difficult pose, with his left arm raised and his body-weight languidly shifted onto one leg. The forms and proportions of the body are those of classical models, expressed through a perfection that was nearly natural but fell sufficiently short of it to create an evocative image of divinized humanity which was supposed to have existed but was never incarnated in a real person: a humanity that allowed artists to rise above the beautiful but restricted world of nature. The greatness of the young Michelangelo lay in his ability to release the cold grip of abstraction and inject the human body with the excruciating pulse of life. The muscles lost the rigidity of ancient models and became softer and more rounded, which conferred on the youthful god an ambiguity that could have only been produced by a profound understanding of pagan sensuality. Michelangelo's Bacchus has a gently protruding stomach and his back, buttocks and breast are soft like those of a boy who has not yet become a man and still retains the traces of femininity typical of adolescence. The ecstatic expression, free from all guilt, unreservedly offers the gift of his youth and untamed candour. More than any other, this sculpture represents the idea of the pagan soul that was beginning to take shape in the minds of men like Raffaele Riario, who were so different from the friar who at the time was fomenting such a climate of ascetic penitence in Florence that no statue of this kind could have been made there. The cardinal's collection of ancient works in marble and his cultured influence were the indispensable precondition for this flowering of perfect paganism, which years later would come back in his *David*, who was closer to the sinewy soldiers of modernity.

Bacchus is one of Michelangelo's very few wholly finished works. This was what the owner wanted, as he could not allow the new statue to be outdone by the ancient statues that surrounded it. Technically the statue marked Michelangelo's maturity as an artist. The joints between muscles are smooth and appear to have been achieved effortlessly. The strength that can be detected in the musculature, which is suppressed in some points and relaxed in others, was the product of the superb understanding of anatomy Michelangelo had acquired during the solitary and macabre sessions at the hospital of Santo Spirito. Above all, he appeared to have completely overcome the problem area that would

continue to trouble other sculptors for more than a century: joints
and limbs. Shoulder and leg joints and the articulation of elbows and
knees lost all their woodenness and artificiality, which contrasted with
fifteenth-century sculpture. *Bacchus* showed the world that it was pos-
sible to compete with the ancients, at least in sculpture, and was consid-
ered an important new development for those circles in Rome that were
preparing the most splendid season in Western art.

Riario generously put his own culture and his art collection at
Michelangelo's disposal so that he could improve his style, but
above all he introduced the young artist to his fellow cardinals, from
whom further important commissions would arrive. Yet Michelangelo
would repay the cardinal's support with harsh words. He told his
biographer Condivi that the cardinal was ignorant and never gave him
a commission. Thus the artist retracted what he himself had written in
letters half a century earlier. Perhaps in 1553, when Duke Cosimo I was
the undisputed ruler of Florence and held the fate of Michelangelo's
successors in his hands, he did not wish it to be remembered that as
a young artist he had shared the table and home of the Medici in Via
Larga, only to disappear when their fortunes began to decline and move
to Rome where he sought the protection of one of the Medici family's
principal adversaries, a cardinal who had taken part in the 1478 plot
that ended in an unforgettable bloodbath. This was the man the young
Michelangelo turned to for protection, while spurning Piero's brother,
Giovanni, who since 1488 had also been a cardinal and who would
become pope with the name Leo X. In precisely this period, Giovanni
was becoming the figure in the system of family patronage.

Michelangelo's ingratitude may have simply been due to the myth
the artist created himself, as this left no room for a second lead char-
acter or for supporters, even in the early stages of his professional life.
The fact is that he lied shamelessly about his Roman debut and his rela-
tionship with Cardinal Riario: he had Condivi write, 'and that Cardinal
San Giorgio knew so little about his statues and drew so little pleasure
from them is fairly clearly demonstrated by the fact that in the time he
lived with him, which was for about a year, he [Riario] never gave him
[Michelangelo] any commissions.'[11] He could not have imagined at the
time that his fame would cause people to dig up not only his old letters
but also the irrefutable evidence of the bank receipts for the payments

made by the hapless Cardinal of San Giorgio, who was even more passionate about art than Michelangelo himself.

The cardinal's generosity allowed Michelangelo to take the first steps towards helping his unlucky family, which now faced famine in Florence following yet another of the crises triggered by Piero's attempts to overthrow the republican government, which culminated with Pope Alexander VI's excommunication of Girolamo Savonarola in June of 1497. After having opened a current account at the bank of the Balduccis' in Rome on 23 March 1497, Michelangelo sent his father Ludovico a payment of 9 gold florins [*fiorini larghi d'oro*], the first in a long series of remittances by which he started to deliver his family from the state of destitution into which it had fallen.

Michelangelo's success as a sculptor did not prevent him from continuing to employ the painting skills he had learnt in the workshop of the Ghirlandaio brothers. On 27 June 1497, just after finishing his *Bacchus*, the artist withdrew three carlins (silver coin minted in the Kingdom of Naples) for 'a painting on wood'.[12] This sum was sufficient to purchase a wooden panel large enough for the *Manchester Madonna* (*The Virgin and Child with St John and Angels*), which some people now attribute to him. The Ghirlandaio style is still very much present in the metallic sharpness of the design and the slight rigidity of the expressions composed in accordance with the psychological code that characterized late fifteenth-century devotion. However, Michelangelo's authorship of the painting remains in doubt, in spite of the fact that the majority of critics are inclined to attribute it to him. The articulation of the figures in space is too simple when compared with the highly proficient work on the *Bacchus*, which would imply that Michelangelo the painter was trailing behind Michelangelo the sculptor, something that was not confirmed by his next painting. Alternatively it could be argued that the painting was executed several years earlier, and therefore cannot be compared with another painting a few years later that is certainly by Michelangelo's hand, the *Doni Tondo*.

3 THE ARTISTIC TREADMILL

The interlude devoted to paintings did not last. Indeed, the considerable sum of 133½ Rhine florins (100 treasury ducats) was paid into

Michelangelo's current account in November 1497. The currency indicates a commission from north of the Alps and another of the highly significant works from his youth: the *Pietà* or *Madonna della Febbre*, which today is in Saint Peter's.

The commissioner was another cardinal and therefore a man high up in the hierarchy of the papal court: Jean de Bilhères-Lagraulas. But this time Michelangelo was not happy with a block of marble salvaged from the rubble and sold on the Roman market. He bought a horse with just one-tenth of the sum received, and left for Carrara and his first encounter with those quarries which for the rest of his life would send him into an unimaginable creative rapture. The wintry cold and snowstorms that afflict the Apuan Alps were particularly harsh that year. In February, Tuscany was in the grip of a freeze that turned the Arno to ice, on which they played football as in Bruegel's painting of a canal. It was an exceptional event, which continued for two months to the desperation of Michelangelo, who was a prisoner of the cold in the mountains that had already been disfigured by the Romans in search of the precious marble amongst the forests and cliffs.

The ambitious young man could not wait for the spring. His success and the patronage he had obtained in the most powerful circles in Rome had convinced him that the obstacles to his career had been removed and his future triumph was worth a few sacrifices. He was so convinced of his own worth that he did not wait for new commissions before buying several blocks of marble: he would not be short of opportunities to use them. Even more unusual was his conviction that he could produce statues on his own initiative and sell them afterwards. By anticipating his needs in this manner when he was little more than twenty years old, Michelangelo became his own very capable manager and invested in his own talent before others were willing to do so.

He spent the summer of 1498 in Rome at the port of Ripetta offloading the marble that the boatman Simone brought down the Tuscan coast from the white sands of Avenza (close to Carrara). The stonemasons whose demanding task it was to bring the marble to Avenza had been handpicked by Michelangelo at the Apuan quarries where his name already inspired awe. During the winter he concentrated on the work that would definitively gain him the title of greatest sculptor in Italy and for which an extravagant figure had been agreed:

450 golden ducats, as stated in the contract signed in Rome on 27 August 1498.[13]

His first masterpiece was the result of the most difficult conditions that could be imagined for such a young man. He was alone and far from his native city and those he loved, and he had lodgings in a miserable hovel for which he paid a rent of one and a half ducats a month. The money that started to flow in enormous quantities into the artist's pockets did not change his lifestyle, which remained barely above subsistence. He did not sleep, eat or dress heavily enough. His brother, who visited him in Rome, found him living in conditions of extraordinary poverty and was worried about him, even though he too was struggling to survive in Florence. Michelangelo was entirely immune to all seductions, even those that youth makes most impelling. His father, who at the time expressed his grave concerns in a series of letters, reminded him that it would be no use saving money if the privations eventually prevented him from earning his living. But Ludovico knew his son only too well and could not have failed to understand that this was a case of pure avarice, a vice that was not only damaging for his son's health but also condemned by his religion and morality. He urged him with all his authority:

[M]eanness is wrong, for it is a vice that displeases God and the peoples of the world, and moreover it will harm your soul and your body. While you are young, you will for a time be able to support these discomforts, but when the virtue of youth is no more, you will then discover some maladies and infirmities that are provoked by these discomforts and by living badly and in poverty.[14]

However, poor Ludovico could not have imagined the power of avarice's hold over Michelangelo. He could not have known that by that time the artist had already deposited hundreds of ducats in his current accounts, and had already earned enough to protect himself from destitution. Still less could he have imagined that his son considered himself a down-and-out even though he had never been one, and that he did all he could to convince others of his penury, possibly to defend himself against the demands for assistance that were heaped upon him (mainly from Ludovico himself, who did little else but complain of

his privations, the bowls he had to wash on his own, his hunger and the miserable life he was obliged to endure in order to guarantee that his children enjoyed his affection without the interference of their stepmother). The sculptor who now was only approached by cardinals lived like the poorest of stonemasons, while he accumulated money and rejected minimal comforts. He neglected his own youth and almost treated it as an obstacle to complete concentration on his work.

These sacrifices and appalling pressures that were entirely channelled into his work, as well as his total sexual abstinence, produced sculpture that appears to have been inspired by the life the artist could not conceive for himself. Cardinal Jean de Bilhères, who was known as the Cardinal of Saint Denis, asked Michelangelo for a *Pietà*, that is a Madonna who holds in her lap her dead son following his deposition from the Cross. This was an image very dear to northern religiosity, because of the tragic and anguished passion it portrayed. The Germans called it *Vesperbild* because it was particularly suited to melancholic contemplations of the evening, when nuns concentrated their thoughts and prayers on that agonized maternity, which was more beautiful and more painful than the maternity granted to other women and in which the suffering and hardship of the human soul dissolved while the sun set on this world.

Michelangelo fully caught the sense of melancholy associated with that part of the day and with that image of devotion (Plate I.6). The Virgin tormented by grief displays to the world the tortured corpse of her son, who has sacrificed himself in order to redeem mankind of its sins. It is an image of profound suffering, and yet Michelangelo's Virgin is a young woman whose features express a sublime purity, while she appears to break the fall of her son's dead body. She holds him under the armpit with her right hand and supports him with her raised knee, thanks to the providential presence of a lump of rock. She is leaning slightly backwards to counterbalance the weight of the lifeless corpse. Christ's left leg is held up by a tree trunk, which like him has been cut down, and this means that it is not obscured by the right one which is in the foreground. Even the arm that is hanging loose is caught up by its fingers in a heavy fold of cloth, forming an arc which is emphasized by the parallel arc of the fold of Mary's austere clothing.

The abandon and sensual physicality of Christ's body are dramatically displayed in his chest muscles, which are swollen by his mother's hold and his head tipped backwards to foreground the neck and the Adam's apple. The hand that holds up his chest does not touch the son's divine flesh but presses its fingers into thick cloth that is modelled by their pressure, while the left hand moves away from the body and hangs in the air to produce a tragic gesture of surprise.

The sculpture's expressive power is mainly centred on that questioning gesture by which the woman appears to demand an explanation of the onlookers, while also signalling her acceptance of the event's inevitability. In contrast with tradition, her expression is extremely restrained. Michelangelo adopted a highly classical form of representation that avoided an overly naturalistic imitation in order to create a facial expression of supernatural sadness. The romanticized countenance diverges from excessive humanization and recreates the defamiliarization that typified the classical representation of the divine. The beauty of the face evokes a contemplative involvement with the divine that is very distant from human reality.

Even Christ's body expresses a pagan idea of divinity. In spite of the way in which it has been tortured, it has immediately regained its beauty. This supernatural beauty, which is so distant from what we actually encounter in this world, manifests his divine nature. The limbs are perfectly proportioned. The looseness of the lifeless body, which generally results in an awkwardness, has been composed in a manner that does not diminish his beauty. The veins, muscles and tendons, which accurately follow the body's posture, are also barely hinted at, in order to produce a credible but not vulgar representation and avoid a mimesis of nature which would have ended up diminishing rather than exalting the divine beauty of the body. As in classical sculpture, flesh loses all its contingent features and becomes pure form, which implies a superior humanity, a divinity that people can only perceive when assisted by the talented artist.

Michelangelo's Christ could be an Apollo asleep on the grass, if it were not for the woman's distress – she appears to be on the point of crying. The emotions, which are barely hinted at in the expressions of the faces and the exquisitely beautiful bodies, leave us lost for words. The image's perfection itself appears to be a divine manifestation. There can

be no doubt that the artist wished to demonstrate once and for all his ability not only to invent perfect forms, but also to achieve them with an unprecedented technique. Many were surprised by the artificiality of the representation, and found it improbable that the Virgin could look so young, when after all she was the mother of the man she held in her arms. Michelangelo, who many years later was still unwilling to admit the overwhelming drive for beauty that had led him to distort even the Sacred Scriptures, attempted to justify this by arguing that virginity conserves health and beauty much longer than do the activities associated with lovemaking. He thus showed how little he knew about carnal love and its beneficial effects on women who are greatly loved.

However, the real protagonist of this sculpture is the marvellous drapery that cushions the body of Christ and frames Mary's lean face with anguished shadows. Her clothing conforms to a precise and hierarchical organization of space. The large and potent fold that frames the statue on the left has the task of emphasizing the curved and diagonal direction of the fallen body. The sculptor's drill has carved out a very deep hollow underneath Christ's buttocks, producing a shadow over which the pelvis is entirely suspended. The heavy cloth absorbs the energy of this tension in the structure of the sculpture and disperses it into the ground through small rounded folds that twist around on themselves. It is however Mary's blouse that we find most astonishing, because of its audacious complexity. The light cloth is flattened onto her breast by a strap on which, according to legend, Michelangelo later inscribed his own name. The blouse, which is held by the tautness of the strap, explodes on the breast into many darting movements of its cloth, so as to lead the eye towards the perfectly smooth flesh of the face and neck. The veil, which is crimpled on her head, concludes the shadowy encirclement of Mary's face.

Whatever the formal and perhaps even symbolic role of this majestic and variegated drapery, there can be no doubt that in artistic terms it constitutes a clear message of Michelangelo's superiority to all other contemporary sculptors. No one had ever managed to create drapery that was so full of movement and so suited to the subject. In spite of the confusion of whimsical creases in Mary's blouse, her body is still visible beneath it: the virginal breasts, the graceful line of her shoulders and even the leg from which a foot and barely distinguishable toes protrude.

Other sculptors represented drapery almost as something independent from the rest of the composition, as if it were endowed with a life of its own, which was rarely very credible. Anyone who attempted to find a fold of cloth in the *Pietà* that violates, suspends or simplifies the rules of nature would be sorely disappointed. Each fold bulges and tapers exactly as on a real item of clothing, and the same can be said of the contact between cloth and the bodies.

This continuously changing landscape could not have been planned in an initial drawing, except as a very vague outline. As he worked, the sculptor had to use his intuition to follow the flow of the pleats that he was forming out of the marble. Michelangelo had an exceptional ability to play with the material by pursuing the fanciful lead of his tools rather than the dictates of an ordinary item of clothing. To get the marble to yield to the delicate ripples of linen and velvet, the artist applied his drill to create undercuts that he then brought together with his chisels and curved tools. Miraculously he managed to remove all trace of the marks they left by using very fine files and then pumice stones. The sculpture received a high degree of finish, given the manner in which he polished the surfaces, something that he would never repeat on later works. To obtain such a powerful effect, this Tuscan artist probably omitted some of the normal processes, and smoothed with pumice or sand the surface that had been sculpted with chisel and gradine almost down to the finished work. In this way, he managed to avoid the rigidity caused by use of a file, which other sculptors used in the approach to the final stage of their works.

This exhibition of skill and artistry was possibly a little excessive, and returned the sculpture to the over-elaborate tastes of the fifteenth century rather than the essentiality of classical sculpture (with the exception of Hellenistic virtuosity, for which Michelangelo would later express his disdain). Whatever the methods used by the artists for the fine detail, the sculpture's effect on both patron and public was sensational. Even fifty years later, Vasari could not restrain himself from extolling the artist's extraordinary and distinctive technical ability, as well as the concept and beauty of the forms: 'Never did a sculptor think of such a work nor was any exceptional craftsman capable of achieving such form and grace, or with great effort such refinement and polish, nor could he drill the marble so artfully as Michelagnolo did, because

in that [statue] you encounter all the meaning and power of art.'[15] And indeed Michelangelo never attempted to repeat such a work of virtuosity, as he perhaps considered it a peak in his career that would not lead anywhere.

Once it was finished, probably in July 1500, the *Pietà* was taken to the chapel of Santa Petronilla, one of the two mausoleums situated on the southern side of the ancient Constantinian basilica of Saint Peter, which was later incorporated in the new Saint Peter's. The generous French cardinal who had commissioned the work died on 6 August 1499, before he could see it finished. But the triumph was such that another extremely prominent cardinal came forward with another important commission. In early 1501, Francesco Piccolomini, the nephew of Pope Pius II, contacted Michelangelo and entrusted him with the completion of the celebrated family altar in Siena Cathedral, which had been started upon a few years earlier. It was a very demanding work: fifteen statues just over a metre in height, made of marble from Carrara, which Michelangelo decided to sculpt in Florence, where he could rely on a network of assistants and support that reduced his production costs.

Besides, his departure from Rome at the turn of the century seemed a sensible choice for other reasons. Relations between his principal protector, Cardinal Riario, and the pope, Alexander VI, were appalling, and the latter obstructed the former at every turn to the point of forcing him to slow down the work on his beloved palace and voluntarily leave the city on 21 November 1499. The Borgia pope established a climate of fear in Rome and Italy as a whole. This affected everything and his son, Cesare Borgia, who was also known as *il Valentino*, had initiated a military campaign with his father's blessing to conquer the small and fragile states of Central Italy: Imola, Forlì, Rimini and Pesaro. He did not baulk at threatening Florence itself. The methods he used to attack men and armies would become legendary, as would his sexual appetite, which was entirely unrestrained. Of his carnal 'exploits', those that made the greatest impact on his contemporaries were his rape of the youthful Astorre Manfredi, the ruler of Faenza and son of Galeotto and Francesca Bentivoglio, whose possessions he had seized on a previous occasion, and his incestuous relationship with his sister Lucrezia, who was married off to Alfonso, the first-born son of Ercole d'Este,

causing great scandal amongst the Italian nobility. His whole family displayed an unequalled talent for murder, and the most famous assassinations for which he was responsible were those against his closest allies: Paolo Orsini, Vitellozzo Vitelli, Oliverotto da Fermo and the Duke of Gravina Francesco Orsini, who were summoned to Senigallia and then strangled in their beds during the night of 31 December 1502. Alexander VI was not to be outdone, and imprisoned many cardinals, and occasionally resolved disputes within the College of Cardinals by administering a little poison.

As the atmosphere in Rome became increasingly soured by the Borgias' irrepressible ambitions, the serious crisis that had been triggered in Florence by Piero de' Medici's expulsion was gradually being resolved. The popular government had become more stable and had been strengthened in September 1502 by the election of Piero Soderini – a man who was universally respected in the city – to the position of *gonfaloniere a vita* ('standard-bearer for life', but effectively the permanent executive head of state). Even the threat of an invasion appeared to lose credibility. It is true that serious problems remained, such as the recovery of its dominion over Pisa, which had exploited the Medicean crisis to gain independence, and above all the serious fiscal pressures caused by the king of France's exorbitant demands in return for his protection of the city. However, the danger of an attack from Cesare Borgia appeared to have been averted, because the king of France had started to face up to the increasing power of Maximilian I of Hapsburg and this led to a new set of alliances that considerably enhanced Florence's autonomy.

The government, which gathered the fruits of the Medicean crisis, was a direct expression of the middle class, of which the Buonarroti had with great difficulty continued to be part, as well as that section of the mercantile aristocracy with which Michelangelo still had good relations. Ludovico lost no time in informing his son that the civic government was well disposed towards an artist who had now become extremely famous and represented an excellent resource for exalting the virtues of a proud republic. So the son accepted the commission for the statues on the Piccolomini altar that took him home, as his father wanted. On 5 June 1501, a contract was signed, and it contained a clause that must have brought no little satisfaction to the artist. He was

to complete the statue that had been started by Torrigiani, the same irascible artist who years before had smashed his nose with his fist. Moreover, Michelangelo had to adapt the sculpture entirely to his own style, thus removing every trace of his former comrade's work. The agreed price was the highly lucrative sum of 500 ducats.

But the real reason for his return to Florence was another. On 16 August 1501, the craftsmen responsible for works on the cathedral ('Operai dell'Opera del Duomo'), who represented the entire citizenry of Florence, entrusted Michelangelo with the task of producing an immense David. It was an official investiture, and it was now up to him to create the new symbol of republican liberty.

4 A DAVID WORTHY OF THE REPUBLIC

Long before Michelangelo's frenzied chisel touched his David, the sculpture had already become a *cause célèbre* amongst the proud artistic community of Florence. On 18 August 1464, the craftsmen Andrea della Stufa and Jacopo Ugolini (both members of the Operai dell'Opera del Duomo), who had become possessed by one of those frequent moments of fevered attention-seeking that for two centuries had been driving the Florentines to seek pre-eminence in every field over the whole of Italy, commissioned Agostino di Duccio to produce a marble colossus almost six metres in height to stand on one of the buttresses of the cathedral whose construction appeared to be never-ending: 'Agostino Antonio di Duccio, sculptor and Florentine citizen, shall erect a figure of white marble quarried in Carrara nine *braccia* high [about five and a half metres] in the manner of a *guglia* [spire-like statue] . . . to be placed on one of the buttresses of Santa Maria del Fiore.'[16] Statues of these colossal dimensions had not been made since antiquity, and with a sudden outburst of modesty the ambitious patrons decided that the sculpture should be made up of four different blocks: one piece for 'the head and neck, two pieces for the arms and the rest in a single piece'. It would, in fact, have been difficult to extract such a large block from the slopes of the Apuan Hills and then transport it as far as Florence.

Initially fortune appeared to smile on Agostino di Duccio, who managed to extract one very large block rather than four smaller ones and then bring it to Florence, mainly thanks to the experienced quarryman,

Baccellino da Settignano. It appears from the documents that on this occasion too, the sculptor went in person to the quarry in order to cut out the shape of the figure and bring it down to something close to the final work, in order to facilitate the transport of such an enormous block. The delicate nature of the rough work is demonstrated by another colossal statue almost of the same dimensions, the *Kouros of Melanes*, which was left for 2,500 years in another Mediterranean quarry, on the Isle of Naxos in Greece. In ancient Greece, sculptors also went to the quarries to sculpt giant statues in order to transport back a lighter stone that was close to the final shape. To avoid mistakes, they rigidly repeated a formal model that remained unchanged. Similarly, the *bozzo* of which Florentine documents spoke meant that layer a few centimetres deep surrounding the figure before the sculptor carved out the final detail. However, Agostino had to abandon the enterprise, possibly because of the time factor or possibly because of the difficulties of working in a quarry for someone who was not accustomed to the environment. It may well be that he was not up to such a unique and onerous task. The fact is that the giant block of marble fairly advanced in this process of 'roughing out' was left on the enormous building site of Santa Maria del Fiore.

The superintendents of the Opera del Duomo were not willing to admit defeat. If Brunelleschi had been capable of constructing a dome with such an audacious plan, it must have been possible for a sculptor to create a colossus which, after all, was no larger than the two warriors of Montecavallo in Rome, also sculpted by men – and pagans at that – who were unable to count on their faith in the Madonna to whom the cathedral and its sculptures were dedicated. On 6 May 1476 they gave Antonio Rossellino the task of completing the work on 'a *guglia* of marble that can be found next to the foundations; the said *guglia* needing to be completed and placed on one of the buttresses of the church'. But the time was not ripe for rivalling the ancient sculptors, and in those days Michelangelo was still attached to the breast of his wet-nurse in Settignano, while he was soothed by the chisel blows that could be heard within the house. Antonio Rossellino had no more success than his predecessor.

Finally in 1501, by a decision taken on 2 July, the Operai dell'Opera del Duomo ordered the erection of the figure 'badly rough-hewn and

lying on its back in the yard called *Opere*.[17] They had to see whether they could find someone capable of bringing the work to a suitable completion. The fact that the sculpture had been started upon and roughed out made the work more difficult, because the initial work decides the final outcome of the statue and can remove marble from areas that will eventually prove indispensable for a successful outcome to the work. But now the right moment had come. A twenty-six-year-old Florentine citizen had already stunned the world with a *Pietà* which everyone was talking about, and there could be no doubt that he was the only person capable of successfully finishing the work. Another great sculptor, Andrea Contucci da Monte San Savino, also known as *il Sansovino*, also put his name forward, but there was no competition. On 16 August of the same year, the Operai awarded the contract to the worthy master sculptor Michelangelo di Ludovico Buonarroti, Florentine citizen, 'for making, thoroughly finishing and rendering perfect the man once called a giant, rough hewn, nine *braccia* in height, made of marble and lying in the said Opera, long ago subject to the rough work executed by Master Agostino . . . of Florence and badly rough hewn'.[18] The price was initially very low: a salary of six florins per month for a predicted period of work of two years. The cunning Michelangelo, however, demanded an amendment to the contract once he had shown what he was capable of doing with that block of marble that had been lying around for nearly forty years, and came away with a much better remuneration: 200 florins as against the initial figure of about one hundred and fifty.

Work commenced in September 1501. Michelangelo was very private about his art, and went so far as to build a wall around this small construction site in order to avoid the stares of his curious fellow Florentines, now all intent upon commenting upon the city's new challenge. The Greek giant of Naxos, which was abandoned because of a leg that broke in transit, can give us some idea of the state the David was in when the artist had to get to work on it. The pose was already defined, as were the maximum dimensions (height, width and depth) of the statue. The young Greek might appear to have been in a more advanced stage of manufacture than Michelangelo's David, perhaps because of the fascination the former exerts from its rustic tomb, its surface smoothed by two and half millennia of rain, and the greater

boldness of the ancient sculptors who went further in the process in order to lighten the load on their journey. Yet the starting point could not have been that different. It comes as no surprise, then, that contemporaries indulged in pure hyperbole and generous accolades when it came to describing the statue Michelangelo produced from the block of marble that had proved too difficult for the best sculptors of the previous generation. In 1504, Pomponio Gaurico listed Michelangelo as one of the greatest living sculptors in his *De Sculptura*, and Benedetto Varchi, always a measured commentator, proclaimed that because of this work, Florence had now overtaken ancient Rome in sculpture by at least as much as the waters of the Tiber exceed in volume those of the Arno.

The *David* (Plate I.7) that was revealed to the city with a spectacular destruction of the wall behind which the artist had locked himself up for three years, established the modern canon of male beauty, which has still not been replaced 500 years later. Michelangelo's decision to abandon the indeterminate abstraction of classicism he had adopted for his *Bacco* and to a lesser extent for his *Pietà* may have resulted from the restrictions imposed by a partially sculpted block of marble, or it may have been a deliberate intent to identify the work more closely with Florence and the Republic. *David*'s body lost the tendency to fuse into pure form cleansed of every accident of nature, and perfectly encapsulates a beautiful adolescent conscious of his own courage and strength. He is no mythical prophet, but rather Florence's most handsome young apprentice who re-dresses after a swim in the Arno with his friends, and is troubled by a wisecrack or offence that he is intending to avenge or has already punished.

The biblical David was the young prophet who against all expectations managed to dispatch the seemingly indestructible giant Goliath with a single shot from his sling, while relying solely on his faith and courage. Michelangelo's David demonstrates the roots of his power and courage in the awareness of his own beautiful body, in spite of its being distant from the classical canons because of his oversized hands and enormous head. His facial expression is theatrical, his eyebrows knitted, the base of his nose pinched and his mouth curled almost in disgust at the vision before him or the memory of what he has done. Michelangelo clearly emphasized the borders of the lips, the pointed

profile of the nose and the eyes whose lids are like embossed metal, almost as though he was acknowledging the Florentine tradition that exalted the outline of figures by persistent emphasis of it. The narrow back and the posture with its slight forward overbalance suggest the restrictions imposed by the original block of stone, which had been reduced to the point of depriving the statue of sufficient space to produce full and rounded muscles in proportion to the swollen curves of the perfectly formed buttocks.

In the rest of the body, the best possibilities nature occasionally grants men all rival with each other: the right hand slightly open to display the perfect line of the fingers, the wide nails as always found on Michelangelo's men, and the slight palpitations of the veins and muscles of the pulse and arms. The chest contrives the miraculous poise of the adolescent body, which has not yet been encumbered by the heavy musculature that is more fully developed by the hardships of war. Exaggerated and provocative nipples linger on a chest that has been sculpted with an extremely light touch. The neck, which has been brusquely twisted to the left, reveals the tendons attached to the collarbone with a naturalness that had never been seen before in Florence or even in the world. And then, under the stomach slightly tautened by the bending of the left leg, the extremely long leg joint creates space for the groin and the most disquieting genitals of Renaissance sculpture. The small bulge of the groin, typical of early youth, which follows the form of an almost feminine attachment to the penis, frames a tuft of exaggeratedly evident pubic hair that deviates from the statue's naturalism and supports a penis full of energy and displays the testicles, also full of vigour. *David*'s graceful abdomen echoes the androgynous fascination that Vasari would draw attention to in the Bacchus already sculpted in Rome for Riario. The softness with which the groin shifts down to the vigorous legs that radiate out and point down to the ground is like an explosion of femininity in the warrior's immature body, especially when viewed from below, as would have been the case if sited, as originally intended, on one of the cathedral's buttresses. Palpitating with life, the new god of male beauty immediately rendered ancient symbols obsolete, as they seemed too ethereal and static to communicate the vital attraction that Michelangelo's warrior has exercised for 500 years. Even the *Apollo Belvedere*, which the Cardinal of San Pietro in Vincoli,

Giuliano Della Rovere, was proudly exhibiting at the time in the church garden, appeared inert and unreal compared with the aggressive movement of Michelangelo's work.

The statue was immediately acknowledged as a masterpiece by his fellow citizens and, above all, Piero Soderini who had kept a close eye on the work's progress. Vasari tells a story about the leader of the Florentine Republic that does not show him in a very favourable light, probably with the servile intention of ingratiating himself with Grand Duke Cosimo I. According to Vasari, Soderini visited Michelangelo and advised him to make the *David*'s nose smaller, and the sculptor responded to his presumption by mockingly taking a handful of dust and pretending to shorten the nose with a powerful blow of his chisel, while in reality not touching the statue at all. The reality revealed by documents is of a very singular situation that a less defamatory language might have had the courage to call 'democratic'.

Although the sculpture had been commissioned by the Opera del Duomo, its exceptional nature triggered a process whereby its identification and symbolic worth became increasingly complex. David standing up to Goliath was a perfect symbol for republican Florence, which had just secured its position against invasion by the monstrous Cesare Borgia through an agreement with the king of France. This was only the last of a long series of struggles that in the preceding century the city had conducted in order to preserve its autonomy and values, which assigned to everyone, even artists, a significant role in the public administration.

With unprecedented far-sightedness, the city's government decided that the statue could and should become the symbol of the city itself. To achieve this, they had to position it in a place of maximum symbolic importance. Remarkably, the government delegated the decision on the appropriate place to a committee of artists, as this acknowledged the political usefulness of art and, what is more, that the talent and experience of artists has a civic role and contributes to the common good. On 25 January 1504, the Opera del Duomo convened a group of artists to take this important decision. They were the most accomplished in the city, as their posthumous fame would confirm: Andrea della Robbia, Cosimo Rosselli, Francesco Granacci, Piero di Cosimo, Davide Ghirlandaio, Simone del Pollaiolo, Filippino Lippi,

Sandro Botticelli, Antonio e Giuliano da Sangallo, Andrea Sansovino, Leonardo da Vinci, Pietro Perugino and Lorenzo di Credi. Putting to one side their personal jealousies and even any resentments that some, like Sansovino, might have felt towards the statue, the artists proved to be equal to their task and to believe in the republic that recognized their qualities. The political importance of what was at stake was emphasized by the government herald, Messer Francesco:

> I turned my mind to the assistance of my judgement: you have two places to erect a statue of this kind, the first where the Judith is [Donatello's *Giuditta* – author's note], the second in the middle of the palace courtyard, where the David is; the first because the Judith is a deathly symbol and is not appropriate, given that we have the cross and the fleur-de-lis as our insignia; it is not seemly that a woman kills a man, especially as she was under an evil constellation; and because since then your affairs have gone from bad to worse, and you have lost Pisa . . . I therefore advise that this statue is placed in one of two places, but preferably where the Judith now stands.[19]

At the end of a long debate in which questions of conservation and greater visibility for the work were thrashed out, it was decided that the *David* should be erected in front of the Palazzo della Signoria in place of the *Giuditta*, as had been strongly suggested by the herald. There was still the problem of how to transport the statue, and this was organised by highly practical Simone del Pollaiolo and other master craftsmen. The giant statue was wrapped up within an enormous framework of beams and was made to slide along the short distance between the Cathedral and the Piazza della Signoria. It took four days and the great bundle was pushed over poles greased with tallow, as though it were a ship being dragged across dry land. At midnight on 14 May 1504, the *David* was taken out from behind the wall where its jealous creator had hidden it, and it reached its port of destination in the *piazza* at midday on the 18th. Along the way it had had to avoid obstacles that could have damage the sculpture. The enormous statue risked meeting the same fate as the ancient Greek statue of Naxos, which broke its leg while being dragged headfirst down the mountain slope and was unceremoniously dumped by its sculptor and quarrymen. It was therefore suspended from a winch

with thick hemp ropes, so that its feet did not touch the ground and any blows could be softened by cords that stopped it from swaying.

Once these practical problems had been so brilliantly resolved, there still remained the political hazards, which were much more dangerous in a city that had always been divided into opposing factions. The Medicean camp immediately understood the political advantage the Republic could draw from that already widely revered symbol. They therefore decided to attack it during the night, as though it were an enemy army that had to be ambushed. Chroniclers of the time recorded the importance of the event and the antagonism it generated: 'It was guarded by night, for fear of obnoxious and envious people. Eventually some young louts attacked the guards, and threw stones at the statue with the intention of ruining it, and so when they were recognized the other day, they were arrested by the authorities and three of them were imprisoned.'[20]

Even before it was put on display, the *David* was paying for its fame. But a much higher price was exacted during the republican revolt of 1527, when benches were hurled from the *palazzo* and struck the left arm, shattering it. The fragments lay on the ground for three days, because no one dared touch them during those turbulent times. Eventually Giorgio Vasari, still a boy, and Cecchino Salviati found the courage to take them to the safety of the Salviati home and from there to send them to Cosimo I. The latter, now firmly in control of the city, had the pieces restored to the statue in November 1543, as he was confident that this benevolent gesture towards the greatest republican symbol would have served his purpose much more than any insult to Michelangelo, who was universally adored in Florence.[21]

5 MICHELANGELO'S WORKSHOP

Michelangelo returned to Florence around the middle of May 1501 and left for his second Roman sojourn in March 1505. During the period of nearly four years spent sculpting the great symbol of republican Florence, he also worked on many other private commissions. If we include all the contracts that were definitely entered into and the works that for thoroughly convincing reasons are attributed to him, his production during this period appears to have been quite prodigious.

And it was stunningly so, if you consider that it took the artist two years just to complete the *Pietà di San Pietro* – from the summer of 1498 to the summer of 1500.[22] In less than four years, a period for which the completion of the gigantic *David* would have been a challenge, Michelangelo completed the following works without any assistance: the bronze *David* which the Florentine Republic commissioned for the Maréchal de Gié, the *Madonna of Bruges* (128 cm), the *Saint Matthew* of the Academy (216 cm), the *Pitti Tondo* (82 cm across the diameter), the *Taddei Tondo* (107 cm across the diameter), the *Doni Tondo*, the magnificent cartoon of the Battle of Cascina, the four statues for the Piccolomini altar in Siena Cathedral, which according to the critics correspond to Saint Peter (123 cm), Saint Paul (127 cm), Saint Pius (135 cm) and Saint Gregory (135 cm).

Michelangelo would never admit that he had 'set up a workshop' for his own art. Attentive as he was to constructing the myth of himself, he wanted his position to be perceived as something quite distinct from that of other artists of this generation. However, when faced with such a vast production in such a short period, doubts over the methods of production of the 'Michelangelo workshop' are entirely legitimate, particularly as some of these works undoubtedly fall below the artist's normal standards. It is very difficult to believe that the *Pitti Tondo* and the four saints of the Piccolomini altar, which are so fifteenth-century in their insistence on over-elaborate drapery and simplification of the facial expressions, could have been wholly produced by the same hands as those that sculpted the *Bacchus*, the *Pietà di San Pietro*, the *David* and the *Madonna of Bruges* – works that are light years away from what we can unquestionably define as workshop production. Even though we cannot be sure about the authorship of all these works, it is important to examine the minor works of this period in a little more detail.[23]

On 24 April 1503, the consuls of the Arte della Lana (Wool Merchants' Guild) commissioned Michelangelo to produce statues of the twelve apostles, four and a half *braccia* in height (about 270 cm), which were to be placed in the cathedral. The artist decided to take a long time to complete this work and undertook to deliver one statue every year for the next twelve years. He wanted to keep himself free for other, more important commissions. Of these statues only the *Saint Matthew* remains (Plate I.5), and today it is held in the gallery of

the Florentine Academy. Even though only the front part of the saint has been sculpted, one can admire his powerful musculature, which is intensified by the fact that he is twisting his body. The left leg creates a monumental spatiality within the figure, partly thanks to the rounded musculature, which very convincingly gives the impression of energy freed by movement. The drapery, which is scanty, is in high relief in the case of the folds of cloth that hang down from the left shoulder and rise back up to the right one. Instead of impeding a proper appreciation of his athletic body, they enhance it by unerringly following the anatomy of his chest. The difference from the proportions of the *David* is so great, and the appearance so similar to the *Bacchus* sculpted in Rome, that one immediately senses how restricted Michelangelo must have been when working on the giant statue that had already been roughed out and brought close to its final posture.

Another 'minor' work was without doubt making demands on his time from early December of the same year, when the Mouscron (or Mascheroni), a family of Flemish merchants, paid him fifty florins (*fiorni larghi*) to sculpt the *Madonna of Bruges* (Plate I.8). He completed the work in August 1506 and sent it to Flanders, from where it spread the Italian sculptor's fame around the wealthy lands of the north. The sculpture is striking for its similarity to the Madonna of the *Pietà* in Rome – the identical melancholy that makes the woman appear very distant and even separates her from the small child who is climbing up her. The identical sentiment that the two Madonnas express cannot be explained solely by their contemplation and premonition of a tragic destiny. The two women's expressions of regal self-possession primarily conveys Michelangelo's conviction that the faces of his figures should not express themselves in a manner that was either too lively or too naturalistic, even if animated by the joy or tragedy of motherhood. The perfection of their features, which here again are fifteenth-century because of their long and pointed noses, can be explained as an attempt to approach the detached abstraction of classical statues, which represent the gods and separate them from ordinary men precisely through their supernatural control of their own feelings.

The sculptor's sensitivity is concentrated in his command of the expressive pose, which the perfection of the Madonna's features and their contrast with the elaborate drapery turn into something unsettling

and enigmatic. Once again, this is where Michelangelo takes the display of his virtuosity to new heights. There is the incomparable effect of the folds in her mantle, which is tautened by the child's left foot in an innocent and highly realistic act of playfulness. Equally remarkable is the cloak crumpled up behind the head, with the very deep shadow that Michelangelo sculpted by narrowing the cloth to an incredible degree – it is only a few millimetres thick. The classical composure of the scene is rounded off with a beautiful brooch that holds the Madonna's clothing together just under the neck, and this evokes an almost antiquarian antiquity. It also constitutes a break in the burnished folds of cloth and prepares the eye for the subtle veils that caress the young woman and her long and perfect neck and her face framed by shadows, which are also very deep.[24]

The *Pitti Tondo* (Plate I.9) and the *Taddei Tondo* (Plate I.10) are dated to around 1503. These two *tondi* in marble bas-relief are today on display in the Bargello in Florence and the Royal Academy in London. They are devotional works produced for rich patrons, and both lack a complete finish. The *Pitti Tondo*, which is generally considered superior to the one held in London, consists of a Madonna enclosed in a circular space that is as usual insufficient for the artist to express his exuberance of form. The Virgin is seated on a small cube-shaped slab and proffers the Scripture to the child with her right hand, while only the fingers of the left hand can be seen as they protectively support the little one in his standing position. The pose is almost frontal for both the figures, and the Virgin's expression is very close to that of the *Madonna of Bruges*, although it is more reassuring. The spatiality of the relief reflects a little hesitation in the use of the block of marble: the figure of the Virgin appears to be squashed against the external plane of the block, and the child has difficulty in finding his space between the deepest layer of the relief and the bent knees of his mother.

In the *Taddei Tondo*, the Virgin stretches her right hand towards Saint John, who is holding a goldfinch, the symbol of Christ's passion, while the baby Jesus, terrified by the bird, clambers onto his mother's leg, creating a very credible twisting of the body. The space created in the block by Michelangelo is much more complex than in his previous attempts, because he manages to give the impression of unlimited depth. The sculptor's complete mastery is underscored, with a burst of

self-indulgent virtuosity, by the young Saint John who folds his arms. The high relief acquired by the figure of the child is emphasized by the strip of his mother's cloak that follows his vibrant back, which is compact and full of movement as it twists around.

The third *tondo* that Michelangelo created during this period is a painting known as the *Doni Tondo* (Plate II.1), which was almost certainly commissioned for the marriage of Agnolo Doni to Maddalena Strozzi.[25] Thus it is a painting and not a sculpture, the only signed panel of Michelangelo's that has survived. The painting is tempera and was applied with a technique that was unavoidably very slow: tiny brushstrokes of colour on regular backgrounds while mixing the pigment with an organic binder. It is astonishing that hyperactive Michelangelo, who was already tested by many works that display his unstoppable and frenzied creative drive, would be able to constrain himself within such a slow, discreet and contemplative activity. Our astonishment is increased by his acceptance of a commission that required a long time to complete during a period in which he was overburdened with requests of every kind.

The *tondo* portrays the Holy Family in a very original pose. The Virgin, seated on the ground and dressed in extremely luxuriant clothes, has turned to take the baby from the hands of Saint Joseph, who is passing the child over her right shoulder. In the background and separated from the family by a low wall, several nudes appear to be in discussion while resting on or leaning against a natural seating area formed by a rock. The freedom Michelangelo is guaranteed by the technique, which has none of the restrictions inherent in marble, provides an opportunity for a masterly foreshortened view of the female figure. The Virgin's twisted pose is so bold that her profile becomes as lithe as the coils of a serpent. The rendition of the anatomies, including the background figures who move in an animated and lively manner, is superb and entirely free from all rigidity. Their muscular bodies are full of energy. None of the figures are presented in the usual frontal or profile poses, and the muscular effort to produce the movements is portrayed very carefully. The outlines are emphasized and highly refined, but this is the only remaining link with the Florentine tradition of the fifteenth century.

The meaning of this painting is obscure. At first sight, this is an exaltation of the passage from the pagan era, apparently alluded to in the

background figures, to the Christian one, symbolized and idealized by the baby that clings to his mother's hair to avoid falling during the difficult transition. The colours, as they have emerged from the recent restoration, are both burnished and transparent, a little unreal, as though in painting too Michelangelo was interested not so much in reproducing reality as the feelings it produces in human beings. The very cold pink of the Virgin's dress is almost cancelled out by the light and the enormous cape covering her legs, which is blue with a suggestion of purple. The cape also alludes to the shapeliness of the young woman's legs, in spite of the burnished folds of cloth. The clear spring light also serves to identify the anatomy of the personalities, and dwells on the relief of the muscles. With a typically fifteenth-century effect, the clear design of the figures even highlights the baby's navel, almost turning the picture into a drawing. However, the picture's real innovations are to be found in the background. The nude figures are slightly blurred, as though they had not been drawn but were created on the canvas purely by the effect of the colours. The mellowness of their bodies sharpens the distinction between their world and that of the Holy Family, but also applies the new form for spatial representation that would produce such stunning effects in the Sistine Chapel.

The Holy Family and more particularly the Madonna and child were common devotional themes in fifteenth-century Florence. It is not surprising then that rich Florentine patricians would ask the most renowned artist of the time to provide an interpretation of this motif that was so dear to the city. What is surprising, however, is that Michelangelo was willing 'to set up a workshop' with such determination, a working practice that he would later resolutely deny.[26]

Critics have occasionally interpreted this frequent return to the theme of the Madonna and child as a sign of the artist's desire to compete with Leonardo da Vinci's cartoon of the Virgin and child with Saint Anne, which had stunned Florence in 1501. In his struggle for the artistic primacy of his city, Michelangelo was unable to avoid a contest with Leonardo, who by that time was fifty years old and had consolidated his position as an unparalleled genius in Florence and Italy. Michelangelo's rivalry with the ageing master does not appear to have been the product of a subsequent myth, but rather reflects the actual mood of the young man whose star kept rising and who felt driven to

surpass a rival surrounded by universal admiration. The opportunity for a direct contest soon presented itself. The republic, proud of the talent of its most admired citizens, decided to call on them to take part in a competition in the city's most important public space and centre of republican power: the hall of the Grand Council in Palazzo Vecchio.

6 THE STRUGGLE FOR ARTISTIC PRE-EMINENCE

On the 23 October 1503, the government commissioned Leonardo da Vinci to produce the preparatory cartoon for the fresco of the *Battle of Anghiari* in the chamber of the Grand Council in Palazzo Vecchio. The fresco was supposed to celebrate the victory over Milan by the Florentines and their allies, the papal troops, in 1440, close to the small town of Anghiari.

In Florence, Leonardo was considered much more than an artist. He himself was very detached in his attitude to his own artistic work, as he was convinced, like many others, that it was an activity of little intellectual merit. The unique esteem in which the city held him was reflected in the very curious contract signed for the commission on 4 May 1504. The Priors of Liberty, who were aware of Leonardo's bizarre character, asked him to complete the cartoon by the following February and promised him a monthly payment of 15 gold florins (*fiorini larghi*). However, they reserved the right to demand the return of their money in the event of the work not being completed. Quite extraordinarily they allowed him to start on the fresco even if the cartoon had not been finished: 'And it may be that the said Leonardo should find it convenient to commence the painting and colouring of the wall of the said Chamber in the part for which he has drawn and submitted the said cartoon.'[27] Moreover the commissioners undertook – something that was also quite exceptional – to provide Leonardo with a kind of 'copyright' over the cartoon that they had handsomely paid for. This was a promise that they would commission no other person to apply the design to the wall and colour the fresco.

The cartoon immediately became something of a cult object in Florence. Leonardo reduced the battle scene to the conquest of the flag, which was fought over by some of the most exalted knights. He dwelt upon the anger that distorted the expressions of knights, and

emphasized all the emotive and philosophical meanings by recourse to a sophisticated symbolism, which his more educated contemporaries would admire as an expression of his considerable erudition. He used classical symbols to denote the battle rage of the combatants: Francesco Piccinino, who commanded the Milanese army, had Aries the ram on his armour, the horns of Amun on his head and ram's hide on his breast. The Florentine military leaders are portrayed with less distorted physiognomies and the iconographical attributes refer to the desire for rational containment of Mars's warlike fury. In some copies of the fresco, it is possible to make out the winged dragon, symbol of wisdom and wariness, and the mask of Minerva, the goddess whose intelligence triumphs over the frenzied bestiality of Mars.

The restless Leonardo used a new painting technique to transfer his masterpiece onto the wall. He prepared the wall with some sealants, so that he could decorate it at leisure with oil colours mixed with wax. Thus he evaded the tyranny of the rush to finish work before the plaster dries. We do not know the exact detail of the technique used by Leonardo to transfer the picture onto the wall, but the note on the materials he used, which was conserved amongst the entries for expenses in the treasury, is enough to send a shiver down the spine of anyone who is familiar with the scrupulous simplicity of fresco paintings. On 30 April 1505, payments were made to 'Francesco and S. Piero Pinadoro, apothecaries, for 260 pounds of plaster and 89 pounds and 8 ounces of Greek pitch for painting at 3 *soldi* a pound, and 343 pounds of Volterra plaster at 5 *soldi* a pound, and 11 pounds 4 ounces of linseed oil at 4 *soldi* a pound, and 20 pounds of Alexandrian white lead at 4 *soldi* and 8 *denari* a pound, and 2 pounds and 10½ ounces of Venetian sponge at 25 *soldi* a pound; Lionardo da Vinci received all items for the said painting.'[28]

Leonardo's experimental use of painting materials caused the rapid deterioration of the work, which the capricious artist did not finish, as he had been lured away by new and lucrative commissions in Milan. So he left his native city and Piero Soderini to inveigh against his unreliability.[29] The contest with the young and ambitious rival would have to be restricted to the cartoons, because Michelangelo also failed to leave his painting to posterity.[30] In the summer of 1504 he was commissioned to produce a portrayal of the *Battle of Cascina* for the wall opposite the one on which Leonardo is supposed to have painted his *Battle of*

Anghiari. The fresco was supposed to evoke the events of July 1364, when Florentine soldiers were surprised by enemy troops from Pisa while they were cooling off in the waters of the Arno. The Florentine commander Manno Donati, who had not joined the swim, saved the day by providentially raising the alarm.

Michelangelo portrayed the moment of the surprise attack. His expressive language was something dramatically innovative compared with Leonardo's. There are no symbolic allusions and no smug expressions of his erudition. There are just naked men caught by surprise while bathing, who hurriedly prepare for the battle. The narration uses a language entirely centred on the body: a kind of muscular rhetoric, as Leonardo contemptuously called it – he was irritated by the effort his contemporaries put into exaggerating the muscles of the men they portrayed. But Michelangelo's bodies never go beyond a pleasant and powerful vitality, and are always perfectly harmonious. The absolute centrality of the naked male body eliminates the need to use erudite references and an iconographical tradition entirely based on a legacy of images taken from ancient sculpture. The young artist thus wrong-footed the wise old man, and suddenly turned his sophistication into something obsolete.

Michelangelo's victory would be ratified by Leonardo himself, who shortly after 1504 returned to his studies of anatomy and drew virile muscular bodies. In this contest between giants, the young artist appears to have impressed the old one, rather than the other way around.[31] But the rivalry between the two also had its existential nuances. Leonardo was profligate and never denied himself anything, not even the satisfaction of his erotic desires which, like those of Michelangelo, were directed towards his own sex. The young man, on the other hand, had already decided to channel all his emotional and erotic drives into his own artistic creativity, which constituted the centre of his social and personal redemption. This different lifestyle, much more than the diverse creativity, could only provoke feelings of resentment. Even though on this occasion Michelangelo won the battle for the esteem of his fellow citizens, the same cannot be said of the battle he continued to fight throughout his life against his own drives towards self-censorship and sacrifice.

3

AT THE COURT OF JULIUS II

1 A WARRIOR POPE

At dawn on 19 October 1503, while Rome was being lashed by torrential rain, distressing news was filtering out just as the autumn light was struggling to do, through the dense layer of cloud trapped between the Tyrrhenian Sea and the mountains of Abruzzo. The unpaved streets were a quagmire, which inexorably dragged all kinds of rubbish into the River Tiber. Torrents of waters crashed down between the roofs which almost touched each other across the winding streets between the Pantheon and Saint Peter's, carved out dark holes, and splattered the walls with the thick reddish soil lifted from the ground.

It rained within the caverns of red bricks constituted by the crumbling imperial palaces, where shepherds took shelter with their little flocks, which in that season grazed between the Arch of Titus and the colossal columns of the Temple of Saturn. It was also raining on the Arch of Septimius Severus, even though its barrel vault, half submerged below the ground, was being contended by ill-tempered cows. But the rain, which gave no sign of relenting after several hours, was unable to hold back the burgeoning crowd that gathered under dark canvas sheets waterproofed with wax and came from the hovels and the palaces of a city that was still fortified like a medieval citadel. The crowd continued

to grow and collected around the Ponte di Sant'Angelo, and then moved in small tearful groups towards Saint Peter's.

Pope Pius III had died, and this pope of the Piccolomini family had been such a good and meek man as to appear a miracle in the Eternal City debilitated by the abuses of Pope Alexander VI and his son Cesare Borgia. The miracle had not even lasted a month, and the pope's passing reopened the wounds of an extremely difficult succession. The death of Alexander VI, which Italians had greeted with joy, had left his son Cesare, who had taken possession of Central Italy with ferocious arrogance to the detriment of the small states and the Church's own territories, at the mercy of those he had offended. Many wanted his head, particularly in Rome. The Orsini, the powerful Roman family whose valiant commander he had strangled a few years earlier, had laid siege to Vatican Palace where he had sought refuge while pretending to be dying.

Wily men waited on every corner to make sure that Cesare did not escape, perhaps disguised as a friar as often occurred in Rome. Immediately after the disbandment of the small army that was supposed to bring pressure on the conclave to elect a pope favourable to him, the other factions that sought to influence the papal election – Spaniards, French and fragmented groups of Italians – could find no better solution than the appointment of a transitional pope who would give them time to cool down the vexed tempers that threatened to explode in Rome and drive it into a civil war.

With the death of Pius III less than a month after his election, the political climate was once more dangerously unstable. The unremitting rain did not appear capable of dampening the passions, but it was sufficient to wash away the people's last hopes of a lasting peace. For this reason, the faithful could not go without the small consolation of kissing the feet of the good pope who had allowed them to dream for a few days and for whom they felt an enormous gratitude that stunned a correspondent of the Duke of Ferrara: 'All day yesterday, his body lay in Saint Peter's, and even though it was raining very hard, the whole of Rome came rushing – both men and women in a great crowd and everyone made every effort to kiss his feet.'[1]

The capture of Cesare Borgia was the least of the problems that arose after Pius III's death. No one wanted to save the life of that

murderous tyrant who in the period of one month went from emperor in all but name to political refugee. The Papal State was in a desperate position. The Borgias had plundered the treasury and fragmented the territories, while papal authority risked becoming permanently subject to the balance of power between European states. Rome was besieged by the French to the north and the Spaniards to the south. In the meantime, the Italian cardinals, who expressed the interests of small regional potentates, were too intent upon enriching their own families to be capable of developing a political project of any significance.

That is everyone with the exception of Giuliano Della Rovere. He had adopted a clearly stated position just before the September conclave that ended with the election of Pius III. Above all he had been very clear in his opposition to the Borgias during the preceding decade, all of which he had spent in exile. Following this return to Rome at the beginning of September 1503, Giuliano, who was born in Albissola in 1443 and had been appointed Cardinal of San Pietro in Vincoli in 1471 by his uncle Pope Sixtus IV, peremptorily expressed his rejection of both French and Spanish ambitions. He would pursue the primary interest for an Italian: the consolidation of the Papal State perceived as the central fulcrum of a national political alliance capable of containing French expansion into Lombardy, Spanish conquests in the south and the no less dangerous designs on the eastern part of the Papal State by the scheming Venetian Republic.

Giuliano, a man of military countenance, started his political negotiations with his adversaries on the same day, without waiting for a break in the rain which seemed to be colluding with the city's assortment of uncontrollable ambitions to drag it down into the Tiber. He was not sparing with his promises, and not all of them were permissible, but his political talent produced the greatest diplomatic masterpiece of the Renaissance: on 31 October, Rome and Christendom had a new pope, who took the name of Julius II. The conclave, which only lasted a single day, was one of the shortest in the history of the Church. The College of Cardinals, who had felt so threatened that they met in the fortress of Castel Sant'Angelo rather than the Vatican, elected their most courageous member. Perhaps it was the Holy Spirit, perhaps it was their terror of an even more terrible crisis that would ruin them all, but what is clear is that they almost unanimously staked everything on the only

man who had shown himself capable of leading the Church out of the dangerous morass.

At the time of his election to the papal throne, Giuliano was sixty years old and his hair was white. His ruddy complexion turned purple with rage when anyone contradicted him. His sunken eyes were small, watery and never still, unlike his mouth, which was always pursed in an expression of indignation. But it was his prominent nose, which his flatterers called 'manly', that expressed the strength of his character. With time, this strength became military virtue, and Italy soon learned to respect him for it. Irascible, energetic and determined, he was more suited to be a king than a pope. But in that critical moment the papacy above all needed a king, and Giuliano provided it with that service. He was impetuous to the point of indecency and incapable of concealing not only his thoughts on government but also his anguish. He shocked everyone when he gave in to uncontrollable sobbing at the death of his much-loved sister Lucchina.

To use the Renaissance terminology, his was a 'melancholic' temperament capable of great fury and great abandon. He lost no time in unleashing his military campaign against the usurpers of the Papal State, and as he could not delegate the work that needed to be done, he personally took part in the military campaigns. His commanders were stunned when he showed up at the siege of the Fortress of Mirandola, and showed himself to be unconcerned about the snow or the enemy fire. He wore a white fur coat and courageously worked with his own hands to drive on the siege against the castle that had so obstinately refused to surrender to him.

Alongside his political and military strategies played out in the courts of the land and on the battlefields, Julius II also pursued another and more important strategy of power: the transformation of the city of Rome into the capital of a state that had to prove itself at least as invincible, just and powerful as the Rome of ancient Romans, whose memory he wished to reinstate.[2] In Rome he had to stand up to the power of the local barons, who were always ready to stir up trouble over issues of local autonomy. In order to reassert the papacy's political supremacy in the city, Julius introduced laws that aimed to debilitate the already timid merchant class, and planned urban and architectural changes that reinforced his political aims and made them more visible.

He started work on opening a new arterial road on the other side of the Tiber, the Julian Way, where his court architect, Donato Bramante, was building the law courts, which were to house and organize the city's magistrature and the notaries that regulated civil relationships. The Vatican Palace had to be turned into a kind of ancient royal palace, and work was started in accordance with Bramante's plans on the construction of the Belvedere, a theatre-courtyard that linked the old Belvedere residence to the palaces next to the Saint Peter's using ramps, porticos and corridors. This basilica was to be rebuilt to a modern design that demonstrated all the triumphal greatness of the Catholic religion. This was part of the reason why Bramante started work on a building project using a centric plan in May 1506.

When it came to commemorating himself, he clearly required the great Florentine sculptor everyone was talking about. In particular, he spoke about Michelangelo with Giuliano da Sangallo, the Florentine architect he held in great esteem, who had already constructed some *palazzi* for him. A community of Tuscan artists had collected around this architect, and they were hoping for rich pickings from the hyperactive pope.

2 A COMMISSIONER WITH ENDLESS PATIENCE

Michelangelo did not have to wait long for his call to Rome. On 25 February 1505, the pope had him paid a hundred ducats in Florence to cover his travelling expenses, and sixty ducats more was almost certainly paid, given that the artist hurried to bank them at the Balducci bank as soon as he got to Rome.[3] A hundred ducats was a considerable sum for an initial payment, given that the monthly pay for a good artist was around ten ducats and the daily pay of a master craftsman was just twenty *baiocchi* (one fifth of a ducat). From that moment on, the relationship between Michelangelo and Julius revolved around money, which the artist was constantly demanding, obtained in abundance and then denied ever having received.

The Rome that Michelangelo attempted to conquer for a second time was very different from the one he had left five years earlier. Now it was the pope who was treating art and artists as priorities for the Vatican. Moreover, the pope was consumed by his personal passion

for collecting ancient sculptures on a scale comparable with that of Cardinal Riario, who happened to be one of his close relations and must certainly have spoken to him about the prodigious Florentine sculptor, the only one in Italy capable of equalling the Greek and Roman artists. The unreal atmosphere of a new golden era, which was affecting Rome at the time, managed to seduce Michelangelo within a few days of his definitive arrival in the city.

On a cold and cloudless day in January 1506, two large serpents appeared and were woken from the millenary hibernation. They were the marble serpents that had crushed the ageing Laocoön and his two young sons for having opposed the deadly gift Ulysses presented to the Trojans. Two sculptors of Rhodes created a statue based on the Homeric story, whose renown spread around the world. Pliny provided a record of it, and claimed that Emperor Titus bought it and had it shipped to Rome. Now the statue had re-emerged from the ground, as though it were a premonitory sign of the excellence art was once again achieving under the rule of Julius II. And this pope lost no time in offering the owner of the land on which the statue was found the fabulous sum of more than 600 ducats so that he could place the statue in a purpose-built chapel at the Belvedere, as though the statue were a Christian relic. The more erudite poets of Rome, including Sadoleto, composed verses to celebrate the event. When telling this story to his brother, Cesare Trivulzio declared himself convinced that it was the most important event of that year in Rome.

On that same cold, dry day in January, Michelangelo was at the home of Giuliano da Sangallo, and had just returned from Carrara, where he chosen the marble for the tomb that Julius had commissioned. When they came to inform the architect of this discovery, he ran excitedly to the vineyard to witness the disinterment. Of course, he must have fully realized that this sculpture would provide him and the world with a new and even higher bar for him and the entire world to leap over, particularly because Laocoön and his sons was not only an example of anatomical perfection but also an expression of convincing pathos, the like of which had been unknown in Italy. But Michelangelo was entirely confident of his own talent and he was not disheartened by the discovery at the very time he was in intense negotiations with the pope. Indeed, he did not hesitate to promise Julius the greatest work

of sculpture the world had ever seen: 'and if you want to do the tomb in any case, you should not mind where I do it, as long as within five years of our entering into an agreement it is firmly established in Saint Peter's, you like it and it is as beautiful as I have promised it will be: for I am certain that, if it is done, it will not have an equal in all the world.'[4] Michelangelo's self-esteem was not shaken even by this awesome example of excellence.

Besides, the artist had already received the first important commission from Julius much earlier than he had expected – a commission without any precedent. As soon as he arrived in Rome in March 1505, he did not have to work very hard to convince the pope to finance a colossal project for his tomb. Within two months they had agreed upon the design and the price, and so as early as 28 April the artist could transfer fifty ducats to Florence for travelling expenses and the purchase of marble in Carrara.[5] The speed of planning the artwork and negotiating the costs was astonishing: these two giants were made for each other. Julius had immediately understood both the artist's talent and his obsession with money. He was never sparing with his compliments and his resources, and this precisely at a time when he was terrifying the entire papal court and much of the European diplomatic world with his abrupt manners, which often involved his fists and his stick bringing the discussion rapidly to the conclusion he desired.

In Florence, Julius had another thousand ducats counted out for Michelangelo, who banked six hundred of them to be used the following January to buy his first piece of land of any significance: a farm near Pozzolatico. He was so sure of retaining the pope's favour that the substantial advance for purchasing marble ended up as a property investment that finally marked a decisive recovery in the financial fortunes of his own dynasty. During this period, everything was proceeding in a highly satisfactory manner. Michelangelo stayed in Carrara through the autumn and early winter of 1505, and he returned to Rome on 29 December, just in time to be present at the unearthing of the statue of Laocoön two weeks later, like a sign of his destiny. Julius successfully reconquered the possessions stolen from the Church. Bramante finished the plans for Saint Peter's and was about to start on its rebuilding, while dividing his time between the work on the courtyard of the Belvedere and the Julian Way, where it was now

possible to see the foundations of the colossal new law courts. In other words, this was the rebirth of Rome, and Egidio da Viterbo, the pope's loyal and learned assistant, made every effort in his official sermons to project the pope as the herald of a new golden age.

Then a sudden, unexpected and violent dispute broke out between the pope and Michelangelo in April 1506. We only know the artist's version of the story, which is sufficiently biased to engender considerable conjecture about the event. According to what he had the docile Condivi write, Michelangelo took refuge in Florence at the end of April and accepted the protection of Piero Soderini, who had always displayed great benevolence towards him. In a letter of 2 May to Giuliano da Sangallo, who ultimately was responsible for having presented him to the pope, he claimed that he had received ill-treatment and threats in Rome such as to put his life in danger: 'Let it suffice that this made me think that if I stayed in Rome, my burial would happen before that of the Pope.'[6] In this and other letters, Michelangelo made no reference to the fact that the pope rightly felt insulted by the artist's pressing demands and thought that he had given him enough money to pay for all the marble in the world: money which had ended up in the farm at Pozzolatico rather than in a quarry at Carrara.

The obscure and tragic tone of the letter appears designed solely to justify the artist's reprehensible behaviour. There is nothing that leads us to think that Michelangelo really did receive death threats. The information that has patiently been put together on this particular incident suggests that his clash with Julius was as usual caused by his desire to increase his income from the commission and, more particularly, to obtain an authorization to transfer the marbles and the work to Florence, where he would have spent a great deal less on the production of the work and could have more easily completed other works he held dear, such as the Piccolomini statues and the painting for the chamber of the Grand Council, for which he had already signed contracts.

Among the recriminations he expressed to Sangallo, who acted as his patient mediator with the pope, Michelangelo claimed that on Good Friday he had heard Julius II tell a jeweller that he did not intend to spend a single lira on stones, large or small – considered a clear reference to his desire to drop the commission for the tomb. This is difficult to believe, given that the pope had already paid out 1,600 ducats, which

had been used by Michelangelo only in part for the purchase of marble, while the rest of the sum had been invested in property or deposited in his current account in Rome. Michelangelo protested that he had been refused on the five successive days when he had returned to the pope to ask for the money to pay for the marble which had been landed at the port of Ripetta; he had not even been received by the pope. Knowing the real state of Michelangelo's finances as we do and as poor Sangallo, who was involved in this sorry squabble, did not, we find it more probable that the long-suffering Julius found absolutely excessive this further demand for money for a work he had never seen and which had already cost him a fortune.

Michelangelo considered himself to have been grievously offended by this refusal. He left Rome and resumed his negotiations with Julius in Florence, with the aim of remaining in his city to work and to return to Rome only to assemble the monument. But Julius had no intention of submitting to this demand, partly because he wished to give him another commission alongside the tomb: the decoration of the ceiling of the chapel that his uncle Sixtus IV had had built thirty years earlier, and had been recently damaged so badly that it required rebuilding work. Contrary to what the artist would later insist through his tame biographers Condivi and Vasari, it was not Bramante who in 1508 suggested to the pope that Michelangelo should be entrusted with the decoration of the Sistine Chapel in the hope that he would fail and fall from grace with the pontiff. A letter sent to Michelangelo by one of his most trusted friends in Rome on 10 May 1506 tells a very different story. At supper, because like all great lovers of art Julius preferred to talk about it in the company of sparkling and gilded glasses of good wine, the pope revealed his intention to recall Michelangelo to Rome to commission him to decorate the ceiling of the Sistine Chapel. Bramante very sensibly raised doubts about the appropriateness of entrusting such a complex task to an artist who had almost no experience of painting frescoes: 'because he has not done many figures, and above all the figures are high and in perspective and it is very different to painting on the ground.'[7] Knowing Michelangelo's avidity for such lucrative commissions and feeling that he was undoubtedly his mouthpiece, the master craftsman Piero Rosselli, who was also present at the supper, started to insult Bramante and ruin the convivial atmosphere of supper

with the pope. Michelangelo, Rosselli argued, would never refuse that commission and was ready to come to Rome to carry it out, in spite of Bramante's doubts over his ability to complete the work.

The 'working supper' among the luminaries of the old Vatican palace ended with an argument. The subsequent facts of the affair proved Piero Rosselli to have been absolutely right and the ageing Bramante to have played exactly the opposite role to the one that Michelangelo would later want to assign him. Rosselli's account also gives the lie to the myth of an irascible and domineering pope who was always ill-disposed to the poor artist. Quite the contrary, Julius II, who was certainly not in the habit of yielding to anyone or anything, had shown himself willing to overlook the artist's shameful behaviour, while the artist owed him a very considerable amount of money he had spent on profitable property investments. Indeed, he sent a papal brief to the Florentine Republic concerning what had now become a matter of state, and in it he showed considerable kindness and understanding towards the bizarre artist, whom he could have had arrested as a bankrupt debtor:

> My beloved children, health and apostolic benediction. Michelagnolo sculptor, who abandoned us for no reason and out of caprice, fears returning, as we understand it, and we have nothing to say against him, as we comprehend the natural dispositions of such men. However, in order that he can put aside all suspicions, we exhort you on the basis of the affection you hold for us to promise on our behalf that, if he returns, no one shall touch him or offend him, and we will return him to the same state of apostolic grace he enjoyed before his departure.
>
> Rome, 8 July, 1506, the third year of our papacy.[8]

Michelangelo could not go any further. Nor at that time could he argue, as he would do later with his heirs, that all the money had gone to buying marble in Carrara, whereas he had in reality spent slightly over one third of the sum received on its intended purpose. Being the prudent and practical man that he was, he decided to heal the rift with the pope by going and prostrating himself at his feet in Bologna, where Julius II had gone to resolve some acute and outstanding political and military problems with the rulers of that city.

On his arrival in Bologna at the beginning of December 1506, Michelangelo immediately received a new commission: a bronze statue of the pope to be placed above the imposing entrance to the church of Saint Petronius. On 19 December, he wrote to his brother Buonarroto, promising him that he would complete the casting of the statue by the next spring and would immediately return home. However, the work presented significant technical problems, especially for a sculptor whose only previous attempt at casting in bronze was a small *David* for French patrons. It involved forming a sculpture in terracotta and covering it with a thick layer of wax, which would later be replaced by a bronze casting. Outside this layer, you had to construct a double in reverse [*controforma*], also made of terracotta and of a thickness capable of resisting the heat of molten bronze. It was not easy, as the molten bronze had to reach every little recess of the sculpture and expel all the melted wax through ducts. The larger the sculpture and the more complex the figure's pose, the greater were the difficulties. A few years earlier, even the great Leonardo, who was certainly very knowledgeable about engineering and technique, had had to give up on the bronze casting of a large statue for the Duke of Milan, a failure that Michelangelo had recently had the impudence to remind him of in public.

Now he was floundering because of similar problems. Once he was convinced that he needed expert assistance, Michelangelo reluctantly turned to two artists, who were of course Florentine, as he obstinately refused to trust anyone else. It only needed a few weeks of work together in the delicate business of casting for the deranged artist to start arguing with his assistants and accusing one of them, Lapo, of having boasted a near equal position in the enterprise, whereas they had only been engaged for the casting. To what was already a grievous sin for Michelangelo, he then added suspicions about the man's honesty, because he was supposed to have appropriated a few small coins while purchasing materials. Michelangelo's diffident and suspicious character and his intolerance of any comparison with any other person thus were turned against him and isolated him precisely at the time he had the greatest difficulties.

On Monday, 1 February 1507, he informed his brother Buonarroto that he had sacked his two assistants. His main reason for doing this was to put him on his guard against the accusations that the two would

undoubtedly make against him on their return to Florence. In a subsequent letter to his father, he did not fail to emphasize the extravagance of the payments to these two: 'I sent Lapo away because he is a scoundrel and a bad man, and he did not do what I required of him. Lodovicho was better and I would have kept him another two months, but to avoid being criticized on his own, Lapo incited him against me so that the both of them left . . . one was paid twenty-seven ducats for a month and a half and the other eighteen *larghi* and his expenses.'[9] The departure of the two experts in casting considerably complicated the task before him. Initially the casting appeared to have been a disaster, although as time went on, the damage proved to have been more limited. In the summer of that year, the statue was cast, but Michelangelo remained in Bologna throughout the autumn of 1507 and the early months of 1508, while he chiselled away at the sculpture to correct the defects.

We know nothing about the statue, because a few years later it was destroyed during a revolt against the Papal State. As nearly always happened during those years, the bronze was recycled for making cannons, which must have been particularly effective, given the character of Julius from which they were made. We know even less about Michelangelo's sojourn in Bologna, although a letter written to his friend, the friar Lorenzo Viviani, on 15 March 1508 demonstrates that there were not only worries and hard work, as Michelangelo would have his family believe in his mournful letters, but also some very happy moments of conviviality, for which the friar already felt nostalgia. He expressed his hope for an early return of the artist.

As usual, Michelangelo depicted himself in his letters to his father as the prisoner of an ugly city, where the air was bad and wine even worse, and where there was never a moment for looking around. The same economy with the truth was applied to the profit from the trip and the enterprise. In 1523, Michelangelo complained to his friend Giovan Francesco Fattucci that he had earned no more than four and a half ducats! But the reality was certainly very different, as on 17 February 1508 his father was able to deposit 250 florins in his name, and this was surely the sum left over from the thousand Michelangelo had received for the statue. That money was used shortly afterwards, in March of the same year, for the purchase of new properties: the houses in Via Ghibellina in Florence, where the Buonarroti established themselves

permanently. The expansion of the family continued apace, and the expectations of new commissions from Rome led to hopes for even better things to come. The time had come to re-establish the family's financial fortunes.

3 THE ADVENTURE OF THE CEILING

Having returned to Rome in the winter of 1508, Michelangelo set about organizing work on both the tomb and the decoration of the Sistine Chapel. A memorandum from April of the same year summarizes his intentions for the coming months:

> For the work on the tomb, I need four hundred ducats now, and then two hundred per month for the same work, as per our initial agreements. For the craftsmen who have to be brought from Florence, who will be five in number, twenty golden ducats each, on this condition: when they are here and if they are in agreement with us, the said twenty ducats each for their room which they will have already received shall go towards their salary, which shall commence on the day they leave Florence to come here; and should they not be in agreement with us, they shall have half of the said money for the expenses incurred in coming here and for their time.[10]

The decoration of the Sistine Chapel ceiling promised to be an even more difficult undertaking than the casting of the statue of Julius in Bologna, as Bramante had wisely predicted. It was an enormous surface to decorate and it was in one of the important sites to Christendom, where the papal court along with its foreign ambassadors and most esteemed guests would occasionally meet to celebrate mass. The difficulties started with the scaffolding, which had to be designed so that highly formal services could continue during the works. The chapel built by Sixtus IV in 1477 had a very regular rectangular form. It was three times longer than its width and its height was half its length (40.2 metres x 13.4 metres x 20.7 metres), making an overall surface of 1,200 square metres to be painted with one's head looking upwards and while taking into account the distortions caused by the curved surface (Plates II.2 & 3).

Up until that moment, Michelangelo had had no experience of paint-ing frescoes, except for a very marginal involvement in the Ghirlandaio workshop some twenty years earlier. This kind of decoration required an extraordinary technical expertise, because the pigments dissolved in water had to be applied to the wall before the plaster hardened, which meant within twenty-four or forty-eight hours of its application. For this reason, following the preparation of a general design and the application of its essential lines to the layer immediately underneath the plaster once applied, which was called the 'rendering' [*arriccio*], a small area of plaster would be applied and was called a 'working day' (*giornata*), or in other words, a portion that an artist could decorate within the next working day. The changes in humidity and tempera-ture made it difficult to obtain each day the same quality of mix of plaster and the same properties once applied to the wall. There was the risk that the difference between 'working days' would be visible if the mortar was applied in different ways and subsequently set in dif-ferent ways.

Once you had resolved the mechanical problem of the composi-tion of the plaster to create uniformity throughout a work of art that could take years to complete and therefore of a composition capable of being used in all seasons, there was still the problem of the colouring, which had to be homogeneous, at least in adjacent parts. The colour was prepared by mixing a very fine pigment into water but, as can be intuitively understood, even small changes in the fineness or quantity of the pigment or its ratio to water could produce different final colours. Even worse was the fact that the final effect could only be checked once the plaster was completely dry, and thus there was a risk of discovering too late that a portion of the painting was not uniform with its adjacent parts. In such a case, there was no corrective action of any kind, because once the plaster was dry, nothing could be done to the painting. There was a single dramatic remedy: demolish the completed work and start from scratch.

Finally the drawing could not be improvised, because the timing was inescapably governed by the drying times for the mortar. There had to be a paper copy of the various scenes on a scale of one to one, which was then transferred to the wall while the plaster was still fresh. This transfer of the outline was generally carried out in two ways. The

first involved pinning the cartoon with the drawing to the wall with small nails and impressing with a pointed iron stiletto in order to trace the outline onto the plaster beneath it. In this case, you had to be very careful not pierce the cartoon while tracing, and not to press too hard and ruin the plaster. The second method involved pricking the cartoon drawing below the area to be frescoed and then, after having placed the cartoon over the plaster and having fixed it with nails, passing a bag of coal dust over the lines so that the dust penetrated the holes and reproduced the lines on the plaster. These lines would then be united by the artist with a brush dipped in colour in order to reconstitute the drawing accurately. All the operations required several people and a perfect coordination with the squad, particularly if everything was going on at a height of twenty-one metres on top of an uncomfortable scaffolding made of wood and rope. The Tuscan workshops of the fifteenth century, and more generally since the time of Giotto, had achieved a degree of excellence in the application of these techniques, which had not been rivalled elsewhere in the world. Michelangelo had had the good fortune to carry out his apprenticeship at the best of these workshops. But the fact remained that such a vast ceiling had not been painted with figures using the fresco method in Italy during the previous centuries, and that particular ceiling had possibly been frescoed by Pier Matteo d'Amelia, who restricted himself to producing a large starry sky, just as artists had done with the Gothic ceilings of the thirteenth and fourteenth centuries (Assisi is still the most famous and most successful example).

In the light of all these difficulties, Michelangelo should have abandoned the enterprise. He felt himself fundamentally to be a sculptor and that is what he was. Perplexingly, that is what he declared himself to be when signing the documents relating to the work on the Sistine Chapel, but his eagerness to get his hands on the money offered him by Julius was too strong for him: he could not lose the opportunity for such exceptional earnings. He therefore attempted to organize the work on business lines by engaging people whose expertise was much greater than his own. He called on his Florentine friends – those who he had known during his apprenticeship at the workshop of the Ghirlandaio brothers and, above all, those few he trusted because they had always remained close. Never for a moment did he think of using Roman

assistants. The Roman world was one he would always find treacherous, and he tried to have as little to do with it as possible.

He first turned to Francesco Granacci, who was of the same age and a very close friend, and he gave him the task of putting together a small but very experienced squad of painters. These included Giuliano Bugiardini and Iacopo di Sandro, as well as two or three others whose identities remain uncertain. A painter came forward who had worked with Pier Matteo d'Amelia, responsible for the original decoration of the ceiling; he asked for a salary that, all things considered, seemed reasonable and it was decided to award the same amount to the others: ten ducats per month.[11]

According to the accounts of his biographers, Michelangelo designed an ingenious scaffolding, which can be considered his first engineering work (although it is difficult to believe the legend that this design surpassed the work of Bramante, in whom the pope rightly placed enormous trust). He suspended the platform from inclined rafters called *sorgozzoni*,[12] which were widely used in Florence for supporting projections from houses and were made out of two beams, one inclined and the other horizontal, both attached to wall behind them. He thus managed to reduce the distance to be reached from the platform from fourteen to seven metres, which was easily achieved with a simple wooden truss (the width of the ceiling is greater above the first cornice).

On 11 May 1508, the day after having received his first instalment for the new enterprise, Michelangelo engaged Piero Rosselli, his loyal master craftsman who, exactly two years earlier, had spied for him during the conversation between the pope and Bramante, to construct the scaffolding and render the ceiling of the Sistine Chapel. Rosselli immediately started to chip away the old plaster and then replace it with a rough coat (rendering), and on 27 July this part of the work was completed. The cardinals, who stubbornly tried to carry out their liturgical offices in the midst of dust and noise, must have found those months exasperating. On Whitsun Eve, some of them went to the chapel in full pomp and with all their regalia. The dust was ruining their white linen and red velvets, but the workers did not want to hear about interrupting their work. They had good reason for working as fast as they could. Above all they had the support of Pope Julius, who had little time for the abstract liturgies of the Church and was so anxious to see the ceiling

finished that he would undoubtedly have liked to learn to paint so that he could speed up the work.[13]

At the time, Michelangelo did not appear to be at all intimidated by the enormity of this undertaking. Convinced that he could work on the tomb at the same time, he had the marble brought from Carrara. He also promised poor Piero Soderini that he would soon return to Florence to finish off the work on the bronze *David*. The *gonfaloniere* trustingly waited for him, just as he had waited for Leonardo, who in the same period had preferred Milan to republican Florence, his beloved country but clearly not so generous with rich commissions as a state governed by one man, especially when you were lucky enough to meet with his full approbation.[14]

In the meantime, they produced the drawings of the scenes they intended to use in decorating the ceiling. According to Michelangelo's own account, the pope's initial intention was to depict the twelve apostles on the pendentives. As a good businessman who was well aware of Julius's overriding passion for art, the artist did not have too much trouble in convincing him to commission a much more demanding work. The pendentives would be used to portray the prophets and the prophetesses (sibyls) who announced the coming of Christianity. The lunettes would display Christ's ancestors (a theme that at the time had had very few precedents in painting). The ceiling itself would be a succession of nine scenes from the Old Testament: the division of the light from the darkness, the creation of the heavenly bodies, the separation of the waters, the creation of Adam, the creation of Eve, the original sin (Plate II.5), Noah's sacrifice, the universal flood (Plate II.4) and Noah's drunkenness.

In all probability, the subject matter was planned by the most learned and highly regarded papal counsellor, Egidio da Viterbo, a theologian deeply interested in recovering the pagan tradition and its hybridization with Catholic culture. The presence of pagan prophetesses in the decoration very courageously expresses this desire to safeguard the legacy and dignity of the pagan world, held in great esteem during this period by humanists and European men of culture. Sophisticated exegesis of ancient texts made it now possible to detect a clear premonition or announcement of Christ's coming in the maxims of ancient prophetesses, and this led to a reassessment of the entire pagan world with

its extraordinary cultural exuberance and to its reconnection with the advent of Christ alongside the biblical tradition. Indeed, studies into and interpretations of the continuity between the pagan and Christian worlds became so authoritative during the reign of Julius II that these two worlds could finally coexist in the Christendom's most important chapel: the prophets of the Bible and the prophetesses celebrated by pagan writers could sit next to each other on their marble thrones.

While the content of the decorations was without question established by the papal court, we can be equally certain that Michelangelo was granted great freedom about how to represent that content. The few remaining studies drawn in the planning stage suggest that the whole project was put together very quickly, and this is confirmed by the documents that record a swift agreement between the pope and Michelangelo, as had already occurred for the project on the tomb two years earlier. The initial plan was suggested by tradition and perhaps the papal counsellors, as well as Bramante, as it is hard to believe that he wasn't consulted over such an important enterprise, and was based on the Roman ceilings discovered in the Domus Aurea di Nerone. A few years earlier, a peasant disappeared down a well he was digging close to the Colosseum, and fell into the buried rooms of Nero's house, which is decorated with strange and polymorphous little figures: animals with the bodies of flowers and men with the bodies of animals or plants, which had been either stuccoed or frescoed. By his fall, the peasant opened one of the most adventurous phases of the Renaissance, the revival of 'grotesques' as a form of decoration, and one that would invade the walls of all Italian *palazzi* in a very brief period. Up to that time the model for decorated Roman ceilings, even small ones, had been a succession of alternating geometric figures: rhombi, squares and circles containing figurative scenes. Even Michelangelo initially attempted to follow this model, as is demonstrated by two drawings, which today are held in London and Detroit,[15] but he quickly abandoned it for a totally new and much freer concept. Within a period of days, the man who continued to sign himself 'sculptor' and whom everyone considered to be such, tore up the entire iconographic tradition of fifteenth-century painting, in order to replace it with a perfect machine for visual impact which was subject to his original and personal creative drives.

In Christendom's most important chapel, Michelangelo decided to invent a narrative entirely centred on the human figure, one that reduced the intrusion of architecture and landscape to its bare minimum. Disregarding all the laws of perspective, he conjured up a polycentric barrel vault, which culminates in a trompe l'oeil and is interconnected by marble ribs that order the sequence of the scenes and give the impression of a real structure inhabited by figures taking part in the celebration with a different function. Youthful nudes are seated on the projections from the ribs and hold up oak festoons in homage to the patron's heraldic symbol. The lower space between the ribs, which is left free by the genuine pendentives, is used for the thrones on which the prophets and sibyls sit. Each of the thrones has its own central perspective and should ideally be viewed from the front, thus relinquishing the idea of a single perspective that encompasses the entire mock architecture of the ceiling. To enjoy this architecture, the observer has to walk within it and not view the work from a pre-set viewpoint. The unity and continuity of the mock architecture is then nicely created by the mock marble cornices that enclose the thrones and link them to the other ribbing that run across the ceiling. The ceiling is a trompe l'oeil in the centre, but alternates scenes of two different sizes: the smaller contains nudes and medallions, while the other is larger because no room is taken up by nudes and medallions.

In this way, Michelangelo brilliantly resolves the problem of alternation imposed on him by the actual structure of the ceiling, which is divided by pendentives and webs. The most wonderful result of this revolutionary perspective is that it is no longer the architecture that forces the human figure to adapt to the artifice of proportion but conversely the architectural decoration that is 'sown onto' the subject matter, which takes full advantage of its framework. To give an idea of how far the artist was willing to go to create the maximum space for his figures, suffice it to consider that when Michelangelo returned to work on the ceiling following an interruption around the summer of 1510, he decided to transform and enlarge the thrones of the prophets to create more space for the figures, and went as far as changing the format for displaying the names of Christ's ancestors in the lunettes.

Michelangelo's creative ideas came so fast that he had trouble keeping up with himself. Within only a few months, he found his own

inventions to be outdated. The potential for ideas and new forms dragged him into an unending process of innovation. Fortunately this frenzied development also infected the commissioners of the work. It is very easy to make out the discontinuities in the ceiling that were created by these changes 'in midstream' to an iconographical structure whose credibility was closely connected to its stylistic unity. However, it required all the intelligence of Julius II to accept the differences in the names of the thrones and in the lunettes and cornices of the pendentives, which are only decorated up to the scene of the original sin.

The very idea of nudes, which had been taken from Roman monuments where 'spirits' [*genii*] celebrated the glory of the dead, emphasized the profoundly pagan nature of the decoration. Those who were expecting angels with wings and symbols of the faith were certainly going to be disappointed, because the narration was entirely secular and almost a precursor of the historical paintings that would encounter such popularity during the Enlightenment. In the chapel in which the greatest painters of the previous generation had just finished paintings that adhered rigidly and painstakingly to the stories of Christ and Moses, Michelangelo introduced a new population that set up home and filled it with life. The main scenes were depicted as paintings of paintings or, most often, mock tapestries. Then there are the nudes, whose vitality and carnality the viewer connects to the scenes, and the prophets who are seated but always restless in their too narrow thrones and always have behind them realistic depictions of their small assistants. The thrones are flanked by marble *putti* who again celebrate the physicality of human beings, and bronze nudes that occupy the space created by the triangles. Finally, the triangles and lunettes represent the story of Christ's ancestors, who are also depicted without any particular symbolic characterization, as they had no well-established iconographical tradition behind them.

Michelangelo did not just restrict himself to the wholesale refusal of perspective, as devised in the fifteenth century, in order to create a ceiling that could be enjoyed while moving along the whole length of the chapel. He also invented a decidedly disconcerting effect in terms of perception, by painting the figures of the prophets as though they were attempting to resist the curvature of the initial part of the ceiling. This curved segment appears flat and hollowed out because of

the anatomical foreshortening, as can be clearly seen in the impressive figure of the prophet Jonah, who leans back to give the impression of having an enormous space behind him. This part of the ceiling, which is the most curved, was the most difficult to transform into an illusionistic depiction. Bramante was rightly concerned about the difficulties of painting in perspective, and he was one of the greatest experts on illusionism. But Michelangelo's craftsmanship, which put all its efforts into foreshortening the figure and the geometric perspective of the architecture, expressed a poetic choice that would remain a constant in his artistic production: the centrality of the human figure within a space entirely constructed around its body.

Michelangelo had succeeded in creating this extraordinary illusion, entirely centred upon his fascination with and knowledge of the human body and its various poses, and in placing it all within the complicated surfaces of the ceiling of the Sistine Chapel, but this did not come without a price: the terrible physical and psychological suffering of Michelangelo and his assistants. This suffering became legendary, together with the painting itself, as soon as the scaffolding was dismantled in the autumn of 1512.

4 THE CRISIS

Michelangelo's decision, dictated by his suspiciousness, to put together a squad of craftsmen that was entirely Florentine had its practical disadvantages. Moreover, the fact that the artists were obliged to live together under Michelangelo's roof and under his obsessive control over their behaviour and comings and goings inevitably undermined an enterprise that was already highly complicated. Above all, the squad encountered dramatic problems arising from their lack of experience with Roman building materials – travertine lime and *pozzolana* (crumbly reddish or grey volcanic gravel), which together were used for mortar.

The painters started to work under Michelangelo's guidance in the autumn of 1508: in this initial phase this group definitely included Francesco Granacci, Giuliano Bugiardini, Aristotile da Sangallo and Agnolo di Donnino. It is almost certain that the painting commenced with the scene of the universal flood (Plate II.4), which is the second one from the chapel entrance. The procedure was very timid and

prudent, and demonstrated the fears and uncertainties with which they started out on the enterprise. The transfer of the original drawing onto the wall was carried out with the system using charcoal dust, which was the slower and more elaborate technique, but also more precise in drawing details on the plaster. This meant a small margin of error when it came to the painting. The image transferred from the cartoon even included details in the landscape, such as the little island on which the hapless victims of the flood find a temporary refuge from the flood God sent to punish mankind's infidelity. The *giornate* of plaster were very small – so small that the scene was broken up into thirty parts.[16] This number was never repeated in any other similar scenes. The painting was not carried out as a regular fresco, but made use of a technique called *velature a secco*, by which the pigment is applied to an organic binder (an animal glue) in order to allow more time for the definition of the image without the really tight schedules imposed by the drying times for plaster. They used pigments that were unable to tolerate the corrosiveness of fresh plaster, such as red lead and cinnabar for the reds and resinated copper for the greens: their instability would later cause a dramatic deterioration of that particular scene.

Unfortunately the expedients used by the squad could not guarantee a good result for the painting. The *pozzolana* and travertine lime worked in a different way from the marl and the sand from the Arno, which were used in Florence. The plaster for the ceiling was mixed in the same proportions as those used in Florence, and this very soon brought about a disaster which may have been worsened by water seeping in through the top of the ceiling. Michelangelo therefore decided to demolish a large part of the painting. The joints between the *giornate*, which restorers have identified during examinations, leave no doubts about a partial demolition and reconstruction of the scene of the universal flood. Of the original work, only the group of figures to the right in search of safety on the small island remains; for all the rest of the work, the plaster was entirely removed, reapplied and repainted.

Once again it was Giuliano da Sangallo who came to Michelangelo's assistance out of his patriotic instinct. He had the joint merit of being Florentine and having lived for a long enough period in detestable Rome to know the secrets of its building materials. The new mixtures he advised very soon produced positive results, but in January 1509 and

through to the whole of the spring, Michelangelo was once again struck down by depression – one of the most difficult crises of his existence. He was so dispirited and frustrated that he admitted for the only time in his life that he was professionally incapable of carrying forward an enterprise he'd taken on without examining it in sufficient depth and, above all, for reasons of overarching greed. The climate, which seemed to personify his adverse destiny, was once more disinclined to assist him: we know that the winter and spring were the driest of the century, and the drought was very probably accompanied by extremely low temperatures that damaged the plaster. The painters, meanwhile, were obliged to work in an environment that was bitterly cold, because of the size of the chapel.[17]

Inevitably these setbacks soon had an effect on relations between the artists. The first victim of the resulting frustrations was Iacopo, who was rudely chased out of Rome at the end of January 1509. On his departure, Michelangelo immediately started to agonize over the rumours his fellow citizens might have spread about him once Iacopo arrived in Florence. He went through what would become his standard behavioural pattern: he notified his father and got him to organize his defence. He wrote, 'That painter Iacopo whom I brought here has today departed, and because he has complained about my affairs here, I expect that he will also complain up there. Keep your ear to the ground, and do no more; for he has done a thousand wrongs and I have good reason to complain about him.'[18]

Moreover, the crisis was made even more dramatic by the internal equilibriums at the Roman court. If two years earlier Michelangelo had run away from Rome as the result of a persecution of which no one could see the basis, we can imagine what he was now feeling: he was teetering on the edge of failure, and working high up on a ceiling that was crumbling with 'mould' as he worked, while a few metres higher up the building, the new star of Italian painting, Raphael (Raffaello Sanzio), was making his explosive debut and, with his first few brushstrokes, had outshone all the competitors convened by Julius II to decorate his Vatican apartments.

Raphael had arrived in Florence in October 1504, clutching a reference from the Duke of Urbino's sister, Giovanna Feltria Della Rovere, who was enthusiastic and generous in her support for this 'discreet and

noble young man': 'in every respect I love him greatly and desire that he perfects his art; I therefore recommend him to your lordship most earnestly and as warmly as I can.'[19] This young man also came to prominence through unusual channels and was supported by powerful friendships. He too was ready to transform tastes in Italian painting, which at that particular time was finding its highest expression in Florence. Following a successful stay in Florence, Raphael arrived in Rome at the end of 1508, already enjoying a precocious fame and, above all, the friendship of Donato Bramante, his guarantor and also a native of the Duchy of Urbino. Raphael's perfect and graceful style of painting was already a great success, and the artist's good looks and good manners appeared to embody his talent.

His life itself was a work of art. As a brilliant conversationalist eager for knowledge, he fascinated and captivated everyone who came close to him. He was a modern man and exquisitely elegant. In no time, he had become the darling of the Roman scene. Just as Michelangelo was savage and moody, Raphael was sociable and ebullient. The tormented physicality of the former yielded to the courtly charm of the latter, and there could be little doubt about their respective natures. It became immediately clear that they had contrasting approaches to the question of artistic production and the workshop: Raphael immediately welcomed the talent of his assistants and gratified them to the point of placing them in important positions. He got the best out of everyone and above all had his assistants share in the success of an enterprise, thus turning everyone's success into his own success. Conversely, Michelangelo perceived his relationship with his assistants strictly in terms of hierarchy: he dismissed poor Lapo da Bologna simply because he had muttered in Michelangelo's absence that they were partners in the enterprise, and as for the Florentine artists who had been his childhood friends and had trustingly followed him to Rome, he was about to discharge them in the most perfunctory manner.

These two different perceptions not only of painting but of life itself were about collide, given that fate or possibly Julius's subtle mind had arranged for them to be working so close to each other, just a matter of a few metres. At that time, it did not appear that Michelangelo would be the one to win the laurels.

Fortunately, however, the problems and uncertainties relating to the painting of the ceiling were becoming less acute as the works progressed. The situation appeared to improve greatly with the scene of Noah's drunkenness, which was painted immediately after the one of the flood. There was less paint applied after the plaster was dry, and the artists appear to have improved their method for mixing the plaster, except in the case of the *giornata* in which Noah plants the vineyard, on which Michelangelo himself was obliged to retouch the defects of the fresco painting with paint applied to a dry surface. The *giornate* required for this scene, twelve in all, were still too many given the area it covered, but the organization of space was much more convincing. Each body took up an entirely reasonable two *giornate* and the landscape was painted over wide fields with a degree of confidence and, most importantly, without the need for preparatory cartoons.

The space in the scene of Noah's sacrifice appears even better organized, and took eleven *giornate*. All the colours are now those of a good fresco. The sky is painted with *smaltino* (a deep blue pigment obtained from a blue-cobalt silicate) on top of a preparation of *bianco sangiovanni* (a white pigment made of calcium carbonate), as Ghirlandaio would have done. The drawing is still intrusive in relation to the painting, and the relationship between the figures still follows a fifteenth-century logic.

Their problems definitely appear to have been resolved by the time they got to the *The Fall of Man*, the fourth scene painted at the centre of the ceiling (Plate II.5). The style and technique of the painting had been defined and remained unchanged throughout the rest of the work on the ceiling. The perfect equilibrium you immediately encounter in the scene is accompanied by a leap in the technical quality that demonstrates the confidence of Michelangelo's team and their full command of the materials. There are only thirteen *giornate*, compared with thirty for the flood scene, which was of exactly the same dimensions. The figures have been positioned in a new and more appropriate manner. Whereas the depiction in the three preceding scenes was entirely fifteenth-century with the attempt at naturalistic landscapes and figures drawn to natural scale, all this changes in *The Fall of Man*, as it does in the lower parts of the chapel: the landscape disappears, as does the naturalistic setting. The space is built around the great figures

of the ancestors, who undergo a sudden change of scale and become at least twice their size in the preceding scenes. From then on, space was no longer wasted and lost through overly complicated subject matter, but always moulded by the perfect poses of a few figures of staggering proportions, which were utterly convincing if viewed from below.

The painting technique follows the evolution of the composition. With *The Fall of Man*, they started gradually to abandon the timid transfer of the image with charcoal dust, and for the first time they marked the fresh plaster by pressing on the cartoon, which gave the artist greater interpretative freedom but also required greater skill and confidence. As though this were not enough, many parts of the scene were actually painted without the assistance of a cartoon. There is no trace of the transfer of the image for the fig tree and the background to the *The Fall of Man*, and even more surprisingly, the snake – Adam's and Eve's temptress – who winds her way up the tree transforming herself as she goes into a treacherous flatterer, was painted without the help of a preparatory drawing. A revolution had occurred. The technique was now mastered, and from this scene onwards, Michelangelo quickly worked his way towards formal completion of the work, which would catapult him into legend and a position that none of his contemporaries could challenge following the early death of Raphael, his only real competitor.

Perhaps because he was now reassured by this new state of affairs and his mastery of a specific procedure suited to this kind of enterprise, he thought it right to discard his Florentine friends and colleagues. He no longer had any need of them and could replace them with other assistants, such as Bernardino Zacchetti, a painter from Emilia who in 1510 was thirty-eight years old and certainly no apprentice, but he would not be as demanding as Michelangelo's childhood friends. His new assistants remained at work on the ceiling even when, in the summer of 1510, Michelangelo had to leave Rome because of serious financial and health problems afflicting his family in Florence. Giovanni Michi, another of his new assistants, reassured him that they were doing him justice: 'and Gismondo and Bernardino are pursuing their portrait work unceasingly, and by my faith, they do you justice and love you, and they implore your favour.'[20]

Once again, documentary sources allow us to reconstruct Michelangelo's behaviour towards his Florentine friends, who had

shared with him the adventure of the Sistine Chapel and the initial impact with a hostile Rome. And that behaviour was far from exemplary. It is true that relations with Granacci and Bugiardini were not too badly affected – in fact they continued to be friendly until the end of their lives. Perhaps because he was conscious of the wrongs he had done to them, Michelangelo later provided them with cartoons and drawings to help their workshop. Many decades later, when his comrades from that period were all dead, the artist spread the lie that was to become one of the principal pillars of the myth surrounding him: 'And thus he completed everything in the end perfectly after twenty months working on his own without the assistance of even someone to mix his colours.'[21] This was the falsehood that gave rise to the romantic legend of the genius clinging to the ceiling in heroic solitude, while he worked on the greatest pictorial enterprise of the Renaissance.

On the other hand, Michelangelo's creative achievement against all odds is stunning. In the light of his inexperience at the beginning and the dramatic consequences he encountered in the early work, it is all the more stupefying that he could achieve the degree of technical and formal knowledge displayed in the fourth scene and afterwards – a knowledge that in the final portions of the ceiling and the lunettes would attain a degree of virtuosity denied to even the most accomplished painters.

5 PAINTBRUSHES

As has emerged from recent extensive restoration, the painting of the chapel ceiling demonstrates the presence of a character and a perfection that far surpasses even the Florentine masters of the fifteenth century. Often described as a fluid painting, Michelangelo's method of layering colour started with a transparent glaze, or in other words, a coat that contained very little pigment and was applied to the fresh plaster. The colour was then built up with small but dense brushstrokes, like the shading of his drawings. They were built up with a sculptural technique, because overlaid brushstrokes define the light and shade effects, as though they were monochrome, by using shadow rather than colour or, rather, using the colour as a function of shadow.

Michelangelo would trace over the first homogeneous coating of a face with a fine brush, using darker colours to create a dense criss-cross of shadows. He hatched them but never mixed them. Close-up you can observe brushstrokes crossing over each other in a manner more typical of a pencil than a brush. In this way, the surface of the plaster became saturated to the required degree and it appears clean, without body and as brilliant as porcelain. The effect was also guaranteed by the use of pure pigments; very few were mixed and, at the most, superimposed in successive coats. The result was a diffused luminosity that appeared to be generated from within the figures.

For the drapery, Michelangelo used wide brushes that produced wide, compact, strong and uniform marks on the plaster. Once again the use of pure pigments created a surprising effect: the changes in tone that the artist adopted to make very clear from below the forms and cut of the cloth resulted from putting one strong colour alongside another without ever mixing, except perhaps very slightly where they met. Orangey yellows were put next to acid greens for the shadows, so that the shadow had its own colour rather than a darkening of the same colour used for the light.

To grade the atmospheric perspective between the various figures, Michelangelo made use of a technique based on unfinished sculptural work. The figures in secondary plane and in the distance were only sketched with firm and rapid brushstrokes that caught expression and bulk but did not define the detail. We find a detailed face that appears to be porcelain next to one that has been barely sketched with an expressive skill that moves this figure to the background of the scene without, however, reducing its emotive impact on the narration.

The mastery of the material gradually became so total that Michelangelo thought up expressive effects that had never before been seen in painting: for example Adam's eyes in the creation scene, in which the grey plaster was left unpainted to give depth and mystery to his expression. The artist decided not to paint pupils and eyelids in order to create expressions with rapid brushstrokes and chromatic contrasts around the eyes.

When it came to painting the lunettes, everything was in place for another surprising innovation: the elimination of the preparatory car-toon. There is no trace of the transferral of drawings on the lunettes,

either by charcoal dust or by marking through the cartoon with a sti-letto. The drawing was created directly on the surface of the plaster with a red line, which the artist could improvise on each occasion. Of course, the flat surfaces of the lunettes must have seemed like child's play to Michelangelo after he had had to deal with and resolve the problems of foreshortening on the curved surface of the ceiling, but drawing without the use of a cartoon was still a hazardous practice, and even today the only evidence we have of it is on the lunettes of the Sistine Chapel. This risky technique was undoubtedly due to the need to simplify procedures and speed up the production process after his first assistants had left and he had formed another less talented team, to whom he could not delegate the actual painting of the ceiling. Although there are no traces of the transferral of drawings, it should be said that there might have been other ways of assisting with the paint-ing of the lunettes. One of these was recorded in Benvenuto Cellini's diary, and referred to Michelangelo and his research into methods of foreshortening:

> We took a young man of handsome build, and then put the said young man in a room which had been whitewashed. We made him sit or stand in various poses, so that we could observe the most difficult foreshortenings. Having placed a lamp behind him, which was not too high, low or distant from him, we put him in such a manner as to bring out the truest and the most beautiful in him. And having observed the shadow he made against the wall and made him keep still, we quickly drew round the outline of the said profile. Then we quickly added a few lines not indicated by the shadow, because there are folds in a bent elbow due to the thickness of the arm, and also in the shoulder front and back, and in the head. . . . Now this method of drawing was used by the greatest masters and produced wonderful paintings. Amongst the best painters we have ever known, Michel' Agnolo Buonaroti, a fellow Florentine, was the greatest of all.[22]

The scene described by Cellini probably took place many times on the scaffolding of the Sistine Chapel, which was very suited to optical projections because of its light conditions. The young model used for the lunettes was probably made to sit on a stool at sufficient distance

to project his shadow on the wall of the lunette and enlarge it to the required proportions. The line of colour, which Michelangelo used to trace the outline, marked the profile of the figure, which was then rapidly completed in the inner parts in accordance with the artist's imagination. This procedure would explain not only the absence of a preparatory cartoon, but also the androgynous nature of the female figures of the lunettes and the lengthening of the arms and legs which could be due to a slight distortion produced by the shadow.

The greatest achievement of the painting of the chapel ceiling was the bright and iridescent colours used for the clothing of the Jews in the lunettes. For centuries the sumptuary laws had laid down the rules for clothing that each social and ethnic was required to follow in the Italian cities. For Jews, the obligation to wear yellow had become such a distinctive feature that Michelangelo adopted a vivacious and brilliant painting style in which yellow, interpreted in every tone, was put alongside various complementary colours. In this manner the extreme iridescence of the ancestors' clothing overcame the shadow that fell over the lunettes because of the pendentives just above them, and at the same time they became the distinguishing symbol of the ethnicity of Christ's ancestors, which was immediately recognizable to all Michelangelo's contemporaries.

Equally, the contrast created by putting different and often complementary colours alongside each other, rather than darker tones of the same colour, was an unprecedented stylistic innovation. Michelangelo may have come up with this solution because of his reluctance to mix pigments, which encouraged him to celebrate the potential of their purity: a taste that would appear to contrast starkly with the sculptor's creative temperament, which seemed to suggest a marked preference for shaded monochrome volume. This created a preconception about the Sistine ceiling that lasted until the recent restoration. For centuries, the bright colours and their explosive contrasts were softened by layers of animal varnishes that were applied again and again to the paintings to reanimate them, and have become blackened by the candles, the only illumination allowed in the chapel. These darkened varnishes meant that the viewer could only see the volumes of the figures, but no one ever imagined that these monochrome volumes were the product of a serious decay in the nature of the original work, and not of the artist's

own taste, in spite of the evidence provided by the iridescence of his *Doni Tondo*. Indeed, a complex theory was developed during the nineteenth and twentieth centuries to explain this fact. When the restoration finally revealed that the complexity of Michelangelo's painting was also chromatic, there was no choice but to accept the fact that the artist also carried out an unprecedented revolution in the use of colours, and that entire generations of critics had been victims of their own preconceptions and the tendency to classify and simplify the immense complexity of art and artists.

6 THE TRIUMPH AND THE LEGEND

The period of most acute crisis for Michelangelo during his work on the ceiling of the Sistine Chapel can be said to have finished around June 1509. At that time, the artist received the very considerable sum of 500 ducats from the pope, as a second payment. He kept back only a small part and deposited all the rest in the account of the hospital of Santa Maria Nuova in Florence, which was still considered the 'family account' and was administered first by his father and then by his much-loved brother Buonarroto.

Michelangelo, however, managed to find some drama even during the months in which it became clear that he had created another artistic triumph. He was wounded by a financial dispute with his father Ludovico, which had continued for more than a year. Following the death of Francesco, Ludovico's brother, his aunt Cassandra had rightly requested the return of her dowry, given that the only slight margin of autonomy for Florentine women was ensured by this sum of money granted by their original families at the time of the marriage. Ludovico refused to return the dowry and Cassandra brought a legal action against him. Before the final ruling, the two parties came to an agreement in September 1509 by which the aunt would receive 196 florins for her dowry. In order to pay off Cassandra, Ludovico withdrew the money from Michelangelo's account without informing him, because the son had on several occasions assured him that he could make use of the account in the manner that he saw fit. But when Michelangelo discovered the shortfall, it came as a very serious blow to relations between father and son. The ageing parent complained to his other children of

Michelangelo's miserliness,[23] while the latter decided in the following winter that his money would have to be administered by his brother Buonarroto, a sign that, at least at that time, he no longer trusted his father.

The relatively small size of the sum and Michelangelo's disproportionate reaction say everything about the artist's obsessive relationship with money, a fundamental link between himself and the world outside. He never lost an opportunity to tell Julius II that he could not work without money, even though he had accumulated as much as a thousand florins from the payments for the Sistine Chapel. He went twice to the pope to demand further payments in the period between September 1510 and February 1511 alone, and the pope, who was engaged in a difficult military campaign against Bologna that was draining his financial resources, agreed to the artist's petulant demands. In the spring of 1512, when work on the ceiling was almost finished, Michelangelo had saved up enough money to buy an enormous estate called Macia, in the immediate vicinity of Florence. While the money Julius had advanced for his tomb had been sufficient to buy the houses in Via Ghibellina, the new payout made it possible for him to buy a property of twice that value. The solitude he had forced on himself, as soon as he saw the opportunity to replace his childhood friends with less skilled assistants, had served to bring about another substantial leap in the family assets.

But whatever pleasure was brought by the financial success of the enterprise was dwarfed by the universal acclaim that Michelangelo received when the scaffolding was removed from the ceiling on 31 October 1512. According to legend, the fame of the Sistine painting started to spread even before the scaffolding was removed from the chapel. This was not because, as Vasari tells us, Raphael managed to take advantage of Michelangelo's trip to Bologna secretly to gain entrance to the scaffolding with the connivance of the duplicitous Bramante. Nor did it have anything to do with Vasari's other story that Julius attempted to climb the scaffolding without the artist realizing, only to risk his neck when the latter dropped a wooden beam in his direction on discovering what he was up to. All this belongs to the false mythology carefully constructed by tradition.

In reality, the documents reveal a very different situation. Michelangelo's enterprise was well known, much admired and carefully

followed in artistic and fashionable circles throughout Italy. His scaf-
folding, like the ones used by modern restorers, was much visited and
home to friendly discussions that involved not only artists but also col-
lectors and art-lovers who wanted to relish the dizzying vision close-up,
which of course would become impossible once the scaffolding was
removed. The record of one of these visits, which occurred when the
work was nearly finished and while the artist and his assistants were
anxiously and frenetically applying the final touches to improve the
general effect, describes for the first time a ritual that has become very
common in our own times, but which clearly goes back a long way in
history. On a stiflingly hot July day in 1512, the Sistine Chapel must
have been one of the coolest places in the city, and it became the refuge
for a festive group that was accompanying the Duke Alfonso I of Ferrara
and the House of Este. His secretary Grossino described the visit to an
extremely envious Isabella d'Este, who would not have hesitated to tear
off all her clothes if she could then have climbed the ladder that led to
the most prized ceiling in the whole of Europe.

> His Excellency desired greatly to see the ceiling of the great chapel
> which Michelangelo is painting, and Lord Federico arranged through
> Mondovì to go and make a request on behalf of the Pope, and his
> Lordship the Duke went up to the ceiling with several persons; at
> length each person came down one by one from the ceiling and his
> Lordship the Duke remained with Michelangelo and could not see
> enough of those figures, and he paid him all sorts of compliments so
> that his Excellency would desire that he should paint a picture for him,
> and he made him talk and offered him money, and he promised to
> make him one. Lord Federico saw that his Excellency was taking a long
> time up at the ceiling, and thus he took his gentlemen to see the Pope's
> chambers, which are being painted by Raphael of Urbino.
> 12 July 1512.[24]

A whole group from high society went up into the curmudgeon's leg-
endary retreat, after having asked permission not of Michelangelo but
his employer, Pope Julius II. In spite of all the work he had on, the artist
did not neglect his social duties. By this stage, his position in the social
hierarchy was beginning to change.

There wasn't even time to make all the preparations and remove all the scaffolding before the great day of celebration arrived: 31 October 1512, the eve of All Saints' Day. The cardinals dusted off their smart velvet and bright linen clothes, and got ready for the social event that no one would want to miss. There was only just enough time to organize the inauguration, which nevertheless was carried out with such skilled management that it would have stunned modern organizers of 'events'. After a sumptuous banquet held in honour of Parma's ambassador, the pope had arranged for two comedies in the vernacular to be played before the enthusiastic audience. At the time for mass, they set off triumphantly to 'his' chapel. He was accompanied by no less than seventeen cardinals, who were in full festive garb for the occasion – a riot of red damasks, gleaming golds and blinding whites. It looked as though the procession wished to compete with the pictures in its contrasting bright colours and the elegance of its forms. The finished work marked the most visible and indisputable of the many successes that had occurred during Julius's papacy.[25]

News of the success of Michelangelo's enterprise immediately spread in all directions by new means and old and along direct and circuitous routes. The astonishment of his contemporaries was expressed in every possible way. Even before the painting was finished, what could be considered the first modern guide to Rome and its treasures was printed in the city: F. Albertini's *Opusculum de Mirabilibus novae & veteris urbis Romae*. The author could not fail to mention the chapel ceiling: 'the most splendid work of extremely beautiful gilded painting by the Florentine Michelangelo, the most brilliant sculptor and painter, adorns the upper arched part'.[26] Similarly Antonio Billi produced a book written between 1516 and 1530, in which he states that Michelangelo 'wanted to show the whole world that all the other painters are his inferiors, and all those who wish to be called masters of that art on a par with Michelangelo must acknowledge that all the other things are just daubs of paint.'[27]

The greatest acclamation came from the artists themselves, starting with Raphael, whose works at that time were highly influenced by Michelangelo. Evidence of this influence can be found not only in the frescoes in the church of Sant'Agostino in Rome, but also in a few drawings directly inspired by the Sistine Chapel.[28] His influence

extended to Venice through copies, drawings and prints, including the well-documented one by Marcantonio Raimondi before 1527. No artist could now avoid the challenge of the painted ceiling. This was a new phenomenon. Up to that time, it had been common to study ancient models of sculpture and architecture, as well as paintings by almost contemporary artists, as demonstrated by Michelangelo's own studies of works by Giotto and Masaccio. Now the Sistine ceiling immediately became a key text in the artistic language of the time: together with the rooms painted by Raphael, an incomparable ideal that all subsequent artistic production had to measure up to.

What Michelangelo had achieved with the statue of *David* not ten years earlier was now repeated, with the painting of the chapel ceiling creating an even greater sensation. At the age of thirty-seven, the ambitious Florentine had become a living legend.

4

BACK AND FORTH BETWEEN ROME AND FLORENCE

1 IN THE NAME OF THE FATHER

The winter of 1512 was very cold in the whole of Italy, and by March Florence and the rest of Tuscany were still covered by snow. On the other hand, the summer was beautiful and very hot. During the August evenings, the peasants in the countryside around Prato happily stayed out in the farmyard to enjoy the wonderful air, the quiet and the sky that slowly faded above their heads. The Spanish army, which at that time was marching down from Mugello, was living off figs and ripe grapes: the peasants in the areas they were pillaging had poisoned the wine and the bread, and the soldiers were obliged to go without.

On the evening of Sunday, 29 August, the scented silence of late summer was shattered by the distant sound of Spanish artillery, which since the previous day had been battering Prato's city walls. Having breached the wall and created an opening at least six metres wide, the soldiers entered the city by the thousand. Immediately afterwards, they set about raping women, girls and boys. This was the fresh meat they had been promised: 'suffice it to say that they showed no one mercy, as they carried off noble women and girls wherever they wanted, and respected neither the male nor female sex, nor holy nuns whom they

brutally sodomized . . . nor boys between seven and twelve whom they ruined by sodomizing them.'[1]

When bodies were of no use even for rape, the Spaniards butchered them. They filled the city's wells with 5,560 corpses. A friar, who could not believe such barbarity was possible, approached the soldiers with a cross, but they tore it from his hands and used it to bludgeon him to death. Another friar fared no better: they quartered his overweight body, cut it to pieces and boiled it to make fat. These brutal and depraved soldiers were paid by a pope and led by a cardinal, Giovanni de' Medici, to whom Julius II, tired of the unreliability of the Florentines, had entrusted the task of punishing the city and its allies, and to whom he had promised the return of the city's government. On this occasion, the massacre was entirely perpetrated by Catholics, so it passed into local history as the 'papal plunder' [*il sacco dei papalini*].

The rape and murder of thousands of Christians who were their fellow countrymen in no way spoilt the joy of the Medici in regaining what they obstinately considered to be their city. In the evening of that same day, in a city devastated by brutal pillage, Giuliano – Giovanni's brother – wrote to Isabella d'Este giving her the happy news, without a single reference to the price that had been paid. The letter exudes an Olympian detachment and no word of what had been happening in front of his own eyes:

> [A]nd therefore I inform you that to the great satisfaction and contentment of all the city of Florence, my brother and lord monsignor and I will tomorrow return to our native city and our home, and to this effect three orators have been sent here by those magistrates and most excellent lords. Numerous citizens have come here to congratulate us on our good fortune, in which I am most certain Your Excellency will take great pleasure, along with the Most Illustrious Lord your consort.[2]

Clearly the Medici did not want to hear the screams of the men whose testicles were being cut after they had been squashed on a table with stones. They did not want to see the women who had been stripped naked in the squares, whose 'nature' the soldiers 'blackened with burning straw'. They did not want to listen to the children, the priests and

the old people. In that moment they only felt joy at having defeated the hated Florentine Republic.

The memory of the terrible massacre in Prato was soon erased by Florence. As soon as he re-entered city on 14 September 1512, Giovanni issued a proclamation prohibiting everyone from speaking of what had happened. Francesco Guicciardini would do the rest by providing posterity with such a heavily reworked version of the events that it appeared that Cardinal Giovanni de' Medici was the protector of the citizens of Prato and not their butcher.

It was the return of the intelligent propaganda that had always characterized Medicean rule over Florence. But it was not so easy to erase every trace of those events. A couple of days after the disaster, the first wounded who had miraculously survived the massacre started to appear in the surrounding towns, and from there the news began to spread around the whole of Italy. It did not help that the people of Prato were forced to celebrate the election of Leo X with public illuminations and bell-ringing – another brutal humiliation. Nor did it help that the Florentines cynically rushed to buy the still bloodied booty from the Spanish looters, as soon as they saw that Prato was in flames and after having left the city without military protection. There was an Italy that shuddered and judged the Medici behaviour for what it was: an ignoble and inhuman crime. Michelangelo was one of these, and he was unable to restrain his urge to condemn the Medici in public. His relations sent warnings from Florence that he should be on his guard: there was a settling of accounts and there were good reasons for taking things out on the artist. His enmity towards Giovanni and Giuliano could only have been perceived as treachery by the Medici: they had all spent their childhood together and Michelangelo's decision to support the republic inevitably produced subtle feelings of bitterness. He responded evasively and softened the harshness of his criticisms. Once again, practical considerations prevailed over justifiable indignation: 'When it comes to matters concerning the Medici, I have never spoken out against them, except in the manner that everyone was speaking in general, as in the case of the events in Prato.'[3]

In any event, the artist did not abandon his duties in Rome and during the scorching summer of 1512 he feverishly worked on putting the final touches to the ceiling of the Sistine Chapel. He wanted

at all costs to finish the work by All Saints' Day, 2 November, but he also wanted to apply the necessary care and attention to meet the high expectations of this much-awaited event. He simply advised to members of his family to flee to 'some place where you are safe and abandon property and all stuff, because life is worth much more than things.'[4] Faced with this emergency, even he reassessed the value of wealth in relation to risk to one's life.

The re-establishment of the Medici's dominion over Florence was followed by what had become its leitmotif: the secret control of the city's institutions through control of the elected offices. Once again the republican institutions remained formally intact, which gave the city the illusion of being the master of its own fate and the appearance that 'civic' relationships, which helped Florentines to identify with their state, still survived. However, the restoration of 1512 had a markedly political nature to it. The purges and violence were kept to a minimum, even though all the republicans were implacably removed from government office. On 12 February 1513, Niccolò Machiavelli, who had been a trusted secretary to Pier Soderini and loyal servant of the republic, was arrested on suspicion of having taken part in a plot against the Medici. No evidence was ever found against him, but he was removed from government and from the city. In vain he struggled in the following years to re-enter the service of the Florentine state, for the attitude of the Medici towards republicans remained one of total rejection.

Michelangelo also followed the fate of the oppositionists. He felt he was the victim of an unjust vendetta, and even thought of moving his family away from Florence: 'think about whether we can sell what we have and move to live elsewhere.'[5] He fell prey to these misgivings at exactly the same time that news of the wonders of the Sistine Chapel was rapidly spreading around Europe. However, this bad temper and his natural tendency to despair were on this occasion based on solid ground. He was so prostrated by depression that he even cancelled his journey to Florence, which he had planned for the All Saints' festivities, and thus went without his well-earned rest. The enormous effort he had put into the ceiling had deformed his spine and damaged his eyesight: for a long time he was obliged to read while holding the reading matter above his head, because he was unable to lower his eyes.

His response to depression was, in any case, more work, which for-tunately he was not short of. This absorbed him even during the days just after the uncovering of the ceiling. On 18 January 1513, Julius II, who was ecstatic about the finished painting, authorized the Fuggers to pay him 2,000 ducats, so that he could resume work on the tomb on the basis of a new contract. This was a staggering figure, especially if you consider the artist's very limited costs in the execution of the enterprise, which on this occasion was carried out in almost complete solitude.

Julius died just one month later on 21 February, and in Via dei Banchi, where bets could be placed on almost everything, the odds were already being calculated for the new pontiff. Florentine merchants and bankers didn't even dare to hope for the election of Giovanni de' Medici, who would have opened the way for immense investments and profits in the city of Rome. With the cynicism and practicality that were their hallmark, they betted on their own man. In the end they collected a double pay-off: the returns on their stakes and the favours they could expect. Giovanni was indeed elected pope with the name of Leo X on Friday, 11 March. In a period of six months, the Medici had passed from being exiles to the conquest of Florence and then all Italy. Giovanni de' Medici had every reason to invite their friends and rela-tions to 'enjoy the papacy', as they put it.

Obviously Michelangelo had few prospects for work with the new pope, but once again Julius II guaranteed him an enviable future through his will. Before dying, the ageing pope had left an enor-mous sum to his heirs Della Rovere for the completion of his tomb, and on 6 May a new contract was signed allocating 16,500 ducats to Michelangelo.[6] This sum was large enough to make the artist and his entire family permanently rich. As his father Ludovico had reminded him on many occasions, you needed at least 3,000 ducats to enjoy a wholly respectable position in Florence. With just that one work, Michelangelo would earn five times that sum!

Amongst other things, the contract made provisions for the sculptor to be given the free rental of a house in the Macello dei Corvi district for the entire duration of the work on the tomb. Michelangelo fitted out a sculptor's workshop in that house. As usual, the craftsmen were recruited in Florence. In spite of his repeated disputes with Florentine

artists, Michelangelo continued to distrust those from anywhere else in Italy. This time, however, the recruitment was not so easy. Everyone wanted to work with him – not for the money, which he continued to scrimp on, but for the prestige now ensured by any professional relationship with him. Many apprentices offered their services and others had them offered on their behalf, possibly exploiting the artist's preferences, because it was known that he was sexually oriented towards young men. For example, someone extolled a young man's qualities by telling Michelangelo that as soon as he saw him, he would rather take him to bed than home. Michelangelo, who bitterly resented that allusion, refused even to meet the young man.

Anyone who met the requirements of this capricious master would not have encountered an easy life in Rome. In October 1514, he was sent a youth from Florence who was supposed to look after the house in return for board, lodging and the chance to spend a few hours drawing. He was a kind boy with a great passion for drawing, but Michelangelo was simply exasperated by the time that this took away from the chores the youngster had to do. He considered him a useless scrounger, 'a dry shit',[7] and pitilessly demanded of the boy's father that he be immediately removed. Nothing could slow down the sustained work schedules, even though Michelangelo – possibly affected by a little compassion – confessed in the same letter that the boy did not deserve to be mistreated; he only needed to be taken in hand, whereas Michelangelo had no time for anyone, even himself. The episode demonstrates not so much Michelangelo's creative zeal as his entrepreneurial one: as soon as he was released from the nightmare of the Sistine Chapel, the artist immediately managed to transform the work on the tomb into another nightmare, as though he didn't know any other way of going about his work.

Besides, the pressing rhythm of work had come second to the expansion of the family wealth far beyond the requirements of financial security. From the very first conspicuous earnings from his work for Julius II, Michelangelo started to acquire one property after another. On 28 May 1512 he had bought the large farm in Macia from the Ospedale di Santa Maria Nuova for 1,300 florins.[8] He bought other properties during the following two years. In July 1513, he agreed to loan his brothers a very large sum of money, so that they could start up their

own business in the Wool Merchants' Guild. One thousand florins were accredited to the account of his brother Buonarroto and his father Ludovico, with the promise that they would be paid the rest ten years later.

Yet Michelangelo's readiness to help was not sufficient to mitigate the family conflicts. His father and his brothers appear to come up with demands upon the now famous son or brother that would have been difficult for a King Midas to satisfy. To use his own words, Michelangelo had to run like a hard-driven horse just to keep them happy and extricate them from a life of privations. Perhaps it was the strict financial control he imposed on spending that created something bordering on downright ingratitude amongst his relations. Michelangelo reminded his favourite brother, Buonarroto, of his ingratitude and tactlessness just before giving him that generous loan. However, the fierce, momentous and dramatic disputes were with another brother, Giovan Simone, about whom we know very little except the hatred he felt towards a brother who was effectively his father and his boss. And he was unwilling to submit to this over-powerful brother. The loan of a thousand ducats for a commercial enterprise, a very heavy commitment, was only one of many acts whereby Michelangelo attempted to free his unhappy family from its misfortunes. During this period, his role was not simply that of financier; it also included the powers and authority of a genuine head of household, which meant he had to intervene in the profound difficulties that affected relations between his brothers and his father Ludovico. The family was the only social unit that Michelangelo acknowledged, and on occasions he had to intervene physically and risk his whole self in order to bring conflict back down to controllable levels.

The most tragic case was the one in which he clashed with Giovan Simone in the summer of 1509, when Cassandra, his uncle's widow, asked for her dowry back and jeopardized their ownership of the mansion in Settignano. The crisis provoked enormous tensions between Giovan Simone and his father Ludovico, and Michelangelo came to hear of the threats his brother had made against his father; we do not know through what channels. The artist's response demonstrated extraordinary passion and vitality, and constitutes some of the best evidence of his profound humanity. Neglectful of all other things – his fortune, his

commitments, his physical fragility and especially the legendary role he come to occupy in the wider Italian society – Michelangelo confronted his brother with the vigour of primitive combatant who saw everything he held most dear being challenged: his emotional attachments, his property and his own rigid system of values. His threat to Giovan Simone became something physical and liberating. Michelangelo promised to seek him out wherever he went and destroy him with his own hands, if he persisted in tormenting his father. As though there were no other brothers willing and capable of dealing with the problem, he felt that he had been invested with the indispensable role of head of the family and it therefore fell to him to threaten Giovan Simone, even though he was in Rome clambering around the scaffolding in the Sistine Chapel, where he even went without food and drink in order to work and earn his living. Having put down his paintbrushes in the summer heat, he grabbed a pen and used it like a cudgel against his irresponsible brother. This dispute recalls the biblical episodes that he was painting at the time on the ceiling of the Sistine Chapel, such as the unhappy scene of the ageing Noah, naked and drunk, being mocked by his sons. The letter to his brother, which was clearly written in haste, is more than any other document a snapshot of the authoritarian and irascible manner in which Michelangelo related to his family:

> Giovan Simone, it is said that whoever shows goodness to the good, makes them better, and to the bad, makes them worse. I have now been trying for some years with kind words and practical assistance to get you to live well and peacefully with your father and the rest of us, and you only get worse. I do not say that you are wicked, but you have a manner that neither I nor the others like. I could give you a long speech about your affairs, but it would merely repeat what I have already told you. In short, I can tell you as a fact that you have nothing in this world, and I give you and, for the love of God, have for some time given you your spending money and the roof over your head, as I considered you my brother just like the others. Now I am certain that you are not my brother, because if you were, you would not threaten my father; indeed, you are an animal and I will treat you as such. You should know that anyone who sees his father threatened or attacked, is obliged to put his life on the line, and that is that.

I tell you that you have nothing in this world, and as soon as I hear of your involvement in the slightest thing, I will come in great haste to wherever you are and will show you the error of your ways. I will teach you what happens when you spoil your stuff and light fires in the houses and farms that you have not earned. You are not who you think you are, and if I come over there, I will show you something that will make you blubber hot tears, and you will realize what your arrogance is made of. I tell you once again that if you attend to honouring, revering and doing good for your father, then I will help you as I help the others, and in a short while I will put you in a good workshop; should you not do this, I'll be up there and I'll sort out your business in such a manner that you'll be much more aware of who you really are than you have been in the past, and you'll understand what you have in this world and you'll be conscious of this wherever you end up. I'll say no more. Whatever I have failed to put into words, I will make up for with my deeds.

<div style="text-align: right">Michelangelo in Rome.</div>

I find that I must add a few more lines: and this is to say that I have been gone these last twelve years and have lived a life of tribulations in the whole of Italy, for I have suffered shame and hardship, have lacerated my body with all sorts of hard work, and have put my own life in a thousand dangers solely to help my family. And now that I have started to relieve it of a little of its troubles, your only wish is to create turmoil and ruin in an hour what I have achieved in many years through much hard work. By the body of Christ, if this is not the truth! I could thrash ten thousand like you, if that were needed. Now be wise, and do not tempt someone who has great passion.[9]

Michelangelo's strategy in relation to his family was very clear: maximum severity and even physical commitment to maintenance of the rules, but also recourse to promises of support in the future for everyone. And the results were excellent, because on 30 July 1513 they set up a business with one thousand florins which, it was hoped, would be lucrative for the brothers and their father.

2 THE PEACEFUL YEARS

From 6 May 1513, the day on which the new contract was drawn up, Julius II's heirs, who had been instructed to have the work on the tomb completed, continued to pay Michelangelo the regular instalments of two hundred *scudi* every month. These sums rapidly accumulated in the artist's current accounts due to the regime of strict economies he imposed on the progress of the work. The Florentine sculptor Antonio da Pontassieve worked on the grotesques on the surround that framed the statues (*opera di quadro*) together with other assistants who were occasionally mentioned in correspondence: a Master Bernardo, a Master Rinieri and also Cecho and Bernardino. From 1513, they all worked on sculpting the cymatia and architraves of the part of the monument that today is displayed in the church of San Pietro in Vincoli in Rome. In the meantime Michelangelo was working on his own on the figures on the blocks of marble, some of which he had already had transported from Carrara in 1506, while others were being sent with new commissions. In the contract, he had undertaken to produce about forty of different sizes according to where they were positioned. We do not know the exact design of the first plan, but the contract of 1513 can tell us fairly precisely what Michelangelo had started to produce.

The new tomb of the Della Rovere pope was to be placed against the choir wall in the Saint Peter's, and was to protrude about eight metres into the room at the sides and 4.4 metres at the centre. This frontal plane, which was considered a base, had to be adorned with about twenty-one figures that were twenty centimetres over natural height, in the manner of Roman triumphal arches. On top of this monumental base there was to be a marble *cappelletta* (literally 'small chapel') 6.6 metres high, surrounded by seated figures much larger than natural scale (of the same size as Moses, which he started upon at that time, together with the Sybil and the Prophet). Finally, the sarcophagus with a reclining pope would be placed at the centre of the *cappelletta* and surrounded by figures, with two at the top and two at the bottom, twice the natural scale because they would be distant from the observer.

As a whole, it appeared to be modelled on imperial monuments rather than catholic ones. The allegories of the 'prisoners' were to be at the lower level, and the prophets and sibyls at the upper one. The

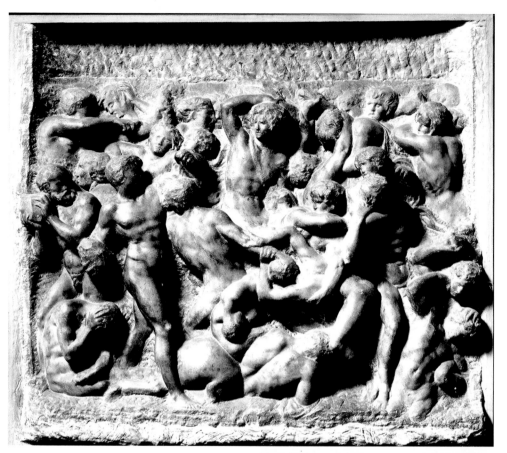

I.1 Michelangelo Buonarroti, *The Battle of the Centaurs*, Casa Buonarroti, Florence. © Alinari Archive-Florence

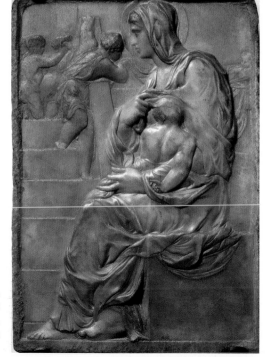

I.2 Michelangelo Buonarroti, *Madonna della Scala*, Casa Buonarroti, Florence. © Alinari Archive-Florence

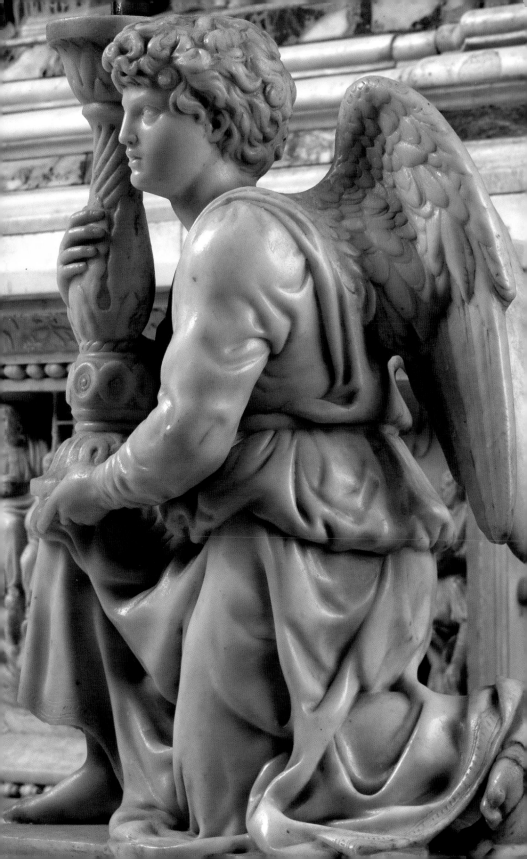

Opposite:
I.3 Michelangelo
Buonarroti, *Angel
Holding a
Candelabrum*, San
Domenico,
Bologna.
© Andrea Jemolo

I.5
Michelangelo
Buonarroti,
*Saint
Matthew*,
Academy,
Florence.
© Andrea
Jemolo

I.4 Michelangelo Buonarroti,
Bacchus, Bargello National
Museum, Florence.
© Alinari Archive-Florence

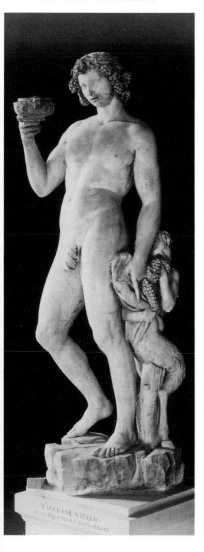

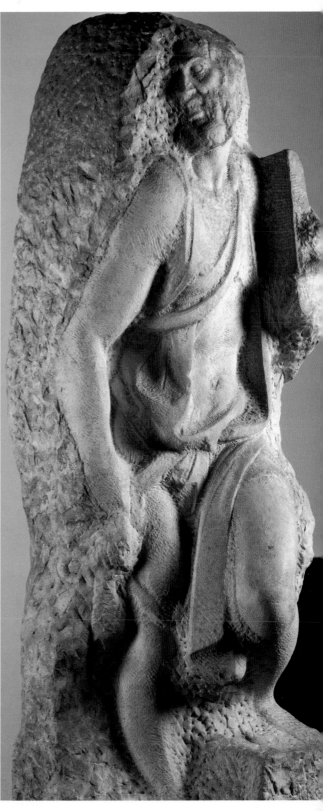

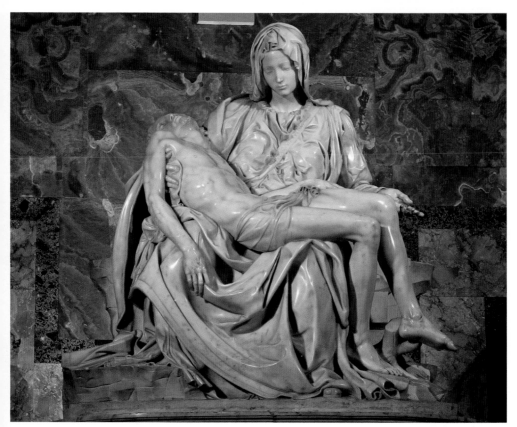

I.6 Michelangelo Buonarroti, *Pietà*, Saint Peter's, Rome. © Wikimedia Commons

Opposite I.7 Michelangelo Buonarroti,
David, The Academy, Florence.
© Andrea Jemolo

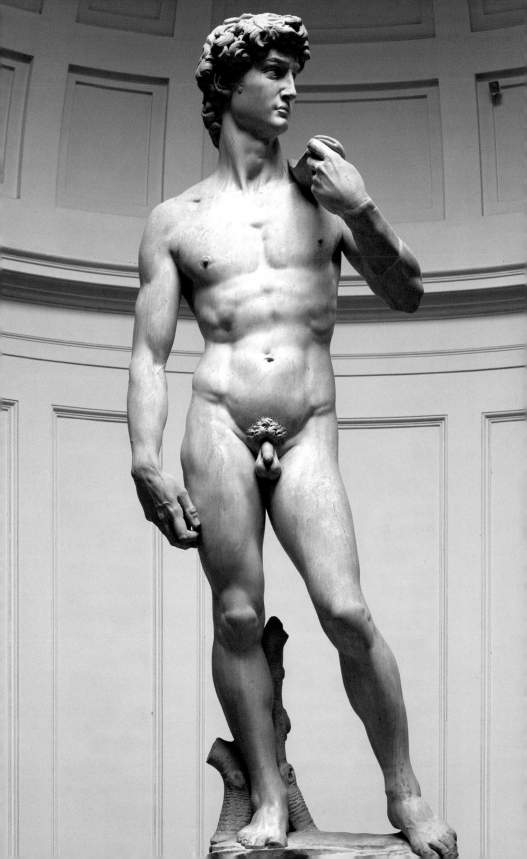

I.8 Michelangelo
Buonarroti, *Madonna of
Bruges*, Nôtre-Dame,
Bruges.
© Wikimedia Commons

I.9
Michelangelo
Buonarroti,
Pitti Tondo,
Bargello
National
Museum.
© Alinari
Archive-
Florence

I.10 Michelangelo Buonarroti,
Taddei Tondo, Royal Academy,
London. © Royal Academy of
Arts, London

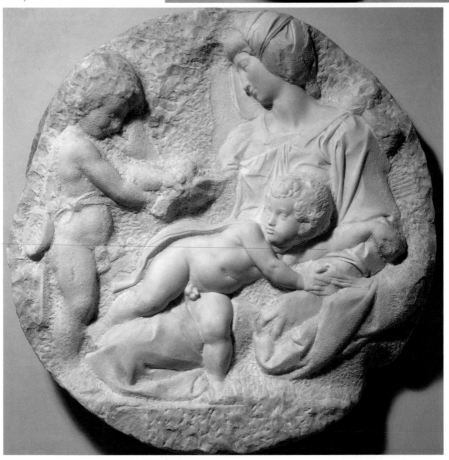

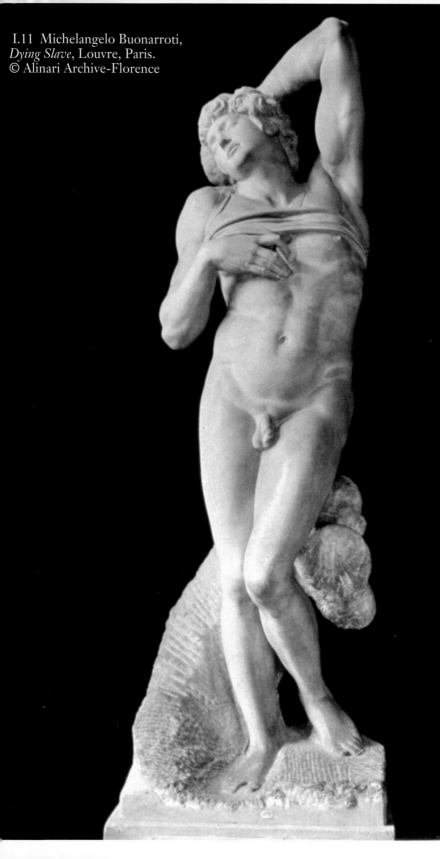

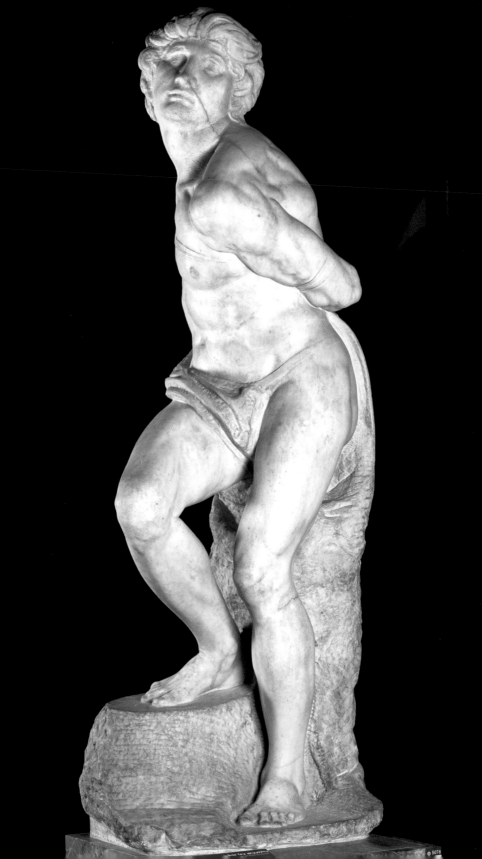

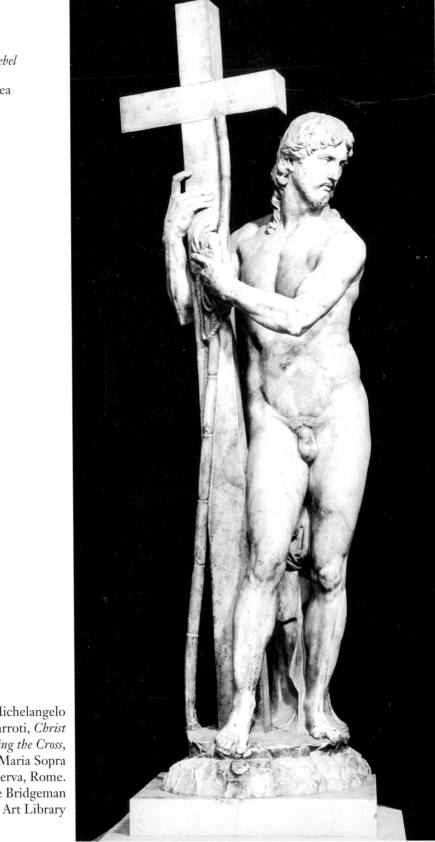

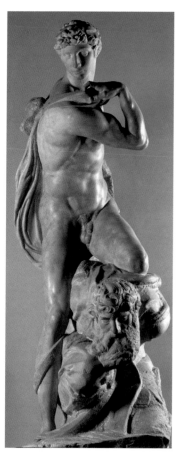

I.14 Michelangelo
Buonarroti, *The Genius
of Victory*, Palazzo
Vecchio, Florence.
© Andrea Jemolo

I.15 Michelangelo Buonarroti,
Prisoner known as Atlas, The
Academy, Florence.
© Andrea Jemolo

I.16 Michelangelo Buonarroti, *Prisoner known as Youth*, The Academy, Florence. © Andrea Jemolo

I.17 Michelangelo Buonarroti, *Prisoner Who Reawakens*, The Academy, Florence. © Andrea Jemolo

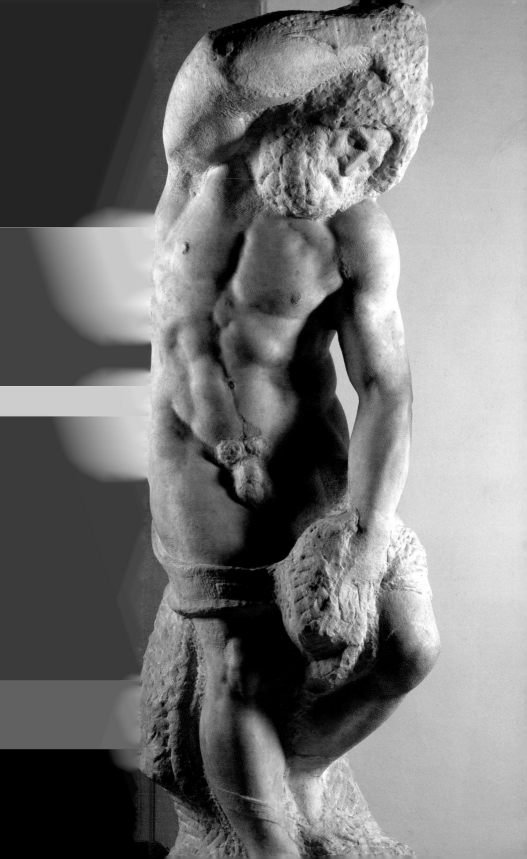

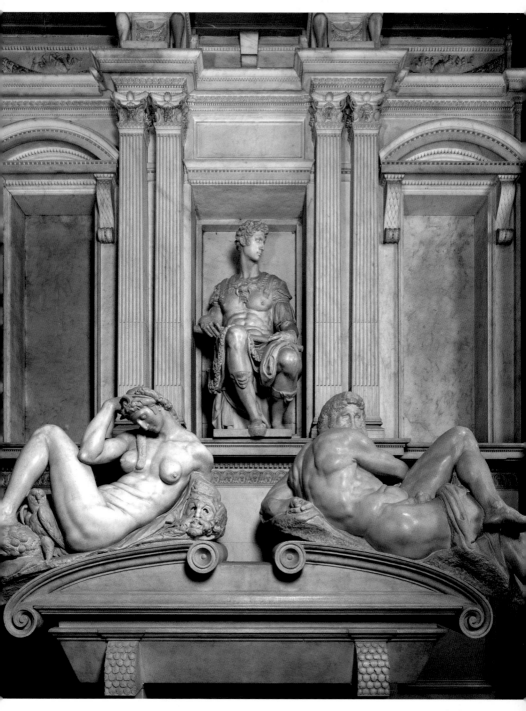

Opposite: I.18 Michelangelo Buonarroti,
Prisoner known as The Bearded Slave.
© Andrea Jemolo

I.19 Michelangelo
Buonarroti, *Tomb of
Giuliano de' Medici*,
Sagrestia Nuova, San
Lorenzo, Florence.
© Andrea Jemolo

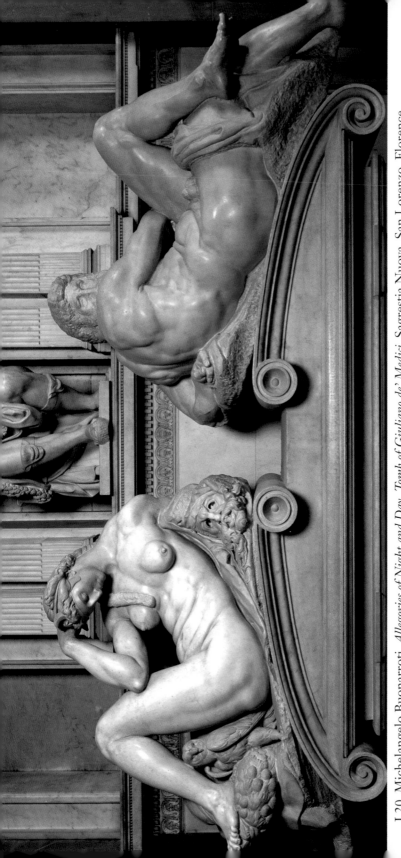

I.20 Michelangelo Buonarroti, *Allegories of Night and Day, Tomb of Giuliano de' Medici*, Sagrestia Nuova, San Lorenzo, Florence.
© Andrea Jemolo

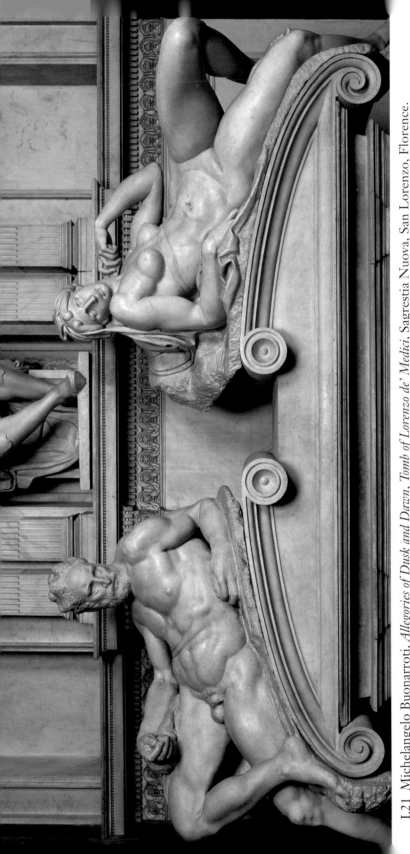

I.21 Michelangelo Buonarroti, *Allegories of Dusk and Dawn, Tomb of Lorenzo de' Medici*, Sagrestia Nuova, San Lorenzo, Florence.
© Andrea Jemolo

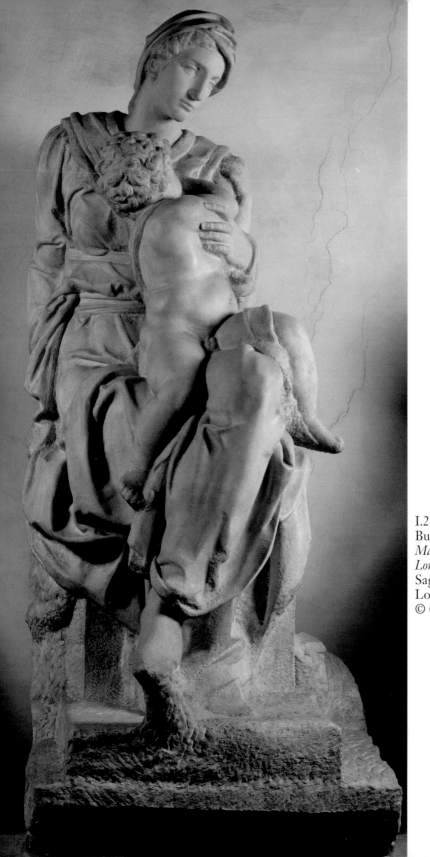

I.22 Michelangelo Buonarroti, *Medici Madonna*, *Tomb of Lorenzo de' Medici*, Sagrestia Nuova, Sa Lorenzo, Florence. © Corbis

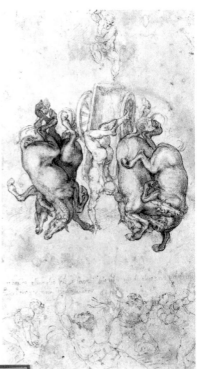

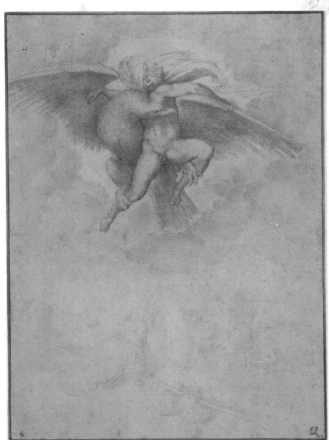

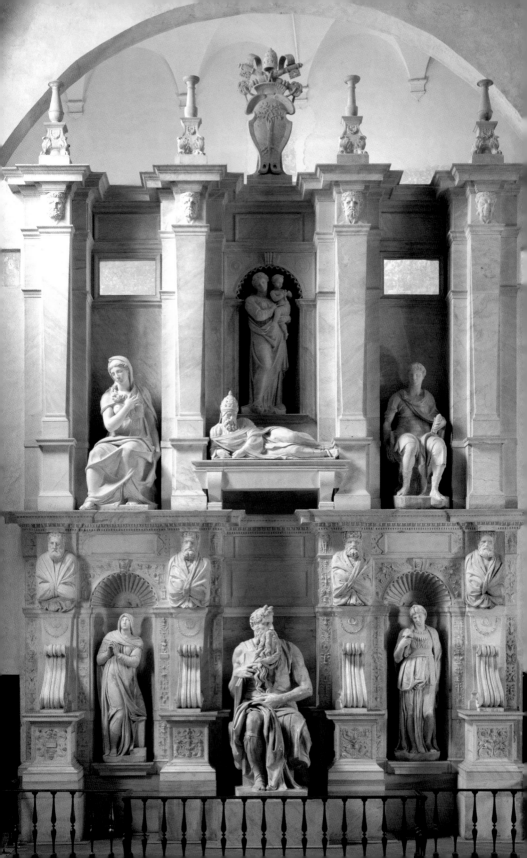

Opposite: I.25
Michelangelo Buonarroti,
Tomb of Julius II, San
Pietro in Vincoli, Rome.
© Andrea Jemolo

I.26 Michelangelo
Buonarroti, *Contemplative
Life*, Tomb of Julius II,
San Pietro in Vincoli,
Rome.
© Andrea Jemolo

Overleaf:
(left) I.27 Michelangelo
Buonarroti, *Active Life*,
Tomb of Julius II, San
Pietro in Vincoli, Rome.
© Andrea Jemolo

(right) I.28 Michelangelo
Buonarroti, *Moses*, Tomb
of Julius II, San Pietro in
Vincoli, Rome.
© Andrea Jemolo

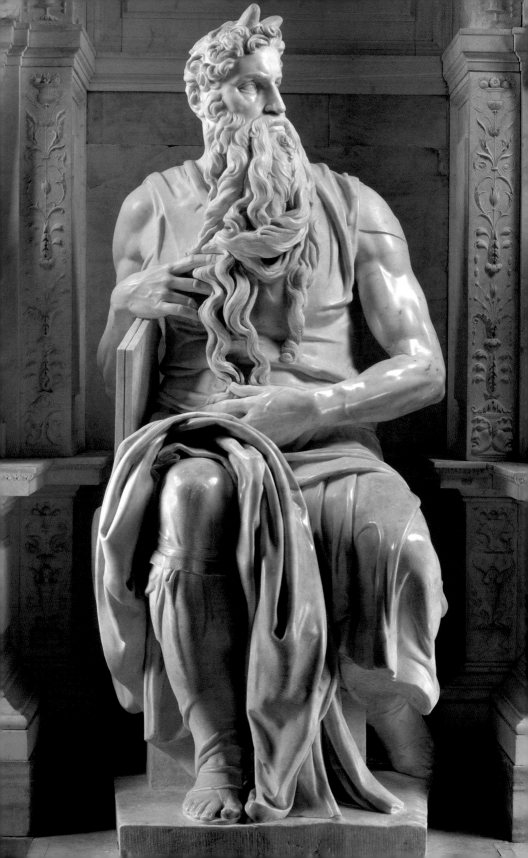

I.29 Michelangelo Buonarroti, *Crucifixion* for Vittoria Colonna. © The Trustees of the British Museum

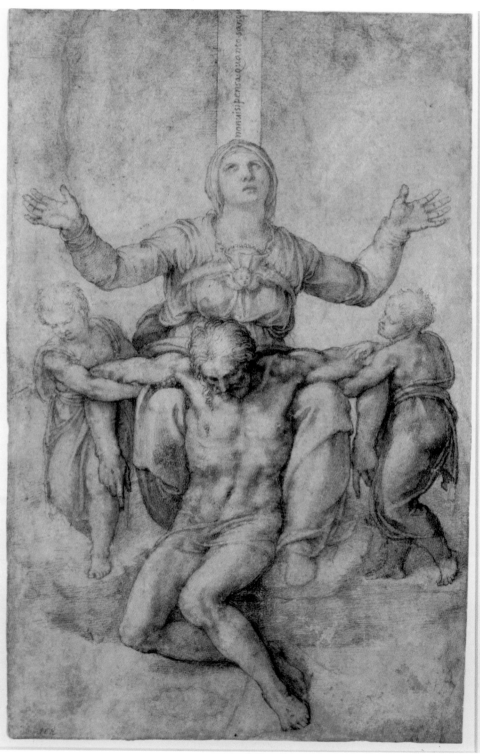

I.30 Michelangelo Buonarroti, *Pietà* for Vittoria
Colonna. © Isabella Stewart Gardner Museum,
Boston, MA, USA/The Bridgeman Art Library

Overleaf: I.31 Michelangelo
Buonarroti, *Pietà Bandini*
© Andea Jemolo

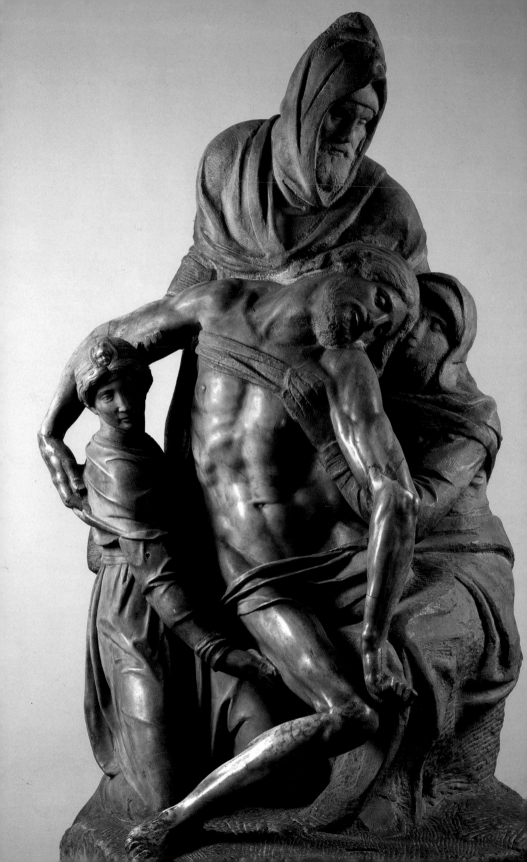

pope would have had allegorical figures above and below him, as the original project had no provision for angels or saints – only for one Madonna. The inspiration appears to have been profoundly pagan, as in the celebrative programme for the Sistine Chapel, in which the appeal of the ancients had the same weight as that of the bible. Indeed, secular paganism was even more evident in the case of Julius II's monumental tomb, as though it had to celebrate a military leader rather than a pope.

The contract committed Michelangelo to producing forty statues, all larger than natural size. While taking into account the value of the surround, we estimate the value of each figure at around three hundred gold ducats: an exorbitant price for the period, and one that was destined to increase rapidly in the coming years, as we shall see. Michelangelo had undertaken to work exclusively on the tomb until it was finished: 'the aforementioned master Michelagnolo promises not to take on other definite and important work of production that could impede the production and work on the said tomb.'[10] But the artist had no intention of observing this particular clause. A few days after having signed this contract with Julius II's relations, the Della Rovere, he came to an agreement with Metello Vari de' Porcari to sculpt a Risen Christ. Although not very rich, this Roman nobleman was willing, along with other members of his family, to pay him two hundred *scudi* for a statue in memory of his relation Marta Porcari to be erected in the important church of Santa Maria sopra Minerva in Rome.

From the summer of 1514, Michelangelo worked on both projects at the same time. He sculpted two of the 'Prisoners' for the Della Rovere tomb, which today are in the Louvre. For Metello Vari, he started on a statue which was soon abandoned in a half-finished state, because a black vein in the stone appeared in the face and compromised its successful completion. Apart from the 'Prisoners', which were to be positioned on the base of the tomb, he sculpted the rough shapes of the larger figures to go on the upper plane: Moses, the Sibyl, the Prophet and perhaps another one about which we have no information. We do not know to what degree of finish he took the seated figures, whereas he was undoubtedly further advanced in his work on the two prisoners universally known as the *Dying Slave* and the *Rebel Slave*, which today are both in the Louvre in Paris.

The *Dying Slave* (Plate I.11), more than any other statue, expresses the pagan nature of the cultural climate in Rome at the time, in which classical antiquity's written texts and artistic artefacts exerted a much greater fascination than did the tradition of the Holy Scriptures. The classical influence is almost literal in both the statue and the monument. On a formal level, that left arm raised in a gesture of waking up or falling asleep, and in any case of sensual languor, was contending with *Laocoön*'s raised arm, which at the time was taxing all Italian sculptors in an uneven competition. The youth's sensuality, a veritable display of homoeroticism, is made even more evident by the tapering, soft and feminine musculature, similar to that of the *Bacchus* sculpted by Raphael. Once again Michelangelo distanced himself from the tense Florentine portrayal, which had influenced his *David*, and plunged back into the softness, the content and the subdued balance of the classical tradition. He very explicitly goes in search of an intense sentimental expression, possibly inspired by the theatrical sentimentalism of *Laocoön*.

Equally, the statue of the *Rebel Slave* (Plate I.12), takes pleasure in displaying a taut and vigorous anatomy that blends with a surprising and determined mimetic expression. The innovativeness of the two sculptures also lies in their divergence from the prescribed proportions of classical sculpture. The 'prisoners', whether warriors or slaves, came from the banks of the Arno and the Tiber, and not from Roman arches or the pediments of Greek temples. The musculature more closely resembles that of real people in flesh and blood, yet avoids a naturalism that would trivialize the intriguing allure of the vaguely abstract. Michelangelo comes closer to nature, but he does not cross over the threshold that demarcates ideal beauty. In this manner he creates a new model of male and specifically youthful perfection, which marks the full maturity of Renaissance sculpture much more clearly than the Florentine *David* – whose profile is still exaggeratedly ostentatious – to the point of reaching fifteenth-century levels of abstraction.

The perfect technique of these sculptures modulates changes in shade in order to invest the anatomies with a truth and a vitality unequalled by any other sculptor of the time. The roundedness of the musculature does not reveal the slightest evidence of technical difficulties. The marble appears not to have been sculpted, but rather to

have been moulded by the artist's own hands. He manages to catch the essential features of the human figure, so as to display its life, beauty and universality, while excluding the representation of everything that in other artists' sculptures tended to make the image of man appear overly accidental. Michelangelo's prodigious creativity consists precisely of this miraculous selection of what needs to be displayed (a swelling of muscles, a vein or a tensed tendon) and what needs to be omitted – a creativity that is much more significant than his technique, even though the wisdom of the latter is spellbinding.

The same can be said of the *Cristo della Minerva* (or *Christ Carrying the Cross*), which today we find to the left of the main altar of the Roman church in the version that Michelangelo sculpted in Florence between 1516 and 1521 (Plate I.13). Unfortunately the statue is now marred by a cloth required by subsequent censorship, which makes it impossible fully to appreciate the anatomy. When it was sculpted for Metello Vari, no one was shocked that a Christ was displaying ample and vigorous genitalia in a Roman church. Indeed, Michelangelo created a figure with a double torsion around the cross, which he keeps at a sufficient distance from the body, in order to avoid interference with appreciation of the anatomy. Once again there are powerful legs and the 'Italian' calves we have already encountered in the 'prisoners', whereas the arms that hold the cross are exceptionally slender, if compared with the possibly excessive fullness of the groin and the buttocks. The anatomy of a mature and therefore no longer young man is displayed in all its generous complexity. Only the ineffable expression reveals the divine nature of the Christ which, if it weren't for the beard, could be mistaken for an Apollo or, even more, a Mars who has been caught in a moment of relaxed thoughtfulness.

When it comes to assessing this sculpture, we must bear in mind that Michelangelo did not complete the work. Much to his regret and that of all Rome, this task fell to his extremely loyal assistant Pietro Urbano in circumstances that infuriated the artist. In the summer of 1521, the statue was loaded on a vessel in Florence, where the patient Metello, who had paid in advance and had been waiting for its delivery for almost a decade, had inundated Michelangelo with pressing and entirely legitimate demands. On arrival in Civitavecchia, the closest port to Rome, the boat had to wait for more than a month because an

untimely hot southern wind had formed a 'bar' across the entrance to the Tiber – a term that is still used to denote the wave that is formed at the mouth of this river in particular climatic conditions. When it finally arrived in Rome to be placed on the pedestal in the church of Santa Maria sopra Minerva, there were still a few details that had to be completed. Michelangelo engaged the loyal Pietro for the task, as he had been doing for some time when it came to responsible and demanding work, because he could not leave Florence, or indeed Carrara, where he went endlessly in search of marbles. But Pietro bungled the job with an act that was heartlessly described to Michelangelo by Sebastiano del Piombo, who kept him up to date with all events in Rome that concerned him:

> But I want you to know that all the work he has done has ruined everything, and most particularly he has shortened the right foot, which can be clearly seen in the toes he has cropped. He has also shortened his fingers, particularly those of the hand that holds the cross, which is the right one, and Frizzi says that it looks as though the people who make crutches have been working on them. It doesn't look as though it is made of marble; it looks as though the people who make pasta have been working on them, they are so stunted. . . . and I believe they will turn out badly, because I understand that he has taken to gambling and, as for the whores, he wants the lot of them. And he goes round Rome like a nymph with his velvet shoes, and he must be paying out a lot of coppers [*baiocchi*: the copper coins used in the Papal States].[11]

Unfortunately even Michelangelo could sometimes lose control of the persons closest to him, and on this occasion the youthful Pietro was clearly more influenced by the seductions of Rome than his master's moral principles. In any event, he appears to have forgiven the young man, because the correspondence between the two demonstrates that relations between them were good for a long time afterwards. The statue was 'adjusted' by another sculptor, Federico Frizzi, who remedied the damage done by Pietro's youthful hormones.

Apart from the everyday incidents of working life, the years 1513 to 1516 were for Michelangelo some of his most untroubled ones. The regular payments from the Della Rovere heirs were rapidly increasing

his wealth, so that in March 1515 he was able to increase the family estate in Settignano by purchasing the Scopeto farm next to his own for 575 gold florins [*fiorini d'oro larghi*].[12] Before this acquisition he had been tempted to also invest his money in Rome, but he had eventually given up on the idea. He was unable to think of himself as a citizen of the eternal city, and Florence remained the goal in this social and emotional life. In spite of this, his anxieties about the management of his considerable wealth deposited in the Florentine bank Ospedale di Santa Maria Nuova was such that he came to the inexplicable decision to withdraw it all and transfer it to Rome and the bank of the young banker Francesco Borgherini, with whom he had, in his own words, become completely infatuated and whom he wished to serve in any way he could. Overcoming his own innate suspiciousness, he entrusted this man with everything he held most dear, his money.

But he did not go beyond the transfer of his money. He didn't even buy his clothes in Rome, and continued to have them sent from Florence, ignoring the fact that the city in which he resided had some of the best tailors in the service of the cosmopolitan society that had formed around the papal court. Like any other emigrant who cannot wait for the painful exile to end and the return home, he even had the most prized food products sent from the Tuscan city. This was his constant hope during this period, in which the launch of a profitable business activity by his brothers gave him hopes in the future he would be free from the continuous and pressing demands for money.

The climate of unperturbed productivity was, however, interrupted in the spring of 1516 by a series of events that plunged Michelangelo slowly and inexorably into the terrifying and wretched period of his life. In spite of the artist's jealousy and cantankerous nature, the studio at Macello dei Corvi had quickly become the reference point for Florentine artists in Rome. He particularly frequented by those artists, like Sebastiano del Piombo, who sought to oppose the excessive power of Raphael's clique, for which Leo X showed an unimaginable and quite intemperate preference. Within seven years, Raphael had become the unchallenged arbiter of the artistic scene in Rome and Michelangelo was becoming increasingly marginalized. On 21 April 1516, Cardinal Leonardo Grosso Della Rovere, the executor of Pope Julius's will, announced the visit to that studio of Elisabetta Gonzaga, the Duchess

of Urbino, who, as he wrote to Michelangelo, 'greatly desires to see your work on the tomb in memory of Pope Julius, and you know how much we and her Excellency hold dear that memory.'[13] Elisabetta Gonzaga, who unfailingly wore a jewel on her forehead in the shape of a scorpion, was at the time the most admired woman in Italy for her beauty, elegance and intelligence, which had enabled her to create Europe's most sophisticated court in Urbino.

However, it was not only her admiration for Michelangelo that drove the sister-in-law of Isabella d'Este to cross the Apennines and travel to Rome. She came in the name of her adopted son Francesco Maria Della Rovere, the Duke of Urbino, to dissuade the pope from his attack on their duchy, which had triggered a war that would have important repercussions on the papacy and, as we shall see, on Michelangelo too.

3 DANGEROUS AMBITIONS

Leo X had been called upon by the College of Cardinals to defend the autonomy that his predecessor Julius II had restored to the Church. To maintain the autonomy of the Church, no foreign power could be allowed to become dominant in Italy, or, to put it in Von Pastor's words, the pope had to do all he could to avoid 'any prince from gaining the crown of Milan and Naples at the same time.'[14] This policy, which required all the pope's energies, had been made more difficult by the very close relationship that had now been established between the Florentine state and the Papal States by the election of a Medici pope.

From 1515, the pope's cousin, Giulio de' Medici, had almost exclusive control of Florence. Born on 26 May 1478, Giulio was the illegitimate son of Giuliano, who was killed during the Pazzi conspiracy. The question of his illegitimacy was quickly resolved by the pope, who invented a false marriage between his father and his mother Fioretta: on 9 May 1513 Giulio could therefore be appointed Archbishop of Florence, and on 23 September of the same year he received the cardinal's hat. Giulio was much more energetic than Giuliano (the pope's brother, who was afflicted by various medical complaints that rumour attributed to the pleasures of the flesh, including his penchant for overindulging in his consumption of meat), and had the important gifts of

restraint and prudence, which made him the ideal candidate for restoring the Medicis' influence over the city. The Florentine people now strongly identified with the republic, while the aristocracy still aspired to government and had never considered the Medici to be rulers of the city, but rather the first amongst equals, in accordance with a formula that the ceremonial artfully invented by the Medicis had contributed to keeping alive even through the republican years.

Giulio co-opted the most brilliant intellectuals in Florence, who generally were and would continue to be the most brilliant in sixteenth-century Italy. The most influential was Francesco Vettori, one of the instigators of the Medicean restoration, and the man who attempted to improve relations between the Medici and Niccolò Machiavelli. Even though he loyally worked for Pier Soderini, the *gonfaloniere* of the republic, Machiavelli saw himself principally as a faithful servant of the Florentine state, and he therefore desired to serve under the new rulers. Even Francesco Guicciardini was skilfully drawn into the restoration of moderate Medicean influence by the Medici cardinal. Unfortunately for the difficult task of creating a balanced solution, as pursued by this brilliant intellectual circle until 1515, two brutal forces of nature were about to produce devastating results: these forces were maternal ambition and the delusions of omnipotence that emanated from the papal crown.

The untrammelled maternal ambition that periodically appeared on the Italian political scene on this occasion took the form of Alfonsina Orsini. This tireless noblewoman was the mother of young Lorenzo de' Medici, the grandson of Lorenzo il Magnifico, and she wanted a state for her son to rule at any cost. Clearly she was not content with the influence he could exert on the government in Florence in accordance with the local institutions. Leo X was certainly aware of the disastrous experiences caused by his predecessors' nepotism, and moreover he inherited the extremely stable papacy bequeathed by the only modern pope that had not succumbed to family ambitions. He was only able to keep his nepotistic instincts under control for three years. The papal crown soon started to exercise its baleful capacity to trigger unbounded ambitions: around the beginning of 1515 he started to adapt Church policy to his family's dynastic desires and sparked off a series of events that would lead some years later to the Sack of Rome.

Lorenzo was the first to upset the delicate political balance in Florence. Encouraged by his mother, he had himself nominated Captain of the Florentine Republic on 23 May 1515. This act broke the unwritten law of the system of government established by the Medici: family members were not supposed to hold important public office, particularly in the case of such delicate appointments as the military ones. It was, in fact, the aristocracy that was most offended by Lorenzo's pretensions. Francesco Guicciardini, who was however quite willing to support a political system centred upon the influence of the Medici family, provided the words that best expressed the discomfort and humiliation of that political affront: 'The person who has controlled this government up till now has believed that his greatness is increased by keeping others in positions of inferiority, and therefore he has decided to place all the resources of the city and its territories at his own disposal.'[15]

In the months that followed, Leo X went even further. He decided to take advantage of the failure of Francesco Maria Della Rovere to support him in the war against France, and use it as a pretext for seizing the Duchy of Urbino from the Della Rovere family and bestowing it on his nephew Lorenzo. Once he had overcome the French king's hostility to the plan and had negotiated an agreement with him in Bologna in January 1516, he marched the papal troops against the Duke of Urbino and ordered him to present himself in Rome for a judicial procedure whose outcome was already known, and failing this he would be tried in his absence. The Dowager Duchess, Elisabetta Gonzaga, went to Rome in place of Francesco Maria, who had been summonsed in early March, to remind Leo X of the debt of gratitude he owed the Della Rovere family, who had taken in the Medici when they had been driven from Florence, twenty years earlier. The pope was unmoved and on 26 May 1516 he issued a public warning against Francesco Maria Della Rovere.

The Della Rovere were also the principals responsible for the completion of the work on Julius II's tomb. For this reason the Duchess wished to visit the author of what was rightly considered their most important family commission in Rome during her sensitive political mission to that city. As a result of that visit, Michelangelo's work came within the highly risky orbit of political threats and demands. Of course

the pope – as Michelangelo would later claim, possibly exaggeratedly – had no desire to have tomb constructed for his predecessor to glorify the family he was now attempting to destroy.

They may discussed a new and slimmed-down plan for the monument, given that three years after signing the contract and in spite of all the money he had received, all Michelangelo had in his studio were two almost complete statues, four that had only been sculpted down to their rough profile, and one of the lower faces of the surround. All this could not have come to more than a fifth of the sum the artist had already received by that date. We do not know exactly what the duchess thought of the excellent but deficient work (according to the contract, the whole work was supposed to be finished within three years, which was now clearly impossible), but it was decided that a new contract should be drawn up with a new design for the tomb. It was signed on 8 July 1516, and increased the number of years for completing the work from seven to nine (while still using a start date in 1513).[16] Michelangelo was required to produce only twenty statues instead of forty – less than half of the number stipulated in the previous contract – but the fee was left unchanged. This meant that Michelangelo would receive a payment of six hundred *scudi* for each sculpture, which was an astronomic figure for the time. Above all, this adjusted the value of the sculptures to contemporary estimates, given that most of the payment had been already made. It was therefore a contract that disadvantaged the purchasers, who had every right to demand the work they had already paid for. Michelangelo had already received 8,000 *scudi* and should therefore have delivered at least twenty of the forty statues he had promised – the twenty that he now undertook to produce for twice the money. However, the Della Rovere wanted more than anything to have the tomb sculpted by his hand and the new agreement acknowledged the artist's extraordinary reputation.

As soon as the highly advantageous agreement had been signed, Michelangelo left for Carrara in search of more marble blocks. Before leaving he asked Pier Soderini to commend him to the Marquis of Carrara in order to gain his assistance in the enterprise. Michelangelo's relationship with Soderini was still a very close one, in spite of the latter's well-known hostility to Medicean rule – hostility that was shared by the rest of his family. Niccolò Machiavelli, who had been invited to

Rome by Francesco Vettori, agonized for a long time over whether it would be appropriate to visit the ex-*gonfaloniere*, which could have been interpreted by the Medici as excessive closeness to the republican cause. Michelangelo, on the other hand, did not hesitate to maintain close relations with the exiled leader, and indeed it was Soderini, two years later, who asked him first for drawings and then a personal commitment to produce a sepulchral monument with a value of five hundred ducats.

In Carrara, Michelangelo immediately started on the exhausting task of negotiating with local quarrymen. He was not content with simply ordering blocks of marble: he wanted to inspect the quality of the marble up close and know the site the marble was extracted from. He wanted to reassure himself about the actual compactness and purity of each single block. Before signing a contract with quarrymen, he wanted to see how they worked, which rocks they quarried and how they transported the marble. He also wanted to assess their ability to cut away the initial material from the block of marble without jolting it and causing damage that would appear later in the production process and ruin the work. Finally, he couldn't even trust the quarrymen of the Apuan Hills, and would run the risk of accidents like the one that a few months later would nearly cost him his life.

As we have seen, a block of marble had to be chipped down until it was roughly the form required for the sculpture in order to facilitate transport. This phase was essential if the work was to be completed successfully, especially in the case of an artist like Michelangelo who wanted to keep open the possibility of changing a statue's pose right up to the last moment. For this reason, Michelangelo's sojourns in the Apuan quarries should be seen as a fundamental part of his work as a sculptor and demonstrate his attention to detail, even when it came to the toughest and most arduous aspects of his work. We do not come across this obsessive thoroughness in any of his contemporary artists, or even in those of later periods. He lived in cold bivouacs or makeshift shacks without any of the comforts of city life, and it was not easy to get hold of food and drink. It was a rough and brutal life that would not have been expected of the wealthiest and most famous artist in the West. And yet this life in the wilds of Carrara could go on for months and later even years, depriving him of what was perhaps the more

intellectual part of his work, but not for him any the less engrossing. Even his father's illnesses, which were frequent at the time, failed to draw him away from an isolation that was perhaps yet another form of physical self-punishment. It is also possible that the attraction of that life and those simple people was caused by a rejection of all the ceremony of fashionable society and a love of an active, virile and material universe, from which women were entirely excluded.

4 THE RECONCILIATION

Michelangelo stopped in Florence on his way to Carrara. The Medicean restoration was finally beginning to inflate artists' expectations, as they could still remember the golden age of Lorenzo il Magnifico. They had hopes of perhaps not its complete return but at least a reasonable echo of its former glory. Leo X himself had referred to his family's astonishing tradition during his triumphal entrance into the city in November 1515. The papal procession was carefully choreographed in a manner worthy of Lorenzo il Magnifico. The papal litter was carried in triumph and preceded by ranks of young nobles, all dressed in purple-red satin habits and holding gilded batons. Purple and gold would have been sufficient on their own to reach the heights of Renaissance aestheticism, but there was more. The pope's litter was topped by an extravagant brocade canopy help up by his guards and grooms. He was surrounded by government officials dressed in luxuriant fabrics and splendid embroideries. This glittering parade filed through the city's streets for three days, to the joyous ringing of bells that alternated with fireworks displays. Perhaps to emphasize that beautiful Florence was not yet sufficiently royal for the tastes of a Medici pope, ten triumphal arches were erected throughout the city. Pope Leo did not stint in his almsgiving.

In these circumstances, it was decided that the return of the Medicis should be visibly marked by that tradition of civic art that was the foundation of Cosimo's and Lorenzo's political strategy. To achieve this, they made the choice of the Church of San Lorenzo and its facade, which Cosimo had had Brunelleschi construct, without however being able to complete it. While the Medicis of the fifteenth century had had Brunelleschi, those of the sixteenth had to have Michelangelo, whatever the cost.

However, relations with the artist were not good, and it didn't look as though it would be easy to improve them. Everyone knew that Michelangelo was under contract to work exclusively on Julius II's tomb, which all the papal court was waiting upon because of the continuing awe in which it held the Della Rovere pope. Nevertheless, the prospects of high earnings for the artist and of artistic excellence for the prospective customer were such that both parties could not allow such trivial impediments to stand in the way of a pope and a genius. Diplomacy started to work furtively in favour of a reconciliation that would have brought prestige to Florence and fame to the Medici dynasty. At more or less the same time that he was signing an exclusive contract with the Della Rovere family, Michelangelo was conducting secret negotiations with Leo X, the very same Giovanni de' Medici in whose home he had lived as a boy, with whom he had eaten and slept, until he had run off never to show his face again, as soon as fortune had turned its back on the Medici family.

Towards the end of October 1516 in the remote mountains of Carrara where the first bitter snow showers were announcing the coming winter, Michelangelo was informed by Baccio d'Agnolo (a skilled and very well connected Florentine architect) that the pope intended to award the work on the San Lorenzo facade to him and Michelangelo as associates. Besides, Leo had already spitefully taken revenge on Michelangelo for his disloyalty by awarding the most desirable contract in Italy to Raphael – that of being the architect for Saint Peter's and the designer and artist for the decoration of the papal rooms. The pope had raised Raphael to such a position of glory that the King of France was demanding his services at the time and a powerful man like the Duke of Ferrara Alfonso d'Este had to wait patiently for the artist to show his benevolence (and be paid exorbitant sums). Michelangelo could not have been unaware that the pope's hostility was damaging him professionally. He declared that he was open to a reconciliation and was driven to this decision by his own dependents and by Sebastiano del Piombo, who was becoming increasingly convinced that Raphael and his assistants were dominating the entire Roman art market. The time had come for the pope and the artist to put their quarrel aside in the name of their shared Florentine interests.

In early December, Michelangelo left Carrara for Rome to speak with

Leo about this new commission. They talked about the costs and the plans. The work would be awarded to Michelangelo, Baccio d'Agnolo and a third architect, Baccio Bigio. Michelangelo should have been happy with the way the work was divided up, as it would have allowed him to fulfil his contractual obligations to the Della Rovere family. But this was not to be. The exile of Francesco Maria Della Rovere, who had sought refuge with his father-in-law Federico Gonzaga, meant that Michelangelo was no longer under pressure from the heirs to Julius II. He therefore started to entertain the idea of obtaining the whole of the San Lorenzo commission and earning an astronomical figure all for himself. Adopting his usual strategy of devious meddling with other people's decisions, he did not immediately and clearly address the matter, but rather embarked on a war of nerves against the other artists involved on the commission. These included the well-established and much-esteemed master sculptor Iacopo Sansovino, who was supposed to work alongside him on the sculpture. The negotiations were typically contorted and secretive. Michelangelo let Baccio d'Agnolo explain his plans, which were then subjected to implacable criticisms. Even the papal delegate, the unfortunate Domenico Buoninsegni, who was very accustomed to the subtle techniques of diplomacy, lost his nerve when faced with this intractable artist. Michelangelo's strategy was inexorable and involved the entire business community in Florence in a campaign of defamation. One after the other, all his competitors were crushed, or rather this was what happened to those who had delusions of becoming his partner. In the end, Michelangelo was the sole contractor for the work on San Lorenzo.

Cardinal Giulio, who was passionately interested in the affair (to the point of discussing not only the identity of the statues on the facade but also their clothing) was more than a little surprised to discover that the cost of the works had risen from thirty to forty thousand ducats. He even asked Michelangelo to explain whether the price had increased because of an error or because the size of the undertaking had also increased. But the artist's compulsive drive for great profits did not stop at eliminating all possible partners in the construction of the facade. As soon as he knew that the commission was definitely his, he came up with the brazen idea of going into partnership with a Carrara quarryman for the extraction of the marble for the work, so that he could also

make a profit on the supply of materials. The text of this temporary partnership agreement, which was signed on 12 February 1517, provides precious details about Michelangelo's expectations of a handsome profit from the enterprise:

> Whereas I have been commissioned by Pope Leo the Tenth, Florentine, to procure a quantity of marble for the facade of San Lorenzo in Florence; whereas I am presently in Carrara for my other commissions; whereas I, Michelangelo, Florentine sculptor, am in search of the said marble; and whereas I have informed Leonardo, also known as Cagione, son of Andrea di Cagione from Carrara of my choice of an ancient quarry of his, where we could establish a good business; I have decided to have him quarry all the marbles there. Whereas the said Cagione holds it dear to go into partnership with me in the said quarry, and I with him, we have today come to an agreement on this twelfth of February in the year one thousand five hundred and seventeen, and we have set up a partnership together, whereby we shall share the cost and the profits equally, and I shall engage the same number of men to work for me as the said Cagione shall engage for himself in the said quarry. And we undertake to each other to maintain the said partnership until I have been supplied with all the marble I require for the aforementioned works, subject to the following conditions: that the Pope or others do not die, that there are no wars, that I am not sick, that I encounter no problems, and that the marble is of good quality and suited to the things I have to do.[17]

On this occasion, Michelangelo's excessive greed was to go badly wrong. The Medicis knew that the marble of Pietrasanta, which was within their territories, was just as good as that of Carrara, and they accused Michelangelo of favouring Carrara for his own interests (as was in fact the case). While Michelangelo was happily signing his agreement with Leonardo Cagione, he received a sharp and resentful letter from Cardinal Giulio, which had the tone of an order: abandon Carrara and organize the extraction and transportation of the marble from Pietrasanta, where the marble was excellent in the opinion of many skilful sculptors. This was not a good start for Michelangelo, who had immediately clashed with those who knew his weaknesses only too well.[18]

The insult and humiliation could not have been more painful. Michelangelo had never been treated in this manner, even when he had not yet become the highly talented artist all Europe admired. It took some Florentines to bring the artist's stubbornness under control, and they did so by treating him almost as an outcast. The Medici used Giulio's letter to remind Michelangelo that his behaviour towards the family had not been forgotten and that they would not put up with any more duplicity on his part. Just as he had been an intimate friend of the pope in his youth, he would now have to be kept at a distance: relations had to pass through the mediation of their secretary, who on the same day wrote Michelangelo a letter full of fear and apprehension. Relations with the Medici family, which had only just been restored, were once again in tatters.

Iacopo Sansovino was on the committee that inspected the marble blocks from Pietrasanta, and he too was meant to take part in the San Lorenzo enterprise, as the commissioners had intended and as Michelangelo had opportunistically led everyone to believe up till that moment. But once again Michelangelo organized the removal of the only skilful artist who could be held up as a challenge, albeit one who would clearly fail. Michelangelo had no intention of sharing anything, least of all the work on the sculpture. Sansovino took his revenge by writing a fiercely hostile letter that is indicative of the way Michelangelo was bitterly resented by some of his contemporaries, and of his colleagues' awareness of his fragility and the fact that he could not boast the same merits in his everyday life that were universally acknowledged in his art.

The final rift between the two came on 30 June 1517 on the road to that highly lucrative commission which, as a result of his overarching greed, would turn out to be the worst business transaction in his life. Sansovino accused him of having fooled and cheated many honourable men because of their involvement in this enterprise and having vilely manipulated the situation to have them excluded. This had revealed his false and petty-minded nature:

Moreover, I tell you that the Pope, the Cardinal and Iacopo Salviati are men who, when they say something, there is a piece of paper and a contract, for they are true to their word and are not what you say they

are. But you judge them against your own standards, as for you neither
contract nor good faith have any worth, and now you say yes and then
you say no, according to what suits your purpose. You should know
that the Pope promised me the stories, and Iacopo as well; and they
are men who keep their word. I have to accommodate myself to you,
as far as my own interests and honour allowed. And I never saw you do
a good deed for anyone else, and, as far as I am concerned, [expecting
you to do so] would be like expecting water not to flow. You know at
least that we have spoken on many occasions, and I'll be damned if you
ever spoke well of anyone in the round. Now let it be as God wills it. I
will not say more. I have been very well informed, and so will you on
your side. That is enough.[19]

The passionate and almost regretful tone of the accusations makes them
all the more dramatic. Sansovino clearly takes no pleasure in describ-
ing Michelangelo's ungrateful nature. At the time, he could consider
himself Italy's second sculptor, and there can be no doubt that he had
attempted in every possible way to reconcile himself with Michelangelo,
even with great humility and acknowledgement of the other man's
greater skills – not an easy thing for an ambitious artist like Sansovino.
The fact they frequented each other, as stated in the letter, confirms
what continuously emerges from documents concerning Michelangelo:
his distrust and ill-will towards the entire world ('you never spoke well
of anyone in the round'). Michelangelo's suspiciousness condemned
him to a painful isolation, and it was as though he found it distasteful to
be compared with people who were a few steps down the ladder from
him. He only felt reassured when he was surrounded by emptiness and
total obeisance.

Thus he was left entirely on his own to face the colossal enterprise of
the San Lorenzo facade. The contract was signed on 19 January 1518.
For the considerable sum of 40,000 ducats, the artist undertook to do
the entire work on his own in eight years: 'and all the expenditure on
the quarrying, transportation, work on the surround and the figures in
relief and bas relief in marble and bronze, and for marble, bronze and
casting, shall be paid by the said Michelangelo'.[20] His next ordeal had
commenced.

5 FAILURE

Michelangelo was obliged to build a road to transport the marble blocks from Pietrasanta, as the pope has demanded. The road enabled him to bring the blocks down the hills to the seashore, where they could be loaded on boats leaving for Florence. The workmen in Pietrasanta were not as expert as those in Carrara, and the artist had to spend most of his time rushing between Pisa and Pietrasanta to deal with minutiae: the heavy hemp ropes used in the transportation of marble blocks, winches, pins for insertion in the marble and iron rings for manoeuvring the blocks. Moreover, the quarrymen of Carrara were furious over what they considered a betrayal, and were refusing to deliver the marble that he had either quarried himself or had had quarried during the preceding months for the tomb of Julius II.

These marble blocks lingered on the beach at Avenza for many years – exposed to the fury of cold winds from the sea or the mountains. They were like so many white phantasms that melancholically imprisoned Michelangelo's latest fantasies: seated figures, standing figures tormented by chains, prisoners and prophets destined for the upper and lower levels of Julius's tomb. Two years later, in February 1520, the boatmen and quarrymen of Carrara, who had confiscated these half-sculpted statues, two and a half metres in height and one metre wide, attempted to sell them to none other than Iacopo Sansovino and some other Roman sculptors, while Michelangelo could only look on in impotent desperation. The quarrymen of Carrara were boycotting the transport of marble because they could see that their prospects of good profits in the future were no longer there. The pope had also decreed that the marble for Saint Peter's would have to be quarried in Seravezza and not in Carrara. The inhabitants of the white caves of the Apuan Hills were witnessing an exodus, as they were increasingly forced to choose between an increasingly difficult life in their native upland or emigration to Pietrasanta, where new quarries and new businesses were being set up to satisfy the Medici pope.

A subdued Michelangelo attempted to make up for the inexperience of the few Pietrasanta quarrymen by taking up permanent residence amongst the quarries there. The works were financed by the pope and the Opera del Duomo, who needed the marble for flooring the

cathedral. He needed to choose the easiest route, but also the shortest one, for the new road from the hills to the sea. They had to cut down forests, consolidate slopes and cut out rocks. In the meantime, Michelangelo was also getting on with quarrying the first important blocks for the San Lorenzo facade. The most prized blocks, which were the most difficult to extract from the hillside, were those for the columns of the first order. Michelangelo wanted them to be made of single blocks, just as the best ancient Roman architects had done. He had to be capable of achieving everything they had, and the San Lorenzo facade had to reflect the best of contemporary Italian architecture.

However, it was not easy to quarry and transport such large blocks of marble. No one had managed to do this since the ancients, and architects had simply plundered Roman monuments for material. The extraction of the columns therefore became the decisive technological test to demonstrate the success of the San Lorenzo enterprise. It was one thing to design a six-metre-high, well-proportioned column, and quite another to cut it out of the hillside and transport it to the building site. Michelangelo started with the procurement of the elementary equipment: iron pulleys, hemp ropes, swivel joints and provisional wooden structures designed for the operation. Ten years after the work on the Sistine Chapel, he was once more taking on difficult technical challenges.

The real quarrying work started at the end of March 1518, and Donato Benti recorded the progress of quarrying the first column. The quarrymen, who were passionate about working on the block, could not wait for their chance to sculpt the rough shape. In June more blocks were quarried. At the end of July, Michelangelo arrived in Seravezza to supervise the movement of the first column down to the valley. The enormous block of marble had to be lowered down the rock face from which it had been extracted, down to a position close to the path where it would be placed on wooden poles for its slow conveyance to the sea. From there it would be carried by ship to the river bends closest to the church of San Lorenzo or the workshop that had been purpose-built not too far from the church.

For this delicate operation, Michelangelo sent his most skilled assistant, Michele Pippo, to Florence to ask the Opera del Duomo for a sufficiently large iron pulley. Michelangelo was the one who prepared

the wooden winch, using two enormous iron pulleys that had been used in the construction of the cathedral. He managed to find a 120-metre length of rope, and with the assistance eleven men, he lowered the column down to the valley. It was such a triumph that word of it soon arrived in Florence and Rome. 'Concerning the marble blocks, I have got the quarried column safely down to a ledge, fifty *braccia* from the road. Lowering it down was much more difficult than I had imagined. Someone was hurt while lowering it, and someone had his joints pulled apart and was immediately killed, and I almost lost my life.'[21]

Unfortunately the illusion of victory was very short-lived. Just two days later, the column was shattered into a thousand pieces while attempting to get it to the valley floor. It was an enormous loss for Michelangelo, who was crushed by this failure and became ill as a result of the effort and frustration. Iacopo Salviati, the commissioner engaged by the pope to finance and report on the works, tried to comfort him and immediately wrote to tell him that such a grandiose enterprise was by necessity bound to encounter such disasters. Thoroughly exhausted, Michelangelo was invited by a friend to rest for a period at his home in Pisa. There, he advised the artist that he could no longer live amongst spikes of rock as he had done for almost two years.

His brother Buonarroto was even more resolute in his judgement, as he was only too aware of what Michelangelo's desperate state of mind would have been during that period. He too wrote to remind him that his life was more important than any great enterprise. Michelangelo had to understand just how dangerous his obstinacy could prove to be, because it tied him to the mountains of Seravezza while he was in a sickly and depressed condition. 'It seems to me that you must value your own person above a column, a whole quarry, the pope and the whole world. And this I believe to be the prudence of gifted men – first looking after the mind and the body, then having done his duty, he can do what one wants, because the most important thing is to save one's life.'[22]

Naturally Michelangelo decided not to abandon his enterprise. He stayed on in Seravezza, embroiled in the insurmountable problems of quarrying and moving marble blocks. Even the pope's secretary, Domenico Buoninsegni, who had been following the building works from the beginning, suggested in the name of the commissioning

party that he should sub-contract the quarrying. But Michelangelo was convinced that without him the quarrying would not produce suitable results. Once again, he could not delegate, he could not trust anyone and he considered himself indispensable to all phases of the works, from choosing the hill to be quarried to the polishing of the finished sculpture. He therefore returned to the hills to a life of privations that were starting to affect his physique, which was no longer that of a youth. Even the Medici pope felt compassion at the sight of the artist putting every fibre of his being into the creation of a work that could become the visible triumph of the Medici dynasty.

In the face of Michelangelo's generous sacrifice, Leo may have recalled their shared adolescence, the great halls full of philosophers in palace in Via Larga, the San Marco garden, and the games of that all too brief period for both of them. Like Julius II before him, he would also have been getting anxious about seeing an end to Michelangelo's work. He begged him to sculpt something with his own hand: a few figures or, better still, the bas-reliefs depicting the story of the Medici family, which were to be included in the facade. He hoped on his next trip to Florence to see the first sculptures, which were of much more interest to him than the structure of the facade. Now that Michelangelo had shown his loyalty and total dedication to the Medici enterprise, the pope even agreed to the purchase of two or three columns from Carrara. This was wonderful news for the artist, who saw this authorization as an opportunity to re-engage with the workforce in Carrara and bring about the release of the marble for Julius II's tomb, which had been held hostage on the beach at Avenza. Salviati very carefully warned him against the possible consequences of his greed: 'As has been said above, if you want to procure two or three columns from Carrara, His Lordship shall be very contented with this, as long as this is done to hasten things towards completion; but if this were done to gain a little more profit, then this would not please His Holiness, because he is desirous that this quarry in Pietrasanta be favoured and assisted.'[23] Michelangelo had to be careful, if he was to avoid losing the trust of the Medici once again.

The work in the quarries regained its proper pace, and the first marble blocks for the facade started to arrive in Florence, after having passed through the port of Pisa and up the River Arno.

Unfortunately, the wonderful spring that ended the freezing weather in the hills did not bring good fortune for Michelangelo. On 16 April 1519, another of the columns that had to be lowered down the hillside was broken. When informing his apprentice in Florence, Pietro Urbano, Michelangelo used the curt and economic prose that makes all comment superfluous: 'Pietro, things have gone very badly: this is because on Saturday morning I set about lowering a column in good order, and everything was in place; and then when I had lowered it perhaps about fifty *braccia*, the ring of the lewis holding the column broke, and the column fell down to the river and shattered into a hundred pieces.'[24]

Michelangelo had just witnessed the destruction of months of hard work. He had risked his person and his physical health; he had clung onto the hemp ropes and the block of marble itself, and could have met the same end as the poor quarryman who had been crushed. There was nothing he could have done. Time and time again when he tried to sleep in the evening, he must have revisited that terrible scene: ropes that snapped, the marble block that plunged down into the void, and the crash as a thousand fragments flew off in all directions and destroyed a dream he had been cherishing for months.

The news that arrived a few weeks later from Carrara was even less comforting: the columns that had been commissioned from local quarrymen were too dark for the facade, and, what is more, the people of Carrara were selling off the marble blocks for Julius's tomb to other sculptors. One of these was Iacopo Sansovino, who thus pursued his slow vendetta for having been excluded from the San Lorenzo contract. On his return to Rome from the quarries of Carrara, he went straight to Cardinal Della Rovere to tell him how Michelangelo had completely abandoned his work on Julius's tomb, for which he had been very generously paid ten years earlier. The cardinal was furious, even though Michelangelo's men in Rome tried to calm him with promises that within a few months the artist would start to dispatch the figures he was sculpting for the tomb.

The heirs to Julius II were not alone in scanning the port of Ripetta for boats bearing white figures carefully wrapped by the scrupulous Michelangelo. Metello Vari was also despairing over the fact that there was no sign of his *Christ Carrying the Cross* for the Church of Minerva,

for which he had already paid three quarters of the enormous cost in 1514. An impossibly kind and patient man, Metello was bombarding Michelangelo with letters, because the relations he had dragged into the enterprise were demanding to take possession of the statue as soon as possible. He implored the artist to send him the statue immediately, even if it wasn't completely finished.

This is not to mention Leo X, who was expecting to see the first finished bas-reliefs for his facade, for which he had paid several thousand ducats. In the spring of 1520 the pope decided to rescind Michelangelo's contract and entrust the management of the Pietrasanta quarries to others. Michelangelo had little choice but to make an assessment of those desperate years and attempt to recover at least part of the expenses incurred, while he was fully aware of the harm to himself, the shame and the extremely awkward situation he now found himself in with Julius' heirs. Once again he attempted to negotiate a solution with the pope's secretary, Domenico Buoninsegni. Michelangelo sent him a summary of the dramatic events that had occurred during those years, in the hope of being able to keep at least part of the advance for the San Lorenzo commission:

> . . . not charging the said Pope Leo for the dispatch to Rome of the sculpted marble blocks for the said tomb of Pope Julius, which will cost more than five hundred ducats. Not charging him for the wooden model of the said facade, which I sent him in Rome; nor charging him for the three years I lost over this; I am not charging him for the fact that I have been ruined by the said work on San Lorenzo; I am not charging him for the enormous insult of having brought me here to do this job and then taking it away from me – and I still do not understand why; I am not charging him for my house in Rome, which I left behind and has since been neglected along with its marble, household goods and finished works for more than five hundred ducats. Not charging for the aforementioned things, I am only left with five hundred ducats out of the two thousand three hundred ducats.

> Now we are agreed: let Pope Leo take the work that has been finished, with the said quarried marble blocks, and let me take the money that has been left in my pocket, and let me be free of all ties. You advised me to draw up a brief that the Pope will sign.[25]

The greatest undertaking in Italy came to grief after three years of hardships and misfortunes. In pursuit of his extravagant ambitions, Michelangelo had thrown away four years of his life and had achieved nothing. Now he had little choice but to resume the commissions he had abandoned, to re-establish his honour and pay off his debts to his customers.

For the pope, the rescission of that contract had become inevitable. His political situation was now beset with difficulties. The war against Francesco Maria Della Rovere had proved to be a much more arduous affair than had originally been predicted. In early January 1517, the duke, with the assistance of Federico Gonzaga and the governor of Milan, Odet de Foix, had put together an army of 5,000 men and had recovered his duchy with little opposition. The pope's young and ambitious nephew, Lorenzo, who had been declared Duke of Urbino in August 1516, did not acquit himself very well. After being slightly wounded on the battlefield in March 1517, he refused to returned to battle, and his mercenaries were complaining that the papal funds, which had been dramatically reduced, were not sufficient for the pay they were already owed. The uncertainty of the times was increased by a plot against the pope in Rome. The Cardinal of Siena Alfonso Petrucci, probably in agreement with Francesco Maria Della Rovere, Cardinal Soderini – an indefatigable opponent of the Medici – and Raffaele Riario, another persistent opponent of the Medici dynasty and also Michelangelo's patron in Rome, had attempted to poison Leo X. The plot was thwarted, and the pope immediately unleashed repressive measures, taking advantage of the moment, much as his father had done, to bolster his power and destroy the opposition. But his position remained weak and he was forced to spend enormous sums to regain possession of Urbino. Francesco Maria Della Rovere withdrew to Mantua, taking the duchy's two most important assets with him: the artillery and the precious library founded by Federigo da Montefeltro.

The war on Urbino had cost the Pope at least 800,000 ducats: an enormous sum that had completely ruined the finances of the Church and the City of Florence, and it was not enough to firmly establish the Medici in that duchy. The armistice with Francesco Maria lasted until the death of Leo X, but the young Lorenzo had already died on 4 May 1519, although paradoxically it would be none other than Michelangelo

who would preserve his memory in stone: his sculpted image was destined to upstage the story of his very mediocre life, and would link him for eternity to the incomparable talent of the sculptor.

6 A PRISONER OF DESTINY

The old scores between Michelangelo and the Medicis were finally settled by a new and more modest commission that Cardinal Giulio found for the artist: the family tombs in the San Lorenzo funeral chapel. Considerable information about this project can be gleaned from the correspondence between the cardinal and Michelangelo from the end of 1520. Giulio was a very cultured and prudent person, and he wanted to engage with the artist in the design of the monument. He discussed its forms, dimensions and details at length as, for that matter, he had already done with the San Lorenzo facade. This new work also served the purpose of restoring better relations between Michelangelo and the Medici, following the failure of his work for the San Lorenzo facade. By the early months of 1521, the artist appeared to have recovered his serenity and the concentration required to return to sculpture after four years away.

The first thing he managed to complete was the *Christ Carrying the Cross* for Metello Vari and to ship it to Rome in the spring of that year. As we have seen, the work was spoilt by Pietro Urbano, particularly the hands and feet, but at least the artist could hope to see an end to the unrelenting and equally justified letters from the patient Metello.

The return to work might well have brought him greater serenity, if it had not been for his father. Worried about the outcome of what should have been his most profitable commission, Michelangelo had asked his family to return the one thousand florins he had loaned them in January 1514. The arbitrators called upon to resolve the dispute ruled that the best way to satisfy Michelangelo would be to transfer the family property in Settignano to his name (a property he had in any case saved for the family from his aunt, Cassandra, more than ten years earlier), if at the same time the artist undertook to pay off his youngest brother Gismondo, who had not benefited from the original investment, with the sum of five hundred florins.

This would be the solution arrived at in 1523, but back in the spring

of 1521, when Michelangelo felt close to bankruptcy, the family argu-
ments became intense and intemperate. The heights of hysteria in which
his father indulged plunged Michelangelo into even deeper despair. At
the end of February, Ludovico abandoned Michelangelo's house in
Florence and withdrew to Settignano, while spreading the word around
that city famous for its gossip and sarcasm that he had been thrown out
of his home by an ungrateful son. There could have been no more pain-
ful accusation for a man such as Michelangelo, who had devoted every
moment of his life to the family's prosperity and had even defended his
whingeing father by threatening to thrash his brother Giovan Simone.
Whereas he had defiantly confronted the pope a month before and
demanded reparation for the insults and losses caused him by the work
on the San Lorenzo facade, he now bowed his head and submitted to
his cruel and ungrateful father, who had exploited him unscrupulously
and would continue to do so. He agreed to accept responsibility for
wrongs he had not committed, solely to quieten the despotic old man,
without whose affection he was unable to confront the rest of the world
in his fearsome manner.

Never again do we encounter the humility and generosity
Michelangelo displayed on this occasion, with the exception of the
devotional thoughts that he began to direct towards God when he felt
close to death. In the same curt and incisive prose he had used for the
pope, he laid his anguished heart free of all diffidence at the feet of his
father Ludovico, who nevertheless continued to torment him:

> Now, be things as they may; I wish to yield to the understanding that
> I drove you from your home and have always brought you shame and
> hurt; and thus, just as if I had done this, I beg your forgiveness. Act
> as though you were forgiving a son of yours who had always behaved
> badly and had inflicted on you all the evils that can be done in this
> world. And thus I again beg you to pardon me, as the wicked man I am,
> and up there do not spread this infamy of my having driven you from
> your home, because this affects me more than you can imagine. After
> all, I am your son![26]

But Ludovico was a hard man, much harder than his son, and was infi-
nitely more diffident and self-pitying. He continued to play the part of

the poor old man harassed by his arrogant son, whom he finally exasperated in June 1523. Michelangelo then abandoned all prudence and filial respect and, falling prey to a fit of uncontrollable anger, asked the old man to leave him in peace: 'Shout and say what you like about me, but do not write to me again, because you do not let me get on with my work, as I still have to pay off what you have had from me in these last twenty-five years.'[27] Unfortunately for him, he would soon withdraw all these remarks and submit once more to a cantankerous and abusive father always ready to resume control of a son who was as bereft of emotional independence as he was talented.

Rome was the source of further vexations, as following Raphael's death, important papal commissions were now there for the taking. Michelangelo's clan – principally made up of Sebastiano del Piombo, Bernardino Zacchetti and Giovanni da Reggio, but also numerous and unknown mediocre artists who gravitated around him – wanted him to return to Rome to take up the position that everyone acknowledged as his. If Michelangelo returned to Rome, he would certainly have been awarded the histories in the Vatican rooms, which Raphael had left unfinished and which were going to be placed with his disciples. And equally there was the chance of many other highly attractive commissions. The artist was considered one of the last great masters of the golden generation that broke onto the scene under the rule of Julius II. People turned to him when they wanted an assessment of other painters' works. In Rome he would undoubtedly have become the unchallenged arbiter of the artistic scene, and occupied the place that was now considered his right.

But Michelangelo had no desire to leave Florence. It was chance this time that decided his fate and helped him out of the difficulty. Just before midnight on 1 December 1521, Leo X, the last of the sons of Lorenzo il Magnifico, died when he was still quite young. The only means destiny had found for containing the Medicis' ambitions was that of cutting short the lives of its prominent male representatives. The network of interests created around him rapidly started to unwind. The new pope, Adrian of Utrecht, who had been the young emperor Charles V's tutor, threw the Italian artists into a state of despair. He was frugal and entirely uninterested in art and, unlike his predecessors, he did not initiate any important works. He wasn't even interested in

Michelangelo, who was destined even then to be the greatest propaganda tool for papal policies.

Michelangelo benefited from this indifference, because in the absence of an outlet with the highest echelons of the Church, his uncontrollable ambition could not harm him as it had in the past. Even Sebastiano del Piombo resigned himself to the new reality, along with the rest of the clan, that demanded his return to Rome. Following the failure of his work on the San Lorenzo facade, the artist could return to his work on the tomb of Julius II, which received an added impetus from the death of Leo X. Without the protection of the pope who had stolen him from the Della Rovere, Michelangelo found himself obliged to fulfil the signed contract under the threat of legal action by Francesco Maria. Besides, Francesco Maria, a highly skilful military leader who had been given the command of the Venetian army, could not be described as tractable. He had been known to administer justice with his own hands, when necessary. As a young man, he had brutally murdered an unwanted suitor of his sister and a cardinal who dishonoured his cloth.

Terrified of the possible consequences of his breach of the Della Rovere contract, Michelangelo started to sculpt new statues in Florence for Julius's tomb: *The Genius of Victory* (Plate I.14) now in Palazzo Vecchio, and the 'Prisoners' now in the Florence Academy (Plates I.15–18). The statues of the 'Prisoners' were intended for the lower section of the tomb and were based on the prisoners depicted in Roman triumphal monuments as part of the emperor's war booty. The exhibition of booty, particularly human booty, celebrated the greatness of the victor. This was the tradition that Michelangelo wished to recall when he planned the monument for the Catholic pope who had re-established the Papal State with the force and energy of an ancient military leader.

Two of these statues had already been sculpted and even walled up in his Roman home in Macello dei Corvi, which the Della Rovere had put at his disposal for sculpting the tomb. During the period of his residency in Florence, Michelangelo was always troubled by fears that someone might see his completed sculptures. His decision to resume work on the 'Prisoners' was no doubt linked to his mood: he felt a prisoner of circumstance and destiny, which had persecuted him in recent years. Unlike the 'Prisoners' sculpted in Rome, those he produced in

Florence reflect a more anguished emotional state. Even their bodies are less youthful and more burdened by pain and by the passing years (like their creator). The struggle of men against oppressive destiny allowed the sculptor to depict the male body as it engages in action and to exalt its anatomical vitality and beauty. The divergence from the classical canon of the carefully proportioned is much clearer in these statues than in the Roman ones. The abstract ideal of ancient virility is abandoned in favour of an expressive credibility that retains, however. the ability of ancient Roman sculpture to catch the essence while eliminating naturalistic elements. In the most fully developed of the statues, the so-called *Bearded Slave* (Plate I.18), you encounter Michelangelo's project in its entirety: these men are powerful warriors who have been overcome by life, which grants victory on the basis of chance – victory that, in any case, is purely transient. His understanding of the defeated is absolute, and we admire the indomitable force with which they withstand destiny.

The unfinished state of the sculptures not only makes it much easier for us to assimilate them to modern aesthetics, but also fully reveals the technique Michelangelo adopted and allows us to understand how different it was from the one used by all other contemporary artists. Ever since the Greek sculptors, the procedure required the artist to cut away all material to produce a roughcast figure, or in other words a figure surrounded with an excess of material that then had to be removed very carefully. Having established a design or model with the measurements and the pose of the figure, the excess material was removed while continuously checking that the predetermined measurements were being adhered to. Michelangelo ignored procedure and adopted one that was much more difficult to control. He attacked the block of marble from one side and wholly developed those parts of it, while other parts remained enclosed in the rough-hewn block exactly as it was when it was cut from the hillside.

This technique is very clear in 'Prisoner' known as *Atlas* (Plate I.15). The man's body and left arm are already almost finished, while the head, back and right arm are still in a block that has been barely squared off. Most people would be anxious about this procedure because after having done a great deal of work on some parts of the statue, it might prove impossible to find sufficient space for the back, the other arm

or the head while respecting the pose and the agreed dimensions. However, this did not happen to Michelangelo: he was so skilled in assessing the space imprisoned within the block of stone on the basis of its surface and volume that he could understand exactly where the rest of the statue was situated. This very particular technical skill made it possible for him to correct figures during the act of sculpting the work as he thought to be best, in accordance with the new possibilities generated by this process. In the case of *Atlas*, the head and the arm still within the block could have had different positions that would have been entirely compatible with what he had already sculpted. If he had worked in set stages, as the others did, he would have been forced to set the head and the arm in a pose that could not have been changed or improved upon as he worked.

Another technical characteristic contributing to the miraculous nature of his art was his very particular use of instruments. Michelangelo used a chisel and often even a stonecutter's chisel for the final surface of the sculpture. These marks, which torment the surfaces and would be adored by romantic artists of the nineteenth century, were produced by chisels that removed the final layer of marble. Prudence would have counselled – as it counselled everyone else – to proceed with files and gentle instruments that did not risk ruining a now almost complete marble statue with a single overly sharp blow of the hammer. Michelangelo did not fear such dangers and marked the marble with heavy instruments, which had the advantage of avoiding the levelling out caused by a file and the gentle wearing down of the stone. With a chisel and flat gradines he was able to switch immediately from the concave to the convex and improvise changes in volume which translated into the continuous quiver of the surface which brought his sculptures alive.

Even *Genius of Victory* in Palazzo Vecchio (Plate I.14), which he produced during those deeply troubled years for the 'tabernacles' of the lower section of Julius's tomb, is entirely free from triumphalism in spite of the subject matter. The youth who subjugates the old man and forces him down with his legs, is once again a young and barely adolescent Florentine, very similar to the *David* at the Galleria dell'Accademia. There is no trace of relish on his face, and he expresses a barely contained pride in having escaped danger rather than in having

defeated an enemy. The contracted pose of the defeated man was due to the restricted space in the tabernacle in which the sculpture was to be placed, and provided an opportunity for Michelangelo to concentrate even further the force and energy that he could only conceive as acute tension. The young warrior's pose is an example of technical virtuosity and exaggerates even further the twisting movement of the body found in the *Cristo di Minerva*, whose anatomical construction it resembles very closely with its back powerfully curved by its musculature.

The gesture of the hand that releases or loosens the sling is a masterpiece within a masterpiece, because of the natural manner in which the fingers hold the leather. The gesture provides an opportunity for Michelangelo to swell and emphasize the musculature of the twisted chest, and the narration has all the precision of an anatomical illustration, as though the subject was a posed bodybuilder. But here again the muscular tension is contained by a lightness of touch that pushes the figure into an ideal world very distant from the equally energetic bodies that anyone could admire in a gymnasium for military training.

5

AT THE BECK AND CALL OF THE MEDICI

1 A DISPUTED ARTIST

One bright June morning in 1519, the priests of San Lorenzo were ambling in the large cloister to enjoy the warmth of the mild season. The handsome and majestic Cardinal Giulio de' Medici arrived amongst them at lunchtime, completely at ease in what had been considered the family church for more than a century. His dark, dark eyes, which a slight squint made all the more beguiling, were saddened by the recent devastating bereavement: the death of his nephew Lorenzo, the Duke of Urbino, the last direct descendant of the Medici dynasty. In the small crowd that formed around him as always, Giulio was looking for one particular person: Giovanni Battista Figiovanni, the meek and loyal prior of San Lorenzo, who had always been devoted to his family and its patron saint. Frightened by Giulio's severe and solemn expression, the prior attempted to hide behind one of the pillars of *pietra serena* (a bluish-grey sandstone found in Tuscany) which time had already weathered and cracked. But Giulio was specifically looking for the prior, and continued to advance. When he was less than a metre away, he stared into the prior's eyes and asked him if his loyalty to the family had remained unchanged with the passing years.

In that moment, the prior lost all his fears and threw himself at the feet of the powerful cardinal to declare his love and eternal devotion.

The commission Giulio was about to give him on that happy day was the best present God could have granted the prior:

> We are minded to spend about fifty thousand ducats on San Lorenzo, on the library and the sacristy together with what has already been done, and it shall be called a chapel, where many tombs shall be used for providing our dead forbears with [an appropriate] burial: Lorenzo and Giuliano, our fathers, and Giuliano and Lorenzo, our brothers and nephews. If you wish to put your shoulder to this wheel, I shall see that it is done.[1]

The recent bereavements had persuaded Pope Leo X and Cardinal Giulio, his cousin, that they needed to come up with some means to celebrate the family's past, given that its glory was more certain in the past than in an uncertain future. The Medici felt that burials could help assert the royal status that republican Florence with its proud and stubborn citizens continued to deny them.

The exceptional nature of this undertaking was guaranteed not only by the enormous sum invested – 50,000 ducats – which was even greater than the staggering sum allocated a few years earlier to the facade of the same church of San Lorenzo, but also by the presence of the most famous artist in the world, Michelangelo Buonarroti, who was immediately given the prestigious commission. On this occasion, however, the Medici, who had learned from their previous difficulties, asked Figiovanni to manage relations with the artist, who was given responsibility solely for the planning and production of the sculptures. In return for these more restricted duties, he was to receive the handsome salary of fifty ducats per month.

Thus the most modern and highly funded building site of sixteenth-century Florence was opened on 4 November 1519. Figiovanni would write:

> The master mason in charge of the architecture was the singular Michelangelo Simoni, with whom Job himself would not have had patience for more than a day. This state of affairs continued for about

five years. Bernardo paid, and I adored Michelangelo as though he were the pope himself, or rather Saint Lawrence . . . even though Michelangelo broke many tools needed in that building work, and was not willing to forgive or respect the pope who had so loyally given me the commission for that work, and he did not think much better of Giacopo Salviati. . . . At the time there were twelve plasterers, twenty labourers and sixty stonemasons, and other master masons.[2]

The poor prior of San Lorenzo was not exaggerating when he described the insufferable nature of his beloved Michelangelo. Shortly afterwards he too would pay the price and fall victim to the artist's intolerance of anyone he had to report to, even in relation to the administrative details concerning that colossal building site. Michelangelo was so insistent that he obtained the dismissal of the loyal Figiovanni from his post and took over all the management responsibilities himself.

Apart from the fate of poor Figiovanni, work on the Medicean chapels progressed very energetically, at least at the beginning. Cardinal Giulio put all his efforts into the enterprise, which seemed to give him the greatest satisfaction of his life. He discussed every detail with Michelangelo, from the wood for the ceiling to the shape of the pews. When in 1521 he was sent the final plan for the tombs, he became heavily involved in the project and particularly assertive over the size and position of individual monuments. He changed his mind so often that in 1523 Michelangelo laid the blame for slower progress at his door. With the death of Leo X and the election of Adrian VI in 1522 there had been further suspension of the works, because the new pope immediately notified Michelangelo of his intention to have the rights of the Della Rovere heirs respected. It was only in January 1524 that Michelangelo finally prepared the life-size models of the figures, which he definitively started to rough-shape in October 1524.

Once again something had to impede his enjoyment of good fortune – his chance to work in peace on the city's most important artistic work, while being cosseted by everyone and envied and flattered by Florence's turbulent community of artists. The whole city was in his thrall, and yet his only happiness was to pass his nights in pursuit of Luigi Pulci, whose adolescent beauty was causing both men and women to fall in

love with him, especially when he started to sing with friends by the side of the Arno River or where the narrow streets smelling of mint widened. Benvenuto Cellini, whom nothing could surprise, given his temperament and the life he led, tells us that as soon as Michelangelo got news of Luigi's whereabouts, he abandoned everything to go and admire the youth ecstatically, mixing with the crowd of loafers in search of respite from the humid summer heat that during the night pressed down on the city like a lead weight. He then ceased to be the respectable citizen who had elbowed his way back into the higher echelons of society abandoned by his grandfather, and he was once again the practical and original young craftsman, like so many other Florentine artists. But even this consolation did not last, and faded with the first light of a new day.[3]

The main reason why Michelangelo could not peacefully devote himself to the grandiose project on the tombs of San Lorenzo was that he was being threatened by Francesco Maria Della Rovere, the Duke of Urbino. Adrian VI's ruling that he should fulfil his contact with the heirs of Julius II caused him deep anxiety over the idea of having either to return the money or to work on a commission he had already been paid for, while he had so many other things to do. Indeed, Michelangelo would have had no choice but to return the money had it not been for fate, which was adored like a god by the Florentines. In November 1523, a long and contentious conclave elected a successor to Adrian VI, who had died two months earlier, and that successor was none other than Cardinal Giulio de' Medici, who rose to the papal throne on 26 November with the name of Clement VII.

The coronation festivities immediately showed that the new pope had less extravagant tastes than those of Leo X, who had indulged in excess and flamboyance. In order 'to enjoy his papacy' as promised, Leo X had filled the Vatican with charlatans and emptied the treasury of the Apostolic Chamber, leaving his cousin with many debts and concerns which in the treacherous papal court were immediately interpreted as a sign of needless unquenchable penny-pinching. Unusually good-looking for a member of the Medici family and a moderate yet innately elegant man, Clement was above average stature and had the shoulders of a Greek athlete. His features were regular and well-formed – noble like those accurately depicted by Sebastiano del Piombo in his

portrait. His dark eyes and black hair emanated a vital energy that few could resist. With his physical attraction, the new pope could easily dispel his reputation for melancholy. At the height of his virility, he did not appear interested in carnal passions. For all his good looks and elegance, he immediately imposed the virtues of an untiring worker and refined connoisseur of music. In spite of this there were some who, during the tragic days that led up to the Sack of Rome, accused him publicly of being a dissolute sodomite whose perversions were bringing terrible punishment down on the city.

His wealth, comeliness and prudence meant that his election was greeted with considerable satisfaction in all the Italian courts, even though his role as Leo X's adviser led people to overestimate his political acumen, as he was attributed with decisions that were in reality taken by his cousin. European chancelleries were receiving profiles of him from their ambassadors and spies who were required to provide private details and publicly acknowledged virtues. The portrait that emerged was of a man whose demeanour was elegant but never smug, and who ate little and never outside mealtimes, and preferred music and literature to hunting and banquets. Some people wondered whether he was really the father of Alessandro de' Medici, who was immediately sent to Florence under the guardianship of Cardinal Passerini of Cortona, a tutor from Siena whose presence the Florentine aristocracy immediately found alien and offensive, as they had been expecting more consideration from the new pope.

Even in the eyes of his less benevolent contemporaries, Clement VII avoided all excesses. However, he was not sparing with his favours. Soon after his election, the ambassador from Bologna lost no time in writing with satisfaction that the new pope had granted more favours in a day than Adrian VI had done in his entire papacy. His sobriety and competence, together with his aristocratic manners which appeared to run in the Medici blood, made him an ideal patron for Michelangelo, who over the preceding years had learnt to know him and value him. But immediately after his election and now that he was required to take personal responsibility for his actions, Clement VII starts to display the persistent indecisiveness that would lead to his political ruin, and this would also affect his relations with Michelangelo. In his letters to the artist he continually raised doubts over the appropriateness of erecting

a monument to the dukes at the centre of the chapel, or whether it should be put against a side wall or a wall at the back.

His ministers paid the highest price for that inability to make up his mind. A letter or even a single word was enough suddenly to overturn a decision arrived at after many calculations and a lengthy examination of the facts, and reignite the perplexities that had tormented the pope before he finally got round to taking that decision.[4] This was the bitter recollection of Francesco Guicciardini, who knew him and could assess him better than anyone else, having taken an active part in Clement's government. Unfortunately it was not a time for uncertainties, because destiny had put the new pope up against two bold and very determined young kings: Charles V and Francis I of France.

Clement VII's tragically unfathomable nature had not yet manifested itself. Indeed, Michelangelo's friends rushed to congratulate him as soon as news spread of Clement's election, as though it were a particularly advantageous marital alliance. Michelangelo himself interpreted the news in this manner, and for a short while after the election many already envied his new substantial contracts: 'In the meantime, I believe that you will have reached an excellent agreement with the Pope, God willing.'[5] Michelangelo was now in an extraordinary position, never before enjoyed by an artist. He was called upon to judge the works of other artists. Everyone was asking for his opinions or for one of his sketches, and people were quite contented with works planned by him but executed by his friends. He had no more rivals now that Raphael was dead, and Clement already wanted the commission for the Medicean tombs to be expanded to include two more: his tomb and Leo X's, both to be placed inside the church of San Lorenzo. There was enough to enrich ten generations of artists! Sebastiano del Piombo, who had now gained an excellent position in the Roman art market, struggled to emphasize the enormous advantages of the situation in which his friend now found himself and encouraged him to exploit his position unhesitatingly.

There was still that persistent and terrifying obstacle: Julius II's tomb and the threats from his heirs, who continued to demand justice. It is no surprise then that a month after the pope's election the first question Michelangelo asked of Giovan Francesco Fattucci, the chaplain of Santa Maria del Fiore, who looked after his interests in Rome,

concerned a possible legal solution to this problem. Fattucci lost no time in swiftly reassuring him that Clement wished to assist him by every means in gaining his release from the burden of this tomb without his having to return the money. The new pope was counting on being able to use him exclusively for his family's ventures in Florence. He was forgetting, however, that the Della Rovere family had paid for their commission many years earlier and the memory of Julius II was still a powerful one amongst the Roman clergy, which included many of his supporters.

Fattucci, with the support of Sebastiano del Piombo and the not too tacit consent of Clement VII, started to seek a solution. Michelangelo was asked to write a summary of this anguished history, so that negotiations with Julius's heirs could commence. At the end of December 1523, the artist wrote a letter in which he consciously falsified all the details of the question, and paradoxically went so far as to demand further payments from the Della Rovere family rather than acknowledging his debt. He was probably convinced that papal arrogance and the desperately poor relations between the Medici and the Della Rovere would be sufficient to carry through his shameless opportunism.

But his miserable attempts to alter the accounts were quickly foiled by the documents shown to Fattucci by the executor of Julius's will, the Cardinal of the Basilica of the Four Saints. On 10 March 1524, Fattucci notified Michelangelo that he had seen the accounts, which conform exactly to what we have been able to establish today on the basis of the documents relating to the artist's accounts.

> Michelangelo, I have spoken to the Cardinal of the Four Saints, who has sent me a bill in his hand and has shown me your account; moreover he has brought me a written document, which contains a receipt in your hand of seven thousand ducats, and there is the one thousand five hundred that you had from Julius, as is made plain in the contract. Thus all in all it is clear that you received eight thousand five hundred ducats and you have eight thousand ducats still to receive.[6]

There can be no doubt that Francesco Maria Della Rovere must have been profoundly disgusted by Michelangelo's behaviour, and he had no intention of backing down to a pope who was increasingly

demonstrating his diplomatic incompetence in the snake-pit of European politics. From that time on, the question of Julius II's tomb became caught up in the precarious political balancing acts that were affecting Italy.

2 A DISASTROUS POLICY

Now that he had been reassured by Clement's promises and put in charge of an army of artists, builders and stonemasons in the gardens of the cloister of San Lorenzo, Michelangelo got on with the business of constructing the visible glory of the Medici family, and thus winning approval for its political pre-eminence. A few hundred metres away, another less numerous but no less determined army was working away to create a new political crisis for that same family.

In the garden of Palazzo Rucellai, just an arrow shot from the San Lorenzo site, the most sophisticated intellectuals in the city would meet to discuss literature, history and, of course, politics. It was a small city garden with lemon trees, unpretentious fountains and box hedges set out in geometric shapes which were the envy of Europe. The natural harmony of that little uncontaminated world helped the thinkers to connect to the eternal values of history and philosophy, which are also immutable and uncontaminated. But those intellectuals, who belonged to the best Florentine families, took pride above all in the ideals of civic liberty, in which they perceived the glory and virtue of the ancient Roman Republic. For some years, they had yearned for the rebirth of the Florentine Republic. Machiavelli read aloud his *Discourses* and his *Prince*, and the youngest of them became inflamed with the idea of Florence being the beacon of universal civilization and liberty for the city states. They systematically reviewed the events of the previous century and discussed forms of civic institutions. More specifically, they tried to understand what kind of constitution could best guarantee the greatness of Florence and the defence of its highly complex social organization.

There were intellectuals who expressed the viewpoints of the magnates, the financial aristocracy that hoped for a government of the few and felt they were the natural allies of the Medici. But the latter were always careful to prevent any of the great Florentine families from

becoming so powerful that they came dangerously close in standing to the Medicis themselves. Thus the Medicis chose their most loyal allies from amongst the lower ranks that were distant from the urban aristocracy, and ended up alienating their potential allies. Then there were the populists who belonged to the middle classes: they believed in a republic open to a participatory process and consistent with their own aspirations, such as the promise of a judicial system capable of rewarding people for their moral virtues rather than their family background. Between these two classes there was a tangle of social and political nuances relating to clan, family and business interests that for two centuries had been turning Florence into a pressure cooker on the point of exploding. But no one, without distinction, wanted to accept the insolent lordship of a single family, and because of this, they turned the idea of a free and republican Florence into the founding myth of their civic identity. The discussions in the quiet of the aristocratic garden went far beyond local matters and touched upon the state of Italy and the iniquitous policies of princes and popes who had invited foreign kings onto their native soil causing it terrible torments. They even went so far as to examine the Protestant Reformation, which was starting to pose urgent questions that would also affect Italian society.

Some of the participants in these encounters – as usual the youngest ones – became so fired up that they compromised themselves in 1522 in an early attempt to free Florence from the Medicean yoke. Many were in contact with Michelangelo and would remain close to him and an influence on both his public and private decisions. Donato Giannotti, born in 1492 to a middle-class family, taught in Pisa and Padua until 1526 and developed ideas particularly concerned with the participation of all citizens in government and the needs for the city to be able to defend itself militarily (a question expressly raised by Machiavelli, who perceived the lack of a citizens' militia to be the greatest weakness of the Florentine state). Battista della Palla, a young aristocratic and utopian dreamer with fiercely republican passions, was force to emigrate after 1522 and made his fortune in France by trading in antiquaries. Antonio Brucioli, a highly sophisticated and prolific writer, produced philosophical and political tracts and came close to the positions of the Reformation. Indeed, he went so far as to translate the Bible into Italian and then have it printed, which attracted accusations of heresy after

the anti-Medicean plot of 1522. He was to spend a long time in exile, starting in Venice where in 1529 he took in a shaken and panic-stricken Michelangelo.

These men, who shared a fervent love for art and the ancient world, and whose humanism was experienced as a political religion, could not remain indifferent to what Michelangelo was creating at the same time at the church of San Lorenzo, where humanism was taking on visible forms that would survive the decline in the movement's cultural influence. However, the short distance between Palazzo Rucellai and the building site at San Lorenzo could only be travelled with the utmost prudence by the sophisticated habitués of the Rucellai gardens, who were torn between their admiration for the artist's work, which twenty years earlier had devoted itself to the republic, and their contempt for the service he was providing the city's tyrants. They were well acquainted with the perilous enticements of Medicean patronage, which had been born as an instrument of propaganda to oppress their aspirations of freedom. In the spring of 1526 the gap that divided them appeared unbridgeable, and yet a few months later the division unexpectedly dissolved.

In 1526 Michelangelo had finished the models of the six statues and made progress on their roughcast. The beauty and serenity that he had attributed to the Medici dukes, who in reality had survived their investiture only by a few months, would blot out the tawdriness of those insignificant and dishonourable lives; indeed, his art would propel them up onto the Olympus of eternal virtue and associate them with a talent which, like magic, turned everything it touched into the fruit of the divine. Lorenzo, the first duke of Urbino, known for his cowardice on the battlefield and submissiveness to his over-ambitious mother, was now transformed into a young Caesar of incomparable physical beauty and noble expression. The statue alluded to thoughts of which the superficial and unformed young man would have been incapable. Giuliano, frozen in the act of twisting his chest, looked like a fierce military captain who has just dismounted from his saddle, with his hair dishevelled by battle and his facial expression one of gratification with his heroic action, even though he had actually been a sickly fellow with a puny physical constitution (Plate I.19). *Allegories of Night*, *Day*, *Dusk* and *Dawn* lay at their feet: all this to celebrate a royal magnificence that

had never previously been known on the banks of the Arno. Florence was stunned and embittered, while Pope Clement would interrupt audiences and political meetings so that he could hear news of all the marvels that he had not yet been able to see.

Ambassadors could never understand why the pope would display childish pleasure every time Michelangelo's emissary told of how the works were progressing, and they regretted not having their own Michelangelo to barter with the pope during their political negotiations. On the other hand, the pope's happiness at the news of the finished models was all the greater because a few days earlier a long dreamed-of success had finally come true and delivered another piece of paradise. The troops of the Holy League, a military alliance between the pope, Venice, the Swiss and the French had started to gather outside Milan's city walls to inflict a defeat upon the imperial army that was supposed to bring an end to Emperor Charles V's influence over the Italian peninsula. This appeared to promise a new era for Italy and more particularly for the Medici family. In June 1526, the League's troops laid siege to the city, where the imperial forces were caught in an extremely difficult situation. The papal army, which was of little military importance, was led by Francesco Guicciardini. The Venetian army, which was much better organized, was ironically under the command of the same Francesco Maria Della Rovere who had suffered the indignity of having his Duchy of Urbino snatched from him by Leo X and was now fighting on the same side as another Medici pope, and moreover in a capacity of crucial importance and responsibility.

The chronicles tell the story of the paradoxical crisis of that period without managing to explain its devastating effects. Francesco Maria, not without the consent of the state he represented, refused to expose his troops to a dangerous attack until the promised help arrived from the French and the Swiss. However, the days lost in waiting for the reinforcements gave the imperial troops a chance to reorganize and recover full control of Milan's castle. On 7 July, a day of insufferable heat and humidity for soldiers already weighed down by heavy arms, Francesco Maria decided to attack and that attack proved unsuccessful. He rapidly withdrew his army to the fury of Guicciardini, who accused him of having betrayed the Holy League. Many contemporaries believed that the Duke of Urbino's behaviour was repayment for the

way he had been treated by Leo X. Whether or not it was some kind of vendetta, Francesco Maria had showed that he had no particular reason to be grateful to Clement VII and, above all, he did not fear him, as the pope had perhaps expected.

The war's fortunes, which in the spring had appeared to be decidedly favourable to the League, were rapidly changing. The alliance was gradually losing control of the enormous imperial army, which was starving, unpaid and desirous of revenge and had started to march south in search of plunder from the hated Italian cities. In Rome, Clement VII did not know how to deal with the situation. If anything, he made things worse with his exasperating indecisiveness and ended up reaching an agreement with the Colonna family, who were allies of the emperor. This agreement put him defenceless into their hands. The agreement had been cleverly suggested by the imperial ambassador, who wished to inflict a severe punishment on the papacy for pro-French policy. The situation became even more critical when, between 7 and 12 February 1527, the emperor's Spanish troops led by Duke Charles of Bourbon, also the Constable of France, joined up with the Landsknechts led by General Georg von Frundsberg in the vicinity of Piacenza. The unpaid wages and the Lutherans' hatred of Italians, who were perceived as papists to a man, had transformed a disorderly group of 22,000 men into a biblical scourge, which often threatened to turn on its own commanders. In a final attempt to discipline his troops, Frundsberg harangued his troops so fiercely that this brought on a heart attack and an inglorious death in full view of his men.

In Rome, Frundsberg's death was greeted as a sign of divine wrath against the landsknechts, because people, having lost their faith in reason, were clinging to superstition. In reality, that death increased the likelihood of the terrible tragedy that was about to befall the Eternal City, because the army was now guided by its soldiers' bestial instincts and the Duke of Bourbon's thirst for power, as he hoped to obtain the post of Italian Viceroy from this violent campaign of destruction. The 22,000 soldiers marched south to the shout of 'Forward at all costs, forward to Florence, forward to Rome.' The snow, which that winter was particularly deep on the central Apennines, held the troops back and the March rains were extremely heavy and warmly greeted by the Tuscans who knew that they were now exposed to the tyranny of events

and only protected by such natural forces. On 16 April, the horde entered Florentine territory. The city negotiated a tribute of 150,000 ducats to save themselves from pillage, but nothing seemed to guarantee it from that scourge, which was leaving a trail of misery across the land and evoked memories of other armies, such as the ones that had brought an end to the glory of ancient Rome.

Clement VII then made the last of his many mistakes. Driven in part by that avarice for which he was now universally reproached and convinced that an armistice was imminent, he paid off his last garrisons and plunged Rome into disaster. It came on the morning of 6 May, as soon as the fresh spring mist lifted from the glassy waters of the Tiber and removed from its banks their very last but very feeble defence. No violence is comparable with the violence generated by religious hatred, and the Lutherans who came down to punish a dissolute Catholic pope left behind an unequalled lesson in atrocities, which once again – as witnesses to those events have told us – were inflicted on the weak and the defenceless:

> . . . the most pious and irreproachable nuns that ever lived in Rome were being sold in Rome for a silver coin each to whoever wished to satisfy their desires with them; [there were] the screams and wailing of poor mothers, whose children they were holding on their laps and breastfeeding were killed or abducted for a ransom . . . the image of the crucifixion *del Popolo* and many other ones held most sacred in Rome were used as target practice for harquebuses.[7]

In Florence in the meantime, the disappearance of the imperial army from its territories had immediately provoked a political rebellion. The city was now exasperated by its expenditure on the insane enterprises of the Medici. Guicciardini, a meticulous chronicler of those events, could not fail as a good Tuscan to draw attention to monetary impositions that so angered the Florentines: 500,000 ducats for financing the war against France, 300,000 ducats to the imperial war-leaders, 600,000 ducats for the war against the Emperor, not to mention 500,000 ducats for the wholly dynastic war against the Duke of Urbino. Another bizarre historical twist was that the latter entered the city in April, shining in his silver armour immortalized by Titian and with his helmet barely

holding in the dark black curls of his hair, and did so while claiming to be the defender of Florence and the pope's interests.

By Friday, 26 April 1527, all the armies had surrounded Florence. From Brunelleschi's lantern, the city's military leaders scanned the horizon to where dust clouds were being produced by the culverins of the imperial hordes, which had come over the Apennines and camped close to Arezzo. They could also see the troops of the Holy League approaching from the north to take up positions very close to Florence. The Duke of Urbino left his camp early in the morning on a reconnaissance trip to choose the next positions for the army, but he was recalled to the city along with the Marquis of Saluzzo to deal with the anti-Medicean disorders in the city. A furious crowd had taken over the Palazzo Comunale and driven off the Medici support- ers. They would not hear of returning the building to the government headed by the Cardinal of Cortona as guardian of young Alessandro and Ippolito.

It fell to none other than Francesco Maria Della Rovere, a sworn enemy of the Medici but also the general of the allied army, to discour- age that enterprise, which in those circumstances could have endan- gered the entire city. Once again, the hot-tempered duke demonstrated the forcefulness and decisiveness that the pope lacked, and resolved a serious political crisis without any blood being spilled. The arrival in the city of a squad of soldiers under his command could only have dis- mayed and frightened poor Michelangelo, who for ten years had been opposing him in a desperate legal case and on that afternoon would not have had much hope of coming out of it as the victor. While he did not have to meet the terrible stare of the only man who could never abide him, he certainly would have been told that evening of every tiny detail of how the duke saved Florence from plunder and earned the gratitude of all its citizens.

While Francesco Maria's action prevented a rebellion on 26 April, no one would have been able to contain the anti-Medicean anger that was unleashed on the city twenty days later, when Florence first heard of the Sack of Rome and how the pope was holed up in Castel Sant'Angelo. It was 16 May. Not even a month earlier, Michelangelo's roughed-out statue had heralded the glory of the Medici family. Now armed gangs were destroying everything that reminded them of that

same family, and systematically demolishing their coat of arms, conscious as they were of how much store the dynasty put by the symbols of its own power: 'They violently effaced the coats of arms of the Medici family throughout the city, even when these were displayed on buildings the family had built; they destroyed the portraits of Leo and Clement in the church of the Annunciation, which were renowned throughout the world.'[8]

Fortunately the statues of Lorenzo and Giuliano were not yet ready. They would never have survived the iconoclastic frenzy that traditionally accompanied rebellions in Florence.

3 IN DEFENCE OF THE REPUBLIC

The site in which the great San Lorenzo monument was being constructed quickly dispersed. The army of stonemasons, builders and master-craftsmen abandoned the Medici dream, whereas the other army, the intellectual one that met at Palazzo Rucellai, left the rarefied comfort of its garden and was ready for the last experiment in establishing a democratic republic.

The new government elected a *gonfaloniere* for a yearly term, and he could renew his position on a further two occasions. They chose Niccolò Capponi, an aristocrat who had always shown a sincere attachment to republican freedoms. Capponi embarked upon a prudent policy of institutional renewal, which attempted not to alienate further the Medici pope and to guarantee his family the constitutional rights to which all other citizens were entitled. But this prudent policy immediately alarmed the more radical faction, who within a few days dismissed him from office and elected in his place Francesco Carducci, a man the Florentine magnates considered unworthy of the highest office in the city.

The new government immediately confronted the military emergency posed by the presence of armies of several countries making incursions from all directions. Machiavelli's reflections on the need to have a popular militia to guarantee freedom had not been in vain. Every district of the city formed its own 'popular militia', and clan connections became very significant. Nobles, rich men and poor men stood side by side in defence of their city, and were spurred on by the fiery

speeches that young and cultured republicans were continuously giving in different parts of the city. Patriotic fever was bolstering civic pride and strengthening the bonds between citizens.

The new government's primary concern was to build up its military supplies and defensive walls. To the amazement of the Medici and the entire city, Michelangelo passionately supported the cause against the family that had brought him up in his teens and for whom he was working up to the day before the insurrection.

His republican faith was so strong that he did not restrict himself to a passive role, and was rewarded with one of the most sensitive posts in the new government: the modification of the city walls to meet the new requirements of war. The fortifications around Florence, which went back to the first half of the fourteenth century, were now obsolete in an age of firearms which posed problems that were entirely new to the science of military defence. Defensive walls had to be inclined in every direction to lessen the force of artillery fire. The blows inflicted by bombards, an early form of cannon, meant that forces had to be concentrated in particular points, and hence imposing bastions were built in order to bring together the defensive artillery. All this had for some time encouraged the great military architects to abandon plain and simplified geometric forms in favour of a more complex dynamism, as can be seen in the work of Francesco di Giorgio Martini and Leonardo da Vinci himself.

The drawings that Michelangelo produced at the time, which have survived in excellent condition, demonstrate his zeal, passion and even the tempestuous commitment to the defence of republican Florence, which he undoubtedly also perceived as the very symbol of Italian liberty and an enlightening example of a state formed by virtuous men. His plans for bastions and fortified gates have something zoomorphic about them, as though the artist wished to use threatening animals to guard the city, whose appearance alone would be enough to terrify the enemy: crabs with gigantic claws, mythical insects whose muscles swell in their defensive effort and a great mass of masonry compressed to the point that it could explode against an enemy to whom Michelangelo was above all sending a symbolic warning. It was also meant as a message to the citizenry, who would be supported no less by those walls than by the virtue of its institutions.

His creative commitment in defence of the republic was so great that it was precisely in those circumstances that Michelangelo managed through the strength of his passion to transcend all forms of the classical and all references to antiquity, and impress his vital energy on forms, as well as a sentiment that he would resurrect years later in the construction of the few architectural structures he brought to completion. Whereas Stendhal saw the failure of that insurrection as the first serious failing in the Renaissance bloom, Michelangelo's drawings demonstrate that that was the moment in which, through the hand of its greatest practitioner, the Renaissance found the strength to tear down every ideological barrier and lay the foundations for all the artistic experimentation of the following centuries.[9]

Many even amongst the military experts were stunned by the innovativeness of Michelangelo's constructions, particularly around the San Miniato Fortress, which everybody considered one of the strategic points in the city's defence, although these experts thought them ill-suited to their purpose. However, Michelangelo's work on the fortifications was very modest, unlike all the other enterprises he had engaged in up to that point. He travelled to many areas to examine other works. He visited Ferrara, considered at the time to be one of the best equipped cities in Europe, thanks to the experience of the Duke of Este. Nor was he above the use of ingenious but inexpensive solutions, such as the mattresses that he suspended from the bastions of San Miniato to soften the blows of cannon balls.

This time, however, his work did not receive admiration from all sides as it in fact merited, if for no other reason than his courage in betraying once again his very powerful patrons. Niccolò Capponi was an aristocrat, and like most aristocrats he was not enamoured of the presence in the government of a man of the people like Michelangelo: 'Apart from that, envy has a certain force in republics, particularly if, as in our case, there are many nobles who are contemptuous, amongst other things, when they see that one of the Carducci is the *gonfaloniere*, Michelangelo on the committee of the *Nove*, one of the Ceis or the Giugnis on the committee of the *Dieci*, and so on.'[10] Michelangelo's position was not an easy one, even though his conduct was held to be one of the most virtuous amongst the citizens during those infernal months.

The situation in the city was made all the more dramatic by the arrival of the plague in the summer of 1527. Michelangelo remained in the city and refused to follow his family to their more salubrious estate at Settignano. His concern was for his family, and fear of contagion dominated his daily correspondence: 'Do not touch the letters I send you.' But it was to no avail. In the summer of 1528, his adored brother Buonarroto died in his arms and left two children, Francesca and Leonardo, on whom Michelangelo and his father Ludovico heaped all their love, because now all the hopes of dynastic continuity rested on the boy. Without that, there was no sense to the wretched life the artist was conducting in order to restore the family's financial fortunes. Even though Michelangelo immediately rushed to take care of the orphaned nephew, Ludovico sent him an order from Settignano which was both a desperate cry of pain and a sign of unexpected vitality:

> Michelangelo, yesterday evening Margherita told me how you sent for the boy and informed me of everything. It is my intention to have the boy, come what may. I want him without anyone else, and I do not want her to take him to Mugello, whatever happens. . . . We do not believe that he is too afraid, because the boy is healthy and is eating like a grown-up.[11]

The Medici were plotting against Florence on all sides, disease was more pitiless than the army, and there were internal political problems. In the dark night of this desperate tragedy, the decimated family clung to that child: the grandfather and uncle were not disconcerted by the sensitive problems of looking after his physical health.

A few months after his brother's death, Michelangelo became one of the *Nove di Milizia* [the 'Committee of the Nine on Military Matters'], one of the most important posts in the city. He was appointed 'governor general and purchaser for the said building work and the fortification of the walls.'[12] But the situation in the city was deteriorating. The violence of the Sack of Rome risked permanently damaging the image of the young Charles V, who as emperor was still the most important political figure in Christendom, in spite of having inflicted a terrible torment on capital of the Catholic Church, which the whole world considered excessive and sacrilegious. If he wanted to continue his

policy of unifying his inherited territories, it was not only appropriate but also essential to re-establish good relations with Clement VII. For his part, the pope had only one obsession, one shared by almost all his predecessors on the throne of Saint Peter's: his family. When the pope's representatives met with those of the emperor in Barcelona, the restoration of Florence to Medicean control was one of the conditions in the agreement they reached. The destiny of the glorious republic was now sealed, because political cynicism had destroyed all resistance even before the armies took action.

Diffident and suspicious as always, Michelangelo perceived the worst kind of treacherous plots directed against him. The rumour was that the captain of the Florentine militias, Malatesta Baglioni, was secretly negotiating with the pope to hand the city over. The measures Michelangelo ordered encountered difficulties in their implementation, because of either internal political opposition or simply lack of organization in the city, which was now on the verge of civil war between those who wanted to negotiate with the Medici and those who would not entertain the idea of surrender. Moreover, wealthier citizens like Michelangelo were being increasingly heavily taxed to deal with the pressing requirements of defending the city, and for him this was no small matter. His conflicting nature was tearing him apart: on the one hand there was his almost irrational passion for the republic, and on the other there were his personal interests, which he had betrayed by siding so openly against the Medici, who were now inexorably reconstituting their power structure.

The artist was rushing backwards and forwards between the lantern on top of Brunelleschi's red dome, from where he could see all the city and the surrounding countryside, and the military outposts, which he visited twice a day to supervise work on the fortifications. In his opinion, work on the latter was proceeding too slowly, and the criticisms he made against the military leaders were put down to his character, which was universally perceived as perverse. However, his anxiety was growing and he was increasingly isolated, which brought to the fore the suspiciousness that left its mark on his entire life. Fear of losing his accumulated wealth and facing a life of hardships prevailed over his republican ideals and his affection for his friends and relations.

On 21 September 1529, he decided to flee Florence with a friend, Rinaldo Corsini, and a young assistant, Antonio Mini. He went round all the city gates to avoid the guards, and finally managed to slip out of the Prato Gate towards the north, solely because he had been recognized as an important member of the government. The three friends found the going tough and covered little ground. They had sewn twelve thousand *scudi* into their dark and heavy surcoats, and Michelangelo desperately wanted to make sure that he could save this fortune for which he had toiled all his life. This decision was even more perilous than his betrayal of the Medici: he had now forever burnt his bridges with the past. The plan was a radical one and he had thought out every detail: he had to reach Venice, from where he would move to France to work in the service of Francis I, his great admirer, who had been advised of this, by his ambassador Lazare de Baie on 14 and 23 October, and again on 16 November.

Following the rebellion of 1527, a leading figure in the Florentine Republic had sent King Francis a special gift: the *Hercules* that Michelangelo had sculpted immediately after the death of Lorenzo il Magnifico and which had been left in the garden of the Strozzi family for many years. The dispatch of this sculpture had been the responsibility of Battista della Palla, a republican exile who had made his fortune in France by trading in works of art and reappeared in Florence immediately after the anti-Medicean revolt, drawn by his political passion. Michelangelo wrote from Venice to none other than Battista della Palla, whom he asked to join him so that they could travel to France together, as previously agreed. This letter reveals something very important that Michelangelo would later always deny: the flight from the besieged city was a premeditated and well thought-out act and not the product of a sudden and irresistible panic attack, as the artist would have us believe. As usual, he would shroud an event in the fog of mystery and ambiguity.

In Venice, Michelangelo awaited his friend for many days, and in the meantime frequented Antonio Brucioli, the other revolutionary who had left Florence after 1522. Brucioli returned in 1527 and then departed definitively that same year. Michelangelo must have frequently been in his company before that date. At the time, Brucioli was completing his Italian translation of the New Testament, which Paul

IV would include in his 'Index of Prohibited Books'. It is probable that this was the moment in which Michelangelo, whose emotions had been severely tested by his flight and the plan that would radically change his life, started to take a serious interest in the questions raised by the Protestant Reformation, which would later prove essential for him and his art.[13]

Meanwhile Battista della Palla replied from Florence in a passionate letter full of hopes for the marvellous adventure that was occurring in the Tuscan city. It was a letter overflowing with revolutionary sentiment, which could have come from the barricades of the Paris Commune. He invited the artist to return to the city, in the name of the many friends who awaited him and had arranged for the retraction of the proclamation of his rebel status which the government had issued against him on 30 September, the day after his flight. And Michelangelo capitulated and was even ready to pay an exorbitant fine for his desertion. His native Florence, his ageing father and the unfinished works of white marble beckoned and his skilful chisel still had work to do, but we cannot be sure what drove him to return without even waiting for his situation to be more fully clarified. Once again, passion had prevailed over reason. But what awaited him was the end of a dream.

The final agreement between Charles V and the pope was celebrated with the emperor's coronation in Bologna on 24 February 1530 and the recovery of Florence on the pope's behalf started in August of the same year. All Michelangelo and his friends could do was wait for the vendetta of the victors, who this time were determined to take no prisoners and destroy the city's republican party forever, so that no one in the future would ever entertain the idea of challenging the rule of the most powerful family in Italy. The Arno had dried up, and the air had been hardened by the summer heat. This added a terrifying stillness to the murderous acts carried out without encountering any resistance, under the orders of the papal commissar Baccio (Bartolomeo) Valori, for whom Michelangelo would be forced to sculpt a *David-Apollo*, which today is in the Bargello. Valori did this on behalf of young Duke Alessandro, who up to that time had been famous for the dark skin he had inherited from his mother and would afterwards be renowned for the viciousness of his bloodthirsty nature. Michelangelo, who came for

a short time came to symbolize the Medicis' enemies, was accused of all kinds of treachery and iniquity – even of inciting the crowd to raze the Medici palace to the ground, the very home in which he had been brought up and cosseted as a boy.

Many people wanted him killed, and Alessandro Corsini, one of Valori's assistants, pursued this end with particular vigour. He perhaps felt that he had very good reasons for wanting to boast of this crime, as Michelangelo, when he was free to do exactly what he wanted, had dissected a corpse of exceptional beauty which had belonged to the Corsini family. Now the family wanted revenge, and they had never accepted the idea of having had to serve art in such an original manner. Michelangelo's divine talent would once more save him and force his past enemies to respect him in a manner not granted to the rich and powerful. One of his victims, the poor prior of San Lorenzo, an indulgent and unswerving supporter of the Medici, had never ceased to love him 'like a San Lorenzo'. During the frenzy of bloodletting that followed the city's fall, he hid Michelangelo where no one would ever have suspected – in the church of San Lorenzo, a few steps away from Palazzo Medici, which immediately reopened and resumed its previous splendours.

Nobody, not even the hired killers who came to ransack on several occasions, managed to find him. Then, after the first few highly dangerous days, intoxicated with a thirst for revenge, Pope Clement himself, who knew he could not completely destroy his future kingdom, announced that he intended to pardon Michelangelo and continue to employ him. Power only values men for the degree to which they can be exploited, and this rule was even more valid for an artist who alone could have ensured the immortality of the Medici dynasty. Figiovanni reassured the artist, let him go and helped him to regain his position on the building site and at the Medici court.

Figiovanni wrote to Michelangelo as early as 17 November 1530, not even two months after the bloody purge, to inform him that Cardinal Cibo, the pope's nephew, was in Florence and wished to see how the work on the tombs was progressing, so that he could report back. Thus everyone took up exactly where they had left off: Michelangelo had to sculpt those statues on which his future career now depended, and once again this career had to be re-established. To survive, he was obliged

to transform his hatred of the Medici into devotion and celebrate them by creating a perfection in stone that no man in this world had ever approached. On many occasions he had annoyed his customers by demanding that an artist must be left in peace and free from all worries if he is going to work well; now he was about to show the whole world that fear is a much more powerful spur to creativity than happiness and freedom. His more sensitive contemporaries perfectly understood that lesson in human desperation, and realized that the sculptor worked 'more out of pure fear than his innate desire to work.'[14]

4 THE GLORY OF THE MEDICI

The form of the Medicean tombs had been thought up by Michelangelo around 1521, although the future Pope Clement VII made his own considerable contribution to the plans. At that time the atmosphere had been very different from that of the following years of calamities affecting all Italy. At that time the celebration of the two dukes, Lorenzo and Giuliano, could not have been separated from a powerful and cultivated reference to ancient forms, which were always useful for exalting the nobility of contemporaries. The reference to antiquity was clear from the architectural structure, in which Michelangelo grafted the architectural grammar used by Brunelleschi in the old Sacristy onto the best and most suggestive of classical Roman architecture, particularly the Pantheon, whose dome he reinterpreted by dividing it into lacunae to give power and sensuality to the light, which in the small Brunelleschian dome flowed with the supreme clarity of a mathematical theorem.

The fifteenth-century approach was refashioned by the use of a classical order that strained the individual elements to such a point that they attained an entirely autonomous formal and plastic evocativeness. By pushing the classical order as far as it could go, to the point of disassembling it and reassembling it in a manner that maximized the expressive potential of each element, Michelangelo was able to invent his own highly personal artistic language which he used to revive the ancient without subjugating himself to any rigid rules of composition. The depth of the niches carved into the facade, the monumental nature of the capitals carved like sculptures, the consoles that concentrated and

divided the forces of their generous curves, and above all the *finestroni* [large window-like structures which are not actually windows because they have stone backgrounds] in the upper section, which taper towards the top and thrust out the curved tympana: these were all elements that served to create movement in the space of the funeral chapel. The contrast between the bluish-grey limestone [*pietra serena*] and the white marble covering the upper section exalts the vitality of the architectural framework, whose imposing plasticity is usually only achieved in sculptures.

Within this rigid and highly evocative framework, Michelangelo placed the actual tombs in the niches, which linked them to the entire chapel without affecting its perfect autonomy. The tombs were like curved arches, like sarcophagi, and it could not have been otherwise in a city that for a century had already been celebrating its dead in sarcophagi made in imitation of ancient ones. Two allegorical figures rested above the sarcophagi, while other figures were supposed to appear in the space underneath them, but these were never sculpted.

Even though it has deep classical roots, the reflection on the theme of death and glory, which emerges from Michelangelo's invention, is radically new in relation to the medieval and Renaissance traditions, which had produced their greatest results in Florence. Given that the figure of the *Madonna with Child* and those of the guardian saints *Cosmas and Damian* were kept well apart on an altar, the tombs of the dukes were free from evident references to the Christian tradition and its symbolism. The dukes are depicted as seated Roman emperors in military dress. The allegories of *Night* and *Day* lie at Giuliano's feet on the curved lids of the tombs (Plate I.20). *Dusk* and *Dawn* lie at Lorenzo's feet in the same position (Plate I.21). The allegories of the rivers were supposed to appear underneath them, to complete the symbols of death.

The representation of death and drama, as well as the victory that glory can inflict on death, is entrusted to the image of time that consumes all before it and ends when life abandons man. This theme was particularly congenial to Michelangelo, whose sculptures always attempted to encapsulate movement stilled within stone, confined by matter. He developed a difficult poetry of poses that consisted in the suggestion of a body full of movement even though it was necessarily

portrayed as immobile. Time is represented in its most simple dimension: the natural cycle of twenty-four hours broken down into four phases: *Dawn*, *Day*, *Dusk* and *Night*. The rivers planned for the lowest part were supposed to symbolize their incessant flow – the continuous movement that typifies the very essence of time in the human imagination.

These were concepts more likely to be shared by the humanist community in Italy than the religious one, and they were more closely linked to natural philosophy than to Christian doctrine. These were also concepts and fantasies that provide us with the few clear traces Michelangelo left of the creative genesis of these allegories. An annotation at the edge of one of his preparatory drawings, now held in the British Museum, alludes to death as immobility of time: 'fame holds epitaphs where they lie, and does not go forwards or backwards, because they are dead and their actions are frozen.' There is another note at the edge of a drawing made in 1524, which is now in the Buonarroti Home: 'Day and Night talk and say, "With our hurried passage we had led Duke Giuliano to his death; it is quite right that he should take his revenge on us. And this is his retribution: that as we have killed him, he in his death has taken light away from us, and with his closed eyes, he shut ours tightly, so that they no longer shine upon the earth. What then he would have done to us while he lived!"'[15]

The artistic manifesto presented by the tombs was therefore clearly understandable to Michelangelo's contemporaries: death, which immobilizes the time of man, can only be defeated by fame and glory, which hand down to posterity the memory of people whose flesh has long since rotted away. This concept of glory helps to explain why Michelangelo refused to produce portraits of the dukes, whom he had known personally, because he argued that within a few years no one would have remembered their faces but everyone would remember them. The celebration of these two men had nothing biographical about it, and was entirely wrapped up in a game of cultural allusions based on a shared knowledge of family symbols and images. Indeed, the biography of the two dukes remains almost the only obstacle to an understanding of the tombs' message. Contemporaries would have been more likely to identify the contemplative figure with mild and thoughtful Giuliano, who advised Leo X not to invade the duchy of their friend Francesco

Maria Della Rovere. Whereas the figure of the young warrior dramatically twisting his body while he waves his baton would more easily have suggested Lorenzo, who died soon after his twenty-sixth birthday and had attempted, albeit unsuccessfully, to assert his legitimacy as a military leader against Urbino – something that his uncle wished to have associated with him in spite of the historical evidence to the contrary. Besides, there is no evidence to produce a precise identification of the dukes, and what there is came after Michelangelo's death: even the sonnet that links Giuliano to allegories of night and day came from a much later period and so there could easily have been confusion over the correspondences, without weakening the iconographic associations of the tombs.

Having established the symbolic reasons that drove Michelangelo to perceive those figures, we still have not resolved the question of the iconography of the sculptures, which are themselves something entirely new in the Western tradition. The idea of monumental figures placed on a curved surface had significant precedents only in the Roman sculptural tradition. On the eastern facade of Trajan's Arch in Benevento, which Michelangelo knew through the drawings of his teacher Giuliano da Sangallo, two naked figures, very similar to those of the Medicean tombs, appear on the arched lintel and follow its curve. They were river gods – another element that connects them to Michelangelo's imagination. They were sculpted in high relief, almost entirely separated from the background wall.

For Michelangelo, this particular arrangement provided an opportunity to portray the human anatomy while enjoying an almost absolute spatial freedom, which up to that moment had only existed in painting. The sculpted figures were generally standing, lying or seated. Michelangelo's figures seem to float in space as though they were made of some ethereal substance, even though they have an extraordinarily powerful and concrete appearance. The spatial freedom of the figures is emphasized by their enormous outward projection, which produces a sense of freedom never before achieved in ancient or modern sculpture.

Michelangelo's exclusive interest in the expressive possibilities of the bodies is demonstrated by his letter in which he states that he is only going to be directly involved in the allegories and has delegated

to others (Montorsoli and Montelupo) the statues of the patron saints, which should have been much more important to the pope. However, the patron saints were seated on either side of the Madonna and they did not represent the same challenge as the marvellous figures positioned on the lids of the tombs.

> This coming week, I will get Master Giovan Francesco to cover the figures in the sacristy that have been rough-cast, because I want to leave the sacristy free . . . I am working as hard as I can and in another couple of weeks I will get work started on the other military leader. Then all that remains of the important things is the four rivers. The four figures on the tombs, the four figures on the ground which are the rivers, and the two military leaders and Our Lady, who will go in the principal tomb, are the figures that I wish to sculpt with my hand; and of these six have been started.[16]

Further evidence of Michelangelo's overriding interest in the expressiveness of the body is that the faces of the figures, such as the 'Prisoners' in the Academy, have been left to last and are less affected by their unfinished state. The artist said whatever he had to say through the bodies. Indeed, he produced bodies that were so devastating that, according to legend, Cosima Wagner fainted just on seeing them and thus they became a very theatrical expression of the emotion that an entire civilization experienced in the presence of Michelangelo's works.

To achieve these results, Michelangelo did not hesitate to stretch the rules of anatomical representation by exaggerating those elements most likely to increase the fascination of his statues. He definitively abandoned the proportions between parts of the body and between them and the body as a whole, which had been a precious guide for previous artists. The chest of *Night*, the most famous figure, extends far beyond the length allowed by mere nature, in order to achieve the perfect expression of absorption in one's own thoughts that only an artist capable of violating the rules of nature could possibly summon up. This same unnatural prolongation was applied to *Dawn*'s arm, which lifts her veil and condenses everything into the gentle gesture of an opening up that extends to the legs which are also parting. The same anatomical alterations can be found in all the other statues.

The process of transfiguration and distortion of the body in pursuit of the exquisitely expressive pose, perceived as a union of natural and psychological movement, was made credible by the perfection of the details. Michelangelo used his anatomical studies not as a representative goal but as the starting point for his realization of an ideal that eliminated everything that did not contribute to the expressiveness and the essentiality of the body. But this vision could not have been achieved without the artist's superhuman technique, which found its acme in these statues. Michelangelo twists Lorenzo's right arm and makes it pass through the entire depth of the space. He has *Dusk* cross his right leg over his left without the movement spoiling the fluidity and muscular energy. He creates a foot hanging in a void and free from all tautness, and a solid and vital penis resting on the muscle of the left leg, which has lost all the abstract bulk and roundedness of Greek sculpture but has not fallen into the trap of prosaic representation. We can easily imagine how the best sculptors reacted to this incomparable virtuosity – by continuously reproducing the frontal images of the figures.

Although working in conditions of terror and despair, Michelangelo had produced the most vital of his works. He had even disproved his own assertions: for many years he had petulantly repeated to popes and princes he wanted to bring round to his own view that only a mind free from all worries can create and create well. In his case the opposite appears to have been true: only psychological oppression and hard physical graft provided him with sufficient energy to free all his creative resources.

Only the defeated and melancholy facial expressions retain something of the misery of that period. There was, however, none of that rhetorical triumphalism that Pope Clement would have liked for those chosen rulers who were supposed to herald the fortunes of the future dynasty. The rhetoric of victory and triumph could not penetrate Michelangelo's suffering humanity. The only solution for such desperation seemed to be forgetfulness, most clearly conveyed by the serene and subdued expression of the allegorical figure *Night*. The artist used *Night*, the symbol of virginity, to say what unfortunately he could not say when Clement had him taken in irons to where he had to work on propagating the glory of the Medici family:

How sweet my sleep, as is my stony being,
While it still lasts – this harsh and shameful despot's rule.
Great fortune for me is not hearing and not seeing;
Do not, therefore, awake me; speak low and do not play the fool.[17]

There can be no doubt that the most significant work on the sculptures was carried out after the republican insurrection of 1527. In a letter to his lawyer in Rome dated 17 June 1526, Michelangelo reported on the progress of the work on statues in the sacristy and it was not very advanced; he provided a schedule for the future work. That particular month was also the one which witnessed the first moves in the terrible series of military events that would eventually lead to the Sack of Rome and the republican revolt in Florence, which in turn meant that Michelangelo suddenly suspended all work for the Medici. Thus the statues, which were conceived and rough-cast before 1527, were actually sculpted only after 1530. They were also heavily marked by the particular circumstances in which the artist was working. Traces of his defeat can be read in the melancholy faces and in the endeavour the figures appear to put into observing or reflecting upon their own lives. The only trace of serenity is to be found on *Night*'s face, as though the only consolation was to be found in the refuge of one's own dreams.

The sentiments of sadness and defeat that were consuming Michelangelo at the time appear to have given life to one of the artist's most absorbing images: the statue of the *Medici Madonna* (Plate I.22). The Madonna's melancholy, full of forbearance, leaves no room for hope of escape or the possibility of happiness, which in portrayals of the Madonna is generally implied through the image of the child. But in this case, we are denied this interpretation by the fact the child has twisted round towards his mother's breast – a movement that allows the artist to display a splendid anatomical viewpoint, but also deprives us of the possible consolation of baby Jesus' happy face. The slightly unfinished state of the sculpture only increases its evocative power of the sentiment and distances the image from the naturalistic realism that could have imposed an overly concrete and restrictive mimesis. There is no hope on the Madonna's face, only the awareness of an all-embracing desolation against which no entreaty would be effective and which is made all the more frustrating by the child's obliviousness. This young

woman's hopeless sorrow, whose essentiality reaches the heights of Michelangelo's classicism, reflects the sorrow of a defeated artist who has been shackled to a life of servility without any chance of redemption.

While his art and talent only hint at the artist's dramatic situation, the historical record leaves no doubt as to the bitter torments Michelangelo had to suffer immediately after the Medicean restoration. The work on the tombs had become so frenetic as to cause concerns even amongst the Medici. The artist's health was in a terrible state. He was not eating or sleeping, and many feared that this self-destructive frenzy would shortly lead to his death. On 29 September 1531, his state of physical and psychological exhaustion was very serious, as was recorded by his close friend, Giovan Battista Mini:

> As Michelangelo seemed to me to be utterly exhausted and wasting away, the other day I spoke about this to Bugiardino and Antonio Mini in the narrow. They are always with him, and in the end we came to the conclusion that Michelangelo will not live long, if he doesn't do something about it. This is because he works a great deal, eats little and not well, and doesn't even sleep. For a month he has been considerably slowed down by kidney stones, headaches and dizziness.[18]

The artist's state of health was such that the pope asked him to slow down his work and even seek assistance from someone else, and he allowed Montorsoli to finish the statue of Giuliano. However, Michelangelo was also drained by his dispute with the Duke of Urbino, who had taken up the issue once more and was demanding that the contract for Julius's tomb be fulfilled. Feverish discussions were taking place in Rome between Sebastiano del Piombo, who was representing the artist, and Girolamo Staccoli, the duke's ambassador. Throughout 1531 and the winter of 1532, the negotiations had their ups and downs, which kept Michelangelo in state of uncertainty. Then, in the spring of 1532, a solution was found thanks to the mediation of Clement VII, and Michelangelo left for Rome to sign a new agreement with the duke's agents.

During this period, Michelangelo cut the figure of a man in despair. Now over fifty, he felt defeated and a prisoner of the ambitions he had failed to achieve. The Medicean sepulchres felt like forced labour, and Julius's tomb, which was supposed to have been a masterpiece of

modern sculpture, had been transformed into a nightmare from which he could not escape. The anxiety that tormented him was palpable. Yet even that wall crumbled quite suddenly when love unexpectedly shone into his life and brought him a sense of release: a love that up to that moment he had only guessed at, but never experienced. And there were no barriers to keep it under control.

During his brief trip to Rome, he had been overwhelmed by the beauty of a young man and his perfect manners. This was Tommaso Cavalieri, who belonged to the highest Roman aristocracy and dabbled in art and architecture. He swept Michelangelo away to his own world as Zeus did Ganymede. His social status can be guessed at through a contemporary description of Sofonisba Cavalieri, probably one of his relations, who appeared at a party 'dressed in an incredibly white camel-hair garment bordered with crimson velvet shot through with sparkling threads, and gold medals around her waist, in accordance with very ancient tastes'.[19] Similarly, the young Tommaso must have had an angelic appearance that dazzled Michelangelo.

The first signs of this explosion of amorous feelings can be found in a letter sent him by his friend Giuliano Bugiardini from Florence in October 1532. It is a strange letter, which shows that life's coincidences can be much more stunning than those imagined in literature. His affectionate old childhood friend wrote to tell him of a dazzling comet that had appeared in the skies over Florence – 'a comet moving towards the east'. However, Bugiardini could not have known that an even more dazzling comet had appeared before his friend a few days earlier. Michelangelo immediately made the connection in his mind, and annotated that strange letter in the frenzy of his uncontainable emotion. In the first lines he attempted to explain to himself the spell that had overwhelmed him:

If I had known at first sight
of this soul that it, like the phoenix before the burning sun,
would renew me in fire, as it does
in the final years of old age, and thus all of me is burning . . .[20]

A few days later, just before leaving for Florence with the sole desire to return to Rome as quickly as possible, Michelangelo wrote to

Tommaso a letter that reveals an existential change that until then would have been unthinkable. The coarse and brusque style that always characterized his correspondence, and the brutality with which he treated princes and cardinals, melted into a timid, acquiescent, pleading and feminine prose, which exposed all the fragility of a curmudgeonly old man caught up in the snares of a passion that rendered him helpless in the hands of a young man to whom he would attribute talents and virtues he had always denied his rival artists, even though the young man in question had none to speak of.

> Sir Tommaso, my most dear lord, I have unthinkingly been moved to write to your lordship, not in reply to any letter received from you, but as the first to make a move, for surely you thought you could pass me by, like crossing a small river or one that low water had clearly made a ford, and yet keeping dry the soles of your feet. . . . However your lordship, who in our age constitutes a unique light shining on our world, could not be satisfied with the work of any other, because you have no peers, no one who can compare with you. And if ever some of the things that I hope and promise to make should please you, I shall consider it more good fortune than good. If I ever manage to bring your lordship pleasure in any manner, as I have said, the present and all my future I shall give to that work, and it shall hurt me greatly that I cannot have back my past, so that I can serve you longer than with my future, which will be short, because I am so old.[21]

This unlimited offer of his services is all the more amazing when you consider that during the same period he was approached by the king of France, the Duke of Mantua, and even Vittoria Colonna, and he would not listen to them. In order to obtain some work produced by the artist's hand, Colonna even made use of her husband's cousin and almost adopted son, the extremely powerful military leader in the imperial forces, the Marquis of Vasto.[22] None of them obtained a single thing, whereas Tommaso had to thank Michelangelo in his first letter to the artist for two drawings sent to him as a sign of the latter's devotion. In the years to come, Michelangelo staked his emotions on the convenient device of Platonic love: the only one tolerated in a social context in

which both men occupied positions too exposed to the public gaze for more radical transgressions.

Tommaso's influence undoubtedly helped to give Michelangelo the strength to leave Florence, a city that made him unhappy because of the tyranny of the Medici and of his own family, as well as the narrowness of a market which he felt he was definitively excluded from. The Rome he had chosen to move to was very different from the one he had left seventeen years earlier, but it still contained sufficient opportunities and ideas to convince him never to leave it again for the rest of his life, which would still be a long time.

6

MICHELANGELO'S GLASSES

1 STILL YOUNG AT HEART

The Florence that Michelangelo decided to leave permanently in the autumn of 1534 was a city at the height of its physical splendour and no longer at war with itself, but morally it was on its knees. The Medici were engaged in a bloody purge of that 'republican society' that in previous centuries had been its vibrant heart and had made it great. From this time on, Florence would be the capital of a dynastic statelet, one of those in Italy that would resist with all their energies the machinations of international politics.

Rome, where Michelangelo's heart now lay, was a city that carried the visible signs of the devastation inflicted during the sack in 1527. Yet it was full of intellectual ferment and quite determined to regain a central role in European politics. The houses that had been burned during the sack were being rebuilt and would be more beautiful than before. The city was benefiting from the energy generated by this rebirth. Like many other artists, Baldassarre Peruzzi, who had escaped the siege in May in underpants and made his way to Siena, returned full of hope and was creating a curved facade for the new palace of the Massimo princes with bricks and travertine stone, as in a section of the Colosseum, while also incorporating the walls and frescoes blackened by the fires which

had been started by the Landsknechts. When the soot could not be removed with water, picks were used to demolish the damaged frescoes, and teams of artists, newly arrived and mainly from the north, were ready with their brushes to paint in the colours and forms that were in fashion, and thus the body of the city was reborn from its eternal ruins with ever greater magnificence. In the Vatican, the plans for enlarging the papal palaces were becoming more imposing by the day. There could be no doubt that the greatest artistic developments would mainly occur in Rome.

Clement VII's patient but not entirely selfless involvement in the dispute between Michelangelo and the Dukes of Urbino had born fruit, and the artist could hope for a final resolution of the whole question. Following mutual recriminations and legal challenges that had to examine three contracts and a series of payments going back to the first one thousand ducats Julius II paid in 1505, the customers and the artist reached a new agreement in Rome during the summer of 1532. The contract, the fourth in twenty-seven years, established that in exchange for the money already received, which was finally estimated at 8,000 ducats plus the house in Macello dei Corvi, Michelangelo would produce a tomb with six signed statues. The tomb would be placed not in Saint Peter's, which was undergoing building work, but in the Church of San Pietro in Vincoli, of which Julius II had been the owner before becoming pope.

Clement VII had agreed to allow the artist to move to Rome for a few months every year in order to finish work on Julius's tomb, but this was not simply a generous concession to the Della Rovere heirs. Now that the Pope had had a work produced in Florence that would ensure the lasting fame of the Medici whatever the future held in store for the dynasty, he wanted another work produced in Rome, the heart of Christianity, this time to immortalize his own papacy. Only one man could achieve this: Michelangelo.[1]

It was almost certainly for this reason that the two met in San Miniato near Florence in the autumn of 1533, while the Pope was travelling to France where his niece Caterina was to marry the Duke of Orleans (later Henry II), as a token of the reconciliation between the papacy and France. Clement asked or forced Michelangelo to agree to decorate one of the walls of the Sistine Chapel in the Vatican, where

twenty-two years earlier the artist had finished the magnificent painting of the ceiling. As a contemporary source confirms, they were already putting up scaffolding behind the chapel's altar to paint a 'resurrection' in the spring of 1534.

Nothing could have made Michelangelo happier than a move to Rome. At the age of nearly sixty years, his passion for Tommaso Cavalieri drew him forcefully towards the Eternal City, and such an exceptional commission would have been an excellent reference to offer up to his highly eccentric love affair. Such was his desire to join his friend that he even agreed to entrust some sculptures to his assistants Angelo Montorsoli and Raffaello da Montelupo, and he wrote to Tommaso, 'I could more easily forget the food that keeps me alive, which the body alone eats unhappily, than your name, which nourishes both body and soul, filling one and the other with such tenderness that I can feel neither irritation nor fear of death while I conserve its memory.'[2] Thanks in part to the work of his assistants, the sculptures for the tomb of the Medici were almost ready, or at least sufficiently advanced to please the pope and his contemporaries, and thus he could organize a move to Rome which, if not permanent, would be lasting. The Florence air was all the more stifling because of his dashed republican hopes and the government of the pope's bloodthirsty nephew, Alessandro de' Medici, who had no liking for the artist.

Michelangelo's father died at the age of eighty-eight, some time between 15 January and 23 March 1531. In Rome, Michelangelo would not have to put up with his insufferable relations, whom he reminded shortly before his departure that he had always done for them 'much more than for myself, and [I have] suffered many discomforts so that you would not suffer any, and you have done nothing other than speak badly of me throughout Florence.'[3] As in every neurotic relationship, the passing of time did not lessen but rather increased his resentment. Almost at the age of sixty, Michelangelo found himself obsessively repeating to his brothers the same things he had said when he was almost twenty – or thirty or forty – as though he too was resigned never to leave the prison he had created around himself, unless it were through death.

Clearly, then, the artist set off on that journey with a young heart,

open to prospects that not even thirty years earlier had so clearly formed within his mind. His recent craving even made him brusque and perhaps cruel towards his old friends – old passions that appeared trifles in the light of a new dawn. A letter written just before his departure has remained in his archive to witness the pain of a lover dismissed with extreme casualness:

> My dearest Michelangelo, don't be surprised if I write these few dis-jointed lines, given that we all know that whoever has lost his every delight and pleasure is almost a senseless thing? This only occurs because the passion of the spirit is too harsh a thing to endure. You should know that, if no discontented or passionate person can be found, then I am the one. Do not consider my young age, for the forces of love can unfortunately do their work in me. I do not know where to turn, as I can only find peace in you.[4]

We know nothing about the man who sent this letter except what is contained within it: he is young, in love and hurting. The rest is shrouded in the shadows that Michelangelo's very prudent character skilfully created around all his amorous passions. His friend's pain clearly affected him deeply, as he kept this lament amongst his papers for many years. But it was not enough to hold him back: Rome was now where his new life was, and during the months leading up to his definitive move, Michelangelo was tormented solely by his longing for Tommaso Cavalieri, as though that love had cancelled out everything else: family bereavements, political setbacks, hunger and plague. All was diminished by that shining star which had brought ardour to his troubled and gruelling life.

In his anxiety to join Tommaso and keep his love, Michelangelo sent this young aristocrat some precious and extremely beautiful drawings, which provoked the envy of Pope Clement and his nephew, Cardinal Ippolito, who were forced to beg a minor nobleman to hand over goods they could not obtain from the artist who owed them his life and his fortune. The three drawings, which Michelangelo undoubtedly sent Tommaso immediately after the start of their relationship, all depict subjects that allude to the torments of love: Phaethon falling from the sky for having dared to come too close to the sun, a metaphor for the

presumption of which Michelangelo felt guilty for having approached young Tommaso, himself a 'sun' (Plate I.23); Tityus tormented by Zeus' eagle for having stolen fire from the gods, and chained to a rock like a lover to his loved one; and the abduction of Ganymede by Zeus' eagle, which was a metaphor for the soul raised up to the heavens by the sentiment of love (Plate I.24). The sophisticated yet playful combination of allusions that Michelangelo constructed in order to declare his love for Tommaso could not conceal the urgency of his erotic desire. The drawings reveal the physicality of his powerful attraction in all its crudity. *The Rape of Ganymede* portrays an erotic ecstasy that leaves no doubt about the artist's identification with the eagle that, during the freedom of flight, wraps itself around the young man in a manner which clearly suggests sexual intercourse. The worldly and discerning papal court considered the drawings Michelangelo sent Tommaso Cavalieri to be an enormous gift. But in reality, they were very little compared with the gift Michelangelo had made to himself by falling hopelessly in love with Tommaso, as love made him ignore all prudence and drove him to admit to being happy for the first time in his life. In greeting his young friend, he did not use his pen to sketch tormented bodies or to write bitter words, but rather to express a simple faith in happiness by declaring that first, entirely banal day of January 1533 to be 'the first and for me happy day of January'.

Contemporaries who had access to the drawings immediately perceived its sensuality. The works of art were sent to Tommaso before the onset of summer in 1533 and provoked the envious admiration of Cardinal Ippolito de' Medici, who immediately asked for their loan, so that he could have them copied and reproduced in crystal. He too had excellent reasons for identifying with Michelangelo's torment: like the ageing artist, he was the victim of an amorous infatuation, which was perhaps even more risky, given that the object of his desires was the stunningly beautiful Giulia Gonzaga, the Countess of Fondi. This woman was so beautiful that Suleiman the Magnificent attempted to have her abducted to decorate his fabulous harem – fortunately without success. But the beautiful Giulia had no interest in the ardent attachments of the heart – or not at least those sparked off by the male sex. Ippolito had to make do with a portrait he commissioned from Sebastiano del Piombo and the poems in which the greatest poets

celebrated the woman most famous for her beauty in Italy. We know of her dark eyes, the perfect oval shape of her face and her sophisticated learning, which a few years later would lead her into one of the most dangerous Reformation circles. We should not therefore be surprised that the young cardinal identified with the lovesick Michelangelo, the most accomplished narrator of that impossible emotion, and implored Tommaso to have the drawing of Tityus copied onto crystal, the material that best evoked the intangible purity of Giulia's heart: 'Cardinal de' Medici wished to see your drawings, and he liked them so much that he wanted to have Tityus and Ganymede made in crystal; and I didn't know what to say to stop him from having that Tityus made, and now it is being done by Master Giovanni.'[5]

In the meantime, they were preparing in Rome and at the papal court to welcome Michelangelo in a manner that the artist could not have hoped for. But once again, things did not go as expected. No sooner was Michelangelo in Rome than his protector Clement VII died. It was 25 September 1534. His successor, Cardinale Alessandro Farnese, was a man of the world, perhaps too much of one. He came from a family of minor nobles in Lazio, and he immediately undertook an extremely ambitious plan to create a kingdom for his own descendants. He had a son, Pierluigi, and a daughter, Costanza, as well as many *nipoti*. The artful and hypocritical language of the court exploited the ambiguity of this word (which in Italian can mean 'grandchildren' or 'nephews and nieces'). In any event, it was necessary to procure wealth and status for these *nipoti*, given that the Farnese family lacked both at the time. The greatest obstacle to his project was the period of his papacy, because the institution was being driven towards a rigorous moralization under pressure from the Protestant Reformation, which was persistently raising accusations against the corrupt practices popes and the papal court used to enrich themselves and their families.

However, the new pope, who had been a cardinal with an excellent grounding and long experience of the job, knew how to deal with political impediments even in his most difficult moments. He knew about the benefits of artistic propaganda and lost no time in confirming Michelangelo's commission to produce the frescoes on the wall of the Sistine Chapel. On 1 September 1535, a few months after his

election, Alessandro Farnese, who had taken the name of Pope Paul III, appointed Michelangelo to the post of 'Supreme Architect, Sculptor and Painter of the Vatican Palaces', with a monthly salary of one hundred *scudi*, of which half was paid out of the Vatican coffers and half collected from duties levied by a customs office on the River Po, which was conferred on the artist as a benefice. Never had a Renaissance artist received such a lucrative post.

And once again, Michelangelo found himself hampered by his signed undertakings to the Della Rovere family. As before, it was the pope who solved the artist's problems. He was probably very happy to do it, given that he had declared his personal hostility to Francesco Maria Della Rovere. He had plans to seize some of Della Rovere's territories and transfer them to his degenerate son Pierluigi. On 17 November 1536, Paul III issued a personal edict [*motu proprio*] in which he confirmed Michelangelo's appointment and freed him from all his commitments to Della Rovere family, so that he could devote his time exclusively to his new commission.

In very little time, Michelangelo became a close friend of the new pope, who was more or less of the same age. His inclusion in the papal court must have been rapid and sensational, because by 10 August 1537 the major-domo Jacopo Meleghino invited him to join the pope, who would be in the palace for a steam bath and had no one to entertain him.[6] His new work in the Sistine Chapel was turning him into an increasingly admired figure, indeed one of the most admired in a court of intellectuals and artists whom Paul III protected and used to demonstrate the virtue of his papacy.

In the meantime, relations with his family had finally become more peaceful, almost certainly because of their separation. Following the death of his brother Buonarroto, he felt he was the guardian of his niece Francesca, and she fulfilled his most ambitious dreams by marrying Michele Guicciardini, member of a noble Florentine family. This marriage marked the first small step up the social ladder, which had always been one of the artist's most frantic desires. On 7 March 1538 Francesca gave birth to a beautiful boy, Gabriele Maria. It seemed that the Buonarroti lineage was on the way to recovery, albeit not through the patrilineal descent. Michelangelo could start to relax.

2 HEAVEN AND EARTH

In the spring of 1535, Michelangelo was already preparing the cartoons for *The Last Judgement* (Plate II.6). His eminence was now such that a year later he was visited at his very modest home in Macello dei Corvi by the pope and at least ten cardinals. His current drawings were already attracting a great deal of attention and were the subject of much debate at the papal court.

In January 1536, they started to prepare the plaster on the chapel wall. Michelangelo felt that such a large-scale enterprise required the construction of a gigantic lining of bricks that jutted upwards so as to avoid as far as possible a build-up of dust. This original contrivance, which would prove invaluable for the future conservation and continuing clarity of the fresco, demonstrates once again the artist's conviction that a work of art was primarily a great technological undertaking.

The most precious colours were bought in Ferrara, where a large Jewish community favoured trade with the East. For instance, crushed lapis lazuli came there from Persia, and Michelangelo would thicken one brushful of it after another to create sky that was in no way inferior to the one that rose up above the mountains from which the precious blue stone was extracted. This time, the artist did not even attempt to form a team of artists. From the very beginning he did everything on his own, with the sole assistance of an apprentice, Francesco di Amadore da Casteldurante, known as Urbino, who took the place of Antonio Mini after the latter's departure for France. His role was to grind up the colours and help the artist to transfer the marks from the preparatory cartoons onto the wall. A plasterer may have mixed the plaster and spread enough for a *giornata* of work. The rest was solitary work.

The drawing, which was to be gradually transformed into an enormous fresco one day at a time, was radically innovative when compared with previous representations of the Last Judgement. Over the centuries, the resurrection of the dead had been depicted through an adaptation of the image of Roman imperial triumphs to the story of the Apocalypse, the text on which the tradition of the Last Judgement was based. Whereas Roman celebrative reliefs showed the emperor flanked by his soldiers or counsellors, Byzantine depictions replaced the emperor with a Christ triumphant and the guards with archangels (who were initially armed

with lances). As time went by, each detail found its precise position, although the lack of a clear and undisputed image that had to be referred to always left some room for reinterpretation by the artist.

A very structured depiction of the *Last Judgement* appeared at the beginning of the fourteenth century; it was produced by Giotto and was found in the Scrovegni Chapel in Padua. Michelangelo was undoubtedly very impressed by the depictions in the Florentine Baptistery and the Cemetery in Pisa, both of which were distinctive for their aggressive and monumental emotive force. Although not entirely rigid, tradition demanded that Christ in a position of judgement be depicted raising the chosen people to heaven with a movement of his right hand and condemning sinners to the flames of hell. Other details made the image more understandable and enjoyable, such as angels announcing the new days with their trumpets, other angels writing the destiny of each person in the book of life and, according to the artist's meticulousness and the available space, the various categories of the chosen people, who were divided into Virgins, Patriarchs, Church Fathers and Apostles. All these iconographic requirements influenced the composition and almost always reduced the Last Judgement to a horizontal superimposition of small crowds that corresponded to a celestial hierarchy dominated by Christ in judgement. Only at the bottom, where hell was depicted, was there an opportunity for anarchic imagery that represented the punishments inflicted on the damned. This allowed for the depiction of poses and emotional expressions that were very different from the pious devotion shared by the other protagonists of the scenes, including the Virgin Mary and Saint John the Baptist, who were positioned respectively on the right and the left of Christ and engaged in the act of interceding in the destinies of men and women.

Michelangelo used and adapted the traditional iconography, but the changes he made were vibrant and highly original. For someone like him, who was in love with the male body, this subject provided the opportunity to express an infinite variety of moods through the equally infinite variety of poses a body can take up in space. The first important innovation was a space ordered by the movement of the figures rather than the geometrical patterns on which men and saints were previously aligned. The hierarchy of the figures is only marked out by slight changes in their proportions. Christ, the Virgin and the principal

saints are portrayed as a little bigger – just enough to demonstrate their importance but not so much that they upset the depiction of a unitary and credible space or render it incongruous.

The energy in this representation is generated by Christ's pose: he is no longer seated but in the act of rising to his feet, drawn along by the gesture of his arm, which sets off a whole vortex of surrounding figures. As a result of this motion, the damned are cast downwards and the saved are propelled upwards, while the ranks of the elect, saints and martyrs, who without distinction are impressed by this majestic and definitive event, surround Christ and crowd an unrealistic and spiritual sky creating an immense biblical vision. In the lower part, an empty horizon of barren land greets the resurrected corpses on the right side and on the left there is a foretaste of hell. Some of the details of hell, such as Charon's boat that ferries and torments the hopeless souls destined for the eternal flames, demonstrate the influence of Dante, a poet Michelangelo revered. The devils are terrifying because of the artist's ability to fuse the human anatomy with fantastic features taken from the most bizarre fish of the Tyrrhenian Sea, something he had already demonstrated in his teenage years using fish he got from a Florentine fishmonger's.

While Giotto in Padua and Buffalmacco in Pisa depicted devils as creatures alien to the human world, Michelangelo followed the example of Signorelli in the San Brizio Chapel in Orvieto and the sculptures on the facade of that cathedral, where the devils are depicted as a slight degeneration of men and the angels. Even with their talons, feathers and birdlike colouring, they never infringe the norms of anatomy and naturalism, and conform to the powerful and seductive forms of the human body in its prime (Plate II.8). They appear to be only men subjected to a physical transformation that goes beyond the known human forms – men who inhabit a very realistic nightmare. Their depiction could be considered one of the greatest achievements in the history of painting, and in it Michelangelo catches the worst sentiments of the human spirit – those that are generally unmentionable and yet common to all of us. Extreme cruelty, badness, greed, the monstrous power of evil: all this is painstakingly brought back within the human universe. One could even say that the devils painted by Michelangelo are the most human devils that ever appeared in Western painting up to that

date. When he conjured them up, the artist probably only thought about the most sinister part of the human soul.

By giving the devils these human features, he was able to portray the entire scene while staying within human parameters. The whole is a maelstrom of bodies clashing together, which for many people suggests an immense gigantomachy. The first impression is that of a desperate struggle between good and evil, which momentarily impact on each other through the force of the bodies and through the energy of the emotions that inhabit those bodies. The angels fight to release the souls that have been saved from the grip of the devils. And, to their great satisfaction, the devils fight to push the 'iniquitous souls' down to their eternal damnation. Even the saints who surround Christ and exhibit the signs of their martyrdom appeared to be as anguished by this battle as the people caught up in it, as though they too were not certain of their salvation (Plate II.7). They almost fail in the traditional 'political' purpose of this scene: to reassure those who remain obedient to the dictates of the Church that their salvation is guaranteed.

In the upper part of the painting between the two large lunettes next to Jonah's throne, the angels who display the symbols of Christ's passion – the column, the cross and the crown of thorns – appear to be struggling with a tempest that is driving them beyond the horizon. They are depicted without wings to give more forcefulness and realism to their physical endeavour. Besides, the entire painting is built around the gestures of the protagonists, who are exalted for their powerful physicality, as though for a single day – for humanity's final day – they had become humans once again, so as to share in history's greatest drama. In a universe in which the saints and the blessed have no haloes and angels have no wings, a single magnificent and desperate humanity plays out the drama of the Last Judgement.

The vertiginous foreshortenings of men suspended in the air in spite of the heaviness of their flesh, the perfect beauty of the anatomies and the affecting restraint of the gestures immediately define this painting as the most beautiful and unrepeatable work of art produced in Christendom. But with equal suddenness, it also attracted criticisms of the artist for its obscenity and lack of faith – for the nudes and the representation of saints and angels as human beings. Michelangelo had pursued a clear and strongly held belief, which was echoed in the

dialogues recorded for us by his great admirer Francisco de Hollanda who, a few years after the completion of the *Last Judgement*, had published an edited version of his conversations with Michelangelo, Vittoria Colonna and Lattanzio Tolomei, a learned Sienese humanist, which took place during the time Michelangelo was working on this great work. The beauty of Man – it was argued in the dialogues – is a product of the greatness of God, and it is impossible to glorify God without showing it. Covering it with clothes would be like celebrating the superiority of a goatskin or fleece over human limbs.

The controversy soon overtook Michelangelo's painting, which attracted the scrutiny of the Council of Trent, as though it were a theological work. For the artist, however, that depiction was the most successful celebration of God and mankind, with whose destiny he identified because of both his humanistic education and his own sensibilities. Hence he was able to perceive and admire a sign of divine will even in the extreme artifice of a work of art. In any case, the problems he had wrestled while he worked alone on the scaffolding during that period had been artistic and theological. He had used the extremely limited means of drawing and colour to portray the greatness, generosity and also fearsomeness of Christ. He had rejected all didactic aids such as wings and haloes, and every other symbolic attribute that the Catholic Church exploited to identify hierarchies and characteristics of its personalities, and to emphasize its divine nature as an institution. Once again his painting was a triumph of classicism in the sense of an absolute primacy of the human body over every other symbolic language, and the force of this voracious sentiment had imposed itself on the painting's didactic role.

Without being aware of it, those who criticized Michelangelo felt betrayed by this outcome. The greatness of art and human talent had prevailed over the power of the Holy Scriptures: an outcome that today is even more evident, given that people of different religious faiths flock to the Sistine Chapel so that they can venerate the *Last Judgement*. To achieve this, Michelangelo fully exploited the expressive potential of the human body – particularly the male body, always the object of his inquisitive passion and his desire. He had reduced everything to the essentiality of the anatomy and the highly spiritual intuition of blue heavens, which engender an unprecedented symbolic contrast with the

candidness of the bodies and provoke a heartrending aesthetic emotion. The result was so extraordinary that even today it is not possible to avoid the powerful feeling of being in the presence of a world recreated all over again on the walls of the Sistine Chapel.

The beginning and end of every movement and every emotion is, as has been said, the perfect gesture of Christ who subdues the flesh now freed from human misery and exulting in that lapis-lazuli sky. The actual history of the fresco and of the colours and plaster used reveals how difficult it was to produce that image of Christ, how important it was to the success of the painting, how much effort Michelangelo put into studying it and how much he relied on a perfect foreshortening of the arm from below. Even though the gesture was the object of meticulous preparatory studies, Michelangelo repainted it, corrected it, erased it and repainted it again, as though he could not find a suitable solution to such a significant detail. The 'second thoughts' observed by restorers say a great deal about the whole of the *Last Judgement*, because they demonstrate that the success of the entire painting depended above all on the perfection and persuasiveness of the anatomical details and the spatial composition. This was something that the artist had to produce out of nothing – that is to say, solely out of his own imagination without the assistance of established iconographical formats. It was as though that subject was being depicted for the first time. No artist had ever adopted this kind of approach to such an important commission. Just as a theatre director rehearsed the leading actor over and over again, Michelangelo worked very hard before creating the gesture that by itself expressed the new and explosive drama, which contrasted between heaven and earth in the single moment that united them in eternity. But without the perfection and enormous symbolic power of that gesture, the figures suspended in the air would have suddenly fallen like celestial bodies no longer held up by the force of gravity.

The success of the painting was once again based on a technique of stunning sophistication, as though Michelangelo had devoted himself entirely to painting frescoes rather than to sculpture during the twenty-year period that divided this work from the one on the chapel ceiling. The plaster, which was applied in a manner that produced a glazed and marble-like surface, absorbed very little colour and shines through the paint. This creates particularly luminous figures. As a result of the way

the brush worked on the white of the plaster, that plaster separated the shadows and part of the representation; indeed, in some areas, such as some of the characters' heads and pupils, the plaster was left bare. The figures in the foreground were painted with meticulously descriptive brushstrokes, but as soon he started working towards the background, the brushstrokes became brisk and perfunctory, as in contemporary painting. This created greater depth in space and increased the descriptive power of the minor figures, who were reduced to pure expression using rapid splashes of colour.

However, the most extraordinary achievement was to impose formal, material and chromatic consistency on a painting that took six years to complete and was made up of hundreds of figures, each broken up into several *giornate*. The whole work took thousands of days. Miraculously the whole thing appears to have been done in a single day, without the assistance of architectural forms or landscape to act as partitions to hide or link dissimilarities. Moreover, every figure in the *Last Judgement* has its own specific and extremely convincing role in the painting's narrative and formal structure, unlike other comparable compositions in which a few principal and carefully painted figures are surrounded by a multitude of ill-defined and unstructured figures. Every person participates and is in dialogue with the whole, while also narrating a small episode about life and feelings, and thus our eyes can always find something wherever they look. There is always a sign. Wherever you look, you encounter an emotional stimulus. It appears that that immense wall – the largest ever frescoed by a single artist – could not contain all of Michelangelo's thoughts, desired forms and imagination, which moulds into a myriad poses the same marvellous instrument – the human body.

When the painting was uncovered in 1541, a crowd of celebrities rushed to the base of the wall. They were stunned and unsettled by such grandeur. The emotions stirred by this vision were intensified by the dramatic news that arrived from the sea off Algiers. Emperor Charles V had organized an expedition against Barbarossa (Khayr ad-Dīn), who now ruled over Algiers. This operation took on the appearance of a crusade and attracted knights and nobles from the whole of Europe. On the night of 24 October, a tempest destroyed 150 Christian ships, killed thousands of men and seriously endangered the life of the emperor

himself, who managed only with great difficulty to return to Europe
with his stricken fleet.

European hopes of exorcizing the threat of occupation by the
Turkish infidel sank along with their ships in the warm waters of the
Mediterranean Sea, although European princes were quite capable
of entering into alliances with this dreaded enemy against their more
immediate, Christian enemies. Things could not have gone worse, and
Christians began to fear that nothing would halt the advance of the
infidels and the empire of the Sublime Porte into a Europe riven by
religious conflicts and dynastic rivalries.

The unveiling of the *Last Judgement* within days of the arrival of
news of the defeat could not have had a greater emotional impact.
Princes and cardinals wanted copies, drawings of that work that became
famous throughout Italy even before the reproductions and woodcuts
started to circulate, as they did in enormous quantities over the follow-
ing years. But the solitude of the miracle-worker, who was now over
sixty, was such that no assistants or associates could be found to engage
in the copying work. Only princes were wealthy enough to secure the
services of the few copyists willing to take on the work.

The accusations of obscenity started immediately. But as Cardinal
Gonzaga's ambassador, Sernini, claimed in correspondence at the time,
the court ridiculed such criticisms, and many cardinals would have paid
thousands of ducats for just one of the figures depicted on the wall of
the Sistine Chapel. Unfortunately for them, Michelangelo's art was no
longer on sale.

3 VITTORIA'S GIFT

Michelangelo would not stop working even after the unveiling of the
breathtaking *Last Judgement*. He only rested for a few days during
the scorching Roman summers, which were universally considered
extremely harmful to people's health. In the summer of 1543, while
he was working hard on the last of the statues for the tomb of Julius II
and starting on the frescoes on the walls of Pauline Chapel, he allowed
himself a short trip to Viterbo to visit his great friend Vittoria Colonna,
who since September 1541 had set up her headquarters in Santa
Caterina Monastery in that city.

Vittoria was born in 1490 in Marino near Rome, the daughter of Fabrizio Colonna and Agnese da Montefeltro. Her family was one of the most ancient and powerful in the city of Rome. Prospero Colonna, Fabrizio's brother, was one of the architects of the youthful Emperor Charles V's military success in Europe. His prudent and calculated military tactics had brought him fame and the infinite gratitude of the emperor during the period around 1520. Always loyal, the Colonna family had supported the emperor in his struggle with Clement VII in 1527, and their actions contributed decisively to the pope being holed up in Castel Sant'Angelo and the city of Rome being overrun by the landsknechts. Vittoria had consolidated her social position by marrying the Marquis of Pescara, Ferrante Francesco d'Avalos, in 1509; he too was destined to gain the emperor's undying gratitude for his military distinction at a time when military skill was the sole foundation of power in Europe. In 1525, the Marquis of Pescara played a decisive role in the Battle of Pavia, which established the emperor's supremacy over his powerful enemy, King Francis I of France, who had been expected to win. Vittoria's husband wrote a letter in his own hand to the emperor to announce the victory in Pavia and the arrest of the French king, but shortly afterwards he died heroically of the wounds he had suffered during the battle. Unsurprisingly then, the emperor honoured her when he came to Rome in April 1536 with a personal visit that signalled her extremely high social position in Europe as a whole.

However, her family prestige was less important than her own talents, which were widely acknowledged at the time. Following the death of her husband, Vittoria devoted herself to her passion for poetry, which was becoming something of a sophisticated ritual in Italy's fashionable society. In her case, however, it was an opportunity to demonstrate a literary skill that was immediately recognized and admired in court circles in Rome, Naples and Venice. Her humanistic education and her acknowledged poetic talents soon put her in contact with the most sophisticated intellectual circles in Italy, who were much cultivated at the papal court of Paul III, given that literary figures such as Bembo and Sadoleto were appointed cardinals under the rule of this Farnese pope.

It is not at all clear how her friendship with Michelangelo came about and flourished. We know that in 1531 Vittoria, who was profoundly

affected by Michelangelo's art, was still obliged to use her cousin, the Marquis of Vasto, as an intermediary in her unsuccessful bid to obtain something produced by the master's hand. By 1538, however, the friendship was already very close, and their conversations mainly on the humanistic themes of art and literature were recorded by a Portuguese painter who published them a few years later. This was the time in which Vittoria Colonna changed the direction of her life. As one of her closest confidants remarked, 'she has turned herself towards God and does not write of any other matter.'[7]

This spiritual journey, centred on the questions of salvation and renewal of the faith, was one shared by very many literary figures educated in humanism, philosophical sciences and ancient culture, who during the 1540s developed an all-absorbing interest in religious reform and the spiritual life of Catholics, clearly under the impetus of the Protestant Reformation in northern Europe. More specifi- cally, Vittoria was influenced by the ideas that were spread in Naples between 1536 and 1540 by Juan de Valdés, a Spanish intellectual and noble who was also a handsome and sophisticated follower of Charles V on his Italian expedition of 1536. In Naples, Valdés set up a circle that argued fervently over the questions of salvation and faith. He introduced a new method: he combined sermons that his disciples spread from the pulpits with debates held in the exquisite Palazzo di Mergellina, a building that looked over the bay of the most beautiful and passionate city in the world, where even religiosity acquired a very particular sensuality.

The Neapolitans responded with surprising enthusiasm to the ideas of Valdés, and the meetings held by those who flocked to his sermons and those of his followers became the stuff of legends. Five thousand *scudi* were collected as alms at just one of these meetings, and this enormous sum even outperformed the collections at the tumultuous sermons of the 'black friar' Savonarola in Florence, a city that was more cautious in its donations and unable to boast such generous acts of char- ity. Valdés gathered together a group of leading figures in Neapolitan society, who were to be Vittoria's companions for the rest of her life: Giulia Gonzaga who was Vespasiano Colonna's widow and the object of Ippolito de' Medici's unrequited love, Marcantonio Flaminio the celebrated writer, Pietro Carnesecchi who had been Clement VII's

apostolic protonotary, and Bernardino Ochino, the Capuchin friar from Siena who became famous for the magnificence and emotive power of his sermons. Indeed, Ochino was the only member of the group who was also a member of the clergy, while the others were all lay people and examples of the passionate interest that religious questions could provoke in Italian society as a whole.

Valdés' most original and powerful ideas concerned divine grace, which God grants human beings not for their merits but for the sincerity of their faith in relation to the sacrifice of Christ who became man in order to gift salvation to mankind. Other questions – such as the idle presumption of good works, the lucidity of the Scriptures and even the non-existence of Purgatory – were discussed in Naples, but their form became shadowy and blurred owing to persecution by the Inquisition. As early as 1538, the content of Valdés' sermons had become a matter of concern to the more zealous members of the Catholic Church, who considered it to be dangerously close to Lutheran heresy and had already decided in 1530 that the only response to the Reformation was a trenchant and uncompromising reaffirmation of the unquestionable primacy of the Church of Rome. In the varied and fast-changing theological reality of 1540, it was not easy to impose religious orthodoxy, especially as devotions were manifesting themselves in such ambivalent and intentionally disguised forms as the private meeting and the impromptu sermon, which were provoking religious fervour at the time.

After the death of Valdés in 1541, his main disciples, Ochino and Flaminio, moved the centre for reflecting on and propagating their ideas away from Naples, as they had become aware of their subversive potential for the institutions of the Church of Rome. Ochino started to preach with increasing success in the main Italian cities under the protection of Vittoria Colonna, who used her aristocratic influence to open the doors of the most popular churches in Italy. This capuchin friar's sermons became so threatening to Roman orthodoxy that in 1542 he was forced to escape to Switzerland, thus creating a profound rift within Italian society.

The radical and irremediable nature of Ochino's break with the Church of Rome was revealed by his flight and his correspondence, particularly one very compromising letter to Vittoria Colonna herself.

It clearly showed that fundamentally his theological doctrine was almost identical to the Lutheran heresy, as he had embraced the idea that salvation was possible solely through faith and not good works. Ochino's asylum in Switzerland convinced Giampietro Carafa – the zealous founder of the Theatine brotherhood who at this very time became the head of the Roman Inquisition, which had just been re-established – of his worst fears over the infiltration of Lutheranism into Italian society.

On the other hand, Valdés' other disciple, Marcantonio Flaminio, joined the retinue of Cardinal Reginald Pole, who was Henry VIII's cousin and had had to flee the latter because, amongst other things, he opposed the king's marriage to Anne Boleyn. Pole's court, which gathered at Viterbo following his appointment as Papal Governor of the Patrimony of Saint Peter (in effect the area around Rome) in 1540, had become the centre of new reformist theological ideas which might have resolved the deepening crisis within the Church of Rome in the face of Protestant attacks. The men who gathered around the English cardinal included Flaminio, Apollonio Merenda, Alvise Priuli, Giovanni Morone and Ludovico Beccadelli, who would remain Michelangelo's friend until the final days of the artist's death. Vittoria Colonna was an unusual member of this group as she was a woman, but this did not mean that her involvement was in any way less significant.

The repression carried out by the Holy Office makes it difficult for us today to establish the distinctive features of this group's theology. However, we can say with some certainty that it must have aimed at some kind of reconciliation with the Lutherans. This possibility was argued with prudence and generosity by Cardinal Gasparo Contarini at the Ratisbon [Regensburg] negotiations in 1541, but was severely reprimanded by the more fanatical wing of the papal court, whose majority perceived such theological options as beyond the pale. The Viterbo group's ideas were expressed in *Il beneficio di Cristo*, a short work which was sensibly published without an author's name in Venice in 1543, and had also been circulating in manuscript form at least since 1541. It was probably written by a Benedictine monk in Mantua and revised by Marcantonio Flaminio in Viterbo. This was happening during the period in which Vittoria Colonna was living there and becoming increasingly close to this circle, disparagingly referred to as the

'Church of Viterbo' [*Ecclesia Viterbense*] – suggesting that it had its own rules which differed from those of Roman orthodoxy. The book clearly expresses the conviction that God's grace is gifted to man through faith and not through good works, which still have the merit of accentuating the truth and the rightness of faith. Religious sentiment was taken back to its original value by decisively rejecting the mediation of the Church as an institution. The observance of the precepts on which the Church established its control over the faithful was moved far into the background, thus undermining the very foundations of the power held by ecclesiastical hierarchies.

The great emphasis on faith belonging to a Christian's inner life and on the salvationist significance of Christ's sacrifice resulted in demands for the Church and its regulations to shift towards a more spiritual organization and a reduction in temporal power. The Viterbo group went as far as to challenge the system of ecclesiastical benefices, which by then were considered purely a form of unearned income with no relationship to pastoral activities. Indeed, they even questioned the absolute authority of the pope and his relationship with the Church councils, as well as those rules and precepts that had no basis in the Gospels, such as the celibacy of priests and the prohibition on eating meat on Fridays. These were all questions that led away from the corpus of rules and disciplines on which the Church of Rome was founded. There was enough radicalism in these ideas for their supporters to be accused of heresy.

The book was condemned in Trent in 1546, even though the hunt for its authors started from the moment it was published. However, the harshest blow to the possibility of reconciliation with the Lutheran heresy was inflicted by the Council of Trent on 13 January 1547, with the approval of a decree that confirmed that salvation is based on both faith and the meritorious value of good works – in other words, the observance of the rules imposed by the ecclesiastical tradition. This was tantamount to proclaiming a definitive and irredeemable rift with the Lutherans and that part of the Catholic Church that was working secretly for a reconciliation. As soon as he realized that the opposing view was going to prevail, Reginald Pole, the papal legate at the Council, left Trent on the pretext of a supposed physical ailment, to the delight of his friends in the Viterbo circle, particularly Vittoria

Colonna and Giulia Gonzaga, and to the annoyance of the hardliners at the papal court who used that decree to proclaim their victory.

The prudence of that nebulous group, which became known from 1540 as the 'Spirituals', was not sufficient to save them from persecution by the Inquisition. It is still difficult to establish just how radical their ideas were and how conscious they were of their own responsibilities, given that the same Catholics who persecuted them never ceased, after their death, to seek their rehabilitation in view of their undoubted moral, intellectual and indeed political strength. The Viterbo group that embraced Michelangelo as a brother in the summer of 1543 left very little trace of itself other than the record of its destruction, which was of course written by their opponents. Fifty years later, Carafa's followers, who emerged as the victors, argued that the *Ecclesia Viterbense* was a heresy and that it had been right to obliterate it.[8] Even though later historians have often attempted to soften their judgement, the fact remains that the Spirituals were defeated in their bitter and cruel clashes with Giampietro Carafa between 1540 and 1559, and Carafa became pope in 1555, taking the name of Paul IV. Their reformist theological arguments were still considered a threat to the official Church at the beginning of the seventeenth century, when Paul IV's biographer Antonio Caracciolo set about the task of demonstrating fully all the offences of Pole and Vittoria Colonna to justify the repression that Paul IV inflicted on them.

We need to be aware of these events, in all their complexity and obscurity, in order to understand Michelangelo's artistic production after the *Last Judgement*. This is not only because his commissions came almost exclusively from this group, even long after they had become victims of the persecution (Giovanni Morone); it is primarily because the friendship between Michelangelo and Vittoria and the other members of the group was based on shared beliefs that were entirely spiritual and religious, in spite of desperate attempts in the nineteenth century to reinterpret it as a sentimental or even sexual relationship. It was an exchange of reflections on the question of salvation, which dominated thinking in the group.

Michelangelo's works, unlike his correspondence with Vittoria and Pole or the books they exchanged, were not burnt or seized (although there were occasional attempts to destroy them). Today they represent

one of the most vital documents of that very particular and dangerous faith that was strangled at birth by the Council of Trent, because now it has been freed from the sophisticated corpus of propaganda designed to arrogate his works to the orthodox party in the Church – the very one they were intended to challenge. Some paid for their faith with their lives; others had to face imprisonment. Vittoria avoided such humiliations, because death came before the Inquisition could.

The dialogue between Michelangelo and Vittoria Colonna remained an unsettling fact for both their destinies, mainly because, in the endless summaries of the Inquisition's trials, the mere association with Vittoria Colonna and Reginald Pole was considered absolute proof of heresy. The solicitude with which Vittoria greeted her friend in Viterbo during the dramatic summer of 1543 is the key to understanding that friendship which was immediately obscured by the persecutions. Vittoria asked her friends to lend her spectacles to assist the artist's eyesight, which had been sorely tested by the work on the Pauline Chapel. The meeting was also with Alvise Priuli, Flaminio and Reginald Pole: the core members of the Spirituals, who would be mentioned along with Michelangelo in the many other documents which demonstrate their familiarity. Vittoria Colonna asked if she could give the artist Pole's spectacles, but only for a few days, as she had already ordered new lenses from Venice which would be mounted on 'a gilt silver frame' to ensure that taste and style were maintained even in such a practical object. Venice had been home to the most advanced spectacles industry for two hundred years, and the extremely refined aestheticism of Venetian goldsmiths and arti-sans turned this product into a splendid and indispensable accessory. Besides, how could she deny assistance to a friend 'who was working hard on the chapel of Saint Paul?'[9] For once, the religious dialogue that dominates the few extant letters leaves a little room for Vittoria's maternal instincts, which confirm a role she adopted years earlier in relation to her other friends, particularly Reginald Pole.

It is difficult to know what Vittoria and Michelangelo talked about behind the damp volcanic rock of the Santa Caterina Monastery. However, we do know what Vittoria was saying to her other friends at that time, and we know it because of the transcripts of the Inquisition, which collected the letters she wrote from Viterbo within days of their meeting, in order to prove her heresy. The charges are listed in a file

that emerged from the archives of the Holy Office just a few years ago: 'Videtur astruere errorem de sola fide et de certitudine . . . Videtur tenere certitudinem gratiae . . . Videtur tenere securitatem et confir- mationem in via . . . Videtur astruere haeresim dicentium Christum purum hominem. . . . Videtur negare propria merita et tantum asserere imputationem etc.' [She seems to build her error from her own faith and sureness alone . . . She seems to have the sureness of grace . . . She seems to maintain certainty and confidence on this path . . . She seems to be constructing the heresy of those who say that Christ is pure man . . . She seems to deny his proper merits and simply to assert the impu- tation that etc.][10] The Inquisition's spies who intercepted the letters of Michelangelo's closest friend had no doubts about her heresy and the dangerousness of her conversations.

Vittoria and Michelangelo almost certainly engage in passionate debate about the works that were damaging the artist's eyesight: the statues for the tomb of Julius II and the frescoes in the Pauline Chapel. Vittoria was convinced that everything that was happening around her during that period was the product of a very specific divine plan: a plan that had entrusted her spiritual mentor, Reginald Pole, with the holiness and prudence required to reform the Church of Rome, and Michelangelo with the inspiration and living faith to enable him to rep- resent the greatness of Christ's sacrifice and the purity of their renewed faith, through his paintings and sculptures.

We can only guess at the reasons that led Michelangelo towards that particular form of worship and involvement in heretical fervour. One of the most fascinating points of doctrine was the manner in which it embraced sinners, who more than anyone else were deserving of divine grace, because – as was said by Saint Paul and emphasized in many of Vittoria's letters and in *Il beneficio di Cristo* – 'those who have not known evil cannot enjoy good.'[11] The imperfection of mankind, when accompa- nied by faith, does not impede salvation but on the contrary favours it.

There can be no doubt that Michelangelo suffered from his tortured and turbulent personality, his repressed or at least never happily expe- rienced homosexuality, and his diffidence, which transformed into a persecution complex on encountering the least problem. All these kept him in a state of continuous guilt and rendered him particularly suscep- tible to the question of salvation, which was unsettling the consciences

of all men and women of his generation. Equally there can be no doubt
that this particular religious interpretation, so compassionate but also
so respectful of the value of every human being, powerfully attracted the
artist and drove him to evaluate his life in relation to the Gospels, which
everyone was now studying and interpreting with frenzied anxiety.

4 A FERVID HERESY

Immediately after the unveiling and public viewing of the *Last Judgement*,
Michelangelo decided that the time had come to finish his work on the
tomb of Julius II. He wished to end the dispute between him and the
Della Rovere family, which had now lasted forty years: a dispute that,
according to his own words, had become the tragedy of his life.

When he had started the building work on the Church of San Pietro
in Vincoli in 1533, Michelangelo had casually decided that it would
be practical to use the material gathered for the monument before his
departure from Rome in 1517. In order to adapt the previously worked
and squared-off marble to the new site, he had a large lunette opened
in the wall against which the tomb was supposed to stand, in such a
manner that the light, which came from behind as well as from the right
and the left, created the effect of spatial ambiguity and the appearance
that the tomb was not set against the wall but floated freely in the air.
This expedient, which was a century ahead of Borromini's and Bernini's
research into the 'internal' light of monuments and the theatrical
ambiguity of architectural forms, was the best way to adhere closely to
the idea of a three-dimensional monument, which he had been work-
ing on for thirty years. The vast architectural structure was therefore
perforated internally so that it could receive the light as though it had
been placed in a free space. This allowed the light to slip down onto the
statues and the moulding in a soft and diffused manner, so as to create
a very spiritual atmosphere and eliminate a brutal and direct source of
illumination (Plate I.25).

This was a bold idea, not only from a compositional point of view
but also in terms of the building's stability, because the wall which
Michelangelo had opened up to create the large lunette – compared
with which, as Sebastiano del Piombo said, 'the Colosseum is a brute' –
was holding up a lower ceiling which was made dangerously unstable by

opening the wall. Confident of his own engineering skills, Michelangelo had the keystone of the lunette's ceiling anchored to the facing wall by an iron chain, which compensated for the resistance eliminated by the demolished part of the wall. The sculptor and painter had now become an excellent architect, who was very sure of his construction techniques.

Having prepared this imposing and evocative scenario, Michelangelo decided to place six statues in it, almost all of which were already finished or at a very advanced stage in their production. The dimensions of the statues had to be compatible with the new narrow recesses carved in the wall. Of the statues that had already been produced for previous plans, a *Sibyl*, a *Prophet*, a *Madonna* and a reclining *Pope Julius II* were destined for the upper section. Two of the *Prisoners* he had started working on twenty years earlier were intended for the base. Apart from the *Madonna*, which he had had rough cast by Scherano da Settignano in 1537,[12] and the pope, which he himself had started working on no more than a few years earlier, the other four statues were almost finished. In theory, he should have been able to finish the work within a few months, and thus bring to an end a commission that had lasted decades.

Yet again, his talent did not help him to find peace of mind. As soon as the enormous enterprise of the *Last Judgement* was finished, Paul III had another project for him, which was less demanding but nevertheless not exactly simple for an artist who was close to seventy years of age. The ageing pope was jealous of the fact that the magnificent chapel decoration, part of which he too had commissioned, was now irredeemably named Sistine after Sixtus IV who had started the works, and thus wanted posterity to associate his own name with the new chapel he had had built by Antonio da Sangallo. Situated at the Vatican not very far from the Sistine Chapel, the new chapel would eventually be called the Pauline. It was to be home to the Blessed Sacrament and, most importantly, the conclaves to elect new popes would be held there. He was so determined to make this new building the most magnificent in Rome that he not only demanded that Michelangelo should immediately start on painting it, but also decided to expropriate the Della Rovere family of the statues the artist had already sculpted for them.

Paul III had no sympathy for the Dukes of Urbino. Like his

predecessors, he had attempted to seize part of their duchy to give it to his son Pierluigi. But Francesco Maria Della Rovere, with his skills in warfare, had succeeded in at least partly impeding this plan by opposing the pope militarily with the support of the Venetian Republic. However, he died in 1538, leaving as his heir the youthful Guidobaldo, whom the pope must have considered to be not such a hard nut to crack.

In the autumn of 1541, Paul III was convinced that his wishes were finally going to be fulfilled. But Guidobaldo, in spite of his youth, proved to be an excellent diplomat. To increase his political influence over the military situation in Italy, he secretly formed an alliance with the king of France and abandoned the imperial camp, which upset the fragile balance of power in the Italian peninsula, now it had been divided up between two European powers. This occurred at the most difficult moment in Charles V's reign, just after his crushing defeat off Algiers in October of the same year. At this stage, the pope understood that he would have to secretly support that decision in his own dynastic interests. As a very acute observer of the time wrote,

> if the French come out on top in Italy, the Pope will have gratified the King with his consent that the Duke [Guidobaldo: *author's note*] serve the King, but if they lose and the Emperor is the victor, the Holy Father could by good fortune have designs on the duchy of Urbino for his nephew by means of the Emperor, while at the same time ensuring his claim over Camerino.[13]

Guidobaldo's skilful political manoeuvre forced Paul III to treat the young duke with greater consideration. This also affected negotiations over 'minor' questions such as the dispute with Michelangelo, which once again was overtaken by politics, as though it now constituted too important an issue to remain within normal relations between artist and patron.

In November 1541, the pope simply 'notified' the duke of the seizure of the sculptures through his commissioner in the Marche, but three months later, following the shift in the political relationship between the two, yet another agreement was signed for Julius II's monumental tomb. Guidobaldo allowed Michelangelo the freedom to serve the pope in the Pauline Chapel and authorized him to have three of the statues

on which work had already commenced finished by another sculptor: these were the *Madonna and Child*, the *Sibyl* and the *Prophet*. The other three statues – the two *Prisoners* and the reclining pope – were almost finished; indeed, the pope had already been placed on the monument under construction, clearly in order to reassure the Della Rovere family of Michelangelo's intentions of completing the commission, but also because the new pope had no use for that particular statue. On the other hand, Michelangelo undertook to provide another statue to compensate the duke for the loss in value incurred by having the three statues finished by his assistant Raffaello da Montelupo. The extra statue was that of *Moses*, which could only be placed in the central recess in the lower section, where there were supposed to be some narrative bas-reliefs marking the ideal entrance to the tomb (some of them had already been installed, but today we cannot see them because of the statue of Moses). In other words, everything could have been completed within a few months, given that all Michelangelo had to do was finish *Moses*, which had been highly regarded even before it had been completed.

But Michelangelo was no longer the same man, and had distanced himself from the practical nature that had always guided his life. The Moses at the centre of the base radically altered the plans he had remained loyal to for forty years, and the *Prisoners* had no reason to be next to a biblical figure who evoked entirely different associations. His own financial interests should have persuaded him to finish the work in that manner, but his restless spirituality, which was now profoundly altered by the heretical ideas from the North, prompted him to different and more laborious ways of completing the work. Those few months were the period of greatest intimacy with Vittoria Colonna and her group, which almost certainly included Eleonora Gonzaga, the wife of Francesco Maria Della Rovere and the mother of the youthful Guidobaldo. Their shared beliefs on faith undoubtedly became tangled up with their ideas about works of art that had to express their profound religious piety through images.

While it is generally misleading to superimpose artists' works onto their convictions, in this case a commission that involved Eleonora Gonzaga and her brother, Cardinal Ercole Gonzaga, must also have evoked in Michelangelo's mind the new and dangerous spirituality they shared. Because of his relationship with Vittoria Colonna, the

Michelangelo of this period broke with all preconceptions. Their relationship was based on spiritual affinities that were free from any taint of trading in a 'service', which normally occurred even with such sophisticated services as the provision of art works. The works Michelangelo produced for Vittoria were an assertion of the spiritual closeness and their shared faith:

> Your products influence the judgement of anyone who looks at them, and for the greater of experience of seeing them, I spoke of increasing the excellence of perfect things. And I saw that *omnia possibilia sunt credenti*. I have very great faith in God, who has given you a supernatural grace in order to make this Christ. Then I saw that it was so marvellous that it exceeded all my expectations. Finally, emboldened by your miracles, I desired what I have now seen marvellously completed, or rather what is now complete perfection in all its parts. And one could not ask for more, nor go so far as to desire so much. I tell you that I am much cheered that the angel on the right is so much more beautiful, because Michael shall place you, Michael Angel, on the right of our Lord on Judgement Day. In the meantime, I do not know how to serve you other than praying to this sweet Christ you have so well and so perfectly painted, and to beg you to command me as though I were your possession in all and every way.[14]

It is only too clear that the spiritual and devotional elements of Colonna's critique prevail over the purely formal and stylistic ones. The work becomes the vehicle for a relationship based on shared sentiments, which was identical to the one between Vittoria and Reginald Pole, in which she commented on his writing with the same intensity of feelings. This was the climate of heartfelt religious devotion in which Michelangelo bravely decided to make a final radical transformation to the tomb, which was against his personal financial interests. This could be interpreted as the fruit of his unique and very passionate faith.

In the spring of 1542, Michelangelo, who appeared unconcerned about the hard work he was creating for himself, started to sculpt two new statues, *Active Life* and *Contemplative Life*, destined to replace the 'Prisoners', even though these were perfectly finished and ready to be placed on either side of Moses. These two figures were sculpted by

Michelangelo, but were the product of the theological universe briefly described in the *Beneficio di Cristo*, which was much debated at that time by the Viterbo circle. Traditionally, Moses was associated with Christ, as before the sacrifice he was the bearer of a law that led towards salvation and therefore his precursor in the Old Testament, and similarly the two allegories [of active and contemplative life] symbolized the path of salvation indicated by Christ through his sacrifice.

Contemplative Life (Plate I.26), an extremely pure allegory of the fervidness of faith, is like a flame burning the almost non-existent body of the woman whose eyes look upwards to the heavens where she searches for the cause of her own salvation. The entire expressiveness of the figures is concentrated in her twisting movement, the transport of living faith that the body can actually transmit, as long as Michelangelo Buonarroti is doing the sculpting. The face is gaunt with ardour and the features fade under the power of feeling. The chalice that distinguished her in so many previous representations is no longer there, for Michelangelo now perceived it as the symbol of an overly superstitious faith. His pure faith had no need of symbols, but only sincere passion.

Active Life (Plate I.27), the symbol of charity, looks straight in front of herself with humility, as Saint Paul demanded of her. She has a generous body and is barefoot, because good works must be solicitous and above all a gift of oneself. Her clothing reflects a greater worldliness and her hairstyle is excessively complex, because it has to draw the observer's eyes towards the small object she is holding in her right hand: a lantern whose flame is fed by that hair which ends up in the lantern. According to the medieval tradition, hair that burns like a flame is the symbol of the good thoughts that inspire charity, and the concept continuously recurs in the metaphorical language of Vittoria and her friends.[15] In her left hand, *Active Life* holds a crown of laurels, the symbol of charity because of its eternal greenness and infinite circularity.

The two figures, thus conceived, refer to the particular role that the theology expounded in the *Beneficio di Cristo*, attributed to faith and charity in its attempt to mediate between conservative Catholicism and the Protestant Reformation. Faith saves, and in its fervour turns towards the heavens, where it appears to ascend like fire. Charity does not save, but is equally valued because of its capacity to illuminate the

truth of the sentiment of faith, just as the flame reveals the ardour of fire. Pole's advice to Vittoria Colonna illustrates this concept very effectively: pray as though prayer should save you through faith, and act as though actions should save you through good works. Michelangelo's sculptures shouted this to the entire world.

Above the two female figures, another sculpture takes us to the centre of the theology of the Spirituals: the pope reclining at the centre of the first order of the tomb. The space available for the sculpture, which should have been the most important of the monument because it was a portrait of the dead man it had to celebrate, was reduced to a protruding surface of 140 by 42 centimetres and presented serious compositional problems, because its height off the ground meant that it was not very visible. To increase the monumental nature of the work, Michelangelo thought up the idea of a reclining figure in the act of lifting himself up and twisting his torso forwards, while his legs draw up and slightly separate. It is a very complex pose, but it succeeds in giving the small figure a grandeur that would otherwise have been impossible. But it was not only in the pose that Michelangelo came up with an unprecedented and bold compositional statement. There was also the subdued and stark expression, with clothes to match – something that had never occurred in a monument to celebrate a pope. Julius II, the pope whom everyone in Italy remembered as prouder than an emperor and always with a sword in his hand, had now become a defeated and doubtful man who agonizes over what awaits him in eternity. His only comfort to lessen this doubt is the crucifix, a symbol of the only secure means for humanity to obtain the salvation that so obsessed the Spirituals. The one on the maniple that hangs from his left arm is the only emblem left on his vestments, which all other artists would have gone to great lengths to cover with gold plaits and precious stones to celebrate the worldly power of the Vicar of Christ.

One couldn't have got further away from Julius's temporal triumphalism, which Michelangelo had celebrated thirty-five years earlier in Bologna with a bronze statue, but also from the decorum that popes insisted upon in all the monuments to preserve their memory (suffice it to think of the contemporary tombs for the Medici popes sculpted by Bandinelli in the choir of Santa Maria sopra Minerva). The soberness and humility of the pope's appearance was intended to celebrate

another sentiment that was being asserted in the Viterbo circle: that of a return of the Church to a purely spiritual dimension that was distant from secular government and the abominable dealings developed in its name. This sentiment – this demand that is clearly expressed by Michelangelo's Julius – was perhaps the tomb's most subversive element, when compared with the traditional representation of a papal regality, and certainly could not have become part of the work without the consent of whoever was supervising its progress.

The statue which Michelangelo plainly produced with the agreement of Eleonora Gonzaga expressed a clear position that had been adopted within the current debate on reform of the Church and the nature of salvation. By chance, the principal protagonists of that highly exposed reform wing were gathered around the tomb of Julius, and moreover they were fully aware that they were breaking the rules. They were Eleonora Gonzaga, who was now commissioning the sculpture, Vittoria Colonna, Reginald Pole and his heretical court. Vittoria's letter, one of the few that escaped the censor, tells of how many of this circle's pious meetings had taken as their inspiration the works of Michelangelo, who had had the gift of expressing on their behalf the sweet passion of a renewed faith. 'My most genial lord, Michelangelo, I beg you to send me the Crucifix, even though it is not complete, because I would like to show it to the gentlemen of the most reverend Cardinal of Mantua, and if you are not working today, you could come and talk to me at your convenience.'[16] The thousands of works of art that Christian Rome had accumulated over one and a half thousand years of worship and dispersed amongst hundreds of churches and houses in the city were not enough to quench the thirst of this new faith that motivated these men and women who wanted to see and comment upon the small crucifix that Michelangelo was painting in his studio but had not yet completed. Julius II's tomb ended up being the same symbol on a monumental scale – the most refined expression of the group's hopes at a time when it was beginning to suffer persecution at the hands of the Inquisition.

5 THE NEW STYLE

The production between 1541 and 1545 of the statues of the *Active Life* and the *Contemplative Life* and of the reclining pope also marked

a stylistic change in Michelangelo's work, perhaps the most important in his very long career. The sculptures are distinguished by a very soft passage from one volume to another, and this gave the marble a waxy effect however much he managed to soften and enhance the contrasts in plasticity. The folds in the fabric of clothes miraculously manage to suggest the underlying anatomies, which are no longer the swelling musculatures that dominated the Medicean tombs, but rather flesh that only expresses sentiment.

The praying figure portrayed in the *Contemplative Life* is consumed by her transport towards the heavens, and of her body the viewer can only make out her small breast, the sharp features of her face and her barely veiled hip visible between the heavy folds of cloth that cover it. Faith is not of this world, but rather entirely spirit and already in heaven. The depiction of the charity in *Active Life* is, on the other hand, a celebration of nature, a Demeter or Flora with wide and fertile hips, strong arms and her legs entirely visible under a delicate and form-less garment, which Michelangelo used to cover all his biblical figures during this period: simple and suggestive cloth that did not relate to any particular ancient or modern fashion, but simply to the idea of pure simplicity to which a mind devoted to good subjected the body.

The hair of *Active Life* is made up in a complex manner that empha-sizes the profusion of her thoughts and the strength that a person must have if they are to work for good in this world. Her legs, which provide the slightest suggestion of movement, are one of the greatest achieve-ments of Michelangelo's sculpture. They are covered by gossamer-like fabric that runs with the transparency of water over their forms in a natural and congruous manner that is difficult to imagine. Once again the tensions in her pose and gestures are governed by a supernatural calm, which is reflected in the softness with which the folds of cloth-ing run into each other and the tenderness of the expression on her regular and dreamlike face, as in the portrait of an ancient goddess. Her expression is modest and composed, in spite of the nobility of her features and her hair. Those who carry out charitable acts have to be aware of the limited efficacy of good works on the road that leads to salvation.

The powerful sentiment contained within these two sculptures, which lack any form of acclamatory rhetoric, makes use of an absolutely

extraordinary technique. The undercut for the clothing and pleats that show up the shape of her body is sculpted to a depth that could not be achieved with other chisels. The difficult nature of the work does not diminish the absolute credibility and naturalness of the most difficult details to sculpt, as in the sequence of the hands joined above the breast of the *Contemplative Life* and the right hip of *Active Life*, where the arm disappears into the profound depths created by the cloak. The nature of these statues is so new that critics have claimed that they were not the work of Michelangelo, in spite of the irrefutable evidence of their authenticity, which is partly based on documents. This emphasizes just how different their sentiment was from the affirmation of life and energy that Michelangelo had embodied in all his previous production.

Another compositional miracle was to be found in the reclining figure of the pope. Michelangelo exploits the double twisting of the body imposed by the limited available space magnificently; he laid out the marble block like a flattened piece of clay, and managed to make it overcome the limitations imposed by the architecture. The right shoulder, on which all the energy of the pope's movement is concentrated, is bent so that it extends beyond the base of the pilaster, and the right foot is over the corner of the other end of the base that marks the outer limits of the work. To provide a more convincing illusion of movement, the left leg is separating from the other and producing a deep shadow, although Michelangelo nearly takes up the whole thickness of the block to produce the groin. But the hands are the most remarkable thing about the sculpture, as they establish an unequalled record for mimesis in the representation of the human body. Previously there had only been two possibilities when sculpting a pope's hands, which along with the face were the focal point of the funeral ceremony, and these were the act of benediction or resting. However, Michelangelo could not be content with what had already been expressed and invented hands that speak through their very particular pose. They are hands of acquiescence and the awareness of the vanity and futility of good works, as these do not determine a person's eternal destiny. They are hands that tell of the humanity of the dead man and his infinite distance from the greatness of God, abandoned as they are after their futile attempt to grasp a substance that is not of this earth. These are hands that reveal

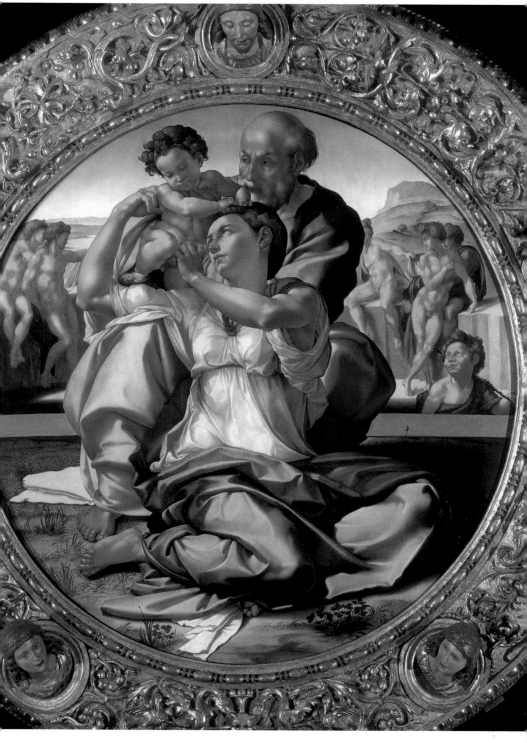

II.1 Michelangelo Buonarroti, *Doni Tondo*, Uffizi, Florence. © Alinari Archive-Florence

II.4 Michelangelo Buonarroti, *The Universal Flood*, Sistine Chapel, Vatican Palaces, Rome (post restoration). © Wikimedia Commons

Opposite: II.3 Ceiling of the Sistine Chapel, Vatican Palaces, Rome. © istock

II.2 Sistine Chapel interior, Vatican Palaces, Rome. © istock

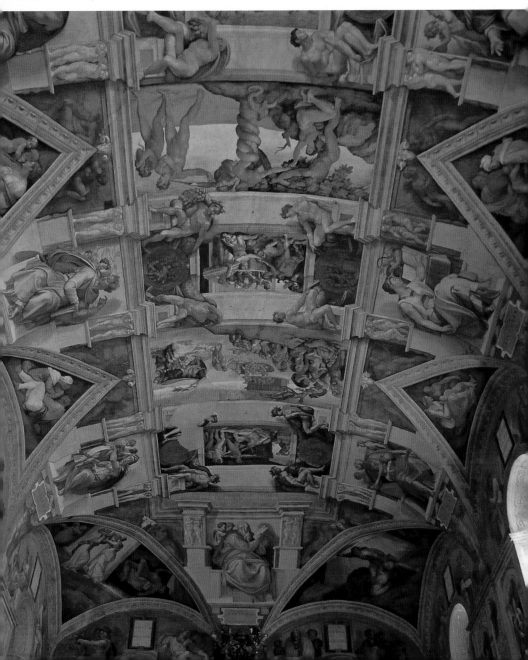

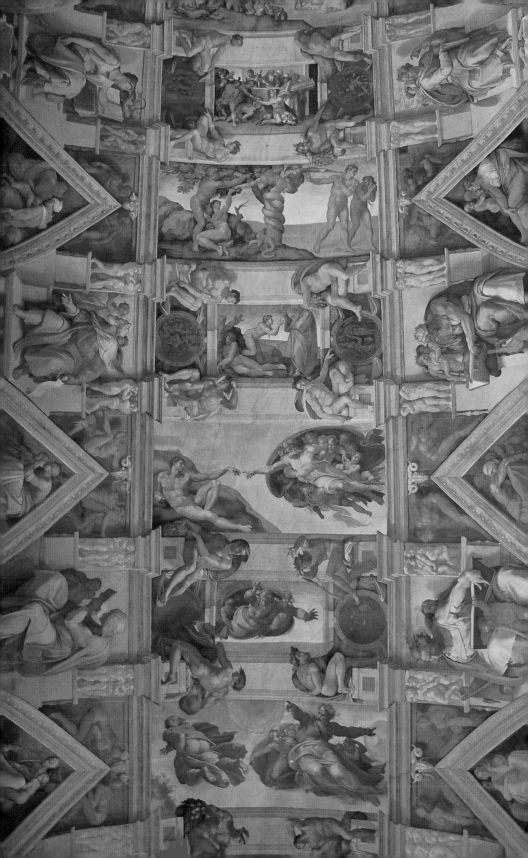

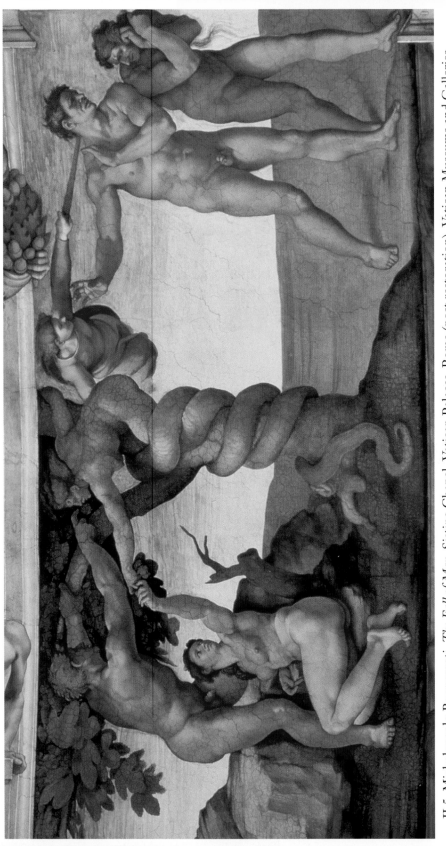

II.5 Michelangelo Buonarroti, *The Fall of Man*, Sistine Chapel, Vatican Palaces, Rome (post restoration). Vatican Museums and Galleries, Vatican City. © The Bridgeman Art Library

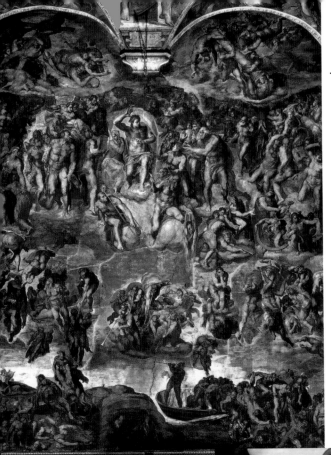

II.6 Michelangelo Buonarroti, *The Last Judgement*, Sistine Chapel, Vatican Palaces, Rome. © Alinari Archive-Florence

II.8 Michelangelo Buonarroti, detail of the devils, *The Last Judgement*, Sistine Chapel, Vatican Palaces. © Wikimedia Commons

Overleaf:
(left) II.7 Michelangelo Buonarroti, detail of Christ in judgement surrounded by saints, *The Last Judgement*, Sistine Chapel, Vatican Palaces, Rome. © The Bridgeman Art Library

(right) II.9 Michelangelo Buonarroti, *The Conversion of Saint Paul* (detail), Pauline Chapel, Vatican Palaces, Rome. © The Bridgeman Art Library

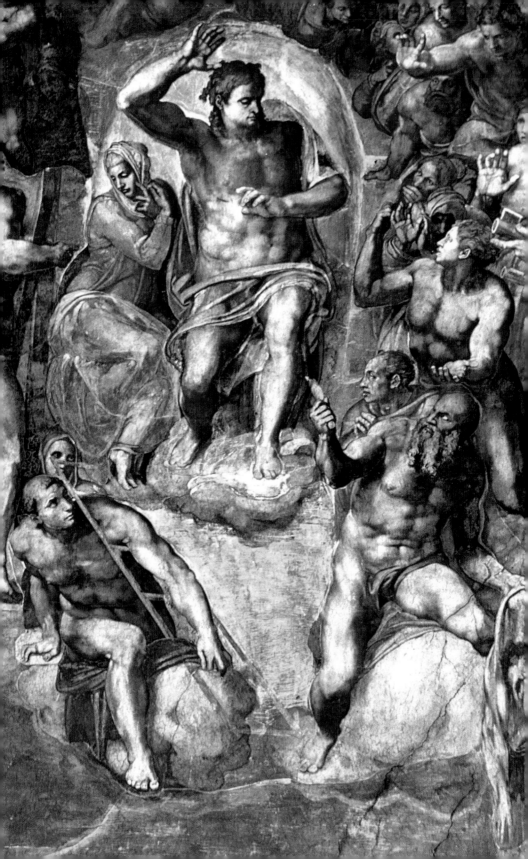

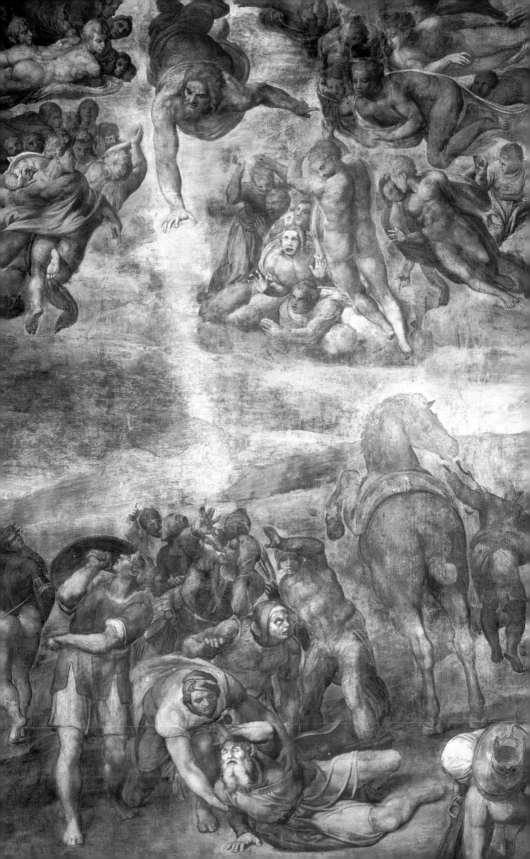

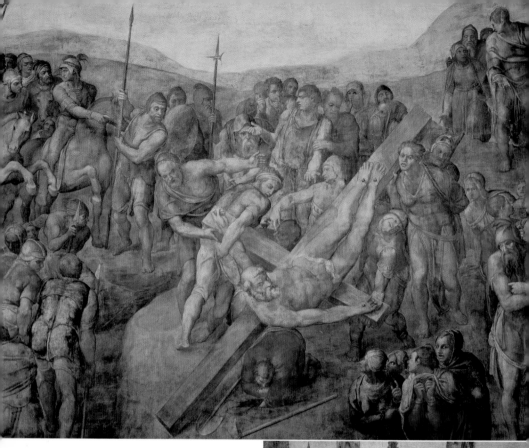

II.10 Michelangelo Buonarroti, *The Crucifixion of Saint Peter*, Pauline Chapel, Vatican Palaces, Rome. © The Bridgeman Art Library

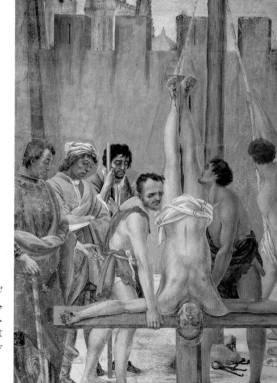

II.11 Filippino Lippi, *The Crucifixion of Saint Peter*, Brancacci Chapel, Florence. © The Bridgeman Art Library

the wretchedness of all humanity, even those who are popes, and the immensity of God's mercy.

There was nothing unplanned about the almost superhuman technical skill expended on the pope's hands. The sculpting of the fingers and their modelling within the tiny space available for drills and chisels was an unrivalled undertaking. The restoration revealed further proof of the frenzy in which Michelangelo sculpted this statue: the deep recesses carved out with chisel and drill were found to contain the marble dust from the original work. There had not been time for all the finishing touches on this precious statue. To give greater prominence to the gesture of the hands, Michelangelo constructed around them the shadow of a chest that was almost entirely to one side of the original block. Even though the extremely intricate sequence of levels would have been very difficult to see from below, the artist brought it to life as though there were a reason for its existence, irrespective of whether the world could see it. The pope's expression was full of the pitiful defeat that his hands were describing. The chisel blows furiously carved into the marble to reveal that unfinished face, with its barely rough-hewn beard already overflowing with emotion, his sunken eyes, his subtly suggested eyebrows pointed like those of an eagle, and his powerful nose slightly drooping with age. His cheekbones are high and wide, and reproduce the human and expressive type that would reach its greatest perfection in *Moses*, but serve even here to bestow force and energy on the ageing pope – force and energy that emanate from beneath the abandonment of death.

The statue was then subjected to various humiliations of fate that have reduced its worth. Damage, possibly during transport, was inflicted on the tiara just above the forehead, which was ineptly repaired so that it shifted the balance of the head's inclination forward. The legs, whose finish was left to an assistant, were smoothed off with a gradine, which thus destroyed the potential plasticity that Michelangelo had instilled in the marble. Once again, the artist only allowed his assistant to carry out very limited work, because he preferred that the sculpture should remain unfinished rather than have its spirit distorted, as was occurring before his very eyes with the sculptures entrusted to Montelupo. The *Sibyl*, the *Prophet* and the *Madonna*, which had already been in a very advanced state, were entrusted to an assistant with the same awareness

with which one makes a sacrifice. They had been finished in every detail, in a way that never occurred in any of Michelangelo's autograph sculptures (even those that were apparently more 'finished' still had some detail or portion that was still in an intermediary stage). Montelupo, however, was very fond of using a file, which Michelangelo never used for sculpting but only for smoothing surfaces, because it stiffened a statue's form and turned it into a mere shadow of the original idea. The faces became inexpressive because of the coarseness of the levels of construction. The *Sibyl* and the *Prophet* were particularly affected by heavy folds and wooden arms, partly because sickness prevented Montelupo from finishing them himself.[17] Vasari very offensively and maliciously put all the blame on him, while also denying his involvement in the statue of the *Madonna*, which had won the praise of Michelangelo. According to Vasari, this statue was the work of Scherano, an anonymous and second-rate sculptor who had only rough-hewn the marble block back in 1537.

6 THE TWO *MOSES*

The genesis of the *Moses* (Plate I.28) was as curious as its success with the public was universal – to the point of becoming a legend in its own time. It was rough-hewn before the artist's departure for Florence in 1517, from a marble block not very different in size from that of the *Sibyl*, of which it was supposed to be a companion on one of the corners of the first order of Julius's tomb. As had occurred with the ceiling of the Sistine Chapel, prophets from the Old Testament were supposed to mix happily with sibyls of the pagan tradition to produce a vision of cultural and religious syncretism which was widespread at the time.

After his final return to Rome in September 1534, Michelangelo discarded the idea of placing the *Moses* in the new structure, because the recesses – now right up against the wall – in the upper level no longer had the necessary space to receive him. Even the *Sibyl*, which was already a few centimetres smaller than the *Moses*, was mutilated by the artist in order to force her into the recess where we now see her. The *Prophet*, which was placed in the recess on the left, was still smaller, and it was sufficient to remove material from the back, which cannot be seen, in order to force him in, as became clear during the restoration

in 2000.[18] But to insert the *Moses* into one of those recesses would have meant such a radical distortion that the statue would have been entirely disfigured.

The mutilation of the sibyl's leg gives us an idea of the advanced state of Michelangelo's work on the statue before his return to Florence. Moreover we know that some time before 1536 the *Moses* was very favourably spoken of by Cardinal Ercole Gonzaga, in spite of its unfinished state. When Michelangelo found himself obliged to offer this statue to the young Guidobaldo Della Rovere in order to compensate him for the loss of value of the three statues entrusted to Montelupo, he had no choice but to place it in a central position within the monument. Thus he started work on it again in the winter of 1542, and completed it over the following two years.

The artist's creative ferment knew no limits, as had occurred with the Sistine Chapel, when a few months' interruption had led Michelangelo to return to his work with a different design of the prophets' thrones. When he returned to work on the *Moses*, Michelangelo wanted to change his pose in spite of the advanced state of the work. This extraordinary technical recklessness has left many traces on the statue, and even a document which went unnoticed until the material anomalies in the sculpture that became evident during the restoration required a cogent explanation. An anonymous witness who was very close to Michelangelo told Vasari after the sculptor's death that he had been present during the miracle that had been worked in just two days: 'And on going to see [what was happening], I found that he had twisted the head round and above the point of the nose he had put a bit of the throat with the old surface, which was certainly an amazing thing. I could hardly believe my own eyes, given that this was almost something impossible.'[19]

The sculpture, which he had planned between 1513 and 1516, was still close to the figurative world of the Sistine ceiling, and perhaps it not only had its face looking ahead but also its feet together as with the Cumaean Sibyl (or so it would appear from the strange shape of the cloak's hem, which is now next to the right foot in the shape of the other foot). In 1542, Michelangelo no longer liked this pose. The motives were certainly of an artistic nature, but the presence of the Altar of the Chains on the opposite side of the transept from *Moses*

may have influenced the decision to turn the prophet's head. The altar was the very symbol of Catholic superstition and the foundation of that temporal power that continued to uphold a Church in which Michelangelo no longer believed. According to an ancient tradition, a fragment of the chains that had held Saint Peter prisoner was miraculously united with a fragment found in Palestine when Eudocia married Valentinian III, marking the symbolic unity of the empire under a new Christian faith.

If *Moses* had been looking straight ahead, as was the original plan, his eyes would have fallen on that altar, whereas the astonishing alteration turned his head towards the light that came from an open window on his left, which today has sadly been bricked up. The ray of light that used to shine on his 'horns' at sunset must have been a very sophisticated final touch to that spiritual evocativeness that suffused the monument.

The turn of the head and the new position of the legs made it possible for Michelangelo to create an inner spatiality in the figure that no sculptor had ever previously managed. The left leg is bent backwards to lift him up and is fully flexed, as the previously sculpted marble did not give the artist room for the foot, unless the leg was twisted back in that manner. Thus the position of the leg became a powerful element merely because of fortuitous circumstances. To change the position of the left leg, Michelangelo was obliged to taper off the knee and widen it to create an immense and ambiguous space in the heavy cloak, which gave rise to the prophet's swollen chest. Because of the lack of marble, which had already been removed from the outer side, the left knee became much small than the right one, and this created an evident asymmetry in the figure. Michelangelo resolved the problem by covering the knee with a fold of cloth that intercepts the viewer's eye and leads it elsewhere – downwards and away from the radical difference between the two knees.

In the upper part of the sculpture, the lack of marble due to previous work is very clear in the treatment of the beard. The right half of the beard, which occupies the space originally occupied by the upper part of his body, is emphasized with unprecedented force. The locks are sculpted in the round and separated out from each other and indeed from the neck, so that one can touch the back of them with one's finger.

On the other hand, the left side of the beard, where there is no more marble, is barely noticeable and lacks depth or internal spatiality. To resolve the problem of the lack of marble in the lower part of the beard, Michelangelo shifted it all over to the right with an understated gesture – the gesture of the index finger, which in real life could never produce the results it does in the sculpture. The locks flow downwards from the chin like a river in flood and then inexplicably thin out at the height of the hand that intercepts them, and the only hair that continues down the left side is so flattened against the chest that it hardly appears to be there, as though it belonged to another sculpture.

The lack of marble also makes itself felt in the movement of the neck. On the right side of the *Moses*, where the artist could still rely on the marble of the original bearded chin, the neck is marvellously turned with a naturalness that takes one's breath away. However, on the other side, where the artist had make use of all the available marble, the movement is abrupt and awkward – entirely unnatural, given that the left shoulder cannot follow the movement of the neck, as should occur.

Equally the strange asymmetry of *Moses'* two horns – the right one pointing upwards and the left one inclined further down – appears to have been caused by the need to follow the sloping shape of the first rough cast of the head, in which even the space for the left ear was sculpted with great difficulty amongst the locks of hair, whereas the other ear clearly rises above the locks. These imperfections were less visible when the sculpture was positioned within the funereal monument. Michelangelo positioned it further back and lower down in the recess, but it was unfortunately moved from this original position in the early nineteenth century by Canova and the Academicians of San Luca, who were mistakenly convinced that the statue of *Moses* was the thing worth saving in this supposedly obscure monument – the fruit of Michelangelo's cynical entrepreneurialism. They therefore chose to put it on a new and contrived mounting.

However, the reinvention of the sculpture and the technical difficulties this imposed appear to have worked to Michelangelo's advantage, rather than cause the harm that would certainly have occurred with any other artist. The pose, which attempts to break out of the narrow confines of the partly worked marble, becomes elusive and ambivalent,

and produces an unsettling impression, which captivates the observer and which was so brilliantly examined by Sigmund Freud. The statue rebels against the original project and, in its final material form, acquired all the characteristics that immediately made it the object of such admiration. The creative process was extremely modern, albeit in an unconscious manner: a process that contemporary artists had been attempting for at least a century to bring under their control, but which Michelangelo took to its highest level because he felt the physical urge and not because of any ideological requirement. The figure's potential imposed itself on the artist's original plan and then guided his hand towards new images.

The technique adopted to overcome the obstacles was at the very limit of what is humanly possible. The *Moses* that replaced the old sculpture appears to emerge from an unlimited availability of marble, while in reality it exploits every millimetre of a highly restricted shape. The undercuts and empty spaces within the marble are so frequent and so imposing that we should not talk of a sculpture but rather of a monumental complex. The majestic leg is separated from the cloak in all its three-dimensional intensity, and we marvel at how the artist managed to sculpt the back of the calf muscle. The heavy cloak that covers the knee separates the folds from each other to such a depth that it suggests cloth that has somehow been magically turned into stone, rather than stone that has been carved. The beard which, as Vasari rather nicely puts it, appears to have been 'tidied up' with a brush rather than sculpted, is sensational not only for its spatial power, but also for the idea and the planning of those curves that flow downwards so gently and smoothly, like the slight spasms in the flowing water of a river in which the eye loses itself in pursuit of each of the locks of hair, freed from the marble that imprisoned them. The perfect poise of the arm muscles adds to the perfection of Michelangelo's modelling with a chisel. He no longer forced and compressed the energy but allowed it to flow freely into every detail of the figure, and concentrated it in those eyes from which it emerges to impact with the world and overpower it with its divine grandeur.

This appears to be one of the sculpture's main fascinations: the humanity of the forms, the power of the anatomy and the natural whimsy are, however, subject to a sentiment that imposes itself on all

the rest and appears to come not from that wonderful body but a world external to it, which uses it as a vehicle of communication to reveal itself. The spiritual power of the *Moses* spreads in the sinuous and irrepressible movements of the beard and hair, and is frozen in the eyes courageously opening to the light that proclaims his salvation, a light that sadly we are no longer able to see because, as already pointed out, the window from which it came has been bricked up.

For contemporary sculptors, all this must have seemed the manifestation of a miracle: marble folded with the naturalness of cloth or flesh, but above all devised with such perfect proportions as to necessarily evoke the presence of God in an essential manner.

7

THE PAULINE CHAPEL

1 PROBLEMS WITH THE DOMESTIC ACCOUNTS

In the 1540s, the seat of Saint Peter's found that its domain had shrunk with the expansion of Lutheranism in northern Europe, and at the same time, the basilica that symbolized Christianity and honoured the apostle had been under construction for decades and was being held back by thousands of problems and misfortunes. As never before, Rome was besieged by religious problems and the frustrated ambitions of the pope's family, which in 1540 started to consolidate its worldly position in Europe's political scene through a few highly advantageous matrimonial alliances.

Unfortunately, Michelangelo could not ignore the more prosaic demands of the flesh and the stomach, even when occupied in the high-minded struggles of the spirit. In particular, there were the demands of Urbino, an assistant to whom he had become much more attached than was good for him. Francesco di Bernardino d'Amadore da Casteldurante, also known as Urbino, had become one of Michelangelo's servants and apprentices after Antonio Mini left for France around 1530, and was now shamelessly exploiting that life and talent that had become inac-cessible to Europe's princes and potentates. He had no gifts and his shared life with Michelangelo, which lasted until his death in 1556, was

not sufficient to turn him into a passable painter or sculptor, except in the eyes of this employer, who wept for him in a manner he had been unable to do for his father, his brothers or even his most noble and affectionate friends. Thanks to Michelangelo's generosity, he would accumulate a fortune in land and property that would be valued at 2,800 florins on his death.

Urbino had an enormous power on the ageing artist, and men of extremely high social position would often turn to him to obtain favours from his cantankerous master that they did not have the courage to ask for directly. Benvenuto Cellini experienced his arrogance when, on behalf of Duke Cosimo I, he asked the artist to return to Florence. He was stunned to see that Michelangelo consulted his apprentice about this possibility: 'I do not wish to be separated from my Master Michelangelo, unless he rips me off or I rip him off.' It was such an insolent reply and so revealing of the artist's dependency on his servant that Michelangelo's goldsmith friend had difficulty in suppressing his urge to slap the servant around the face, given that for a great deal less he had run men of greater social standing through with the sword. Urbino, wrote Cellini, had treated Michelangelo 'more as a boy or servant-girl than anything else, and the reason was clear: the fellow had never learnt his art'.[1]

Urbino ground up the colours for Michelangelo during the work on the *Last Judgement* in the Sistine Chapel and the work in the Pauline Chapel. He even managed to get himself appointed *mundatoris picturarum Cappellarum palatii apostolici* in a papal brief issued by Paul III on 26 October 1543, which secured him the adequate remuneration of six ducats a month: an allowance for life that would have been the envy of many a talented artist. It appears that only the unlimited mediocrity of servants on the make could thrive in the company of the great master. Most surprisingly, Michelangelo gave Urbino two paintings that appear in the inventory drawn up on the latter's death in 1556: 'one of a Christ and one of an Annunciation'.[2] These were very rare paintings, because Michelangelo produced them after the 1540s, when even cardinals who were very close to him did not have the courage to ask such things of him. As he himself repeated, he did not trade in his art, but only granted it as a sign of his intimacy and deep affection.

Not content with the income he had assured as the master's assistant,

Urbino succeeded in 1542 in convincing poor Michelangelo, who was oppressed by demands from the pope and the Duke of Urbino, to sub-contract half of the 'surround work' to him – basically the frame of the upper level, which was necessary for completing Julius II's tomb in the Church of San Pietro in Vincoli. As Michelangelo was not completely blinded by love and was a very competent professional, Master Giovanni, 'sculptor in Pincers Square', was instructed to work alongside Urbino and supervise the proper progress of the works. Determined to exploit his employer's weaknesses, Urbino enlarged the house in Macello dei Corvi and used the extension as his own studio and private apartment. A few months later he persuaded the artist to exclude Master Giovanni from the subcontract and allow him to work alone. This was a very dif-ficult moment for Michelangelo, who personally undertook to resolve the dispute caused by his apprentice, and in the end he decided (as was obvious) to give into his protégé. The latter produced such shoddy work that it is difficult to understand how Michelangelo could have put up with such shabby behaviour – he who had sculpted his best statues for that tomb.

The servant's self-assurance had succeeded in winning Michelangelo's trust, something that very few achieved in his long life, and he convinced him that the highly lucrative contract was not enough. Michelangelo, who was tormented by the wishes of his servant, the pope who wanted him to start on the paintings in the Pauline Chapel, and Guidobaldo, the Duke of Urbino, who was demanding the com-pletion of Julius II's tomb, was overtaken by a period of black despair in the autumn of 1542. Once again, he attempted to change the condi-tions of his agreement with the Della Rovere family and asked permis-sion to have the work finished by Raffaello da Montelupo, to whom he had already entrusted the task of finishing the work on the *Madonna*, the *Sibyl* and the *Prophet* the previous winter,[3] even though the statues of *Active Life* and *Contemplative Life* were already in a very advanced state. Once again, he persistently asked the pope to get involved, and the pope did indeed get his very able grandson and in effect his sec-retary of state, Cardinal Alessandro Farnese, in the negotiations with Guidobaldo.

This pressure achieved nothing and the Duke of Urbino proved immovable: Michelangelo had to finish the sculptures personally.

Complaining bitterly and feeling deeply sorry for himself, the ageing artist resigned himself to having to undertake the massive task of starting on the frescoes in the Pauline Chapel and at the same time completing his *Moses* and the two female statues in his studio. The two works required energies that you could not really expect of a man who was nearly seventy years old, and his friends were concerned that the exertion would be too much. Sebastiano del Piombo, who was the most loyal and solicitous, and also the only one blessed with an established talent for art and politics, had advised him to paint in oil or on dry walls even when he was working on the Sistine Chapel, so that he would not be slave to the gruelling pace of painting frescoes. In return he received one of those grunts for which the curmudgeonly Michelangelo was famous: 'oil painting was a woman's art or for affluent and sluggish people like Fra Bastiano'. And that was the end of the matter. Michelangelo could not conceive of art as anything other than the beauty of the material in which it manifested itself.

2 THE EMOTIVE POWER OF LIGHT

Michelangelo started to paint the walls of the Pauline Chapel in the Vatican either at the end of 1542 or the beginning of 1543. This commission would keep him busy for the next eight years, even though the paintings were much smaller than the endless expanses of the *Last Judgement*, which he had managed to complete in just six years.

The first documents that demonstrate his involvement in the Pauline Chapel record the payments to Urbino for grinding up the colours: '16 November 1542. Eight ducats paid to Urbino, the servant of Master Michelangelo painter, for his usual service of grinding up the colours to paint the new chapel of Saint Paul.'[4] The task for Urbino, who followed Michelangelo onto the two sites to fulfil entirely different responsibilities, was the preliminary phase of the master's painting. Urbino had to refine the colours by grinding and pounding them in a marble mortar, and freeing them of all impurities through repeated washes.

The range of colours used in the Pauline Chapel is exactly the same as that of the *Last Judgement*: *terra d'ombra* (brown pigment made of coloured clays containing iron peroxide and varying from orange-brown to greenish brown) and *bianco sangiovanni* for the flesh tones, *terra verde*

(complex brown useful for Mediterranean landscapes), yellow ochre, Mars brown, red ochre and *morellone* (one of the many red ochres from a ferrous mineral) for landscapes and clothes, and for the skies the very costly lapis lazuli that came from Persia via Ferrara.

The two paintings produced in the Pauline Chapel from 1542 to 1549 were massive – six metres by six metres – and each consisted of more than eighty *giornate*, according to the inspection report published after the 1930 restoration, which provides us with some extremely precious information. One thing the survey tells us is that the ageing artist barely changed the amount of painting he concentrated into one *giornata* or the amount of plaster used for one day's work.[5] We would expect that, at around the extremely advanced age of seventy and having to climb up on a wooden platform that, however big, could not have been comfortable, Michelangelo would not have been able to produce large areas of painting within each day's worth of plaster. However, he in fact dealt with very significant portions of work each day, thus demonstrating that he was as vigorous as ever.

This simple fact lays to rest once and for all the widespread conviction that the paintings in the Pauline Chapel were the defective fruit of a man now in speedy decline. Their peculiarities have to be explained in other ways. Michelangelo himself provides us with a shining image of those years: temporarily freed from his hypochondriac obsessions, he told his niece in a letter that he felt no different from when he was thirty. The paintings fully back up this claim. In the *Conversion of Saint Paul* (Plate II.9), the complicated head of Christ takes up just one *giornata*, and it took another to do the two arms and a superb section of his chest. And we cannot detect anything less than brilliance in the complex *chiaroscuro* with which he modelled the figures' fleeting arms. A brief glance at this scene and those that Vasari was laboriously painting during the same period in the Sala dei Cento Giorni in the Palazzo della Cancelleria is sufficient to demonstrate how pitiful is the potential of youth and comfort when compared with a boundless talent and a voracious passion.

In a single day, Michelangelo also painted the arms and chest of the warrior who unsheathes his sword to the left of Saint Paul. Equally, the soldier who appears with the baggage at the bottom of the painting was completed within a day, and is almost a literal quotation from the

southern relief on the Arch of Constantine in Rome: yet further proof that, even at a time when he was greatly influenced by Catholic spirituality, Michelangelo conserved his love for the models and culture of classical antiquity, which was increasingly held in contempt by both the Lutheran faction and the Counter-Reformation.

The *Crucifixion of Saint Peter* is only slightly more broken up into separate *giornate* (Plate II.10). Many heads – indeed almost all – were painted within a single day, whereas in the case of the *Conversion of Saint Paul*, a *giornata* included part of the chest as well as the head. The figure of Saint Peter required eight days as against the four for Saint Paul, although the anatomical presentation of the first vicar of Christ is unrivalled in its perfection and fluidity. The other feature that distinguishes the *Crucifixion* from the *Conversion* concerns the meticulous manner in which the *giornate* follow the direction of the drawing, while breaking it up into small fragments. In the *Conversion of Saint Paul*, the *giornate* are wide islands that include arms, legs, heads and feet in a single portion. In the *Crucifixion of Saint Peter*, the edge of the *giornata* exactly follows the detailed shapes and almost coincides with them. If we ignored the colour and looked only at the outlines of the shapes, we would still be able to read most of the drawing of the *giornate* of the *Crucifixion*, given the manner in which the profiles coincide with those portions of plaster. This particular evolution in painting technique appears to be the only valid element in favour of placing the *Crucifixion* after the *Conversion*, given the lack of other genuine clues to the chronology of the two paintings.

The accumulated experience of many years made it possible for Michelangelo to improve the gradations in the light and shade effects to the point of fully involving the viewer's emotions. The diffused light from high up on the left – higher up than the Christ – exalts the gestures and expressions of each single figure. Without too many contrasts, without violent shifts in light and dark, the light slipped softly over the wriggling anatomies and the details of their clothing. It is an 'emotionally charged' light, in the sense that it underscores the passion of the action and would only be understood and taken to even greater extremes sixty years later by Caravaggio, that other great Michelangelo of Italian painting. But we very rarely reflect on light when we examine Michelangelo's work critically, because we are overcome by his

composition which was already considered the distinctive feature of the artist in the simplistic critical writings of the sixteenth century. The manner in which he chooses to use light for the action and essential details in the Pauline paintings reaches a perfection that was not achieved even in the *Last Judgement*, with its excessive contrasts that are too sharp and theatrical. Particularly in the *Crucifixion of Saint Peter*, the light emphasizes that part of the pose that most characterizes each person in the painting and brings it to the viewer's attention. Light strikes the arm and leg of the curious soldier who leans forward to view the martyrdom. It isolates the arm of the captain who arrives on horseback and points to the cross. It emphasizes how the two horses have ceased their gallop. It draws attention to the gesticulations of the pious man who wishes to rebel against the situation, and the friend who implores him to remain silent, while pointing to the sky where the destiny that is being played out has been decided long ago.

Lastly, the absolute homogeneity of the range of colours used in the two works has to be stressed. Yellow ochre and *terra verde* dominate the landscapes of both paintings, as do the isolated patches of red and white that mark the moments of greatest tension in the narration, just as high notes suddenly break into an *andante* score. In both scenes, a fluid background dominates and matches the nuances of the natural landscapes without giving excessive prominence to individual episodes. Even though it took seven very long and undoubtedly very troubled years to produce these paintings, there can be no doubt that their stylistic uniformity was maintained throughout.

Unfortunately there are very few documents that allow us to examine the events surrounding the pictures. Most certainly there were various interruptions, but these did not result from the master's age, with the exception of a serious illness that in June 1544 kept him in bed at the Strozzi home in Rome for many months. But in all probability Michelangelo was already back at work on the second painting, the *Crucifixion*, in the autumn of 1545, because on 10 August 1545 there was a payment to

> Francesco (alias) Urbino, servant of Master Michelangelo painter [the sum of] four *scudi* and fifty-four and half Y for the sum he spent in plastering and rendering one wall in the Pauline Chapel, newly created

in the Palazzo Apostolico, where Master Michelangelo is painting, as shown in the list, where the mandate also appears.[6]

3 THE CONVERSION OF SAINT PAUL

Contrary to all custom in figurative painting, the centre in the *Conversion of Saint Paul* is shifted to the upper left – to the figure of Christ. The groups of angels and the elect who surround the figure of Christ are converging on him like wedges bursting with energy in a space that is becoming so crowded, it is almost solid. This centripetal force is building up within the figure of Christ, who absorbs and compresses it in his powerful shoulders and then disperses it into his red cloak. Only a small part of this force is dispersed upwards through the right foot and the fluttering cloak. The greatest energy is offloaded like a lighting bolt through the muscular arm and the ray of light that strikes Saint Paul to the ground. The ageing saint is physically crushed by the sudden influx of this unnatural force. In this way and despite the asymmetry, the centre of the narration proves to be immediately and dramatically evident, and the story is entirely wrapped up in the dialogue between Christ and Saint Paul.

Michelangelo abandoned the traditional and official iconography in order to follow this narrative motif and bring it alive. His vigorous Christ, pushed forward by the angels and the elect, is completely upside down and stretching out towards what is below him, in a pose that had never been used before and would never be used again. His contemporaries were bewildered by that freedom, and the more zealous of them, who were convinced that art should illustrate and not interpret the scriptures, forcefully attacked that image of Christ as soon as they felt they could, as did Monsignor Andrea Gilio in 1564:

> It seems to me therefore that Michelangelo failed terribly in his Christ that appears to Saint Paul who, lacking all dignity and all decorum, appears to be falling from the sky in an act that brings little honour and majesty as would befit the King of Heaven and Earth, and a son of God.

The Church, which as an institution emerged victorious from the Council of Trent, had great difficulty in identifying with the freedom

of religious feeling expressed by Michelangelo. Raphael carefully avoided running such risks when he was producing his tapestries for the Sistine Chapel, as did Salviati in the Chapel of Alessandro Farnese at the Palazzo della Cancelleria, which were almost contemporary works of the paintings in the Pauline Chapel. The same can also be said of the Christs that appear in another two important depictions of the conversion of Saint Paul: Francesco Rosselli's woodcut, which can be dated to the 1510s and the one Domenico Campagnola produced in 1511. These were the principal iconographical sources with which Michelangelo's painting would have been compared.

In all these depictions, Christ majestically leans out from the clouds without ever renouncing the decorum in keeping with his divine nature. In Raphael's tapestry, the impossibility of inclining the figure of Christ prevented the artist from creating a relationship between Christ and Saint Paul. Christ actually seems to be addressing the fleeing soldier behind Saint Paul, and of course he is in the centre of the composition in perfect symmetry between the group of soldiers that has suddenly arrived and the saint's own group, which is stricken with fear. Overturned and placed in a rather unkingly but nevertheless powerful and dynamic pose, Michelangelo's Christ becomes a source of vital energy. The same is true of the figure of Saint Paul, who had already appeared as a man of advancing years in previous depictions by Michelangelo, but never as an old man totally crushed by the vision which immediately transforms him from aggressive soldier into a saintly prophet consumed with faith. Raphael had insisted on the careful depiction of his military insignia to provide him with strength and decorum. He had dressed him in full military regalia and armour. Michelangelo, in contrast, dressed him in simple clothing and only the hilt of his sword, just visible at his side, reminds us that he was a soldier.

Around this scene which underscores the wholly direct and spiritual nature of the dialogue between Christ and Saint Paul, the artist unfolds the secondary narratives that emphasize the exclusivity of this dialogue. Just as the angels and the elect in the sky concentrate the energy around the figure of Christ and charge the force in a beam of light, this same energy is dispersed in every direction in the lower part of the painting. The curve of Saint Paul's body is prolonged on one side by the figure of

the man who assists him and then dissolves into the rearing horse, after a rapid flurry around the shocked expression of the man immediately behind the saint.

The violent force unleashed by Christ is concentrated in Saint Paul's group and the figures closest to him and then disperses outwards towards the wide and desolate landscape. The fleeing horse is the first thing we see and it tells us that a drama is taking place. In traditional depictions of this scene, the horse was often present and lent a sense of the unnatural and dramatic to the event, as in a battle. However, no one before Michelangelo had ever given so much space to this detail and assigned such an important role to it in the composition. The figures that swarm in every direction also have the function of dispersing the accumulated energy towards the exterior, thus returning our attention towards the central theme – the link between Christ and Saint Paul. The sight of the men and the large horse fleeing forces the viewer to look for the reason for their flight. Then we have to consider the manner in which the centrality of the divine dialogue is exalted by the landscape in which the drama takes place, because it is simple to the point of self-disintegration, with the shapes of the hills forming a perspective cone that converges on the valley in which the encounter takes place. With an act of intellectual imperiousness, Michelangelo strikes out all the Umbrian trees with their frayed foliage, the dainty little clouds that float across the sky and the ravines over the sea in which all contemporary painters indulged, including the great Titian who had used landscapes to reinforce the psychology of his characters.

The composition Michelangelo invented definitively shattered the rhetorical language that for at least a century the Church and the artists in its service had been reviving by developing Roman models. The symmetry and the static equilibrium, the parallels and the hierarchies of perspective were all laboriously refined during the preceding years and triumphed in Raphael's rooms, a veritable manifesto for the papal court's artistic rhetoric, and then they crumbled under the destructive impact of an emotional force that screamed in an innovative language that meant there could be no continuators.

An essential range of colours that skilfully adapted colour to the narrative contributed to the perfect drama of this composition. Christ's fiery red cloak is the first thing you see when you look at the

painting, and this was a method for shifting the centre away from Saint Paul (who traditionally played the role of protagonist) and towards the figure of Christ, who immediately imposes himself as the origin of the event and its absolute protagonist. Red is the most violent colour after black, which could not be used for obvious symbolic reasons. To reinforce the centripetal effect of the angels without wings and the surrounding figures, red clothing is found amongst them too, in shapes that appear like sabre slashes in the spiritual sky, for which Michelangelo once again wanted the precious lapis lazuli from the east. The cold blue of lapis lazuli is the best preparation for the explosion of red that is His cloak and for the band of yellow light that strikes down the old man and dazzles him. Blue, red and yellow are the three primary colours, which strengthen each other and provoke a powerful visual impact.

In order to glorify in colour his relationship with Christ, around whom the whole composition has been built, Saint Paul is also wearing a wonderful red cloak, which is struck by the luminous ray and exalts the foreground where he has been placed. He is so close to the edge of the painting that he looks as if he is on the point of rolling out of it. Thus the chromatic force of their clothing is such that Christ and Saint Paul are isolated and immediately perceived in the picture as protagonists of an exclusive dialogue. In his determination to strengthen their relationship, Michelangelo did not hesitate to defy the realism in the depiction by wrapping up the saint entirely in vivid red and having the cloak raised behind him, while it should have been on the ground behind him and therefore not visible. But such a naturalistic representation would have made Saint Paul less isolated from the others and not so clearly linked to the figure of Christ above him.

This manifest bending of the rules could only have intentional, powerful and creative reasons. However it is not the only infringement of naturalism we find in the painting. The figures in the foreground on the right, who emerge from below, should be of the same size as the saint, if not bigger, whereas they are incongruously smaller. With a mystical emphasis that we will find even more evident in the *Crucifixion of Saint Peter*, the central narrative follows a compositional hierarchy that disregards natural proportion. Here again, there is a precedent in the *Last Judgement*, in which the more significant figures in the narrative are

larger than the others, even though they are depicted by the artist in a natural space that includes all the figures.

More sabre blows of red appear on the chests of a few external figures to help the viewer's eye to follow the dispersion of the energy generated by those in flight. However, they are small flickers that stimulate the flight in perspective and do not interfere with the two patches of red on Christ and the saint. The rest of the colours are graduated over the tones of the desolate landscape: the green, yellow and purple are distributed in a manner that assists the dispersion of energy, while they are mediated by the reds and browns that fade into the countryside.

In the lower part of the painting, the eye, once caught by the open shell of Saint Paul's cloak, is attracted to the two sides by two garments of equal weight: the wonderful purple surcoat of the soldier who protects himself with his shield, and the golden yellow of the soldier who, with a splendid twisting of his body, covers his ears. The two figures, along with the other three closest to the saint, are sufficient to conclude a perfect narration. For this reason, their formal vividness is emphasized by such striking colours, while the rest of the figures are used to enrich the narrative further and enumerate the various nuances of amazement and consternation.

4 DANGEROUS IMAGES

The compositional choices made in the *Conversion of Saint Paul* led to a decisive shift in the meaning of the story compared with the previous iconography. The few existing depictions of the episode were based on the accounts in the Acts of the Apostles: the soldier Saul or Paul, a persecutor of the early Christians, was suddenly overcome by a vision while travelling on the road to Damascus, and that experience converted him to the new religion. Traditional iconography preferred the martyrdom to the conversion, and his martyrdom and that of Saint Peter would become the foundation of the authority of the Church of Rome. This is what we find in the decorative cycles of important Catholic churches, including the old Saint Peter's, the Basilica of San Paolo fuori le Mura in Rome, and the Church of San Piero a Grado near Pisa. Saint Paul was a figure of secondary importance in the

Christian art of the Middle Ages, and generally artists only depicted episodes of his life that concerned the life of Saint Peter and glorified the latter's actions.

But around 1540, Saint Paul was at the centre of the debate between reformers and conservatives. His writings lent authority to the Lutheran interpretation of salvation and were therefore subjected to continuous and detailed exegeses. He became a more important figure and naturally the depiction of his life was increasingly seen as a means to intervene in that debate. During the time that Michelangelo was working on the Pauline Chapel, Cardinal Alessandro Farnese, in part to pay homage to the name chosen by his grandfather Paul III, had Salviati paint a fresco in the chapel of the Palazzo della Cancelleria, a *Conversion of Saint Paul* that was profoundly different from the one by Michelangelo and therefore helps us to understand the latter's innovativeness.

Raphael's previous representation had all the characteristics of institutional officialdom. A young and vigorous Roman centurion lies on the ground, dressed with antiquarian precision in all the attributes of a soldier, and twists around as though hit by an arrow rather than a call from the heavens. The attempt to produce a scene of virtuousness comes to grief because of a grotesque feature that does not even manage to sustain the symmetry of the scene. The protagonist appears to be the soldier in the foreground who attempts to recover the frightened horse, which is fitted out with all the harnessing for an ancient battle. All around, scenes of dismay give the impression of a troop of soldiers acting in a manner more characteristic of a battle than a spiritual event. In Salviati's *Conversion* (he had already drawn a *Conversion* in 1545 for a woodcut by Enea Vico) we find the same composition, with the addition of smug virtuosity in the theatrical gestures and contorted anatomies (especially those of the frightened horses). Here too, the narrative has the precision of an antiquarian chronicle, as clearly the commissioners wanted and as would soon be recommended by the Council of Trent. No digressions and ambiguous interpretations: the Scriptures had to be represented effectively and accurately.

Compared with these two previous works, Michelangelo's composition introduces an important innovation, about which he must have

thought a great deal, and which therefore constitutes the principal interpretative key to this painting. There are not only the traditional angels supporting the figure of Christ in his apparition, but also groups of men and women who are evidently the ranks of the elect who encircled Christ in the *Last Judgement*. We need to reflect very carefully on this iconographical innovation if we are to understand fully the spirit in which the artist planned the painting and at the same time contributed to the debate on salvation. There can be no doubt that if he decided to change the traditional composition, it was because he intended to assert a particular interpretation of the episode which he had painted on previous occasions in important institutional buildings. His decision markedly to emphasize the presence of Christ and the circle of the 'elect' around him must have served this purpose. There is no question that they are recognizable: the man leaning forward in the foreground of the lower clouds while opening his hands as he contemplates Christ in fearful astonishment is almost a replica of the figure that appears in the *Last Judgement* on the left of Christ and above the head of Saint Peter. Around him, there is a crowd of people who appeared to be contained by the angels in the foreground and who have the same formal characteristics, the same gestures and the same clothing as the crowds of the elect who circle Christ in the *Last Judgement*, which could be seen a few steps away from the new painting: the reference to the earlier work is very clear. The identification of the characters with the first martyrs and the most authentic followers of Christ undoubtedly helps us to understand the meaning of their presence in Michelangelo's composition.

The account in the Acts of the Apostles is in fact very meagre, but in the translation into Italian edited by Antonio Brucioli, the friend with whom Michelangelo sought refuge in 1529 during his flight from Florence, the story underwent a very specific interpretation. Brucioli's translation was one of the first to appear in Italy, and there can be no doubt that Michelangelo used it as a source when it came to representing the conversion of Saint Paul in paint, although Vittoria Colonna and Reginald Pole must have also been involved in developing this iconological programme, just as they must have been with the tomb of Julius II, which was decided upon at the same time. Brucioli's interpretation helps us to understand the manner in which Michelangelo broke

the rules of existing iconography by suddenly introducing personalities that had never previously appeared, at least in the important depictions used in the Church's institutional propaganda.

> And Agrippa said to Paul, you are allowed to speak for yourself . . . In order to deal with these things and going to Damascus with authority and the commission from the leading priests, at midday – oh king – while I was on the road I saw a light from the sky and above the splendour of the sun – it shone around me and around those who were walking with me. And we all fell to the ground and heard a voice, which spoke to me and said in the Hebrew language, Saul, Saul, why do you persecute me? It is a difficult thing for you to repulse your urges. And I said, who are you, Lord? And he said, I am Jesus whom you persecute. But get up and stand on your feet, because this is why I have appeared to you, so that I can ordain you as minister and witness to the things you have seen and those in which I will appear to you, taking you from the people, and from the peoples to which I now send you, so that you can open their eyes and they can be converted from darkness to light, and from Satan's rule to God; so that they can receive remission of their sins and the destiny amongst those who have been sanctified by faith in me.[7]

In all probability, Michelangelo was referring precisely to this passage when he first depicted those who had been sanctified by their faith in Jesus and who crowded around him in the company of the angels. The iconographical innovation, which had been thought up and courageously brought into the very heart of the Apostolic See, served to emphasize the centrality of faith on the path to salvation. What other meaning could we give to Michelangelo's dramatic change to the iconography of the conversion of Saint Paul? To portray 'those who have been sanctified by faith in me' around 1543, during a period of fierce theological differences, was clearly to take sides in the debate on salvation, which was occupying his mind and the minds of his friends in Reginald Pole's 'school'. These friends were quite capable of grasping to their satisfaction the valuable emphasis he was making, given that they, like the Lutherans, were convinced that salvation was assured by living faith and not by good works.

Contrary to what had been depicted in previous compositions, the presence of the elect charges the visitation of Christ with very particular messages. It does not only cause the conversion, but demonstrates the way to salvation through the vision of those who populate the eternal kingdom because they had believed in him. The presence of the elect was much clearer before the paintings were censored with pieces of cloth to cover the nudity of the figures. The angels, when nude, were immediately distinguishable from the elect, who crowded around fearfully and full of piety behind the angels, as is depicted in Beatrizet's woodcut, which was produced before the censorship. When, a few years later, the nudity of the angel was covered with coarsely painted pieces of cloth, their identity and above all their difference from the figures behind them was weakened. Thus censorship, which was apparently of a 'sexual' nature, ended up as much more urgent censorship of a theological nature. Only a return of the painting to its original condition could fully reveal Michelangelo's theological message.

The theological value of the composition is as always difficult to assess, but there is a strong impression that Michelangelo was adopting an explicit position in the contemporary debate by stressing the salvationist value of faith in Christ, and was doing so in the very chapel where the pope wished to hold a conclave. The turbulent times should have prompted the artist scrupulously to follow the previous tradition, which would have meant leaving out that multitude of saints, bearded and emaciated worshipful followers, and charitable women in an ecstasy of faith. Moreover, his decision cost him dearly in terms of time and money. He could have left the sky empty as he did in the *Crucifixion*, but instead it took up about one third of the *giornate* expended on the painting. It is a galaxy of bodies, which has about the same weight as the lower part of the picture. Why did he take on so much extra work? The only reason can be that he wanted to paint the chapel in his own way, which was to assert his religious beliefs, comfort his friends and leave the mark of his devotion on the very centre of the Church. He wished to oppose the rhetoric of the institutional hierarchies and advocate a people of the faithful who would be as simple as shepherds transfigured by faith, without insignia and wrapped in veils like most of the figures he had drawn or sculpted during that period. Thus he identified the

people of the faith and contrasted them with the people of the prelates, who like princes had met in that hall to elect a king who was now increasingly distant from the spirituality of the living faith.

In the *Conversion of Saint Paul*, Michelangelo reveals both the origins and the consequences of faith. The powerful ray of light that links the saint and Christ immediately demonstrates that faith is by nature individual and direct, and an entirely inner experience. This is not the light that shines around Raphael's Christ, an emanation of power and majesty. It is not the institutional light that shortly after the painting's completion would become even more closely associated with the presence of the Holy Spirit, the symbol of Roman orthodoxy. It is the light of an individual calling, and of dialogue between souls. It is not spread like a revealed glory, but is concentrated in the spirit of the simple people.

The mystic, spiritual and supra-historical nature of the story was also underscored by other variations in the contemporary iconography. The landscape has been reduced to a spiritual landscape. The city of Damascus in the background appears to be the evanescent profile of a symbolic city, without precise characteristics. Christ seems to point it out to Paul as the place where he will have to fulfil his destiny as a preacher and converter of souls to the true faith. Even the depiction of the saint in a sorrowful state, devoid of any trace of the warrior, is another powerful innovation in the story. We need to look hard to find the handle of his sword barely protruding from the side of his ageing, prostrate body. There is no sword, no helmet and above all no breastplate. The still vigorous man gives himself up unconditionally to the column of light. Even his comrades-in-arms lose their military bearing and aggression, and change into a troop of men scattered and confused by the power of God. The figures who emerge into the foreground are perhaps soldiers, but they are carrying their baggage on their shoulders like deserters or wayfarers. The symbols of war, offence and temporal power have gone. The event is entirely enclosed in their consciousnesses and located in the supra-temporal dimension of faith. The spiritual minimalism serves to renew the conversion as an event and make it topical by transforming it into the portrayal of a meditation, as Ochino had suggested. The episode is removed from its historical past and from a precise date, and consigned to the infinite present of the conscience and the 'living faith', which involves all the senses.

Those who looked at the painting, from the cardinals of the conclave to the newly elected pope, had to feel the need to renew their own act of faith in Christ and be reminded that it is faith that saves and distinguishes the true Catholic from the superstitious. The exclusion or understatement of historical features in the composition aimed to involve the viewer and make him or her no longer feel a detached witness to an event that occurred 1,500 years earlier, but rather a participant in an act of faith that must be continuously renewed within the spirit. Michelangelo could not be content with restating a 'story' that had been depicted many other times and locked within its iconographical structure with its rigid symbolic value. He urgently wished to mould that event to the devotion that filled his soul and transformed the ancient parable into a new story. Thus he asserted once again the true exclusive sentiment that permeated his entire being – a faith in Christ that saves – and affirmed his own particular character by imposing that abstraction and that suspension of historical time in the very place where the supreme power of the pope would be created: the chapel of the conclave.

5 SAINT PETER'S EXPRESSION

Like the *Conversion of Saint Paul*, the composition of the *Crucifixion of Saint Peter* was unprecedented in Renaissance painting for its visionary power. Indeed, it would not have its match for a very long time.

The absolute protagonist of the depiction was Saint Peter, portrayed in perspective as an athlete who gathers all his forces to cast one last expression of admonishment at those who witnessed his martyrdom, inside and above all outside the painting. With his tensed muscles, the figure of the saint is the truly active agent and mainspring of the scene, rather than the passive object of a symbolic martyrdom as in most previous compositions. The figure is isolated and given prominence through the exaggeration of the dimensions and the vacuum created around him. In spite of the bold perspective and of his being positioned further back than the figures closest to the viewer, the figure of Saint Peter is larger than all the others, which creates a foregrounding that is both obvious and undeniable.

Michelangelo's use of a different scale for the figures is however

prudent, because the majesty assigned to the saint never upsets the balance of the scene with effects that contemporaries would undoubtedly have considered grotesque. In this manner, the observer's attention is drawn to a few narrative motifs without disrupting the verisimilitude and credibility of the whole, and without the difference of scale being too conspicuous.

The inclined cross creates a plane of light, a spatial pause and a silence of forces on which the saint's titanic struggle is displayed, and he draws up the upper part of his chest towards his legs, as though in a gymnastic exercise. The centripetal tendency of this movement, which turns and closes in on itself through the whole body, is continued in the small group of men busy at raising the cross. The interweaving of arms tensed by the exertion and lit up by powerful direct light creates a circle that links the martyr to his executioners. Once again, men separated only by a different destiny confuse their roles without conceding anything to the outward appearance of the divine and the human.

The lights that flicker on the arms of the saint and his executioners, who are deployed in a circle, create the effect of a circular flash of lightning sustaining with its energy Saint Peter's enormous effort. He is suspended in an exhausting position, which makes his look of reproach all the more resolute. The eye continuously follows the movement of this circle, at least half of which is made up of his taut body. Here too, the colour sustains the dynamism of the bodies. The clear light on the saint's body continues without interruption in the white trousers of the workers and in their naked arms. The centre imposes itself through the luminosity of this group of figures, briefly interrupted by a balanced pause – by the two optically equivalent colours of the purple surcoat to the left of Saint Peter and the golden yellow one on his right. As occurred on the opposite wall in the scene of the *Conversion of Saint Paul*, purple and yellow anchor and embellish the central event, which is removed from geometric harmony by the light and composition.

The light that crosses the scene is captured in the upper part by the cross, and materializes in the forceful contraction of Saint Peter's legs and is directed towards the chest, the shoulders and ultimately the saint's raised head, where it concentrates in his look of admonishment, from which the narrative takes its starting point and to which it always returns. Saint Peter's expression is the real subject of this painting. The

red patch of the surcoat worn by the man digging a hole underneath his shoulders serves to give him strength, supporting him like a pillar. We do not see the expression of the man digging the hole, and nothing in his depiction distracts us: we only see the patch of red colour that alarms us and is a forewarning. It is a shapeless patch of colour which grabs our attention and then switches it to Saint Peter's fierce and intense expression.

Taking this centre as the starting point, the anecdote is organized with gradually decreasing rhythm towards the external parts. Having separated the central group from the pause of the ditch, the narrative is played out once again with a circular but relaxed motion, condensed in a circle of figures that embraces the action and always leads back towards the centre in a powerful and perpetual movement. The figures seen from their backs who are climbing up from the left lead us to the soldier who is leaning forward so as better to see the same thing that we shift our eyes to see: the martyrdom of Saint Peter. Even the central group of figures immediately takes us back to the action through the arm and then the pointed index finger of the man in the foreground. In the figures on the right of the cross there is then a release of the tension – a dispersion of energy that expresses the effects of the martyrdom. The pain, the dismay, the resignation and the suffering are all encompassed in the wonderful personality in the foreground, almost a brother of Saint Peter because of his physical strength, a monument to that utterly pure devotion that despises every worldly seduction. This lonely, bare-footed and ragged figure celebrates the anguished soul. At his feet in a position that is difficult to explain in terms of perspective and propor-tion, we come across four women whose dazzling white veils and faces once again shamelessly capture the observer's attention and take it back to Saint Peter. All this recommences with a circular motion around the cross, while the landscape is formed under the sky overhead and with the abstract silhouettes of the hills that rise and fall in correspondence with the action. The hills too direct us towards the central action.

Michelangelo brilliantly (hopefully this modest word does not offend the undoubted demonstration of genius) resolves the problems associ-ated with a scene that had always been unsatisfactory, because of that upside-down cross that incongruously puts the martyr's head below the heads of the walk-on parts. Filippino Lippi first had the idea of

depicting the crucifixion of Saint Peter not as an accomplished fact but an event still to be played out. This depiction in the Brancacci Chapel in Florence (Plate II.11) reveals the efforts of the men at work, and therefore humanizes the scene according to the rigorous dictates of Florentine humanism of the late fifteenth century. However, he had to accept the unsatisfactory solution of the martyr's head being almost on the ground, where all the bystanders are looking. Of course, Michelangelo understood the energy of this painting and its communicative potential, but he could not accept that the protagonist of the scene should be put in what was, in effect, a ridiculous position. To achieve his purpose, he therefore abandoned the symmetric composition in favour of a system of energies that followed a more complex formal arrangement. He replaced the symmetry and geometric centrality with active forces evidenced by a carefully thought-out chromatic fabric and a light that established a hierarchy of roles and sequences of actions.

The comparison with the previous iconography helps us to understand not only the ways in which Michelangelo innovated the tradition, but also the reasons why he had to break with it. The traditional iconography of the crucifixion of Saint Peter is very effectively demonstrated by the paintings in the apse of the upper basilica of Assisi, those in the portico of old Saint Peter's in Vatican, which were still there for Michelangelo to see, as they were only demolished during the reign of Pope Paul V, and those in the church of San Piero a Grado in Pisa, close to a coast much frequented by the artist during the time he stayed in Carrara. Other important precedents were certainly the predella painted by Giotto, now in the Vatican Museum, and the fresco by Filippino Lippi in the Brancacci Chapel in Florence. The sources on which these depictions, including Michelangelo's, were based were a few passages in the Apocryphal Gospels, and principally the *Legenda Aurea* by Jacopo da Varagine. In thirteenth and fourteenth-century cycles, the schema was very rigid and almost invariable: a frontal view of a crucified Saint Peter appeared between two wings of a crowd made up of Roman soldiers and early Christians who looked on in impotent despair. Two monuments which symbolized the city of Rome in the Middle Ages were recognizable in the background: the Cestius Pyramid and Nero's Obelisk, close to which it was believed that Saint Peter had been put to death.

Great is the discord that reigns between writers over the identifica-
tion of the place of martyrdom of the Prince of the Apostles. . . . Some
argue that Saint Peter was crucified at the Vatican and others on the
Janiculum. Moreoever, according to a tradition derived from the
Apocryphal Acts, Saint Peter is supposed to have been put to death
close to Nero's palace next to the obelisk.[8]

These symbols disappear in Michelangelo's painting.

The martyrdom was represented in a highly symbolic manner and in
no way resembled an event that was unfolding. Its representation fol-
lowed an extremely rigid iconographic tradition. The cross was turned
upside down and the saint's body was motionless – a helpless victim of
Nero's cruelty. In the basilica of Assisi, Cimabue attempted to resolve
the problem of the saint's head being too low by designing a cross with
an enormously prolonged lower part, so that his head is at the same
height as those of the other protagonists. In San Piero a Grado and the
portico of the old Saint Peter's (as shown by the drawings made before
its destruction), the effect is incongruous because the viewers' eyes are
drawn to the martyr's feet rather than his head.

We encounter a touch of genius in the depictions by Giotto: some
soldiers on horseback were brought into the scene from the sides to
remedy the empty space created in the upper part of the scene, and this
even filled the highest part of the picture. Michelangelo appropriates
the arrival of the soldiers down to their gestures, which show them to
be engaged in conversation, albeit in a different context. But of course
Michelangelo's main inspiration was the painting in the Brancacci
Chapel in Florence. Although Saint Peter is portrayed frontally and on
the cross, tradesmen are working hard all around him at positioning
and raising the cross. They are holding the cross in their arms, and this
transforms the scene into one of real action in which the executioners
around the saint are involved in highly credible activities. It is clear that
Michelangelo had this painting in mind when he thought up his own
martyrdom of Saint Paul, because of the presence – almost a textual
quotation – of the soldier in the group of figures on the left, who is
leaning on his spear in order to look at the martyr.

The action initiated in the Brancacci Chapel becomes even more
engrossing in the Pauline Chapel, because the active participation of

the saint produces two immediate effects. Firstly, it dramatizes the event: in accordance with the schema already adopted in the crucifix he made for Vittoria Colonna, the torment is emphasized by the martyr's vitality which before our very eyes stops the action as it is played out and draws us into its development. While the exhibition of the dead body, martyred and motionless, distances the action from our sentiment by placing it in the past, albeit the very recent past, the display of a vigorous body involves us in the scene and makes us participate in the martyr's pain and actions. The unequalled power of Michelangelo's art rests on his ability to stage a credible visual representation in emotive terms, based on his naturalism. Saint Peter's taut gesture as he twists on the cross captivates and suspends us in the expectation of its dynamic resolution. Capturing the force in action was for Michelangelo, both in his sculpture and his painting, a means to make the scene topical and involve the viewer. His persuasive ability arises from his ability to imagine the most effective pose and the most natural form for the observer.

Of course, in terms of the narration, the viewer needed to know the sources in order interpret the action. And Michelangelo remained fairly faithful to the traditional sources. There can be no doubt, however, that his aim was to shape the narration so as to produce a new emotion: his own religious sentiment, which in this case was expressed by forcing the prelates who met for the conclave to think about the martyrdom and the foundation of the Church as a living reality and not an event in the distant past that the liturgy celebrated. It was once again the sense of the meditations shared with Vittoria Colonna that returned and brought to light the profound significance of the Scriptures and history to make them topical, so that believers could relive those events in their emotions.

In the *Legenda Aurea*, there is a tale of how, during Saint Peter's martyrdom, some of the Christian converts started to protest at such wickedness and threatened to rebel. It was Saint Peter himself who told them to calm down, because his destiny of martyrdom had to be fulfilled. The painting faithfully tells this story. The figure on foot at the centre of the scene indignantly points out the martyr to the Roman soldiers who run to assist in the execution, as in Giotto's painting. His friends hold him back and calm him down by suggesting that silence is best with the eloquent gesture of the index finger against the lips. With

the other hand, the neophyte who stands directly above Saint Peter's head points to the heavens with his right index, undoubtedly recalling attention to the divine will to which everything must be ascribed. Once again, the martyrdom manifests itself as the implementation of a divine plan, even if it is difficult for the bewildered people to understand.

The small scene is very important because it helps us to identify the numerous people on Saint Peter's right who are watching the execution. This stream of apparently simple, perhaps even destitute, people crosses the whole right-hand side of the painting. People of all ages appear from the top of the mountain, opposite Nero's soldiers who arrive on horseback from the left. Downhearted, they file down from the mountain, while soldiers seen from behind are powerfully making their way up the other side. The men on the right are dressed in rags, as though the Church in its early days gained new adherents only amongst the simple and the poor. These humble people who witness the martyrdom of Saint Peter are entirely identified with a sentiment rather than a social or historical characteristic. Presumably they are the early Christians, the people who followed the preaching of Saint Peter. These people are the Church itself, in the sense of a community of those who share the same sentiment of faith, and they represent the true foundation of the Catholic tradition. By characterizing them as so poor and unassuming, so remote from the manner in which they were depicted by the institutions that surrounded Michelangelo at the time, he turned his portrayal of the martyrdom into a proclamation in favour of the Church of the faithful and against the institutional Church: an idea that he shared with the 'Spirituals' and which had for a few years already been considered subversive by the most conservative wing of the papal court. Even Rome was no longer recognizable in that utterly spiritual event, following the disappearance of the spires of the pyramid and the obelisk that had always been present in any depiction of the martyrdom.

There is also an austere essentiality in the details to characterize the purity of the faith of the early Christians, as had already occurred in the circle of people surrounding Christ in the *Conversion of Saint Paul* and in the devotional drawings for Pole and Colonna. Their clothes are scraps of cloth with no shape, ragged shrouds for a body reduced to a mere extension of the soul. The landscape becomes a pure abstraction

of land and air. The beauty, force and harmony of the muscles set in motion a theatrical machine, which through gestures and mimicry tells of a sentiment without conceding anything to propriety, institution or acknowledgement of the hierarchy of personalities – above all, without conceding anything to history as fact enclosed in any particular epoch. Michelangelo achieves a spiritual representation situated in an eternity that coincides with the perpetuity of faith.

We should always remember that we are in the chapel Paul III wanted to use for the conclave. Saint Peter's expression was therefore directed at the cardinals who would elect the pope and would have been the first thing that the new pope would see immediately after his election. Saint Peter would remind that pope of his Church, made up not of the powerful and the well-armed, but of a people touched by devotional faith: an elect people who rightly occupied the right-hand side of the crucified martyr, just as in heaven it will occupy the right-hand side of the other crucified Martyr, the first and most holy symbol of salvation.

Of course, we cannot take this reading of the painting too far, because in many ways it is still obscure. And yet the small variations from a rigidly codified tradition, that which was very often present in institutional surroundings, communicated something that none of Michelangelo's contemporaries could fail to notice: the disappearance of Rome and therefore the physical reality of the institutional Church, Saint Peter's severe expression and his gesture admonishing the viewer, and finally the presence of that people who had taken on such an important role within a representation of the martyrdom. That people's very physical appearance was a reference to the purity and simplicity of the true faith that we find in all Michelangelo's late works, from *Active Life* and *Contemplative Life* to the Maries at the foot of the cross in so many drawings of that period, and from the paintings gifted to Vittoria, Pole and Morone to the stone figures that appear in the last versions of the *Pietà*.

Moreover, the cardinals gathered in the conclave and the future pope could not have failed to register another clear iconographical statement in the painting: Saint Peter's tonsure. The position he invented for the saint appears expressly designed to highlight his tonsured head. The scrupulousness of the artist's work, which becomes clear on close observation of the fresco, shows how important the small portion of the

painting was for Michelangelo and puts it on a level of perfectionism also found in Christ's arm in the *Last Judgement*, also the product of many changes. In previous depictions of the scene, this detail had never been highlighted to such a degree. In spite of the deteriorated state of the paintings in Assisi, the subsequent drawings of it prove beyond doubt that Saint Peter was not tonsured. At San Piero a Grado his hair is clearly visible, as it is in the painting in the Brancacci Chapel, even though in this case his hair is in deep shadow.

What was the significance of this ostentatious tonsure in Michelangelo's painting, a tonsure that had already appeared on the Saint Peter of the *Last Judgement*? Once again, the *Legenda Aurea* provides us with the key in its account of the celebrations in the Cathedral of Saint Peter:

> The fourth reason for this feast-day is the honour attributed to the tonsure because, according to tradition, it started with Saint Peter. When the saint was preaching in Antioch, they cut the hair at the top of his head to show their contempt for the Christian faith. Then that which had been done to cause offence to the first of the apostles became symbol of honour for all the clergy. The tonsure of the hair signifies purity of life, because the impurity of the head is gathered in the hair: the abandonment of all outward beauty because hair only serves as an ornament, and the renunciation of all worldly goods because nothing must come between the priest and God, and close must be their embrace and without mask the vision of divine glory. The tonsure is moreover of circular form because this shape has neither beginning nor end, just as neither beginning nor end is to be had by God of whom priests are ministers.[9]

The question of the tonsure was widely debated amongst reformers during the years in which Michelangelo was painting the Pauline Chapel, and this was because of its highly symbolic significance. The polemical purpose of that tonsured head could not have eluded the cardinals at the meeting of the conclave. Nor does it seem excessive to interpret the artist's decision as yet another reminder of the necessarily spiritual nature of the papacy, of its humility and of its evangelical purity. These were the positions clearly expressed by Reginald Pole

who, because of the forcefulness with which he argued them, would fail to be elected to the papal throne in the conclave of 1549, which was held when Michelangelo's frescoes had not yet dried and under the glaring eyes of an indignant Saint Peter.

6 CENSORSHIP CASTS ITS SHADOW

There can be no doubt that Michelangelo used the decoration of the Pauline Chapel to intervene once again – and in a very forceful manner – in the contemporary debate on Church reform. Generally it is argued that the iconography was part of the artist's remit, as he was restricted to depicting the subject in a manner previously defined by the commissioner. Particularly here in the Pauline Chapel, a place of supreme official status within the Church, it is difficult to believe that Michelangelo could independently decide how the pictures would be composed. However, when Paul III asked Michelangelo to paint the frescoes in the chapel, the artist was close to seventy and had excellent reasons for refusing the commission. Freedom of expression was most certainly one of the elements in the negotiations, as had already occurred with the *Last Judgement* and would occur with the continuation of Saint Peter's, where Michelangelo's involvement was devastating for the Church establishment: even cardinals had to submit to the artist's demands. Evidence can be found in the learned polemics of Gilio, Dolce and other censors, who did not complain about the intellectuals of the papal court, but criticized Michelangelo in person, as they found him responsible for the decisions and transgressions that had occurred. This shows that Michelangelo Buonarroti was accorded a creative freedom that was not conceded to such artists as Giorgio Vasari in the Palazzo della Cancelleria, as the latter had to follow the dictates of Paolo Giovio, a scholar in the service of Cardinal Alessandro Farnese, even in relation to the minutest details of a series of paintings, including the position of each figure.

Michelangelo's freedom of action in this period was such that he could refuse to give the pope's grandson, Cardinal Alessandro Farnese, the cartoons he had used in the *Last Judgement*. He was now outside the rules and structures imposed on all the other artists of the Renaissance. Besides, we should not speak so much of revolution as of

an iconographical transgressive shift in the case of both paintings in the Pauline Chapel. Strictly speaking, he did conform to tradition. Yet the message that alluded to Michelangelo's own particular religious beliefs was developed through the addition of new details (the elect) and above all his highly articulate artistic language, which gives different weight to the various elements that had always been depicted in order to communicate a sense of the anguished individual participation in faith. He was not celebrating the authority of the institutional Church, as happened in the frescoes in the Palazzo della Cancelleria (and would later occur in the work to complete the Pauline Chapel itself), but the purity of spiritual devotion which feeds off a direct relationship with the Scriptures and the teachings of the martyrs. We are once again faced with a 'meditation' rather than a passive celebration of the institution. We are faced with events in which we are asked to participate with powerful emotions and which should push us towards an active reflection on faith and its roots.

This sentiment, which arose from a project of much wider reform and from a profound reflection on the state of the Church and religion during that period, was perfectly understood by Michelangelo's contemporaries. To some extent, it derived from a shared project, not perhaps for the most influential group in the papal court, but certainly for a circle of people sufficiently powerful to legitimize the presence of such paintings in an official setting. This was the group of Pole, Morone, Bembo, Sadoleto and Giovio himself – the very group that the Farnese family decided to have portrayed in the celebrative frescoes in the Palazzo della Cancelleria behind the portrait of Paul III, thus emphasizing their moral and religious virtues. The entanglement of moral rigour and political cynicism rendered relationships at the papal court extremely complex in the period immediately before the Council of Trent. But the project supported by Pole and his friends was destined to be defeated by an authoritarian demand for a return to the Church tradition, its explicit liturgies, and its centuries-old instruments of control and domination.

This is what is proved by the events surrounding the Pauline Chapel. The two existing paintings are only a part of a vast programme planned by Michelangelo and completed between 1542 and 1549. He would have continued to work on this programme had it not been for the

death of Paul III, which abruptly brought work to a halt. According to the account of the Duke of Florence's ambassador in Rome, the pope went to see Michelangelo on 13 October 1549, a few days before he died. He found the artist working on the scaffolding and climbed up ten rungs of a ladder, an act of vitality that stunned everyone. No one, therefore, was expecting his death and the suspension of the works in their current state. The cartoons for the other paintings to complete the cycle were ready, and Michelangelo, in agreement with Paul III, was to leave the actual execution of the work to Marcello Venusti. We know this because of an extremely important document held in the Vatican Archive next to the records of the 1549 conclave, in which the secretary of the conclave asked the cardinals whether Marcello Venusti should continue the decoration of the chapel as agreed by Michelangelo and Paul III:

[From 10 November 1549 to 7 February 1550]

To the Reverend Master Giovanni Francesco [Bini], Master of Ceremonies.

Whereas the Mantuan painter finds himself already delegated by Pope Paul and B[uonarotti] M[ichelangelo] to continue the work on the new chapel; whereas he has started on its cartoons; whereas he cannot finish the work without provisions because of his poverty; he begs all the Very Reverend and Very Illustrious [lordships] to make the commission and provisions so that he may proceed with the work. And he reverently kisses their hands.[10]

The preparation of the cartoons was actually the completion of the complex and laborious preliminary process in the creation of a fresco. If a cartoon already existed, one could say that the painting would inevitably follow. Thus in 1549 there was a well-advanced plan by Michelangelo for the completion of the decoration of the Pauline Chapel. Or perhaps it would be more correct to say that Michelangelo's paintings only lacked their final phase. Indeed, the cartoon was produced when all the smallest details had been decided. Michelangelo had practically organized the completion of the chapel with cartoons for the other scenes. The famous cartoon held in the Museo di Capodimonte di Napoli, which was for the panel depicting the crucifixion, can give us

an idea of the degree of detail the artist had already gone into in order to complete the decoration of the chapel.

Why was this cycle of paintings never completed? Why did the papacy renounce its rights over Michelangelo's genius when he was at its complete disposal and free from all other commitments, and moreover when he was universally revered and had been practically stolen from the Della Rovere family so that he could paint the chapel? Would it be too rash to assert that the prohibition that blocked Michelangelo's work reflected the form the Inquisitorial censorship was adopting in relation to works of art?

We can only speculate on the whys and wherefores of the censorship that was to damage Michelangelo so much. But there can be no doubt as to the fact that the sentiment expressed in his works was now very distant from the papal court's artistic needs and from the new balance of power that had been established. Suffice it to look at the nature of the paintings produced after 1572 and compare them with those of Michelangelo in order to realize what an immeasurable distance there was between his devotional work and that produced by Sabbatini and later by Federico Zuccari under the watchful guidance of the post-Tridentine theologians.

The suspension of the works decided upon by the conclave that followed the death of Paul III coincided with the beginnings of Giampietro Carafa's hostilities against the group of Spirituals. The immediate result of the denunciation of Reginald Pole's heresy in the session of 5 December 1549, under the damp walls that had just been frescoed by Michelangelo, was that Pole's candidature to the papal throne was ruled out.[11] From that moment on, a furtive struggle continued on its implacable course. The paintings, which Michelangelo had expected to celebrate the election of his friend Pole and the long-awaited shift in Church policy, actually assisted in his defeat. The new pope, Julius III, was a great admirer of Michelangelo and was not particularly hostile to the group of reformers, but the Holy Office, which was increasingly held in Carafa's tenacious grip, proceeded unremittingly to gather information to be used against Pole and his school, so that a real possibility of their being tried for heresy began to materialize. The political negotiations between Emperor Charles V and the Protestant princes, as well as the very close ties between the emperor and Pole and his

entourage, meant that the circle was relatively safe even in Rome. But the increasingly poisoned environment of the papal court left no room for an open expression of the religious devotion typified by the group through Michelangelo's paintings. The work was not completed, even though the cartoons only had to be transferred onto the wall.

This theory is reinforced by the enormous esteem in which Michelangelo's cartoons were held at the time. His autograph works and his preparatory drawings were enough to increase the value of a painting by one of his assistants by a factor of ten. For example, the two small pictures gifted to Urbino were almost certainly the work of Marcello Venusti, but produced from small cartoons by the master: in 1557 when both the artist and Venusti were alive, this was enough to make them worth infinitely more than a simple copy of one of Michelangelo's works by Venusti's hand.[12] There can be no doubt therefore that contemporaries were also aware of the inestimable market value of the cartoons prepared for the Pauline Chapel. Yet they refused them, with a gesture that was almost tantamount to the destruction of existing paintings, and only the lack of public knowledge detracted from the scandal. The refusal to continue the decoration in accordance with Michelangelo's plans was a radical repudiation of his poetics and an admission of the distance that now existed between the artistic needs of the papal court and the devotional feelings of the great artist who was approaching the end of his life.

8

NO MORE ILLUSIONS

1 DEVOTIONAL SUBJECTS

With the completion of the work on his *Last Judgement*, Michelangelo rose to a social and cultural position that had never been reached by any other artist before him. In 1547, Benedetto Varchi, a leading exponent of the Florentine Academy Cosimo I established in order to boost the cultural standing of his political dominion, gave a memorable lecture on one of Michelangelo's sonnets, which marked the point when the artist entered the pantheon of perfect demigods. His closeness to the circle of Reginald Pole and Vittoria Colonna also consolidated the position he had achieved through his long and arduous climb up the social ladder.

Michelangelo's 'lesser' production was for these friends, and was created during the free time left from commissions imposed on him by the pope. The subjects of the paintings and drawings produced during this period were centred exclusively on devotional themes discussed and examined in the meditations, sermons and literary compositions of the Spirituals. Unfortunately this production, which involved people and events that would later be swept away by the persecution of the Inquisition, has left few traces or accounts, all of which are shrouded in mystery and vilification. An ivory crucifix was mentioned in the

collection put together by Alessandro Farnese in his Roman *palazzo* around 1570: 'An ivory crucifix and ebony title and tiara gilded by the hand of Michelangelo' together with 'a paper picture stretched on walnut frame containing a pencil drawing of a living Christ on the Cross by the hand of Michelangelo'.[1] Two pictures – 'in one a Christ and in the other an Annunciation' – were given by Michelangelo to Urbino, and appeared in an inventory on the latter's death in his house in Casteldurante: they were copies from two paintings that used the preparatory autograph drawings and as such were entered in his catalogue.[2]

A thick fog has obscured this production, and attempts by critics to dispel it have met with little success. Only two drawings have been identified, one now held in London and the other in Boston. Their subjects are a *Crucifixion* and a *Pietà*, which in the opinion of Ascanio Condivi can be traced back to the ones that the artist produced for Vittoria Colonna. Although some doubts about the authenticity of the two drawings remain, there can be no doubt about the identification of their subjects. Both were produced between 1540 and 1545 from Michelangelo's reflections within the *Ecclesia Viterbense* on the question of Christ's sacrifice as the foundation and origin of mankind's salvation.

> Jesus Christ on the cross, not in the likeness of death as generally he is portrayed, but in a living act with his face raised to the Father, and it seems that he is saying – Heli heli – where a body is seen not as an abandoned corpse hanging down, but alive to the bitter suffering which causes him to regain consciousness and twist around.

Thus Ascanio Condivi describes the Christ in great detail, condensing all the power of the thought and passion that Michelangelo and his friends devoted throughout that period to the Saviour's redemptive sacrifice. The significance of infinite grace contained in that gesture was exalted in the devotional literature of the time that emerged from the group around Pole. Michelangelo managed to condense all the thought and intellectual passion on that subject in a single very simple image. The image became an icon, and it passed through states of consciousness with the suddenness of a stabbing,

only to sink deep into the heart with all the force, pain and beauty of that event.

In the *Crucifixion* made for Vittoria Colonna, beauty is the key to Michelangelo's desire to seduce viewers and involve them emotionally in the martyrdom. The Christ who writhes around in the most human of gestures has nothing abstract or superhuman about him; he is a beautiful man who could abandon the cross, embrace the whole world and welcome it into the arms of his perfectly proportioned body. If he were not nailed to a cross but held up in some other way, that Christ could become an Apollo who proudly displays his beauty. His athletic figure is so convincing in its movements that the entire portrayal could be reduced to the essentiality of body and pose. Everything has gone: the landscape and even the cross. All the power of the event is in the body that twists around but maintains even in the pain of martyrdom a regal presence that arises from the conviction in his own sacrifice and from the will to offer his own body for mankind's salvation. More than a hundred years earlier, Brunelleschi had rebuked a youthful Donatello for having put a peasant on the cross, while neglecting the beauty and royalty appropriate to Christ. With his *Crucifixion*, Michelangelo completed the long process whereby artists of the Italian Renaissance eventually came to identify beauty with godliness, as the Greeks had done two thousand years earlier.

The same elements of beauty, subdued elegance of sentiments, and essentiality that becomes communicative force can also be found in the *Pietà* drawn for Vittoria Colonna and her friends. Once again the beautiful body of the Christ-Apollo is presented wholly for us to view, as it is opened up by the angels who seem to be putting the lifeless young man on display rather than holding him up. The anguished pain, which is always restrained and never grotesque, is all contained within the mother's gesture of desperation and resignation, as she gives birth to him for a second time and consigns him to a death destined to save mankind.

The two drawings, or rather the two icons, are the highest point in a mystical representation, but also the highest point of the 'pagan' representation of the Catholic passion. This is why they were produced and consumed within a circle that was steeped in classicism and paganism, two ways of defining a heritage of sentiments and images with which Reginald Pole, Vittoria Colonna, Marcantonio Flaminio and the other

friends for whom Michelangelo created these small masterpieces still identified. The two compositions are 'ancient' not only because of the studied and sophisticated proportions of the Apollonian body of Christ, but also and above all because of the composure of the emotions, which are never weighted down with the excessive naturalism that can descend into vulgarity in most of the works of Michelangelo's artistic contemporaries. Their classicism, which was charged with symbolic meaning for Pole's late-humanist circle, is the threshold of abstraction at which the image halts and is suspended between an ideal beauty and a natural verisimilitude. This balancing act between an abstract canon and a naturalistic allusiveness is the distinguishing feature of Michelangelo's classicism, which reached its fullest maturity in this period.

One thoroughly 'classical' means of communicating through images is the skilful use of the body to emphasize every nuance of emotion and spirit through its mimicry, beauty and manner of being in space. Michelangelo had been trying to do this all his life, and he finally achieved it during this period when he used it in the service of the profound and sophisticated religious beliefs of the Viterbo circle. The complete disappearance of the landscape in both frescoes is by itself sufficient to demonstrate how classical his art had become in his later years, and how much it was centred exclusively on the body and its pose. It was a classicism imbued with ancient images rather than treatises of Platonic philosophy. It comes as no surprise then that these images had become evidence of faith and culture within a restricted but powerful circle. For the Spirituals, they were a symbol of identity that transformed their reflections and studies into pure sentiment.

It is almost certain that Michelangelo also produced a *Crucifixion* and a *Pietà* specifically for Vittoria. Meanwhile, other images or copies of his paintings produced from original drawings by trusted painters like Venusti started to circulate amongst friends who were frequenting the artist at the time. Reginald Pole, who was deeply involved in the demanding proceedings of the Council of Trent, took a small picture by Michelangelo with him while on that business, and he offered it as a precious and worthy gift to Cardinal Ercole Gonzaga, the powerful ally of Emperor Charles V in Italy, while claiming that he could obtain more like it from Vittoria Colonna. Ercole could not accept that precious object, but he was happy to get it copied:

My Monsignor, like a brother when you can let me have that picture of the image of Christ of the Most Reverend Pole but only so that I can have it copied by Master Giulio Romano here and send it back to him. It will be a very rare thing for me to have when the Cardinal's courtesy allows this symbol to be lent to me. I tell you freely that I do not wish him to be deprived of it in any way, as I cannot think of a better place for the image of Christ than in the hands of the person who carries it by faith sculpted on his heart.[3]

It is clear from Gonzaga's words that this is not simply a picture but rather a genuinely sacred treasure, which an artist like Giulio Romano was barely capable of copying but could never have thought up, as he lacked the piety that, according to all his friends, had enlightened Michelangelo's heart.

Other friends were very interested in the work, such as the Florentine exile and wealthy banker Francesco Bandini, who had been close to Michelangelo since the time of the Republic and had a sculpture made from the drawing of the *Pietà* produced for Vittoria and taken by Pole on his trip to Trent. Morone, some years later, asked Michelangelo to depict the Christ he had had the gift of interpreting like no one else could. All the leaders of the circle of reformers therefore received a gift from Michelangelo, which demonstrates how the artist's work was for them a sign of their membership of the group.

Through these devotional drawings and small pictures, Michelangelo formed a bond with his friends and managed to create a perfect synthesis with Vittoria Colonna's meditations. It is difficult to know who was influencing whom, and it is doubtful that it would be very useful to know. It is certain that the output of both reflected as in a mirror Michelangelo's paintings and Vittoria's devotional prose, uniting them in a struggle for spiritual understanding that removed them from the purely creative sphere and projected them into a complex dimension, where art is subject to the faith that becomes the real goal of their aspirations.

2 THE ROMAN FAMILY

On 1 September 1535 Pope Paul III Farnese, who in everyone's opinion did not have much life ahead of him, granted Michelangelo a substantial

life allowance, in order to guarantee his control of the artist's services for the rest of his life. It was an important provision, because it established Michelangelo in the role of leading artist for the Catholic Church. This salary for life was made up of the taxes and duties collected from travellers crossing a pontoon bridge over the River Po close to Piacenza. The revenue was estimated to be around six hundred ducats per annum, which was supplemented by a further six hundred in cash, paid out from the papal treasury in monthly instalments of fifty ducats.

This was an extraordinary figure – sufficient to maintain an entire family in luxury. The allocation of such an income should have definitively removed all the artist's financial worries and allowed him to devote himself to his creative work without further cares. Michelangelo, who did not have great needs for the luxuries of life and had no great expenses to pay, continued to invest the proceeds of his work in his Florentine family, concentrating on his nephew Leonardo (17 April 1522–18 November 1599) for his expectations of redeeming his family, an ambition that had pursued him throughout his life.

Even in the 1540s, this strategy concentrated on lucrative investments for the family's descendants, in whom, however, the ageing and diffident Michelangelo had not great trust. As he gradually accumulated conspicuous sums of money, he suggested to his brothers Giovan Simone (11 March 1479–9 January 1548) and Gismondo (22 January 1481–13 November 1555) that they should invest in land and industrial activities. But his diffidence made it very difficult to take a decision on these investments. Every time there was an opportunity to buy a house, some land or a workshop, he took action in Rome to gather information on the transaction through his dense network of Florentine agents and more generally the substantial community that divided its time between Rome and Florence, and in which he could boast some very influential friends. His diffidence became a torment for his relations, who were obliged to obey the orders that arrived from Rome. He had no intention of delegating important decisions to his brothers, who were of course on the spot. On the other hand, his predilection for the Florentine market reveals the continuing mindset of an exile. Even though his age and his Roman commitments made it very difficult to return to Florence, he continued to feel that his

position in Rome was precarious and to plan his future back in his native city.

Very soon the family situation came to be dominated by his nephew Leonardo, the son of his favourite brother Buonarroto. On Buonarroto's death in 1528, Michelangelo had to take direct responsibility for the child; he had seen him grow up and considered him much more than a nephew. The boy was lively and exuberant, and, unlike his uncle, absolutely determined to enjoy life with minimum expenditure of energy. It is no surprise then, that from the mid 1540s, Michelangelo's correspondence was almost entirely devoted to his nephew, with whom he established his usual tormented and tormenting relationship, as even in this case he was unable to abandon the diffidence that had blighted his whole life and to allow that enjoyment of a warm relationship he had always denied himself, even within the family context.

Even though his thoughts about his family were almost exclusively directed towards his nephew, Michelangelo kept him away from Rome as much as was possible, as though he were an unbearable annoyance and a tiresome interference in his Roman life. He prevented the nephew from visiting him too often and he deprived himself of the lad's company, as though he had too many important things to do which could not be reconciled with family life. Every attempt by Leonardo to visit his uncle in Rome, even for a few days, was seen as a calamity by Michelangelo. The nephew's presence was a threat to the new family that had been formed in Rome with a few loyal and patient friends and his servant Urbino, to whom he was accustomed and for whom he had the affection of a blood relation. In appearance at least, he was more tractable with Urbino.

In the summer of 1544, Michelangelo became gravely ill, and there were fears for his life. His nephew came to see him in Rome, as was natural, but Michelangelo interpreted this visit as a cynical attempt to ensure that nothing was removed from the conspicuous inheritance the young man was expecting. Urbino or some other malevolent adviser might have been fanning the flames of his diffidence, as they knew that in Florence they did not approve of his intimate relationship with his servant, because of the latter's supposed excessive dominance. His reaction to the nephew's visit was harsh and ferocious, a demonstration of

how, even in his old age, Michelangelo was unable to soften his terrible character, which had poisoned his whole life. His dear and loyal friend Luigi del Riccio, who was also the principal intermediary between him and the pope, took care of him through his illness. He had him looked after in the home of Roberto Strozzi, another rich republican exile, and treated by the best doctor in Rome. As soon as he got his strength back, Michelangelo wrote a terrible letter to Leonardo and threatened to disown him. He gave a free rein to all the suspicions that prevented him from enjoying the only descendant of the family line, the man for whom ultimately he was working so desperately hard:

> *Leonardo, I have been ill; and you, in the room of Ser* [title of a priest or notary] *Giovan Francesco, came to give me death and to see if I was leaving you anything.* Do you not already have so much of mine in Florence? Is it not enough? You cannot deny that you are like your father, who drove me out of my own house. You should know that I have made a will in such a manner that you should not bother your head about what I own in Rome. So be off about your business, and do not come to visit me, and do not write to me ever again, and do as the priest bids you.[4]

The other victim of his harangue, the 'priest' who, in his opinion, had sent Leonardo to Rome to check whether Urbino had stolen his inheritance, was his old friend Giovan Francesco Fattucci, who had spent his life in assisting and serving him.

The destructive anger that would take control of him could not have been good for Michelangelo's health while he was convalescing. He lay in a bed that had been prepared for him at the Strozzi household, because his own home in Macello dei Corvi was not suitable for such an emergency, in spite of all the riches he had accumulated. Even when old and sick, the artist could not soften his violent and irritable character, just as his republican fervour would never fade. He and the few friends who frequented his home continued to dream of the rebirth of the Florentine Republic, even though the expert politicians in Italy now considered it would be very difficult to oust Cosimo de' Medici from the government of Florence. Whether this was a vice or virtue, Michelangelo was never able to resign himself to the death of the few solid ideals to which he had devoted his life. From his bed in Palazzo

Strozzi, from which he could see the dried-out riverbed of the Tiber turning yellow like the cut hay of his native land, Michelangelo made it known to Francis I, the king of France, that if the latter were to bring freedom to Florence, he would erect a bronze statue to him in Piazza della Signoria. And what was truly extraordinary was that Michelangelo would have done it at his own expense.

His anger against his much loved nephew did, however, cool down, and even the priest Fattucci was pardoned. In his usual brusque and childlike manner, Michelangelo wrote to him a little afterwards and sent him a sonnet, as in the old days, to make it known that he was still alive and still had a light of gratitude in his agitated soul, which was haunted by the phantasms of diffidence. His republican faith, which was so obstinate and out of touch with reality, was inevitably a source of worries for his relations in Florence, where Cosimo's spies were sending in regular reports on the republican activities of Michelangelo and his friends. For his part, Cosimo had implemented an intelligent policy to reintegrate the best and most energetic Florentines and could have asked for nothing better than to have absorbed Michelangelo into his pacification plan. In the mid 1540s, he became very concerned about his destiny and the works of art he had in his home. At the time of his second illness in the winter of 1546, he did not hesitate to send the young Leonardo to Rome, while instructing Lorenzo Ridolfi to help in recovering all his uncle's property in the event of his death. He thought this was the surest way to take possession of Michelangelo's available works, which the artist denied him.[5]

The manoeuvres to ingratiate the artist also involved old friends like Benvenuto Cellini, who around 1551 visited Michelangelo on Cosimo's behalf to propose his return to Florence, where he would have been covered with honours. But Michelangelo was of an entirely different opinion. The Florence he loved and which he could never renounce had been rebuilt in Rome in the small and exclusive group of friends who frequented his home assiduously: Donato Giannotti, Roberto Strozzi, Luigi del Riccio and Francesco Bandini, all republican exiles who belonged to some of the noblest Florentine families, in the sense that they could boast centuries of direct involvement in the city's public affairs – something that, in Michelangelo's eyes, defined the highest level of the city's nobility.

Donato Giannotti in particular had been one of the leading intellectuals in the republican revolt of 1527, and from then on he had become inseparable from Michelangelo. Very cultured and sophisticated, Giannotti was appointed secretary to Cardinal Ridolfi, and he introduced Michelangelo to the world of literature. He came up with the idea of a sculpture of Brutus, which Michelangelo offered to Cardinal Ridolfi, the central figure in the anti-Medicean party in Rome, to celebrate the assassination (or 'tyrannicide', as they preferred to call it) of the wicked and devious Alessandro de' Medici by his cousin Lorenzino in 1537. He was the one who corrected Michelangelo's sonnets and even his elegant letters, such as the ones written to Vittoria Colonna. We are also indebted to him for one of the most marvellous accounts of Michelangelo's life in the mid 1540s. His portrayal is of a relaxed and untroubled man who loved his friends and the learned conversations they held while taking walks around Rome, which these Florentine exiles could not fail to love. His Michelangelo devoted the little time that remained from his artistic labours to his passion for Dante and poetry in general, as well as music and true friendship, to which he was apparently addicted.

Fortunately for us, Giannotti transcribed and published as a dialogue one of these dreamy days, in which a small group of sprightly seventy-year-olds wandered unhurriedly around the Capitol, the marble Forums covered with bay-trees and holm-oak, and the old and new parts of the constantly changing city. The information we can garner from this is extremely precious and confirms suspicions raised by many other documents concerning Michelangelo. In the dialogue, he says that he is unable to yield to the sensuality of his affections and passions, because they distract him from creativity and work, which can flourish only in conditions of sombre concentration and denial of every other vital need. The greatness of art arises from the acknowledgement of the need to forego happiness in this life, as though the two spheres were starkly opposed to each other. This was a very 'modern' way of interpreting his own creative mission, which other artists in very recent times would attempt put into practice with a conscious sacrifice. Michelangelo instinctively arrives at his idea, and only at the end of his life does he appear to have been untroubled about the decisions he had made during his life. Those decisions brought light to the sufferings of

the previous seventy years spent in building the glittering wall of his art against the fears caused by his own drives.

In the light of this mechanism, we can also explain the difficulty he had in completing his works and his propensity to live much better in the open space of the possible than in the restricted space of the real. Everything that occurs within the person has to undergo complex transformations if it is going to be externalized and made acceptable to the self and to others, and these transformations can end up producing incomparable masterpieces through artistic inspiration, superhuman talent and extraordinary manual ability. For Michelangelo, art was the enemy of life and life the enemy of art: to attain great artistic achievements individuals must sacrifice their own lives. We are a very long way from Raphael and the intensity of his life. Michelangelo's vitality was subject to his creative effort, without any concessions to another pleasure, and what is most impressive about his words is his profound awareness of this inner mechanism – the artist's acceptance of the consequence of having chosen the perfection of art.

The scene, then, is that of a bright spring day in Rome with a sky, a sun and a fresh clean air that invited them to the idle pastimes of which those who live on the banks of the Tiber have always been the supreme masters in all ages. The fragrance that hung in the air was of young grass and the first almond blossoms that punctuated with pink the vines growing in every part of Rome. Michelangelo is invited by his dearest friends to come out to enjoy this sweet reality, but they are stunned to encounter his refusal for even more astonishing reasons:

> Michelangelo: You are greatly mistaken, and to demonstrate that you have, as we say, hit your own foot with the axe by this argument you have used to persuade me to come and lunch with you, I will have you know that I am the man most inclined to love people who was ever born in any period. Whenever I see anyone who has some virtue, who displays some adroitness of genius, who knows how to do or say something more stylishly than others do, I am obliged to fall in love with him, and I give myself up to him like a prey, so I am no longer mine but entirely his.
>
> If I, then, came to lunch with you, your being all gifted with virtue and courteousness, each of you at the lunch would take away a part of

me, over and above that which each of you three has already stolen
from me. Another part of me would be taken by the musician, another
by the dancer and so on as each of the others would have his part of me.
Though I would hope to cheer myself up with you and recover myself
and feel myself at least as you have told me, I would wholly lose myself,
so that for many days I would not know what planet I was on. . . . And I
remind you that when it comes to finding oneself and enjoying oneself,
it is not appropriate to indulge in too many pleasures and too much
gaiety, but rather one needs to think about death. This thought alone
is the one that makes us acknowledge our selves and maintain the unity
of our selves, without allowing ourselves to be stolen by our relations,
friends, great masters, ambition, avarice and other vices and sins that
one man steals from another and keep him in a dispersed and dissipated
state and will not allow him to find himself and become one.

A marvellous effect is to be found in this thought of death, which, by
destroying all things in accordance with its nature, preserves and main-
tains those who concentrate their thoughts upon it, and defends them
against all the human passions. This is something that I remember
having already mentioned most stylishly in one of my short madrigals,
in which, while discussing Love, I conclude that nothing defends us
from him like the thought of death.

> Not death but thought of death
> Defends and releases me
> From the iniquitous and beautiful Woman
> Who in every hour kills me
> And, if on occasions she flares up in me
> Rather than having used the fire which I have encountered,
> I find no other relief
> But the image halted in the middle of my heart.
> Where there is Death, Love will not approach.[6]

It is clear from this poem that the artist clings desperately to the
thought of death so as not to succumb to the loss of his self caused by
any amorous entanglement. But by that time in his life, Michelangelo
must have been very gratified to have avoided those everyday mishaps
and reached an Olympus where he now ruled alone.

3 MARRIAGE PROPOSALS

Because of the respect and devotion of his own exclusive social circle and the increasingly intense love of Paul III who was of the same age, Michelangelo found that his prestige in fashionable society continued to rise after it had reached its highest point in terms of artistic recognition. His Roman life, which was entirely centred on the development of artistic and intellectual talent, became increasingly distant from his Florentine family life, which was endlessly afflicted by conflicts with relations he was unable to trust. There can be no doubt that his strongest passion was for those terrible relations, who triggered his most visceral instincts.

His search for a wife for his nephew Leonardo soon became the most delicate part of his strategy to raise the family's social status. The spiritual concerns he shared with persons of the highest social rank did not distract Michelangelo from the sufferings that had tormented his entire life, and the search for a wife worthy of the Buonarroti name, who would mark the dynasty's changed fortunes, became an obsession that kept him awake at night and pitilessly emphasized his fragility and solitude. He wanted the nephew to marry as soon as possible, in order to continue the Buonarroti dynasty and make sense of the sacrifices he had made for so many years.

The ferocious misogyny he had cultivated throughout his life exploded in these circumstances, when Michelangelo felt so involved that he started to imagine that he too should take a wife. His natural diffidence became overwhelming when matters concerned a woman, but one on whom the advantage of a social alliance depended. The ageing artist's opinion of women is very clear from the advice he gave his nephew: it was very low and fully explains his decision to keep them at a distance throughout his life. Being completely indifferent to that love he had exalted in poetry in recent years, he wanted his nephew to have a wife who was neither beautiful nor even rich, but she had to be noble. She needed to come from a class that allowed the family to climb up the social ladder. He had managed to marry off his niece Francesca to a Guicciardini, and this had brought him considerable satisfaction. But the choice for Leonardo was much more complicated, as the future of the dynasty depended on it.

Beautiful and rich women, Michelangelo explained, tend to prevail over the husband's authority and bring ruin with their frivolities or even vices, given their weak nature. Even some physical defect is tolerable, as long as the woman is submissive and devoted exclusively to the family, the care of its descendants, and the prudent administration of its assets.[7] Such a conviction could only be held by a man radically indifferent to female beauty.

Offers of marriage arrived directly from Florence. As far as he could, he screened them before sending them on to his nephew. Leonardo, for his part, was not exactly a model of rectitude: he loved the good life and he did not spurn unacceptable company, which infuriated his uncle who had never indulged himself because of his craving for wealth and the restoration of the family honour. From 1546 his search for a wife for Leonardo, which he conducted as though his own future was at stake, eventually became entangled with other painful events that triggered a period of black despair for the ageing artist.

In 1546 came the death of Luigi del Riccio, who had been not just a friend but also a protector and the mediator necessitated by the artist's irascible personality. Even the pope was in despair, because relations with Michelangelo became problematic without his intercession. The death of his friend and adviser could not have come at a worse moment: the pope's son, Pierluigi Farnese, who had just become Duke of Parma and Piacenza, was trying to take away the bountiful right to the taxes and duties collected on the bridge over the River Po. Pierluigi, whom the Emperor's correspondents in Rome described in 1545 as the most abominable man in the world,[8] had horrified the whole of Italy with his nefarious enterprises which always received his father's protection. It was not, therefore, entirely unexpected that he contrived to return the income to its original beneficiaries, so that he could more easily appropriate it to the Duchy of Piacenza.

Michelangelo's reaction to this injurious imposition was immediate and drastic: he promptly suspended all work on the Pauline Chapel and started to bombard the pope with protests and complaints. Fortunately Paolo III, who loved Michelangelo intemperately and perhaps considered him a fellow survivor from an age that had irredeemably passed, would not allow his son to molest the old artist, even though he had allowed him to get away with much more wicked

plans. He therefore demanded that Pierluigi give up his plan, espe-
cially after the death of Antonio da Sangallo the Younger who had left
vacant the post of Architect of Saint Peter, which could only be filled
by Michelangelo if the works were not to be beset by even greater
failures and scandals than the ones that had plagued them for twenty
years.

Pierluigi's correspondents in Rome carefully recorded his father's
furious protests against the plan to deprive the artist of income from
the bridge over the Po. Their accounts tell of a Michelangelo quite
determined to defend his own financial interests:

> Our lord argued that, if ever he were needed, it is now, particularly for
> the building of Saint Peter's, given that Sangallo is now dead, and if
> ever it were difficult to keep under control and manage him, then it is
> now, following the death of Master Luigi, who controlled him and was
> the means by which he [Michelangelo] was persuaded to conform with
> his Holiness's plans.[9]

Thus at the age of seventy-one, Michelangelo Buonarroti held the
Church of Rome hostage with his talent, especially as the Church was
engaged in the greatest undertaking of the century: the building of
the new Saint Peter's. Even the pope did not know how to deal with
the ageing despot and struggled to prevent all the potential conflicts,
as he wisely understood that talent is the one resource you cannot
extract from people with either force or cunning. The false and mali-
cious Pierluigi was obliged to abandon his plan and scornfully brought
the matter to an end by dictating an abrupt and insolent order to his
envoy: 'Find him and tell him in our name that we believe that he does
us wrong to trust so little in the affection we bear him and have always
borne him.'[10] As though it were easy, even for someone less distrustful
than Michelangelo, to trust a criminal like Pierluigi, a man who had
sodomized a young bishop and caused him to die in agony. Not even
Titian's indulgent talent could mask the signs of syphilis and perversity
when it came to painting the despot's portrait.

However, this matter would have a disastrous outcome for
Michelangelo. On 10 September 1547 Pierluigi was stabbed to death
by a group of armed plotters led by Ferrante Gonzaga, the brother

of Cardinal Ercole and one of the principal and most loved allies of Emperor Charles V. The duchy, which the Farnese family had only just annexed by stealing it from the Church, now passed with all its benefices into the hands of Charles V. But the pope compensated Michelangelo with another benefice in Romagna.

Another terrible blow was inflicted on the artist at this time: the death of Vittoria Colonna, who passed away in Rome on 25 February 1547. That death deprived Michelangelo of a solid affection that gave him support and of an important interlocutor who could contain the profound anxieties that arose from his tormented religious beliefs. He was now about to embark upon the greatest undertaking of his life, which soon proved to be a very harsh battleground: the continuation of the building work on Saint Peter's.

4 BUILDING SAINT PETER'S

In 1546, on the death of Antonio da Sangallo the younger, who for many years had been the director of the building site for Saint Peter's, there was only one man in Rome who could have taken his place. Naturally this was Michelangelo, and Paul III appointed him to that position in November 1546.

Very powerful interests relating to the contracts for supplying materials and recruiting the workforce had grown up around the building work at the Vatican, and these had been controlled for decades by a group of Florentine artists and contractors with whom Michelangelo had clashed many times since the work on San Lorenzo. The construction of the new Saint Peter's had used up so many resources that it risked bankrupting the treasury of the Catholic Church, and the waste had become an international scandal, which the Lutherans had not failed to exploit as it demonstrated the greed and corruption of the Church of Rome. It could be argued that the Reformation itself was ultimately started with the construction of the new basilica, when Leo X granted an extraordinary indulgence to whoever paid an offering towards the building costs, and entrusted the Fugger family with the collection of these tributes. The Fuggers' collectors proved to be rather insensitive in the way they promoted this indulgence, and Luther was so outraged that he set off on the course that led to a break with Rome.

Europe became divided, and the religious wars had created so many war dead that the new basilica, if it were ever completed, would not have been big enough to hold them all.

Completion of the building work had become a political priority which went far beyond the architectural problems. But it was true that these also had to be resolved, if the work was to be completed. Shortly after having received the commission, Michelangelo received a letter from Florence that informed him of the poisonous whispers about his appointment which had been spread by the master builders of the 'Sangallesque sect', as the writer defined the Florentine contractors who for so long had been bankrolled by that building site. He immediately became aware of the appalling difficulties he would have to overcome. In May 1547, a group of architects were already manoeuvring to discredit him, and these included the Nanni di Baccio Bigio, whom Michelangelo had excluded from the Saint Peter's site and who was now seeking to retaliate by making a great number of shameful allegations. This was making it very difficult for Michelangelo to manage the enterprise. The reputation that Michelangelo enjoyed as a painter and sculptor did not prevent his enemies from accusing him of amateurishness in architecture and lack of entrepreneurial skills. In Rome, even the gods could easily lose their altars if they stood in the way of financial interests.

For Michelangelo this was a heavy blow, partly because his relations with Florentine and Roman professional circles were poisoned by his not overly sincere behaviour towards them over the previous decades. However, the old artist put all his energies and all his religious convictions of that time into the Saint Peter's commission, and these fused perfectly and helped him to push forward with the contract and overcome the increasing difficulties. The 'Sangallesque sect' had its work cut out when it came to dealing with Michelangelo. Paul III was utterly convinced that only he was capable of getting the Church out of its difficulties and completing the works in a dignified manner. He said as much to one of his son's friends, Fabio Coppalati, who recorded this in a letter he wrote in November 1546.[11]

As he was confident of the pope's unconditional support and his faith in Christ, Michelangelo turned up at the Congregazione della Fabbrica [the works committee] on 25 February 1547 and dictated his conditions

to the wheeler-dealers of Rome. As usual, these conditions were drastic but also categorical:

> Our Lord has sent one of his grooms to tell me that I had to come to this gathering to explain what I want to your Lordships. Since his Holiness has put me in charge of the construction of Saint Peter's, I inform you that I do not want anyone other than myself to take responsibility for it, and nothing will be done other than that which Master Giovambattista here will instruct you on my behalf. (He turned to the said Master Giovambattista). Nor do I want there to be so many deceits and thefts in the construction works, as I understand that the same person who sells travertine is the person who issues the contract. And I do not want walls to be built with lime, stone and *pozzolana* I have not approved.[12]

Michelangelo's intransigence seemed almost visionary in the corrupt Rome of Paul III, but the brutality of his words on that day was the fruit of the terrible pain he felt over the agonizing death of his adored friend, Vittoria Colonna, which was happening at that very time, not far from where he was engaged in a cynical negotiation.

In a Rome picked dry by corrupt contractors, Michelangelo was preparing to clean up the richest public contract of the century, an unprecedented undertaking compared with which even the painting of the *Last Judgement* and the ceiling of the Sistine Chapel seemed mere trifles.

Of course he had been a witness to the birth of the new Saint Peter's at the time of Bramante and Julius II. The tomb planned for that Della Rovere pope had in fact been intended for the new basilica. He knew that the building had been conceived to emulate ancient buildings, and for this reason they had chosen the magnificent central plan: an ancient temple was considered the most appropriate way to honour the apostle Peter. Bramante's plan was in the form of a cross inscribed within a square, which was further complicated by great ambulatories that increased the space around the choir and the arms of the transept. Bramante immediately started work on the choir and the corresponding ambulatory by demolishing the apse of the old Constantinian basilica. But after Julius II and Bramante had died, the enterprise was picked

up by Leo X and Raphael, who at the pope's request prolonged and enlarged the basilica until it entirely covered the space only occupied longitudinally by the previous building, thus consecrating all the land which had been devoted to the martyr in ancient times.

The construction work proceeded along these lines during the second decade of the century, but with the crisis during Leo X's reign and then with the sack of Rome, it became evident that Bramante's grandiose plan could never be completed. Baldassarre Peruzzi was then given the task of scaling down the plan. However, the election of Paul III in 1534 marked a return to the grand ideas. Against the wishes of Antonio da Sangallo, who in the meantime had taken over the direction of the works, the pope insisted upon the grandiose ambulatories that created the immense space within the church. To give an idea of what this plan would have been like if it had been implemented, we need to imagine entering the colossal Saint Peter's as it is today and seeing a space multiplied beyond the current walls, the choir and the transept into other equally gigantic spaces.

Even though he opposed excessive grandiosity and wished to eliminate Bramante's ambulatories, Antonio da Sangallo was obliged to keep them. He therefore attempted to find solutions to the plan's other outstanding problems, such as the construction of a loggia for benedictions on the facade, from which the pope could speak to the crowd, or the covering of the entire length of the original Constantinian basilica, which had become a cultural emergency. He found some convincing solutions, because he added a vestibule that prolonged the centralized plan towards the city. Under Paul III's reign, however, the site was paralysed by its grandiosity and excessive demands. The building had to conform to a classical tradition and its interpretations by successive architects. Creative requirements had to be reconciled with practical architectural ones, which were far from irrelevant. Above all, it had to conform to the wishes of various popes, which arose in part from the requirements of religious worship but mainly from their delusions of grandeur and desire to associate their names with the greatest building in Christendom.

In this climate, the amount of waste had become scandalous and everyone began to feel that the building was one of the papacy's principal political problems. By the time of Sangallo's death, the situation

appeared very difficult. Saint Peter's was an enormous carcass full of holes, and closer to a ruin than a building under construction. Paul III, however, felt the project was his child, and in 1545 he had Giorgio Vasari paint his portrait on a wall of the Palazzo della Cancelleria Apostolica, depicting him with the framework of the building in the background and thus celebrating him as a new Hercules along with the greatest of his labours. But that was the very time when it was becoming increasingly clear that there were not sufficient funds to complete the project. Just to buy Emperor Charles V's consent to his nepotistic plans, the pope undertook to pay him enormous sums of money as a contribution to his wars against the Schmaldkaldic League.

In a desperate crisis, Michelangelo at least had the authority to impose decisions that previous master builders would not have been allowed. He understood that the recently constructed ambulatories were part of an overambitious project which would have led to the ruin of a large part of the Vatican palaces, and he had them demolished, although this caused endless controversy. There was a massive resistance to the demolition of what had only just been built, but Michelangelo was stubborn enough to persuade the entire court that this sacrifice would eventually bring its rewards, because it made it possible to save millions of *scudi* and complete the building work. On this occasion, he managed to get his way even though everyone was of a different opinion.

In spite of the repudiation of one of the most distinctive elements of Bramante's project, he salvaged nearly all the other original characteristics. He went back to the simple and luminous central plan and got rid of the vestibule. He also went back to the idea of a painstaking correspondence between the form of the exterior and the form of the interior. He even restored the rhythmic girder that alternated pilasters and superimposed windows, which was invented by Bramante but abandoned by Raphael and Sangallo. His debt to the artist he had never ceased to criticize was enormous, and for a moment he was even tempted to acknowledge this, so long as he could bury the ideas of Sangallo who, as a great engineer, had made considerable contributions to the development of the building, which Michelangelo defined as a comfortable place for 'infinite villainies, such as secretly hiding exiles, producing false coins and making nuns pregnant.'[13]

Michelangelo's truly innovative idea concerned the light, which could finally enter all parts of the church freely, following the elimination of the many filters originally devised by the previous architects or perhaps constructed compulsorily for structural reasons. Michelangelo concentrated the downward pressures in the tambour and discharged them through colonnaded buttresses, so that he could free the walls and open up twice as many windows as had been intended by his predecessors. By also reducing the thickness of the walls around the windows, the light in the church became clearer and more direct, and this played on the visitor's emotions, whereas this kind of involvement had previously been entrusted to the effects of the penumbra. This use of light can undoubtedly be explained by Michelangelo's religious feelings, since he interpreted the clear and direct light as the emanation of the divine spirit that calls the faithful to Christ.

Alongside the need for luminosity in which the artist concentrated his own religious sentiments, his plan expressed a complete awareness of the symbolic value of ancient architecture on which Bramante's original project had also been based. It could be argued that it was Michelangelo who, after an interval of decades, restored and demonstrated the power of the classicism of the High Renaissance, even though, unlike Bramante, he was aware that that plan in no way corresponded to the archetype of the ancient temple, whose real historical tradition had been sorted out by scholars in the meantime.

5 OUTLIVING HIS FRIENDS

While he was stubbornly and untiringly engaged in the battle against the profiteers who had gravitated around the great Vatican building site, Michelangelo received another terrible blow: the death of Paul III, who had placed all his trust in him and his direction of those works, over which he had complete authority. The pope had even supported him when he was at his most intransigent. The uncertainty surrounding his successor kept Michelangelo in a state of apprehension during the very cold days of the long conclave of 1549. At the beginning of the conclave, the general opinion was that Reginald Pole would be the new pope. Evidence of this could be found in the odds offered to gamblers in the Strada dei Banchi opposite the Vatican, and also in the instructions

Paul III left to his nephew, Cardinal Alessandro, in which he asked for the votes over which the Farnese family had influence to be cast in favour of Pole. The election of the English cardinal would have been highly beneficial to Michelangelo, not least in purely spiritual terms. He would have witnessed the affirmation at the highest level of the religious views that had inspired his works during the previous decade and were however about to be challenged for their heretical content. With a pope like Pole, the Saint Peter's commission would have been a happy adventure to crown his life's achievements both as an artist and as a man. Almost as an auspicious act, he had painted the walls of the Pauline Chapel, where the actual conclave would take place.

Unfortunately things took a turn for the worse. Following the first ballots, which almost gave Pole a majority, his main rival, Giampietro Carafa, who had chosen the Inquisition rather than debate the means by which to resolve religious controversies, decided to come out into the open and make a violent accusation of heresy against the English cardinal. On the morning of 5 December 1549, when Carafa realized that Pole would gain the papacy at the next ballot and bring about his ruin, he entered the conclave and accused Pole of Lutheran heresy. He had two items of evidence, which were as heavy as millstones: his departure from the Council of Trent when it was voting on the decree on Justification and his involvement in writing the heretical work, *Il beneficio di Cristo*. The accusations hit their mark, and Pole's chances of election rapidly receded, which caused a rift that was destined to widen in the following years.

Following a series of highly complex negotiations, the choice finally turned out to be Cardinal Del Monte, who was elected pope as Julius III. The new pope was an extremely sensual man, and inclined to the pagan culture that had dominated the scene and the education of men of his class at the beginning of the century. These were, however, characteristics that inevitably led towards a rapport with Michelangelo, who, albeit in a more austere manner, could also boast an identical humanist education and an identical passion for art.

One of Julius III's first provisions, amidst so much scandal, was to appoint as cardinal one of his young protégés, whom he had literally picked up in the street and whose family background was entirely unknown. Otherwise the pope appeared to interpret his role exactly

as did his predecessors. He started building two splendid family tombs in San Pietro in Montorio, and he contracted Vasari and Ammannati to do the work under Michelangelo's invaluable direction. Above all, he started the construction of one of the most beautiful and extravagant monuments of the sixteenth century, Villa Giulia outside Porta Flaminia (now Porta del Popolo, the northern gate of the Aurelian Walls), where some visitors of the time saw him naked, taking a bath in the garden while surrounded by pages. In its architectural style, its paintings and its layout, the villa explicitly referred back to Villa Madama, which was built by Raphael for Leo X on the hill opposite. Julius deceived himself that in the 1550s he could indulge in the same fantastic and leisurely pastimes that had been allowed the great popes thirty years earlier.

Michelangelo shared the same aesthetic passion as the new pope, and their friendship became even more solid than the one that had bound him to Paul Paolo III. Thus the artist, now seventy-five years old but still very careful about money, had hopes of having his salary increased. Following the loss of the toll over the Po, Paul III had given him the benefice of the Notarial Office of Romagna, which produced revenue of about twenty *scudi* each month, which was less than the fifty for the bridge toll but still a very considerable sum. This income continued to be supplemented by the fifty *scudi* in monthly salary that Michelangelo was paid directly from the Vatican's coffers, so the annual salary on which he could count was the fantastic sum of 837 *scudi*. In August 1550, just after the investiture of Julius III, Michelangelo asked his nephew Leonardo to send him from Florence the two papal briefs in which Paul III promised him 1,200 *scudi* per annum. Very probably he wanted to show these to the pope in the hope of obtaining at least that figure. But he did not succeed, and his salary remained unchanged.

During this period, he was almost exclusively working on the construction of Saint Peter's, which he considered a commitment of a religious nature. Even though he received a salary that no architect of this building had ever received before, he treated this professional undertaking as a votive offering to his own faith, and thus in his correspondence or in the memoirs he dictated to Ascanio Condivi at the time, he declared that he had never received any compensation for that work. This lie probably concealed Michelangelo's own conviction that

his commitment to the building was such that no salary could ever had repaid him.

Besides, he was enjoying an unprecedented position during this period. Whereas forty years earlier Duke Alfonso of Este had refused to write directly to the 'divine' Raphael, as he considered it unbecoming, although he did not hesitate to have his attendants threaten the artist, Michelangelo was now receiving letters from the king of France, Queen Catherine [Caterina de' Medici], Duke Cosimo and numerous cardinals, who approached him with the same manners they would have adopted for their peers. Following Varchi's public lecture at the Florentine Academy, which had more or less institutionalized the cult of the artist, Torrentini's edition of Vasari's *Lives of the Artists* was published in 1550, and its biography of Michelangelo, the only artist in the collection who was still alive, was very much a hagiography.

Yet that biography must have perplexed Michelangelo, who agreed to dictate his own version of his long life to a not very talented disciple, Ascanio Condivi da Ripatransone. The author loyally gathered the information his master provided and published it in 1553. We know very little about Ascanio Condivi, and if he had not linked his name to Michelangelo's we would know even less. For a period he was in the service of Cardinal Ridolfi, who was a friend of Michelangelo and the 'patron' of another dear friend of his, Donato Giannotti (who must have been involved in editing this biography, if you consider his intellectual genius and his supervision of everything that had to do with the master's literary passion). In any event, Condivi's *Life* was the first case of a memoir published before the subject's death in order to correct the many errors of another biography – the one in Vasari's collection. This affair alone demonstrates the high esteem in which Michelangelo was held during this period.

However, the artist's days were still soured by the usual troubles, the most important of which were caused by his family. Leonardo was having difficulty in fulfilling his uncle's impatient desire to see a continuation of the Buonarroti line. After eight years of hard work and repeated requests about marriage, Michelangelo found out that his nephew had made pregnant the wife of a stonemason. The news spread quickly from the Florentine quarries to the great construction work on Saint Peter's, where the workers took great pleasure in slowing down

their work for a little gossip and talked of nothing else but the cunning nephew and the unhappy uncle, who has worked all his life to increase the comfort of his nephew's bed. Michelangelo was furious ('he did not want to leave the fruit of sixty years of hard work to someone who, after his death, perhaps intended to spend it all on a good time with whores and trollops')[14] and he threatened to leave all his money to orphanages and hospitals, while his friends bombarded his nephew with reproaches and threats, including a hypocritical warning from Urbino, who never failed to inform the uncle of his nephew's every misdeed in order to steal his affection and wealth, although he always acted with appropriate caution.

For his part, Leonardo had very good reasons to believe that Urbino and Michelangelo's other assistants in Rome were taking advantage of his uncle in the basest manner. News circulated incessantly through a dense network of skilled workers who divided their time between Florence and Rome, and it was further poisoned by the smugness of popular gossip. Urbino had become a kind of adoptive son, so that on his death in 1556, Michelangelo acted as executor for his young sons Michelangelo and Giovansimone. His boundless affection for Urbino could only alarm the distant family, particularly as Michelangelo continued to be irritated every time his nephew visited him in Rome, even though he loved him with all his heart and never failed to call him 'most beloved' in every letter, which he rarely did with people who were close to him. Within his plan to redeem the family name, to which he devoted his life, Leonardo and his Florentine family were placed the sphere of social and family duty. But now the plan was beginning to appear distant and abstract, even though Michelangelo never retreated from his final aims until the last day of his life.

In his daily life, the loving support came from Urbino, who cared for him like a son, a servant and an assistant, and occupied a position of absolute pre-eminence in that strange company that constituted the house in Macello dei Corvi. This pre-eminence of his servant from Le Marche also manifested itself in the latter's total control over who could get close to the ageing artist. From the 1550s, nearly all Michelangelo's servants came from Urbino's hometown, including Antonio del Francese who stayed with his master to the very end, partly because no one could impede that intimacy once Urbino was dead. In

his own small way, Urbino became an important clearing centre for the protégés who orbited around Michelangelo. We find that even on the Saint Peter's site, one of his relations, Cesare di Casteldurante, was an important master builder and one of the very few in whom Michelangelo could place his trust.

Relations with Florence and the family there were also made more difficult by fortune's stubborn refusal to allow Michelangelo the joy of a continuing family line. Leonardo's son, Michelangelo, who was born in April 1554, died a few months later. The drama appeared to touch the ageing artist only in as much as it affected his 'dynastic' plans.

The arrival some years later of another son to his nephew at least reassured him on that count. In spite of all the honours that were bestowed upon him, the period of Julius III's papacy saw no let-up in the conflicts with overseers on the Saint Peter's site, given the enormous financial interests involved. According to one of Vasari's letters, Michelangelo had recently saved him from robbers and murderers. Given that he was determined to check all details concerning the works, from the consignments of lime, bricks and stone to the drawings of the capitals and cornices, Michelangelo, whom many now considered mad and who had made his absolute and unchallengeable authority a condition of his acceptance of the post, had become a nightmare for those working on Saint Peter's. His perfectionism and enormous expertise were a terrible scourge for the unscrupulous architects, contractors and master builders of Rome.

Unsurprisingly, then, there were times when people tried to create difficulties for him when the building work was at a particularly critical stage. In spite of his age, Michelangelo showed no intention of releasing his obsessive control over the fantastic and gargantuan building site. He felt increasingly wound up in this enterprise and managed to have one of the Casteldurante 'relations' appointed superintendent of the site. This was the previously mentioned Cesare, who lived in his house and gave him daily updates on the progress of the works. Following the period of Sangallo's direction in which so much money was squandered, this was a terrible penance for the Roman contractors.

In this desperate struggle, which was also a struggle for the idea of faith, Michelangelo found that the friends who had supported him through his most difficult years, which now must have appeared the

best, were getting fewer and fewer. This was not due to inattentiveness or disloyalty but to the fact that their time had simply run out or, as in the case of the incautious Cesare – the poor master builder who assisted him at home and on the mammoth scaffolding of Saint Peter's – that they were unable to contain the demands of the flesh and allowed themselves to be caught by jealous husbands between the legs of their easy-going wives. The three knife wounds the husband inflicted on Cesare proved to be fatal, but the four inflicted on the wife were not sufficient to kill her. For Michelangelo, this imprudence was to cost him one of his most effective instruments for controlling the immense building site.

Luigi del Riccio left him in 1546. In 1547 he was deprived of the only female friend of his life, Vittoria Colonna, who was surrounded by an aura of legend and suspicion about her heretical faith, which increased with the passing years. In 1551 he was abandoned by Reginald Pole, who was first dispatched to his monastery in Verona and then to England, where he assisted Queen Mary in the difficult task of restoring the country to Catholic orthodoxy. With his departure, the group of Spirituals broke up and dispersed – a group that had been so important for Michelangelo not only for religious reasons but also for existential ones. He had found very dear friends in that group, such as Ludovico Beccadelli, who went to Augsburg in 1555 with Cardinal Morone for one last attempt at a dialogue with the Protestants and the reconciliation he had been seeking all his life. Beccadelli would later be exiled to Ragusa, far from the repressive atmosphere of the papal court in Rome. However, the letters they were writing to each other in 1557 still spoke of their religious passion, now inevitably veiled by the melancholy of their defeat and the tormented nostalgia for the time when they were all close to each other: the years spent in Viterbo and Orvieto dreaming of a new world which, they now knew, would never come.

> I wish to know that in body your Lordship is enjoying good health, for I am certain that your soul can only be well, knowing as I do how prudence and piety are your continuous companions, who will never allow you to be perturbed by the great tempest that occurs in this stormy world.[15]

The tempest had of course been provoked by their odious enemy, Giampietro Carafa, who was elected pope in 1555 as Paul IV and committed himself to a violent campaign against the ideas shared by the two now distant friends. The break-up of the Spirituals also marked the deteriorating situation of one of the centres of greatest political power at the papal court, which had provided Michelangelo with protection at the highest level. The failure to elect Pole and his removal from Rome were accompanied by the rise of the group's principal enemy, Cardinal Giampietro Carafa, who for years had looked on them as the most tainted source for propagating heresy in Italy. Lost in the theatre of his classicist nostalgia, Julius III only provided Michelangelo and the Spirituals with momentary protection, while the political negotiations between Charles V and the protestant princes still maintained a precarious balance between the European confessions at least until the Peace of Augsburg in 1555. However, Julius III was not capable of seriously obstructing the obsessive and unrelenting work of Carafa and his Inquisitorial Tribunal.

Ten years earlier, Pole and his friends were writing books while Carafa was extorting permission from Paul III to set up a tribunal of the Holy Office in Rome. Without waiting for funding from the papal court and in spite of the fact that he was so poor that he had to beg for a pension from the emperor, he wasted no time in spending his limited financial resources on instruments of torture and bolts for the doors of the building he had been allocated. Time would demonstrate that he had made the right choice. The books written by Pole and the other Spirituals were sought out and burnt, while the confessions extorted under torture by the Inquisition were recorded in the increasing number of secret files held by the tribunal, and could be used by Carafa to blackmail almost everyone and influence the policies of the Holy See.

The decisive step was taken in the dramatic conclave following Paul III's death. From then on it was plain sailing. Pole had been removed, and this left the way open for fixing the trial that Carafa was preparing for him and his friends. The English cardinal's increasing fame would not help him, even though he was restoring his country to Catholicism with the active support not only of the queen, but also Charles V and his son Philip.

The climate of suspicion in Rome and Italy became oppressive after 1550, and this explains the very peculiar version Michelangelo dictated to Ascanio Condivi (possibly at Giannotti's suggestion) in relation to the last statues for Julius II's tomb, which were sculpted at the time of his greatest closeness to the Spirituals. The allusion in *Active Life* to the concept of good works as an instrument to enlighten the true faith, but not as an instrument of salvation, had now become very dangerous. It had been refuted in the Tridentine decree of January 1547, a few months after a defeated Pole had abandoned the assembly to avoid voting on what he considered a profoundly mistaken decision. Condivi's biography very purposefully deflected the various suspicions surrounding Michelangelo's career, which proposed a reading of the statue described as

> Active Life, with a mirror in the right hand, in which she contemplates herself, which means that our actions must be carried out only after due consideration, and a garland of flowers in the left hand. In this, Michelangelo has followed the example of Dante, of whom he has always been a scholar. In his Purgatory, Dante pretends that he found Countess Matilda, whom he takes for Active Life, in a meadow full of flowers.[16]

Anyone who wanted to find this statue at the tomb of Julius II would search in vain, as it simply does not exist! There is a woman who in her right hand holds a crown of laurels and in her left holds up an object that could never be considered a mirror. She is prudently averting her eyes from it to avoid burning them, for it is evidently a small lantern.

If its purpose was not explanatory, then Condivi's unusually long description of *Active Life* served to distance the work from the dangerous pages of *Il beneficio di Cristo*, its true origin, and move it to the meadows of Dante's *Purgatory*, a book that could not in any way be accused of heresy. The expedient was entirely justified in the Rome of 1553.

6 PAUL IV, THE ENEMY

Unfortunately, the manner in which Michelangelo distanced himself from the work that more than any other linked him to a circle of

heretics which the Tribunal of the Inquisition was now pursuing with increasing ferocity did not achieve very much. Once he was elected pope in April 1555, Giampietro Carafa, who had turned the fight against heresy into his life's work, did not leave any doubt about his repressive intensions. Besides, clemency could not be expected of a man who had declared that he would have burnt his own father, if he had known him to be a heretic. Indeed, there would be no clemency even for Michelangelo. Relations between the artist and Pole's circle were too well known to Carafa, who had gathered information on the entire circle and all Michelangelo's friends. However, the latter held a decisive position concerning Catholic finances and propaganda. The new pope, who was as old as Michelangelo, knew the artist's weak point only too well, and he immediately damaged his financial interests by suspending payment of his emoluments. In fact he did this on the first day he was elected, as though he had been waiting for that moment for years.[17]

The very long accounts ledger for Michelangelo's revenues shows a dramatic zero for the period of Paul IV's papacy. For the first time in his life, Michelangelo did not receive from the Church of Rome any remuneration for his work and he disappeared from the very prominent position in the accounts of papal treasury he had now held for a full twenty years. These were terrifying days for the artist, on a par with his period of confinement in Florence but without the resilience of youth. He fell from the incredible heights he had reached down to a weak and precarious position, at a time when persons of even higher rank were being disgraced or even put to death during the unrelenting fury of the fanatical Paul IV.

His financial punishment, which was particularly cruel for Michelangelo, risked becoming not the only one to ruin the final years of his life. To the horror of Europe as a whole, Paul IV ordered the imprisonment of Cardinal Giovanni Morone, the close friend of Michelangelo and especially Pole, with whom he had shared the spiritual guidance of the group now considered dangerously heretical beyond a shadow of a doubt. Once Morone was in prison, the other friends also started to fear the worst. Paul IV's nephew left Rome with the file the Inquisition had produced on Pole in order to convince his protectors, Philip II of Spain and Queen Mary of England, to hand him over to the Tribunal of the Holy Office. Both monarchs raised

objections, and the situation was only resolved when Sir Reginald Pole died in England on 17 November 1558.

In the face of ferocity that did not even back off from the highest monarchical powers on the continent, Michelangelo's advanced age could not guarantee his safety, nor could he be sure of his position at Saint Peter's, which Carafa immediately challenged by appointing Pirro Ligorio, a bitter enemy of Michelangelo's, to be the site superintendent in the hope of exasperating and excluding Michelangelo from the work he had now been doing for almost a decade. With admirable punctuality, Cosimo I sent his ambassador to Rome as soon as he knew of the election of the new pope, thus avoiding having to reveal the awkward considerations on which he based his invitation to the old artist to return to Florence immediately to avoid the vendetta of a pope who would stop at nothing and feared no one. The emissary arrived in Rome in mid-June 1555, a few days after the pope's election. Michelangelo wrote about this to Vasari.

> My dear friend Master Giorgio, I have been visited these last few evenings at my home by a very discreet and well-mannered young man, that is, Master Leonardo, the Duke's chamberlain, and with great love and affection on behalf of His Lordship I made the same offers you made in your letter. . . . and I beg His Lordship that with his permission I should continue to work on the building of Saint Peter's until it be completed, so that it cannot be changed and given another form, because if I were to leave earlier, I would be the cause of a great disaster, a shameful act and a great sin. I beg you to explain this to the Duke, for the love of God and Saint Peter.[18]

Michelangelo summarized his motivations very clearly: the building of Saint Peter's had become the goal of all his aspirations as a man and an artist, something that went far beyond the tiresome and miserable contingencies of everyday life. In spite of everything, his decision to stay in Rome was an extremely courageous one, dictated perhaps by an effective detachment from life, a sentiment that was beginning to make itself felt at the time. Completion of the building work on Saint Peter's or at least taking it to a point where it could no longer be modified, was becoming the conclusion of an artistic career that had never achieved,

as he would have wanted, a truly grandiose work, a viaticum for the salvation of the soul that had been tormenting for more than a decade.

The vital energy that Michelangelo had always displayed in resisting the harsh blows life inflicts was sorely put to the test by Paul IV and also by cruel fate. In November of that same terrible 1555, his brother Gismondo died, taking with him to his grave an important part of Michelangelo's life of which no one else had any personal recollection. The family with which he had shared his life had now disappeared.

But that mourning was a small thing when compared with the pain that awaited him a few months later. On 3 January 1556 Urbino died, causing Michelangelo such torment that he was literally losing his mind, to the point where his worried friends declared that his life was in serious danger and decided to get his Florentine relations involved. On this occasion, Michelangelo consigned his pain to paper in a letter to Giorgio Vasari, which is perhaps the finest example of his literary production:

> You know that Urbino is dead, and how he was for me the very great grace of God, but to my serious hurt and infinite pain. The grace was that, while in life he kept me alive, in death he taught me to die not with displeasure but with desire for death. I kept him for twenty-six years and I found him invaluable and loyal, and now that I have made him rich and expected him to be my support and relaxation in my old age, he has disappeared. Nor has he left me any hope of seeing him again in paradise . . . even though the larger part of me has been taken away with him. I have been left with infinite misery.[19]

Michelangelo had never expressed such words of lucid and excruciating desperation for either his brothers or his father. His solitude was now complete and Paul IV's cruelty only increased his pain. The friend who was looking after him was convinced that if the pope had restored his pension, then Michelangelo would have recovered in a short time.[20] But his enemies never failed to exploit the situation and make it difficult for him to continue with the work on Saint Peter's, which was slowing down and came to a complete halt in September of the same year, as a result of the war the pope declared against the Spaniards who were besieging Rome. This climate set the scene for one of the obscure

tragedies in Michelangelo's life: the destruction of his marvellous *Pietà*, on which he had been working for years.

7 THE DESTRUCTION OF THE PIETÀ

Around 1548, according to Vasari's account, Michelangelo was working on a marble *Pietà* at his home in Macello dei Corvi. After forty years, the sculptor was again taking up the challenge of the theme that had made him famous: the body of Christ held in his mother's arms after his deposition from the cross. At that time, this subject was at the centre of new reflections on Christ's sacrifice, which had been developed with particular sensitivity by the Viterbo circle. One of Vittoria Colonna's most important and famous works was *Pianto sul Cristo morto* [*Tears Shed for the Dead Christ*] which we can consider effectively a literary expression that mirrors the sentiments shared with Michelangelo on the nature of Christ's sacrifice, so that we can also argue that this sculpture was directly inspired by Vittoria shortly before her death.

In Vittoria's lament,[21] Mary's pain emphasized the value of the sacrifice Christ had made in order to save mankind. This particular interpretation of the theme of devotion, in which Christ is the very centre of the drama, moved Michelangelo to conceive a composition in which Christ's body was no longer, as with the *Pietà* in Saint Peter's, settled upon his mother's legs and partly removed from the public's view, but shown frontally in all its communicative power. The desire to exalt the Saviour's body above all other things drove Michelangelo to produce a complex composition, in which three figures support the lifeless body.

Sculpting four figures in a single block – moreover ones not aligned on the same plane – was a challenge that no Italian sculptor had previously attempted. Christ's perfectly centred body brings to mind the words of the Bishop of Fano who praised the *Pietà* owned by Pole when offering it to Cardinal Ercole Gonzaga: a Christ 'in the form of *Pietà*, although you can see the whole of his body'. Michelangelo portrays the falling body, devoid of vital energy, held from behind by Nicodemus and by Mary Magdalene on the right. On the left, his kneeling mother attempts to break the fall with a very dramatic gesture, as though she wishes to enter her son's body and share his physical torment.

The figure of Nicodemus is a self-portrait of Michelangelo. He wanted to use the sculpture on his own tomb and by so doing wished to signify his very deep involvement in the worship of Christ, the instrument of mankind's salvation as celebrated by the theology of Pole and Colonna. The identification with Nicodemus reveals his guilt over not having the courage to celebrate more openly his dangerous religious beliefs. Christ's figure, even when lifeless, is portrayed as very beautiful; it is still that of a sleeping Apollo or Adonis with perfectly proportioned limbs, in spite of the unseemliness of death. The drama of the crucifixion is celebrated through the composed anguish of Nicodemus, Magdalene and the Virgin, and is still faithful to the expressive canons of High Renaissance classicism, which avoided excessive dramatizations and above all celebrated the beauty of Christ, the mirror of the beauty of God.

As Vasari emphasized even before the sculpture was completed, the marble group was the most majestic Michelangelo ever produced, because of the presence of so many figures and the manner in which he positioned them. This composition posed technical problems of the highest order, partly because it was difficult to use a chisel inside that entanglement of figures which were impossible to move around, and partly because, before starting, the sculptor had to calculate perfectly the space that each figure would have occupied at the end, in order to avoid intersections of the planes, which would have ruined the sculpture.

Michelangelo resolved all these problems perfectly, as can be seen from the current state of the sculpture. The first part to emerge from the block is the left knee, which coincides with the point of maximum projection from the block in the front part of the statue. Following a well-polished thigh with relaxed muscles, Michelangelo starts to sculpt the young man's abdomen above a loincloth so fine that you can sense its transparency: a cotton loincloth that has slipped down to the pubes. Christ's shoulders are held by Nicodemus, who displays Christ's imposing beauty. The right arm is held in the most stunning pose by Mary Magdalene, while the Virgin takes the force of his falling chest. This 'open' depiction of Christ's body served to subordinate the other figures in the scene to the figure of the Saviour. Their only purpose is to free up the depiction of Christ and increase its visibility. In this way Christ's body, the thing that most interests the sculptor, organizes the space and the narrative, even though it is lifeless.

As was logical from a technical point of view, Michelangelo first sculpted the Christ, bringing it to a state of perfect completion and then continuing with Mary Magdalene. Nicodemus is almost finished, and the Madonna is rough-hewn but still complete in her spatial relationship to her son. Christ's figure has been taken to a degree of finish that is very rare in Michelangelo's sculptures; it has already been smoothed with pumice stone and it is ready to receive and reflect the light that should have emphasized the statue's spiritual fascination. The artist has already experimented with the same effect on the *Moses* in the Church of San Pietro in Vincoli, which was smoothed on the side that was to receive and reflect the direct light from the window on the left.

However, on one of the darkest days of the late 1550s, Michelangelo's self-destructive rage was to come crashing down on that figure of Christ, which he had completed so perfectly – beyond all expectations. It was the time when the whole of Rome was horrified by the incarceration of his friend, Cardinal Morone, and he was depressed over Urbino's death and Paul IV's financial penalties. The eighty-year-old artist grabbed a heavy hammer and flung himself at that marvellous body. Before anyone had time to restrain him and protect the statue, he had mutilated the left knee, the collarbone, and the left arm, shattering them into several pieces. Some of the damage could be repaired, but some of the parts could not be reattached. The sculpture remained permanently mutilated, a symbol of a tormented conscience and an uncontrollable anger. The 'infinite misery' of which Michelangelo had written to Vasari at the time was the ageing artist's misery in the face of the broken remains of his most beautiful and spiritual work of art.

This event was too tragic, too devastating to find a place in the artist's biography without raising disturbing questions concerning the anguished events of the last few years of his life. Giorgio Vasari knew everything about this and, although in 1564 he couldn't even remember the exact number of figures in the *Pietà*, writing of the '*pietà* of five figures, which he broke',[22] in 1568 he published a new version, in which he had duly purged the tragic incident. In spite of the fact that it was obviously without any foundation, the new version would survive for a long time, because it was useful to the myth that Vasari himself had helped to create by cleverly manipulating the awkward incidents and grimness in Michelangelo's life. The causes, he explained, were to be

found in the artist's irritation with the pressure Urbino was putting on him to finish the sculpture and a defective vein in the marble which made the work difficult.

No document suggests that the damage to the sculpture was inflicted before Urbino's death. On the contrary, there is not a trace of this event in the correspondence between Michelangelo and Vasari just after the death of his beloved servant. The reference to a 'crack' in the marble is even more untenable: this was the claimed defect in the adhesion or the small fissure that was supposed to have made Michelangelo lose his patience. There is no sign of a 'crack' in the surviving sculpture, nor can we speculate that it was in the destroyed knee, as that was the first part to be completed perfectly and without any problems (as the finish on the groin proves). No one can reasonably believe that Michelangelo completely finished the work on Christ's leg and then destroyed it because of defects that, if they had been there, would have revealed themselves at the start of the work. Besides, there is sufficient evidence in the *Rebel Slave* held in the Louvre, which has a very clear fissure running right through it. This demonstrates the degree of perfection that Michelangelo could produce with marbles that had far more serious faults in the rock.

Vasari's attempt to attribute the self-destructive rage to Michelangelo's terrible character and his senility has no foundation in the picture we have of the artist during this period. Moreover, the surviving sculpture is the best evidence of the inaccuracy of Vasari's explanation: even in its present state, the sculpture is a great deal more finished than most others that Michelangelo had delivered to his customers and to posterity without damaging them, as can be seen even in the case of the statues on the Medicean tombs. Because of his enormous psychological investment in the work of art, the damage he inflicted on it could be compared to killing one's own offspring. And then the work was so extraordinary and included the only self-portrait of the artist. Even Michelangelo's prickly character cannot on its own explain such a self-destructive crisis.

The story of the months in which the tragedy occurred tells us many things about its possible causes. Michelangelo had many reasons to be overcome by desperation: Urbino's death, the election of Paolo IV to the papacy, which opened the hostilities by suspending his emoluments and threatening more serious punishments such as the imprisonment

inflicted on Cardinal Giovanni Morone 1557. As he found himself in this situation of total defeat of his ideals and his practical ambitions, the attack on the *Pietà* and in particular the Christ portrayed within it allows us to speculate on other scenarios, especially if considered in relation to the story about his shouting 'Why don't you speak?' at the statue of Moses, which is a myth but no less significant for that. The sculpture of Moses was not attacked and there are no signs of hammer blows, but myth might have confused the stories and the timing of a drama too intense to be repeated without some risk. If during the destructive anger of the hammer blows the 'Why don't you speak?' was shouted at the Christ of the last *Pietà*, the episode would have a different meaning in Michelangelo's history. Disheartened by the turn of events, the artist would have asked Christ why he did not intervene in the religious and human catastrophe perpetrated by those who should have been his ministers. His legendary bad temper would have appeared less extreme, and besides the artist had also known how to use it for his own self-promotion at every critical moment in his life. This would also point to the dramatic nature of the still unresolved question of his involvement with the group of Spirituals and his fear of sharing their persecution under Paul IV.

In any event, Michelangelo lived the last years of his life in this climate of fear and imminent punishment. The building work on Saint Peter's, which for him was both a votive offering and a guarantee of survival because no one else was capable of successfully progressing with this project without inflicting impossibly high financial losses on the Catholic Church, was almost suspended during the reign of Paul IV. The punishment the pope inflicted on him with the cancellation of his emoluments was exacerbated by the threat of destroying his most important work, *The Last Judgement*, which was already famous in the whole of Europe because of the reproductions and copies in circulation. Even Vasari refers to the threat of Paul IV: 'At this time, some people reported that Pope Paul IV was minded to have him tidy up the wall of the chapel with the *Last Judgement*, because he said those figures were displaying their shameful parts in an overly dishonest manner.'[23] But it was a considerable undertaking to cover the nude figures in the *Last Judgement* for several reasons, not least the technical one, because they would need to put up enormous scaffolding. They would have to

wait for the decision of the Council of Trent to commission Daniele da Volterra, one of Michelangelo's disciples, to carry out the task of mercifully covering the nudity in the *Last Judgement* and defacing it with those bizarre underpants which were unfortunately left in place in the recent restoration and thus continue to mock the painting. But another work by Michelangelo was censored during this period – the paintings in the Pauline Chapel, where the nudity of the angels holding up Christ in the *Conversion of Saint Paul* was covered up, as was the naked abdomen of Saint Peter. In the payments made to Daniele da Volterra in 1565 there is no mention of the paintings in the Pauline Chapel, so it may be that Paul IV not only excluded Michelangelo from the work, but also did what he intended to do on a larger scale in the Sistine Chapel after he had had the scaffolding assembled.

If, as the pope was threatening, the painting of the *Last Judgement* had been destroyed, Michelangelo would have been put on the same level as a heretic and his religious ambitions would have been swept away by a sentence of the Inquisition. An entire life devoted to building a position of pre-eminence would have been put at risk by politics and a strange turn of events.

The dismal Rome of Paul IV was close to another enormous tragedy in 1557. The fearful citizens, shut up behind their walls, heard of the closeness of Spanish troops who had set up camp in the sleepy countryside ready for their assault. Fear of another sack of Rome was palpable. The old artist, now more than eighty years old, found the strength to resist and survive this further nightmare, once more drawing on his vital resources which seemed to be inexhaustible. He clung to his control of the building work on Saint Peter's, where the contractors were desperate to have him removed and to have the directorship handed over to his most treacherous enemy, the Florentine architect Nanni di Baccio Bigio. Michelangelo gave what remained of his marvellous *Pietà* to Francesco Bandini, his last friend in Rome, whom he had known since the time of the siege of Florence and who certainly shared his religious views, given that he had had the image of the very particular *Pietà* Michelangelo had painted for Pole and Vittoria Colonna transferred onto marble. Once again the artist's intimacy and trust did not go outside the very exclusive circle with whom he had shared his most powerful passions.

Paul IV's death and the subsequent election of Pius IV, a pope well disposed towards Michelangelo, allowed him to resume greater control of the commission he most cared about. In September 1563, the delegates of the building works of Saint Peter's tried once again to have him removed from his position. The letter in which Michelangelo rejected the attack is a masterpiece of audacity and lucidity, which demonstrates that his mental faculties were still intact and his passions entirely reasonable a few months before his death. He replied sarcastically to the delegates who had told him that the pope had to entrust the building commission to Nanni di Baccio Bigio:

> In this case, I can tell your lordships that you have acted like the Genoese nuns, because first you have done what you wanted and then you have informed me of it. As to whether this is an order from His Holiness, I answer that His Holiness is capable of ordering me to do something if he wants something from me, as he has done on many occasions, and I am here in Rome for no other reason than to obey him and serve him.[24]

At the age of nearly ninety, Michelangelo would not give in to anyone, and he revealed that exuberance and moral fibre that had allowed him throughout his life to depict people of exceptional humanity and depth. This showed that without this psychological fortitude artistic skill on its own would not have been enough to create the portrayals of Moses, the prophets and the saints that still impress us so much. Even his physical faculties were in good shape, given that he was still working with hammer and chisel to sculpt the last work he left us, another sacrificed Christ and yet another anguished mother. Almost certainly working on a block of marble left amongst the damaged ones from Julius's tomb, he chipped away the previous sculpture and, leaving only one arm in order not to upset the balance of the marble, he cut into the back of the statue in search of the new figure. The lack of space remaining in the block drove him to make the Christ thinner and thinner to the point of reducing his body to the semblance of a soul in anguish. The accident of this reworking gave rise to yet another masterpiece, the last one in his life: Christ's body frees itself of every pointless encumbrance and finally becomes pure sentiment, in relation to which even the anatomy ceases to be important.

In October of the same year, 1563, Michelangelo appeared one morning in front of the Church of Santa Maria sopra Minerva on his black horse, accompanied by two assistants who never left him alone: Antonio del Francese and Pier Luigi da Gaeta. Old age was tiring him,[25] but his mind was still lucid, albeit with the melancholy that forces old men close to death to remember the most distant parts of their lives. Michelangelo still remembered the terrifying days of the Pazzi conspiracy, the crimes and violence that marked the three-year-old child. The Florence he was preparing to take with him on his last journey was still the tragic and grandiose Florence of the struggles for political supremacy. That was the Florence of sparkling gold and bloody events always lying in wait.

A few months after that October, on a cold and rainy February day, he took leave in his own fashion of the Rome he had served for half a century and had made greater still, without, however, ever loving that city. He was an old man who struggled on alone under the freezing rain and wearing threadbare clothes he continued to look after carefully in his wardrobe. Nothing could have been further away from the powerful circles he had served with his sculptures and paintings. Four days later, while he was comforted by the New Testament and the story of Christ's passion, which was read to him by his most affectionate disciple, he died in his very modest home in Macello dei Corvi. His lifestyle during these last few days was all written down in the inventory of his goods drawn up on 19 February by the notary Roberto Ubaldini: a few 'threadbare' items of clothing, 'an iron bedstead with sack of straw, three mattresses, two white woollen blankets and one of white lambskin', the linen that his nephews and nieces had sent from Florence and which had been put away as new, no piece of furniture of any value, no pictures and no precious objects. But one by one, they pulled out dented copper vases, chipped ceramic ones, knotted handkerchiefs and worn sacks. They were all full of small treasures – the gold coins he had collected and hidden around the house. The wardrobe was not at all what you would have expected of a man of his standing. The notary searched the house, now immersed in the silence of death, for precious furnishings, mirrors, silverware, gold-plate, damasks and oriental silk. But he found none of this – none of what you would have expected to find in the house of any affluent man in Rome. The objects he found appeared to have been left

eighty years earlier in his father's impoverished house. The accumulated wealth had concerned others, not him.

The house had also been stripped of the works of art. They only found a few drawings and three rough-hewn marble blocks, including the *Pietà Rondanini* which he was still attempting to work on, in spite of his fever. A few days earlier he had had all his drawings burnt, except for two or three sketches and one more elaborate work that he was finishing for Cardinal Giovanni Morone, the only friend left from the group of the Spirituals and the only one whom Paul IV had managed to get his hands on and imprison in Castel Sant'Angelo.

The cartoon and drawings that escaped the fire were seized. Michelangelo's assets and his works were of public interest, and nothing demonstrates this better than that sequestration. The corpse was taken to the nearby Church of the Holy Saints and then under cover to Florence. The arrival of the corpse in the city, which was kept secret for just a few hours, triggered an outpouring of emotions amongst all Florentines – artists and ordinary citizens. Ignoring the ceremonial rule that should have governed Michelangelo's funeral, a crowd of tearful men holding torches to light up the night moved in procession to venerate the corpse which was dressed in the simple clothes used for the escape. From that night on, all that remained of Michelangelo – his corpse, his memory and his art – belonged to the powerful, just as the powerful had always owned his miserable life.

Notes

Introduction

1 Letter from Don Miniato Pitti in Rome to Giorgio Vasari in Florence, 10 October 1563, in G. Vasari, *Der literarische Nachlaß Giorgio Vasaris*, ed. by K. Frey, 2 vols. (Munich: Georg Müller Verlag, 1923–1930), vol. II (1930), p. 9. Michelangelo's last hours are recorded in great detail in the chronicle which Daniele da Volterra sends to Vasari a few days after Michelangelo's death: 'When he got ill, which was on Carnival Monday, he sent for me, as he always did when he felt unwell, and I sent word to Master Federigo de Carpi, who immediately came, but pretended that it was by chance [so as not to frighten him, *author's note*], and then I did the same. As soon as he saw me, he said, "Oh Daniele, I am finished, I commend myself to you, and do not leave me"; and he made me write a letter to Master Leonardo, his nephew, that he should come, and he told me that I should await them in the house and should not leave for any reason. This is what I did, even though I was not feeling so well. His sickness lasted five days: two when he was up at the fireplace, and three when he was in bed. Thus he expired on Friday evening, may he rest in peace, as I believe we can be certain. On Saturday morning, while the house and the other things were being tidied up, the judge came with the governor's notary on behalf of the pope, who wanted

an inventory of what was there. We could not prevent this, and so everything that was there was written down: four cartoons. One was that one . . . another was the one that Ascanio was painting, if you recall; and one apostle, which he was drawing so that he could sculpt it in marble in Saint Peter's; and one *Pietà*, which he had started on, and of which you can only make out the pose of the figures, as there is little finish. That's it, the one of Christ is the best, but all have been taken away, so it will be difficult to see them, let alone have them back. Nevertheless I have reminded Cardinal Morone that it was an undertaking for him, and offered to make him a copy, if I can ever get it back. Some small drawings – those Annunciations and the Christ in the garden – which he gave to his Jacopo [Jacopo del Duca, *author's note*], friend of Michele [Michele degli Alberti, *author's note*], if you remember. But the nephew will take them away in order to give something to the duke. No other drawings were found. Three unfinished marble statues were found: a Saint Peter dressed as a pope, . . . a *Pietà* in the arms of Our Lady and a Christ holding a cross in his arms, like the statue of Minerva, but smaller and different. No other drawings were found. The nephew arrived three days after his death and he immediately order that his corpse be taken to Florence, just as he had ordered many times when he was well and even two days before he died. Then he went to the governor to have the return of the said cartoons and a chest in which there were ten thousand in ducats of the Chamber and in the old ones of the sun and about one hundred in coin, which equalled the count made on a Saturday for the inventory, before the body was taken to the Church of the Holy Saints. The said chest was immediately handed over with the money inside, which was sealed. But the cartoons have still not been returned, and when he asks for them, they tell him that he should be happy with having had the money. So I don't know what will come of it' (Daniele da Volterra to Giorgio Vasari on 17 March 1564, p. 53).

2 Cosimo I de' Medici in Florence to Averardo Serristori in Rome, 5 March 1564, in F. Tuena, *La passione dell'error mio* (Rome: Fazi, 2002), p. 205.

3 Vincenzio Borghini to Giorgio Vasari, 21 February 1564, in Vasari, *Der literarische Nachlaß*, ed. by K. Frey, ibid., vol. II, p. 23.

Chapter 1 Childhood

1 Ludovico Buonarroti's memoir is in the *Ricordanze di casa Buonarroti* and was published in *Vita di Michelangelo Buonarroti narrata con l'aiuto di nuovi documenti*, ed. by A. Gotti, 2 vols. (Florence: Gazzetta d'Italia, 1875), vol. I, p. 3.

2 The description was taken from the land-registry survey of 27 April 1564, which can be found in R. Hatfield, *The Wealth of Michelangelo* (Rome: Istituto Nazionale di Studi sul Rinascimento, 2002), p. 485.

3 L. Landucci, *Diario fiorentino dal 1450 al 1516, continuato da un anonimo fino al 1542* (Florence: Sansoni, 1883), pp. 21–22. For Michelangelo's memory of that period, see the meeting with Miniato Pitti in early October 1563: 'I asked him how old he was. He said that he was eighty-eight, and that he was carried on someone's shoulders at the time of the Pazzi affair. And he remembers when Master Jacopo de Pazzi was taken prisoner in Casentino, where he had fled after the outrage was done' (G. Vasari, *Der literarische Nachlaß*, ed. by K. Frey, vol. II, p. 9).

4 The document is published with J. K. Cadogan's lengthy comment in 'Michelangelo in the Workshop of Domenico Ghirlandaio', *The Burlington Magazine*, CXXXV, 1993, pp. 30–31. Vasari claimed that he had seen the document pertaining to Michelangelo's engagement by the workshop in the Ghirlandaio records and published it in his *Lives*, but the date is wrong and it needs to be reassessed in the light of the document that recently emerged from the Florentine archives: see G. Vasari, *La vita di Michelangelo nelle redazioni del 1550 e del 1568*, ed. by P. Barocchi, 5 vols. (Milan–Naples: Ricciardi, 1962), vol. I, p. 6. On 1 April 1488, Ludovico signed an apprenticeship agreement for his son at the workshop of Domenico and Davide di Tommaso di Currado Bigordi, later known as the Ghirlandaio brothers. The contract stipulated that for the next three years 'the said Michelagnolo must stay with the said persons for the said period to learn how to paint and carry out the said trade and he is commanded to do this by the above-mentioned. And Domenico and Davit must in these three years give him twenty-four florins by way of remuneration.'

5 A. Condivi, *Vita di Michelagnolo Buonarroti*, facsimile reproduction

of the original 1553 edition, ed. by G. Nencioni, with articles by M. Hirst and C. Elam (Florence: SPES, 1998), p. 10: 'Having been given a head so that he could do its portrait, and he portrayed it. He then returned the portrait to the employer as though it were the example, and the deceit was not discovered until the young boy started talking and laughing about it to his companion.'

6 For the exact location of the garden, see C. Elam, 'Il giardino delle sculture di Lorenzo De' Medici', in *Il giardino di San Marco. Maestri e compagni del giovane Michelangelo*, ed. by P. Barocchi (Florence–Cinisello Balsamo: Silvana, 1992), pp. 157–72.

7 For the Pazzi conspiracy, see F. Guicciardini, *Storie fiorentine dal 1378 al 1509*, ed. by A. Montevecchi (Milan: Rizzoli, 1998), p. 117. There is also a very vivid account in Landucci, *Diario fiorentino*, p. 17.

8 'Tyrant is the name of an evil man, and the worst amongst all other men, for he wishes to rule over all others by force, particularly he who has made himself tyrant of the citizenry.' See G. Savonarola, *Trattato sul Governo di Firenze* (Rome: Editori Riuniti, 1999), p. 53.

9 Condivi, *Vita di Michelagnolo*, p. 11. For this episode and the faun mask, see also C. L. Frommel's historical entry in *Giovinezza di Michelangelo*, ed. by K. Weil-Garris Brandt, C. Acidini Luchinat, J. D. Draper and N. Penny (Florence–Milan: Artificio Skira, 1999), p. 226.

10 Condivi, *Vita di Michelagnolo*, p. 13. For a critical analysis, see K. Weil-Garris Brandt's entry in *Giovinezza di Michelangelo*, p. 75. The relief appears to have been inspired by the legend narrated by Ovid and would therefore be of the rape of Hippodamia. See Ovid, *Metamorphoses* (London: Penguin, 2004), Book XII, p. 475.

11 For this relief, see *Giovinezza di Michelangelo*, p. 170.

Chapter 2 Youthful genius

1 Lorenzo's death is narrated in detail by Landucci: 'And on the fifth day of April 1492, a bolt of lightning struck the lantern of the dome of Santa Maria del Fiore at about three hours in the night, and it more or less cut it in two; that is to say, it took away one of the marble niches and many other pieces of marble towards the gate

that goes to Servi, in such a miraculous manner – for we do not see lightning having such an effect in our times' (Landucci, *Diario fiorentino*, p. 63). 'And on the eighth day of April 1492, Lorenzo de' Medici died in Careggi in his own home, and it is said that when he heard news of the lightning, and he, in his sickness, asked where it came to rest, and from what side. He was given a reply and was told; and he said, "Well now, I am dead, because it fell towards my home." Perhaps this never happened, but this is what is said. On the said day, they took him to Florence at five o'clock in the night, and put him in San Marco at the Brotherhood; there he stayed all the ninth day, which was Monday. On the tenth day, Tuesday, he was buried in San Lorenzo, at about 20 hours' (*Diario fiorentino* p. 64).

2 'On the twentieth day of January 1493 [1494 according to the standard calendar, *author's note*], Saint Sebastian's Day, there came the heaviest snowfall ever recorded in Florence . . . Thus it lasted on those mountains, as it lasted eight days in the city. Anyone who saw it believes it' (*Diario fiorentino*, p. 66). Another source for the snowfall was published by Gaetano Milanesi in G. Vasari, *Le Vite de più eccellenti Pittori Scultori ed Architetti Scritte da Giorgio Vasari con nuove Annotazioni e commenti di Gaetano Milanesi* (Florence: 1881), vol. VII, p. 341: 'There was a great snowfall that lasted more than a day, and it was more than a *braccio* deep in Florence, and in places where the wind was blowing, it was two or three *braccia* deep' ('Ricordanze di Ribaldo d'è Rossi', in Ildefonso di San Luigi, *Delizie degli eruditi toscani* (1770–98), vol. XXII, p. 286.

3 His flight is narrated in G. Poggi, 'Della prima partenza di Michelangelo Buonarroti da Firenze', *Rivista d'Arte*, IV (1906), p. 34: 'Know that Michelagnolo, a sculptor from the garden, has gone to Venice without saying anything to Piero. When he returned home, I think that Piero took it very badly. Written on the fourteenth day of October 1494.' The letter was also published in Elam, *Il giardino di San Marco*, p. 167.

4 N. Machiavelli, *Lettere a Francesco Vettori e a Francesco Guicciardini* (1513–27), ed. by G. Inglese (Milan: Rizzoli, 1989). The letters constitute definitive and incontrovertible proof of the tolerance towards homosexuality in cultured circles in Florence. See

particularly Niccolò Machiavelli's letter to Francesco Vettori of 5 January 1514, pp. 210 ff. Another important document relating to Florentine tolerance towards male homosexuality can be found in Francesco Guicciardini's family memoirs, in F. Guicciardini, *Diario del Viaggio in Spagna* (Pordenone: Edizioni Studio Tesi, 1993), p. 99: '[Rinieri Guicciardini] He was a man of quick intelligence and ingenuity, but furious and changeable and of little courage. He had a powerful memory by which he recalled all the facts and things concerning him, even though he never wrote anything down. His habits were bad, because he was very given to lasciviousness particularly with men, and it was noted publicly that he had this vice, and he indulged in it greatly not just as a youth but also as an old man and up to the time of his death.' The criticism mainly concerns the excess rather than the nature of his sexual tastes, which did not however prevent Rinieri from leading a splendid life and becoming the Bishop of Cortona in 1502. He died in his bed with all the consolations provided by religion and society.

5 F. Guicciardini, *Storie fiorentine dal 1378 al 1509*, ed. by A. Montevecchi (Milan: Rizzoli, 1998), p. 278.

6 Condivi, *Vita di Michelagnolo*, p. 15.

7 Vasari, *La vita di Michelangelo nelle redazioni*, vol. I, p. 13.

8 Sermon of 28 July 1495, in *Vita di Girolamo Savonarola*, ed. by R. Ridolfi (Florence: Sansoni, 1981), p. 110.

9 The document showing the return of the money to the cardinal is published in M. Hirst and J. Dunkerton, *Making and Meaning. The Young Michelangelo* (London: National Gallery Publications, 1994), p. 72, n. 25: 'The Very Reverend Cardinal of Saint George [Riario, *editor's note*] must be given on the fifth day of May 200 ducats and 10 carlins for each ducat received from . . .'

10 Michelangelo to Lorenzo di Pierfrancesco de' Medici, 2 July 1496, in *Il Carteggio di Michelangelo*, 5 vols., posthumous edition of G. Poggi, ed. by P. Barocchi and R. Ristori (Florence: SPES–Sansoni, 1965-83; hereinafter referred to as *Carteggio*), vol. I (1965), p. 1.

11 Condivi, *Vita di Michelagnolo*, p. 19. According to Michael Hirst, Michelangelo's lie hides his desire for revenge on the cardinal who is supposed to have rejected his Bacchus after having commissioned it; see M. Hirst and J. Dunkerton, *Michelangelo giovane. Pittore e*

scultore a Roma, 1496–1501 (Modena: Panini, 1997), pp. 33 ff. This theory is not however acceptable because of the payments relating to 'progress with the work', all of which were made by the cardinal. No customer continues to pay for work only to get rid of it once it has been purchased. The cardinal must have been happy with the sculpture that Michelangelo made for him; otherwise he would have made his displeasure known before the last payment.

12 'On the twenty-seventh day of June, three carlins to Michelangelo for first wooden base to be painted', in R. Hatfield, *The Wealth of Michelangelo*, p. 350. In the note on p. 5, Hatfield discusses the possibility of this panel being used for painting the *Manchester Madonna*. Unfortunately he compares it with the payment for another panel costing 400 carlins. There can be no doubt, however, that this latter painting had already been laboriously prepared with the layers of chalk and glue that Michelangelo still had to apply to the panel, whose price (3 carlins) is entirely consistent with the dimensions of the *Manchester Madonna*. For a current exegesis of the *Manchester Madonna*, see the entry by K. Weil-Garris Brandt in *Giovinezza di Michelangelo*, pp. 334 ff. See also Hirst and Dunkerton, *Making and Meanin*, p. 37.

13 The contract appears in Gaetano Milanesi, *Le lettere di Michelangelo Buonarroti pubblicate coi ricordi ed i contratti artistici* (Florence: Le Monnier, 1875), pp. 613–14.

14 *Carteggio*, vol. I (1965), p. 9. Ludovico Buonarroti to his son Michelangelo on 19 December 1500.

15 Vasari, *La vita di Michelangelo nelle redazioni*, vol. I, p. 17.

16 G. Poggi, *Il duomo di Firenze*, ed. by M. Haines (Berlin: Bruno Cassirer Editore), 1909, vol. I, p. 81. This work contains the essential documents for reconstructing the history of sculpture before Michelangelo.

17 '. . . quod quidem homo ex marmarmore [sic] vocato Davit, male abbozzatum et resupinum existentem in curte dicte Opere, et desiderantes . . .,' in K. Frey, 'Studien zu Michelangiolo Buonarroti und zur Kunst seiner Zeit', *Jahrbuch der königlich Preussischen Kunstsammlungen*, 30 (Supplement, 1909), p. 106. We have presented Frey's version, which is slightly different from Poggi's and more believable. The documentation in this case is extremely

important, because it clearly demonstrates that the statue already existed and that Michelangelo was working on an existing work. Michelangelo scholars all too persistently ignored this fact.

18 G. Gaye, *Carteggio inedito d'Artisti dei secoli XIV–XV–XVI*, 3 vols. (Florence: Molini, 1839–40), vol. II (1840), p. 454: 'Incepit dictus Michelangelus laborare et sculpire dictum gigantem die 13 Settembris 1501 die lune de mane, quamquam prius alio die eiusdem uno vel duobus ictibus compulisset, quoddam nodum quod habent (?) pictores; dicto die incepit firmiter laborare.' Poggi provides a slightly different version of this passage (Poggi, *Il duomo di Firenze*, p. 84): '. . . lune de mane, quamquam prius videlicet die 9 eiusdem uno vel duobus ictibus scarpelli substulisset quoddam nodum quem (!) habebat in pectore.' For the current scholarship, see J. Poeschke, *Michelangelo and his World* (New York: H. N. Abrams, 1996), pp. 84 ff.

19 Gaye, *Carteggio inedito*, vol. II (1840), pp. 456 ff., which publishes large passages of the debate.

20 P. Parenti, *Storie Fiorentine*, quoted in *Vita di Michelangelo*, vol. I, p. 30, note 5.

21 This at least is Vasari's version, which is exhaustively commented upon in Vasari, *La vita di Michelangelo nelle redazioni*, vol. II, p. 207. This has however been disproved by recent diagnostic investigations during the restoration of the *David* which ended in May 2004, and have revealed that there were at least seven pieces. See F. Falletti, 'Historical research on the David's state of conservation', in *Exploring David. Diagnostic Tests and State of Conservation* (Florence: Giunti, 2004), p. 60.

22 Hirst and Dunkerton, *Making and Meaning*, and Hirst and Dunkerton, *Michelangelo giovane*. Hirst, who keeps faith with the Vasari tradition, tends to place the conclusion of the work in the summer of 1499 and therefore a year after commencement, but examination of the contract published in Milanesi and the payments published by Hirst himself in Hirst and Dunkerton, *Michelangelo giovane*, p. 61, n. 33, provides grounds for believing that the sculpture was finished only in the summer of 1500, when on 3 July Michelangelo was paid 232 ducats.

23 The works listed in the text are attributed to Michelangelo on the

basis of a very disparate documentation of varying philological weight. The documents relating to *David* are amply reproduced and commented upon in Poggi, *Il duomo di Firenze*, and in Frey, 'Studien zu Michelangiolo'. The contract with the consuls of the Wool Corporation of 24 April 1503 for the statues of the twelve apostles, which is correctly connected with the *Saint Matthew* in the Gallery of the Florentine Academy, has been published by Gaye, *Carteggio inedito*, vol. II (1840), p. 473. The payments for the *Madonna of Bruges* of 2 December 1503 by the Mascheroni, a family of merchants, have been published together with other documents relating to the work in H. R. Mancusi Ungaro Jr., *Michelangelo: The Bruges Madonna and the Piccolomini Altar* (New Haven–London: Yale University Press, 1971), pp. 160, 168, 170. The contract with Cardinal Piccolomini for the altar statues was drawn up in Rome and signed by Michelangelo in Florence on 5 June 1501, and is fully commented upon in Mancusi Ungaro, p. 64. However, critics are not in agreement on the actual timing of the work on the four statues, which dragged the affair on to the time of the artist's death, without fulfilment of the contractual undertakings or the return of the advance. It was only two months after Michelangelo's death that his nephew Leonardo returned the residual debt of 100 ducats to the Piccolomini heirs, and this corresponded to the amount he unquestionably received on signing the contract. Thus Leonardo retained most of the money paid out for this work, which he had received from his uncle. The bronze *David*, also commissioned during this period by the republican government on 12 August 1502, is documented in the letters from the government published in Gaye, *Carteggio inedito*, vol. II (1840), pp. 55 and 58–59. Recently the affair has been studied in F. Caglioti, 'Il David bronzeo di Michelangelo (e Benedetto da Rovezzano): il problema dei pagamenti', in *Ad Alessandro Conti (1946–1994)*, ed. by F. Caglioti, M. Fileti Mazza and U. Parrini, one of the *Quaderni del Seminario di Storia della Critica d'Arte* (Pisa: Scuola Normale Superiore di Pisa, 1981–96), VI (1996), pp. 87–132. The cartoon of the Battle of Cascina is documented in the provisions of the *fogli reali bolognesi* on 31 October 1504, in Frey, 'Studien zu Michelangiolo', and previously in Gaye, *Carteggio inedito*, vol. II (1840), p. 92: '31 October

1504, Bartolomeo di Sandro stationer, 7 lire for 14 notebooks of *foglie reali bolognesi* for Michelagnolo's cartoon, as in the said journal'. The authorship of the *Doni Tondo* is demonstrated by Condivi, and his evidence is sufficiently reliable (*Vita di Michelagnolo*, p. 22): 'In order not to abandon painting altogether, he did a painting of Our Lady on a round panel for Master Angelo Doni, Florentine citizen, from whom he had seventy ducats,' although the accounts of Condivi and Vasari must be treated with considerable caution, given that a little earlier Condivi confused the *Madonna di Bruges* with a bronze statue: 'He also cast a bronze Madonna with baby son on her knee, which [was bought] by the Flemish merchants De' Mascheroni.' Vasari, on the other hand, wrote about the marble *tondi* after also having confused the *Madonna di Bruges* with a bronze *tondo*: 'And also in this period, he did the coarse work on but did not complete two marble *tondi*, one for Taddeo Taddei, now in his home, and for Bartolomeo Pitti he started on another' (Vasari, *La vita di Michelangelo nelle redazioni*, vol. I [1962], p. 23). For the works of his youth, see the indispensable work of C. de Tolnay, *The Youth of Michelangelo* (Princeton: Princeton University Press, 1947).

24 Another important work of the time, which had a highly political tone, was the bronze *David* the republican government of Florence commissioned from Michelangelo in August 1502. The statue, which was later lost, was commissioned as a gift for Gié Pierre de Rohan in order to strengthen the friendship with France, the Republic's traditional ally. Unfortunately the marshal fell out of favour with the king, and the statue remained in Florence until 1508 when it was cleaned by Benedetto da Rovezzano and sent to France. The contract for the bronze sculpture is published in Milanesi, *Le lettere di Michelangelo*, p. 624. For matters concerning the statue, see F. Caglioti, 'Il David bronzeo di Michelangelo (e Benedetto da Rovezzano): il problema dei pagamenti' in *Ad Alessandro Conti (1946–1994)*, ed. by F. Caglioti, M. Fileti Mazza and U. Parrini, p. 103. Caglioti summarized the affair as follows: 'As is well known, the finishing, cleaning and casting were not in fact carried out by Michelangelo, who had not touched the work since 1503 or 1504 at the very latest, but by Benedetto da Rovezzano.'

25 This highly credible hypothesis is G. Poggi's and is examined in Vasari, *La vita di Michelangelo nelle redazioni*, vol. II, p. 240.

26 One of Michelangelo's letters to his nephew Leonardo dated 2 May 1548 is crucial to an understanding of his attitude to his own artistic activity. In the letter, Michelangelo claims to have a very special status and denies he is a craftsman: 'for I was never a painter or sculptor like those who work in workshops', *Carteggio*, vol. IV (1979), p. 299.

27 The document is published in Frey, 'Studien zu Michelangiolo . . .', p. 131, and acutely examined by F. Zöllner, *Leonardo da Vinci. Sämtliche Gemälde und Zeichnungen* (Cologne: Taschen, 2003), pp. 164–68 and 209.

28 The list appears in Gaye, *Carteggio inedito*, vol. II, p. 89.

29 Letter from Pier Soderini in Florence to Jafredus Kardi on 9 October 1506, *Carteggio inedito*, p. 87: 'Once again we ask pardon of Your Lordship for on a certain date having entered an agreement with Leonardo da Vinci, who did not behave as he should have towards our republic, because he took a large sum of money and made only a small start on a great work he had to make.'

30 Michelangelo left Florence after having been attracted by Julius II's alluring proposals in the winter of 1505. He had drawn a cartoon that we know through a painting by Bastiano da Sangallo. On his departure, Michelangelo instructed his father not allow anyone to see the cartoon, which however soon became an admired example of the new classical style.

31 Zöllner, *Leonardo da Vinci*, p. 174.

Chapter 3 At the court of Julius II

1 Letter from Beltrando Costabili to the Duke of Ferrara dated 19 October 1503, in L. von Pastor, *Storia dei Papi dalla fine del Medio Evo*, ed. by C. Benetti (Rome: Desclée Lefebvre & C.i Editori Pontifici, 1895), vol. III, p. 1772 (original publication: *Geschichte der Päpste seit dem Ausgang des Mittelalters*, Freiburg 1886–1933).

2 For Julius II and his strategies for urban development, see M. Tafuri, 'Roma instaurata. Strategie urbane e politiche pontificie nella Roma del primo Cinquecento', in C. L. Frommel, S. Ray and M. Tafuri, *Raffaello architetto* (Milan: Electa, 1984), p. 53.

3 For an examination of this payment, see R. Hatfield, *The Wealth of Michelangelo* (Rome: Istituto Nazionale di Studi sul Rinascimento, 2002), p. 17. On p. 371, there is the important document of the registration of the reopening of Michelangelo's current account in Rome on 27 March 1505: 'Michelangelo [son] of Ludovico Buonarroti, sculptor, must be paid on the twenty-seventh day of March sixty golden ducats in wide gold. He brought cash. He said assistance of Giacopo Rucellai by order of our lord.'

4 *Carteggio*, vol. I (1965), p. 14. Michelangelo in Florence to Giuliano da Sangallo in Rome, 2 May 1506.

5 Hatfield, *The Wealth of Michelangelo*, p. 409: '1505, Monday the twenty-eighth day of April. Copy to Florence to the Fazzi on the twenty-eighth day of April. This is to inform you that the bearer of this letter will be Michelangelo of Ludovico Buonarroti, sculptor, to whom you will pay at his request and without delay the exchange of fifty wide gold. And the money is here to the value from the said person. And put against our account 54 *denari* [pennies].'

6 *Carteggio*, vol. I (1965), p. 13. Michelangelo in Florence to Giuliano da Sangallo in Rome, 2 May 1506: 'But this alone was not the full reason for my departure, but was also another thing, which I do not wish to write about. Suffice it that it made me think that if I stayed in Rome, my burial would have occurred before that of the pope. This was the reason for my departure.'

7 *Carteggio*, vol. I (1965), p. 16. Piero Rosselli in Rome to Michelangelo in Florence, 10 May 1506.

8 Papal brief issued by Julius II to the Priors of Freedom and the *Gonfaloniere di Giustizia* of the Florentine people, in *Raccolta di lettere sulla pittura, scultura ed architettura, scritte da' piu celebri personaggi dei secoli XV, XVI, e XVII pubblicata da M. Gio. Bottari e continuata fino ai nostri giorni da Stefano Ticozzi* (Milan: Silvestri, 1822–25), vol. III (1822), p. 472. However, Michelangelo was too fearful of Julius II, and the *gonfaloniere* Pier Soderini tried to convince him with every means at his disposal to leave for Bologna. He went to a great deal of trouble, as he confessed to the Cardinal of Volterra in a letter written between 7 and 22 July: 'Michelangelo, sculptor, is very frightened; in spite of Our Lordship's brief, the Very Reverend of Pavia needs to write a letter to us, signed in your hand, in which you promise

his safety and that he will not be harmed. And we have done all we can to get him back, and guarantee Your Lordship that we will not treat it lightly if he leaves here, as he has already wanted to do twice', *Carteggio inedito*, vol. II (1840), p. 83. Soderini clarified the situation in another letter of 28 July 1506: 'We have had Michelangelo in our company, and there was no lack of diligence in persuading him to go to you, and in short, we have found him unwilling to put his trust [in you], because Your Lordship has not promised anything very definite' (ibid., p. 84). To get him to leave Florence, they had to wait for the letter from the Cardinal of Pavia to the government of Florence on 21 November 1506. Diffidence and suspicion were already proving to be Michelangelo's dominant traits.

9 *Carteggio*, vol. I (1965), p. 22. Michelangelo in Bologna to his brother Buonarroto in Florence, on 1 February 1507, and letter from the same to his father Ludovico dated 8 February, p. 26.

10 Entry for 1 April 1508 in *I ricordi di Michelangelo*, ed. by L. Bardeschi Ciulich and P. Barocchi (Florence: SPES, 1970), p. 1.

11 *Carteggio*, vol. I (1965), p. 73. Giovanni Michi in Florence to Michelangelo in Rome, 22 July 1508: '. . . Raffaellino painter . . . will be at your command when he believes that he will get a higher salary than the one he has already been given by master craftsman Pier Matteo d'Amelia. He says he was getting ten golden ducats a month.'

12 For this question, see A. Forcellino, 'Sul ponteggio michelan-giolesco per la decorazione della volta Sistina', in *Michelangelo, la Cappella Sistina: documentazioni e interpretazioni*, 3 vols. (Novara: De Agostini, 1994), vol. III, p. 57.

13 'Vesperae in vigilia pentecostes. Hodie papa non venit ad vesperas, quae habitae sunt in capella palatii, ad quam cardinales cum citius solito venissent, forte putantes papam ad illas venturum et cum ipso, ut solent, de contigentibus collocuturi, cardinalis celebraturus, qui fuit cardinalis s. Georgii episcopus Albanensis, hora condicta venit et fuit ultimus omnium. In altis cornicibus capellae fabbrica-batur cum maximis pulveribus, et operarii ita iussi non cessabant. Ex quo cardinales conquaesti sunt. Ego autem cum aliquoties operarios arguissem, et illi non cessarent, ivi ad papam, qui mecum quasi turbatus est, duod illos non admonuissem, et excusatione

facta fuit opus, quod papa duos successive de suis camerariis mitteret qui iuberent cessari ab opere, quod vix factum est. Vesperae ipsae factae sunt ordine et more solito.' [Vespers on the vigil of Pentecost. Today the Pope did not come to Vespers, which is held in the chapel of the Palace. The cardinals had come, sooner than usual, possibly thinking he would come, in order to talk with him as they usually do, about things cropping up, but one Cardinal, the cardinal of St George, bishop of Albano, came at the proper time to celebrate, and was last of all. Work was going on high up on the chapel's cornices, with great quantities of dust, and though the workmen had been told to stop, they didn't. The Cardinals therefore complained. I had argued with the workmen several times, but they still didn't stop, and so I went to the Pope, who was pretty upset with me on the grounds that I hadn't ticked them off, and when I had made my excuses it was necessary for the Pope to send two of his chamberlains in succession to order a cessation of work, which was achieved with difficulty. Vespers then took place in its usual order and manner.] From the diary of Paris de Grassis, 10 June 1508, in E. Steinmann, *Die sixtinische Kapelle*, 2 vols. (Munich: Bruckmann, 1905), vol. II, p. 699.

14 We know about Michelangelo's promises to Pier Soderini from Soderini's letters to Giovanni Ridolfi in Gaye, *Carteggio inedito*, vol. II (1840), p. 102; on 24 August 1508, Pier Soderini in Florence wrote to Giovanni Ridolfi: 'Michelangelo's David will be finished, it should be here by All Saints' Day.'

15 On the genesis of the ceiling, see the informative article by C. L. Frommel, 'Michelangelo e il sistema architettonico della volta della Cappella Sistina', in *Michelangelo, la Cappella Sistina*, vol. III, *Atti del convegno internazionale di studi, Roma marzo 1990*, ed. by K. Weil-Garris Brandt, 1994, p. 135.

16 For the diagrams of the *giornate* and other technical information on the paintings, see 'Rapporto sul restauro della volta', ed. F. Mancinelli, in *Michelangelo, la Cappella Sistina*, vol. II, p. 235.

17 This theory is well founded, because the records of that winter are extremely explicit; see Landucci, *Diario fiorentino*, p. 291: 'And on the sixth day of May 1509, they had the panel of the Madonna di Santa Maria Impruneta, as the weather had been good and with no

rain, and the other day it rained, as God wished it, which always gives us the protection of the prayers of the blessed Virgin.' Note on p. 291: 'In the roll of priors, for Giacopo De' Rossi one can read a lengthy report on how this tabernacle arrived, a decision made because it did not rain for five months', from G. B. Casotti, *Memorie istoriche della miracolosa immagine di Maria Vergine dell'Impruneta raccolte da Giovambattista Casotti lettore d'istoria sacra e profana nello studio di Firenze* (Florence: Giuseppe Manni, 1714), p. 141. Intense cold is the greatest threat to plaster because it hardens it and makes it almost impermeable to colour, and in the case of frost during the night, the plaster can be completely ruined. Yet no one has considered the relationship between the climate of that particular winter and the causes of the damage to the first Sistine paintings. For other theories, see G. Colalucci, in *Michelangelo, la Cappella Sistina*, vol. II, p. 18.

18 *Carteggio*, vol. I (1965), p. 88. Michelangelo in Rome to his father Ludovico in Florence, 27 January 1509.

19 The single letter of recommendation printed in *Raccolta di lettere sulla pittura*, vol. I (1822), p. 1: 'The bearer of this letter is Raphael, painter from Urbino, who, being skilled in his trade, decided to reside for a period in Florence in order to learn. And because I know that the father is very virtuous and I am most fond of him, and so also is the son discreet and well-mannered, in every way I love him greatly and wish him to achieve a high degree of perfection: I therefore commend him to Your Lordship most heartily.' The authenticity of this document has recently been challenged by J. Shearman, *Raphael in Early Modern Sources* (New Haven–London: Yale University Press, 2003), vol. I, p. 18, and vol. II, p. 1457. But the document remains credible if taken as a whole, as has been stressed by T. Henry and C. Plazzotta in *Raffaello. Da Urbino a Roma* (Milan: 5 Continents, 2004), p. 34.

20 *Carteggio*, vol. I (1965), p. 110. Giovanni Michi in Rome to Michelangelo in Florence, 28 September 1510. For the problem of Michelangelo's working on the ceiling of the Sistine Chapel, see W. E. Wallace, 'Michelangelo's Assistants in the Sistine Chapel', *Gazette des beaux arts*, 1987, pp. 203–16, which is still the most up-to-date study of the question.

21 Vasari, *La vita di Michelangelo nelle redazioni*, vol. I, p. 39.

22 B. Cellini, *Opere*, ed. by B. Maier (Milan: Rizzoli, 1968), p. 849.

23 On this question and the size of the sums that led to this family litigation there is a vast amount of documentation, and consequently there are many different interpretations. The significant documents appear to be Ludovico's letter to Michelangelo on 26 September 1510 and Ludovico's letter to his son Buonarroto on 29 September. Cf. the account provided in *Carteggio*, vol. I, p. xx, and the apparently more persuasive one by Hatfield, *The Wealth of Michelangelo*, p. 42.

24 This account appears in Steinmann, *Die sixtinische Kapelle*, vol. II (1905), p. 729.

25 For the papal diarist's account, see Paris de Grassis, '31 October 1512. *Hodie primum capella nostra, pingi finita, aperta est: nam per tres aut quatuor annos tectum sive fornix eius tecta semper fuit ex solari ipsum totum cooperiente. Alia more solito*', in Steinmann, *Die sixtinische Kapelle*, vol. II, pp. 735–36:

26 F. Albertini, *Opusculum de mirabilibus novae et veteris urbis Romae* (Rome: per Iacobum Mazochium, 1510), Book III.

27 *Il libro di Antonio Billi esistente in due copie nella Biblioteca Nazionale di Firenze (1516–20)*, ed. by K. Frey (Berlin: Grotesche, 1892), pp. 52 ff.

28 For Raphael's drawings inspired by the Sistine Chapel and more generally the fortune of models based on the ceiling, see *Michelangelo e la Sistina: la tecnica, il restauro, il mito* (Rome: F.lli Palombi, 1990).

Chapter 4 Back and forth between Rome and Florence

1 For the detailed account of the sack and the outrages carried out by the troops led by Giovanni and Giuliano de' Medici, see J. Modesti, *Il miserando Sacco dato alla terra di Prato dagli Spagnoli, Archivio Storico Italiano* (1842–1941), vol. I (1842), Florence, pp. 242 ff.

2 Letter from Giuliano dei Medici to Isabella d'Este from Prato on 31 August 1512, in Von L. von Pastor, *Storia dei Papi dalla fine del Medio Evo*, ed. by C. Benetti (Rome: Desclée Lefebvre & C.i Editori Pontifici, 1895), vol. III (1895), p. 796.

3 *Carteggio*, vol. I (1965), p. 139. Michelangelo in Rome to his father Ludovico in Florence, October/November 1512.

4 *Carteggio*, vol. I, p. 135. Michelangelo in Rome to his brother Buonarroto in Florence, Sunday 5 September 1512.

5 Carteggio, vol. I, p. 140. Michelangelo in Rome to his father Ludovico in Florence, October/November 1512.

6 The contract appears in Gaetano Milanesi, *Le lettere di Michelangelo Buonarroti pubblicate coi ricordi ed i contratti artistici* (Florence: Le Monnier, 1875), pp. 635 ff., 6 May 1513: 'Let it be known to whoever [is concerned] that I, Michelangelo, Florentine sculptor, am commissioned to produce the tomb of Pope Julius in marble by the Cardinal of Agenna and the Datary, who, following the pope's death, have become the executors of this work, for sixteen thousand gold Chamber ducats and five hundred of the same, and the composition of the said tomb will be in this form: a block that can be viewed on three sides, and the fourth side against the wall and cannot be seen. The front side, i.e. the head of this block, is to be twenty spans [one handspan is roughly nine inches] wide and fourteen spans high, and the other two sides that go back towards the wall, where the block is against the wall, are to be thirty-five spans in depth and fourteen high, and on each of these three sides there will be two tabernacles, which rest on a base that surrounds the said block and have their adornment of columns, architrave, frieze and cornice, as has been shown in a small wooden model. Two figures about one span larger than life-size are to be placed in each of the six tabernacles, making twelve figures, and a figure of similar size will be placed in front of each column that stands in the middle of a tabernacle, and as there are twelve columns, that shall make [a further] twelve figures; and on the plane above the said block there shall be a box on four legs, as seen in the model, on which there shall be the said Pope Julius between two figures that are holding him up and between two more figures at his feet, which makes [a further] five figures on the box and all five larger than life-size, almost twice as large as life-size. There shall be six plinths around the said box, on which there shall be six figures of a similar size, all six seated. Then on this same plane where there are these six figures, above the front of the tomb which is attached to the wall, there shall be a *cappelletta*, which shall be about thirty-five spans high and in which there shall be five figures, all larger than the others,

as they are further away from the eye. Moreover, there shall be three storeys of either marble or bronze, as the said executors shall prefer, on each side of the said tomb between one tabernacle and another, as shown in the model. And I undertake to finish the said tomb at my expense with the aforementioned payment, constructing it in accordance with the manner stipulated in the contract, in seven years, and if at the end of seven years, some part of the tomb shall not be finished, the aforementioned executors must give me time to finish the remaining work while not working on anything else. . . . Firstly it is agreed, and thus the aforementioned Master Michelangelo undertakes not to take on definite and important construction work that might impede the construction and work on this tomb; but he must continually attend to the construction and work on it; he promises to make and wholly complete the said tomb within the next seven years starting from today and in accordance with the drawing and model, or in other words the figure of the said tomb, or rather close to it, and in accordance with the said drawing and model, as far as he can, for the greater dignity and beauty of the said tomb. In a like manner, the said parties of the said names have agreed that the aforementioned Michelangelo shall have his remuneration and salary for the said tomb and for all the expenses pertaining to the said manufacture, to which the said Michelangelo is due: sixteen thousand five hundred Chamber ducats in gold to be paid at the undermentioned times, manner and terms, and that the value, assessment and perfection of the said tomb shall be up to the judgement and conscience of the said Michelangelo as he values his honour and fame. In a like manner, the aforementioned Michelangelo acknowledges that, of the said sum of sixteen thousand five hundred ducats, he has already received one thousand five hundred ducats from the aforementioned Julius the Second of blessed memory and two thousand from the hands of the Florentine merchant Bernardo Bini, and of that three thousand five hundred he declares himself well contented and paid for that work as shall be his successors and all others.' Whatever theories have been put forward in the past over the magnitude of the first plans for the tomb, there can be no doubt that this document remains the principal source for the history of the monument and Michelangelo's story over the

following years. Some important aspects of the contract need to be emphasized. Michelangelo declares that he has received 3,500 ducats for the tombs, which was handed over by Julius II. He undertakes to work exclusively on the tomb for seven years, and he is declared the expert adjudicator of himself in the sense that his judgement is unappealable on the premise that he is the person most interested in producing the best possible work of art. For plans during this period, see C. L. Frommel, 'Capella Iulia: Die Grabkapelle Papst Julius' II in Neu-St. Peter', *Zeitschrift für Kunstgeschichte*, XL, 1977, 1, pp. 27–62, and C. Echinger-Maurach, *Studien zu Michelangelos Juliusgrabmal*, 2 vols. (Zurich–New York: Hildesheim, 1991). The bibliography of the exegesis of the tomb has been recently produced by M. Forcellino in Appendix II to A. Forcellino, *Michelangelo Buonarroti, Storia di una passione erotica* (Turin: Einaudi, 2002).

7 'Now I've got this dried shit of a young man who says he does not want to lose time, that he wants to learn. And he told me in Florence that he needed two or three hours a day, but now the whole day is not enough; he would also like to draw throughout the whole night,' *Carteggio*, vol. I (1965), p. 151. Michelangelo in Rome to his father Ludovico in Florence, on 21 October 1514.

8 In Hatfield, *The Wealth of Michelangelo*, p. 434: 'And on the twenty-eighth day of May 1512 one thousand three hundred florins of wide gold in gold [*sic*]. They are for the value of a farm bought from this hospital in Macia, as it appears on the map drawn by Ser Giovanni da Romena on the said day.'

9 *Carteggio*, vol. I (1965), p. 95, July/August 1509. Michelangelo in Rome to his brother Giovan Simone in Florence.

10 See above, n. 6.

11 *Carteggio*, vol. II (1967), pp. 313 ff. Sebastiano del Piombo in Rome to Michelangelo in Florence, 6 September 1521.

12 Hatfield, *The Wealth of Michelangelo*, p. 466: '*Unum podere cum domo pro domino et laboratore et terris laborativis vineatis et olivatis et fructatis, positum in populo Sancte Marie de Septignano predicto.*'

13 *Carteggio*, vol. I (1965), p. 186. Cardinal Leonardo Grosso Della Rovere in Rome to Michelangelo in Rome, Monday 21 April 1516. There is a detailed account of this visit in the letters of Elisabetta Gonzaga to Isabella d'Este, in A. Luzio and R. Renier, *Mantova e*

Urbino. Isabella d'Este ed Elisabetta Gonzaga nelle relazioni famigliari e nelle vicende politiche (Turin: Roux e C., 1893).

14 Von Pastor, *Storia dei Papi*, vol. IV, 1 (1908), p. 61.

15 The critique of Guicciardini is published and commented upon in R. von Albertini, *Firenze dalla repubblica al principato* (1970), preface by F. Chabod (Turin: Einaudi, 1995), p. 32, n. 1.

16 The contract appears in Milanesi, *Le lettere di Michelangelo*, p. 649, Third Contract, Rome 8 July 1516: 'Firstly they agree jointly and severally, and especially the said Michelangelo promises not to take on any other work of importance, which could impede the aforementioned work, indeed he promises to work assiduously. And he promises to finish the said tomb within the next nine years starting from some time ago, that is to say on the sixth day of May 1513, and thus finish in the following manner, according to a new model, figure and drawing produced by the said Michelangelo for the said tomb, and in accordance with the said drawing and new model he promised the said Very Reverend [gentlemen] to do this as far as he can for the greater beauty and magnificence of the said tomb in accordance with his conscience. The general nature of the new model is the following: "The model is approximately eleven Florentine *braccia* wide on the frontal side; across this width there is a base on the bottom level with four plinths with their frieze that surrounds everything, on which there are four round figures in marble, each one of three and a half *braccia*, and behind the said figures on each plinth there is a column that reaches up to the first cornice, which rises up six *braccia* from the level of the base; and two columns on one side with their plinths have a tabernacle between them, the inner space of which is four and a half *braccia* high; and similarly on the other side two other columns create a similar tabernacle between them. Thus there are two tabernacles on the frontal side for the first cornice downwards, in which there is a figure similar to the aforementioned. Then between one tabernacle and the other, there is a space of two and a half *braccia*, which rises to the first cornice, in which there shall be placed a history in bronze. And the said work shall be set up on the wall at a distance from the wall equal to the width of one of the said tabernacles, which are on the frontal side and the parts that turn inwards from the said side,

in other words at the top there are two tabernacles similar to the
ones with plinths, and these shall have figures of a similar size: thus
making twelve figures from the first cornice downwards and a his-
tory, as has been said; and from the first cornice upwards, above the
columns which have tabernacles between them in the lower part,
there are two more plinths with the decoration; above there are half
columns that go up to the highest cornice, that is to say they go up
eight *braccia*, just like from the first to the second cornice, and this
completes the work; and on one side there shall be a space between
the two columns in which there shall be a seated figure, which shall
be three and a half Florentine *braccia* high in its seated position. The
same shall occur between the two columns on the other side. There
shall be a space of about three *braccia* between the heads of the said
figures and the highest cornice from all sides, into which a history
in bronze shall be placed, which makes three histories on the frontal
side. Between two seated figures there shall be a space above the
space of the history below, in which there shall be a *tribunetta*, in
which shall be placed the figure of the dead man, i.e. Pope Julius,
with two other figures on either side; and one Our Lady above in
marble, also four *braccia* high; and above the upper tabernacles, or
in other words above the niches of the lower part, there shall be the
niches of the higher part, in each of which there shall be a seated
figure in-between the two columns, with a history above similar to
the previously mentioned ones." Similarly, the said parties agree in
the said manner and with the said names that the aforementioned
Michelangelo shall have as his remuneration for the said tomb and
building work and for all the expenses involved in the said building
work, which he must have for his hard work, sixteen thousand five
hundred ducats in gold of the Chamber, to be paid by the afore-
mentioned to the said Michelangelo in the undermentioned form,
times and terms with the agreement that in the assessment and per-
fection of the said tomb and figures we shall be guided by the opin-
ion and conscience of the said Michelangelo. Moreover, because
in the first contract drawn up by Francesco Vigorosi, as above, the
said Michelangelo has acknowledged that he has had and received,
out of the said sixteen thousand five hundred ducats, three thou-
sand five hundred from Pope Julius, i.e. one thousand five hundred

from the hands of the said pope and two thousand from the hands of the Florentine merchant Bernardo Bini, of which he hereby declares himself paid and satisfied. Moreover they agree on the payments to be made for the remaining thirteen thousand ducats out of the sum of sixteen thousand five hundred, which the said Michelangelo is to have and shall have every month two hundred gold ducats, starting from the month of May 1513, for two years; and at the end of two years, commenced as above, he shall have one hundred and thirty ducats every month until completion and perfection, and the rest of the payment of the said sum of sixteen thousand five hundred ducats [shall be made] as above. Moreover they agree that in the event of the said Michelangelo finishing the said tomb before the above-mentioned time, having finished the work in accordance with the second model, as above, then the payment of the entire aforementioned sum shall be made to the said Michelangelo, in spite of the things he promised. Moreover they agree, for the greater convenience of the said Michelangelo and so that he can work more easily in Rome and outside, the said cardinals promise the said Michelangelo that for the period of nine years starting from the sixth day of May 1514 they grant and concede to the said Michelangelo here present for habitation, just as today they grant and concede him for habitation only by himself or others for him or on his commission as a grace and favour, and without any payment or rent during the above-mentioned period: a house with flooring, rooms, bedrooms, land, vegetable garden, wells and other appurtenances, situated in Rome in the Region of Treio close to the property of Gieronimo Petrucci da Velletri . . . close to Santa Maria del Loreto . . . and in which the said Michelangelo has had several figures and marbles and work, and has worked for many months on the said tomb. And therefore the Very Reverend Monsignor Cardinal Lorenzo de' Pucci put an end to all and any form of pension that he could demand of the said Michelangelo for the aforementioned house. . . . Cardinal Agenna promises below and for the remaining time spent on the said tomb to grant and concede, as today he grants and concedes, to live in the said . . . and working outside Rome or in Rome he shall have use of the house. . . . Similarly the Very Reverend Cardinal de' Pucci promises the said

Michelangelo here present and signatory [of this agreement] that he shall give and pay every month for the first two years, commencing as above, two hundred ducats for as long as he should be paid and up to the sum of seven thousand ducats of the Chamber, which remain from the sum of twelve thousand five hundred ducats that the said and our most saintly pope Julius left for the said tomb.'

17 Milanesi, *Le lettere di Michelangelo*, 1875, p. 660, 12 February 1517. For Michelangelo's entrepreneurial approach to this commission, see W. E. Wallace, *Michelangelo at San Lorenzo. The Genius as Entrepreneur* (Cambridge: Cambridge University Press), 1994.

18 '*Spectabilis noster charissime*, we have received your news and shown it to our lord, and considered all your continuing perseverance with the affairs in Carrara; you have caused no little surprise among us and His Holiness as to why you do not reply in your own words to what we have understood from Giacopo Salviati, who has been to the site of the quarries and marbles of Pietrasanta with many intelligent craftsmen and he reports that there are most wonderful marbles in very great quantities which are easy to transport; this being the case, we are a little suspicious that you want to favour the marbles in Carrara for some personal convenience of yours, and take away from the reputation of Pietrasanta. This is something you certainly should not do, and it imperils the faith we have always had in you. . . . Therefore you should see to the execution of what we have ordered you to do; and do not fail, because if you were to do so, this would be contrary to the desires of His Holiness and ourselves, and we would have reason to be greatly displeased with you. Our Domenico [Buoninsegni, *author's note*] must write to you himself: you must reply on this matter promptly and tell him what you require, having removed all stubbornness from your head. And be of good health' *Carteggio*, vol. I (1965), p. 244. Giulio de' Medici in Rome to Michelangelo in Carrara, Monday 2 February 1517.

19 *Carteggio*, vol. I, p. 291. Giacopo d'Antonio, also known as Sansovino, in Florence to Michelangelo in Carrara, Tuesday, 30 June 1517.

20 The contract is in Milanesi, *Le lettere di Michelangelo*, p. 671.

21 *Carteggio*, vol. II (1967), p. 82. Michelangelo in Seravezza to Berto da Filicaia in Florence, 13–14 September 1518. For the chronology of the works, see also Wallace, *Michelangelo at S. Lorenzo*, pp. 46 ff.

22 *Carteggio*, vol. II, p. 85. Buonarroto Buonarroti in Florence to his brother Michelangelo in Seravezza, Monday 20 [?] September 1518.

23 *Carteggio*, vol. II, p. 143. Salviati in Rome to Michelangelo in Florence, Saturday, 15 January 1519.

24 *Carteggio*, vol. II, p. 185. Michelangelo in Seravezza to Pietro Urbano, his assistant, in Florence, Wednesday, 20 April 1519.

25 *Carteggio*, vol. II, p. 220. Michelangelo in Florence to Domenico Buoninsegni in Rome (?), late February–10 March 1520.

26 *Carteggio*, vol. II, p. 274. Michelangelo in Florence to his father Lodovico in Settignano, second half of February or early March 1521.

27 *Carteggio*, vol. II, p. 374. Michelangelo in Florence to his father Ludovico in Settignano, mid June 1523.

Chapter 5 At the beck and call of the Medici

1 G. Corti, 'Una ricordanza di Giovan Battista Figiovanni', *Paragone*, XV, 1964, 175, p. 27.

2 Ibid., pp. 28 ff.

3 B. Cellini, *Opere*, ed. by B. Maier (Milan: Rizzoli, 1968), p. 123: 'Luigi Pulci . . . was exceedingly handsome in grace and form . . . And therefore, when this young man was in Florence, there were gatherings in the streets in various parts of the city during the summer nights, where he was amongst those who would sing impromptu; it was so beautiful to hear his voice that the divine Michelangelo Buonarroti, the most excellent sculptor and painter, always knew where he would be, and greatly desired to go and hear him, in which he took much pleasure.' Pulci, overcome by syphilis, finished his days as a male prostitute in Rome.

4 In Von Pastor, *Storia dei Papi*, vol. IV, 2 (1912), p. 165. Pope Clemente VII's indecision would cause much harm to Michelangelo as well, by greatly delaying work on the chapels and the library at San Lorenzo, as he would report in a letter dated April 1523 to Giovan Francesco Fattucci, see *Carteggio*, vol. II (1967), p. 366, which makes it clear that at that time the work was still up in the air because of Giulio de' Medici's vacillation; he was still a cardinal at that time. See also F. Guicciardini, *Storia d'Italia*, ed. by S. Seidel Menchi, 3 vols. (Turin: Einaudi, 1971), XVI, 5, vol. III, p.

1668: 'Thus when it came to making decisions and implementing any decision he had made, every little factor that was then discovered and every slight impediment that occurred seemed sufficient to throw him back in that confusion that had affected him before making the decision.'

5 *Carteggio*, vol. III (1973), p. 3. Piero Gondi in Florence to Michelangelo in Rome, 12 December 1523.

6 *Carteggio*, vol. III, p. 43. G. F. Fattucci in Rome to Michelangelo in Florence, 10 March 1524. The memorandum he sent to Fattucci for submission to the pope had been drawn up and very carefully edited the previous December: *Carteggio*, vol. III, p. 10, Michelangelo in Florence to Giovan Francesco Fattucci in Rome, late December 1523. Michelangelo argues that in 1505 he left for Carrara and six months later he took the marble block to Rome and had started to work on them with his assistants: 'and I started to work the block and the figures, and there are still men working on them; and by the end of eight or nine months the pope changed his mind and did not want to continue.' In reality, Michelangelo did not start to work on the marbles, nor did he spend all the money received from Giulio when he was in Carrara but he deposited 600 ducats in his account in Florence and used this to purchase some real estate. He had returned to Rome from Carrara in December 1505, and in April 1506 he had departed once more; there had been no time to set up the expensive site for which he was demanding extravagant expenses in 1523. The second passage in which Michelangelo lies is the one relating to the bronze statue made in 1507 in Bologna for Julius II: 'Suffice it that in the end, having set up the figure in the place in which it had to stay, I found that I had only been advanced four and half ducats after two years to my great impoverishment.' The entries in his current accounts tell us that as soon as Michelangelo returned to Rome from Bologna, his father deposited 250 florins in his account (Hatfield, *The Wealth of Michelangelo*, p. 65), which, together with the 600 deposited and taken from the advance of 1000 received before leaving for Carrara, came to a very substantial sum. The greater sum that Michelangelo attempted to conceal from the accountants of Julius's heirs was the 2,000 ducats received shortly before Julius's death for resuming work on the tomb and which he

was now trying to pass off as posthumous payment for the painting of the Sistine Chapel (*Carteggio*, vol. III, p. 9): 'and complaining of this one day with Bernardo da Bibbiena and with Attalante – that I could no longer stay in Rome and I had to go with God's blessing, Bernardo said to Attalante that he remembered this and that he wanted to give the money anyway, and he ordered that I should receive two thousand ducats of the Chamber, which were the ones, together with the first thousand for the marbles, he put into the account for the tomb; and I reckoned I should have had more for the lost time and the completed works.' Michelangelo therefore attributed as much as 2,000 ducats received for the tomb to the payment for the Sistine Chapel, but in 1513 he had signed a clearly stated contract with Julius's heirs that stipulates: 'Similarly the said Michelangelo acknowledges that of the aforementioned sum of sixteen thousand five hundred ducats he has had and received three thousand five hundred ducats from the said Julius the Second of blessed memory, i.e. one thousand five hundred ducats from the hands of that blessed memory and two thousand from the hands of the Florentine merchant Bernardo Bini. He declares himself very happy and paid on that account', Milanesi, *Le lettere di Michelangelo*, p. 638. During the years following this contract, Michelangelo pocketed the tidy sum of a further 4,000 ducats without a word to anyone, as well as the availability of a house, which according to the contract should have been returned to the heirs once the work had been finished. Instead, Michelangelo now claimed that the house was his. During the period in which he was working for Julius II and later his heirs, Michelangelo had received sensational earnings which, according to the evidence of his current accounts, came to almost 15,000 ducats, a totally disproportionate sum for an artist if you consider that during the same period even Leonardo da Vinci had earned less than a tenth of this fabulous sum. With the money he received from Julius, Michelangelo had bought houses and land, launched his brothers' commercial enterprises and could still count on a very high level of liquidity. As with no other commissioning party, Julius's heirs had had the patience and humility to accept the artist's derogations and breaches of contract while he continued to receive handsome payments and failed to produce evidence of his

work. One could say that, on that date, Michelangelo had received the sum of 8,500 ducats for the tomb, but had made no more than a few rough-hewn statues and had produced a derisory amount of decorated blocks, which remained in his house in Rome.

7 Letter from G. Battista Sanga to Uberto da Gambara, dated 27 June 1527, published in Von Pastor, *Storia dei Papi*, vol. IV, 2 (1912), p. 726.

8 Guicciardini, *Storia d'Italia*, vol. III, p. 1870.

9 Stendhal, *Cronache Italiane*, introduction by D. Fernandez (Rome: Tascabili economici Newton, 1993), p. 19: 'It was precisely that period [1600, *author's note*] which saw the end of Italian originality, which had already been put seriously at risk by the fall of Florence in 1530.'

10 Letter from G. Battista Busini to Benedetto Varchi, in *Opere di Benedetto Varchi con le lettere di Gio. Battista Busini*, 2 vols. (Milan: Nicolò Bettoni, 1834), vol. II, p. 41, letter no. 15. For Michelangelo's political experience, see G. Spini, *Michelangelo politico* (Milan: Unicopli, 1999). Giovan Battista Figiovanni's memoir provides a significant account of Michelangelo's flight, which does not leave any doubt over the real motives for his flight from Florence: 'and thus I aided and abetted his glory, particularly as Michelangelo took himself off to Ferrara fleeing the danger to his wealth threatened by a people in need of war' (Corti, *Una ricordanza*, p. 29).

11 *Carteggio*, vol. III (1973). Ludovico in Settignano to Michelangelo in Florence, 23 September 1528, p. 260.

12 The appointment is recorded in Milanesi, *Le lettere di Michelangelo*, p. 701, and dated 6 April 1529: 'remembering the hard work and diligence he had expended on the aforementioned work up to this date free of charge and out of love . . . they appointed the said Michelangelo general governor and attorney in charge of the said building work and fortification of the walls'. Michelangelo's commitment to the republic was therefore immediate and unconditional.

13 For the activities of Antonio Brucioli (1495–1566), see E. Campi, *Michelangelo e Vittoria Colonna: un dialogo artistico-teologico ispirato da Bernardino Ochino* (Turin: Claudiana Editrice, 1994), p. 156: 'In 1530 in Venice the New Testament edited by Brucioli was published on the press of Lucantonio Giunti, the same Brucioli

who published the Psalms in 1531 and the entire *Bible* in 1532 . . . Whether or not he was faithful to the original text, there is no doubt that Brucioli's *Bible* had an enormous influence, as is demonstrated by the numerous reprints up to 1559, the year in which Paul IV placed it on the Index.' See also Von Albertini, *Firenze dalla repubblica*, p. 73, n. 2: 'Born in the last decade of the fifteenth century, Brucioli was a student of Diaccetto and was introduced to the Orti Oricellari [the Garden of Palazzo Rucellai] possibly by Alamanni. Following the conspiracy of 1522, he sought refuge first in Venice and then in Lyons. He then embarked on a career of intense literary and editorial activity. He was in contact with humanist circles in the north-Alpine region. In 1527 he returned to Florence, but as a friend of Alamanni and an adversary of the *Piagnoni*, he was immediately under suspicion. Following the fall of Niccolò Capponi, he was put under investigation for his links with the Reformation and then sent into exile. He spent the rest of his life in Venice.'

14 Benedetto Varchi, a very shrewd observer and great admirer of Michelangelo, understood and gave an account of the dramatic conditions in which the artist sculpted his most beautiful and electrifying statues of his long career: 'Because after someone had whispered in his ear, Michelangelo went out and got to work, more out of sheer fear than from any desire to work, not having seen, let alone lifted, a hammer or a chisel in many many years; and very soon he had changed the new sacristy of San Lorenzo in a new and marvellous manner and had adorned it with many very beautiful figures created with such art (not provided by God) that, because of that work and others by Michelagnolo, our age (if the most knowledgeable artists are to be believed) is in no way inferior to the ancient one, either in Florence or in Rome', *Opere di Benedetto Varchi*, vol. II, p. 375. Figiovanni's contemporary account in his 'memoir' is equally unequivocal: 'Bartolommeo Valori, official, attempted to have him killed by Alessandro Corsini, one of the pope's men, for the many offences he had committed against the Medici family. I saved his life and I saved his possessions. They are endlessly asking for my pardon' (Corti, *Una ricordanza*, p. 29).

15 Passages shrewdly examined in the recent study by Poeschke, *Michelangelo and his World*, pp. 109 and 113.

16 *Carteggio*, vol. III (1973), p. 227, Michelangelo in Florence to Giovan Francesco Fattucci in Rome, 17 June 1526.

17 Commented upon in G. Vasari, *La vita di Michelangelo nelle redazioni*, vol. I, p. 63 [the poem no. 247 appears in *Rime*, the collection of Michelangelo's poetry – *translator's note*].

18 *Carteggio*, vol. III (1973), p. 329. Letter from Giovan Battista Mini to Bartolommeo Valori, dated 29 September 1531.

19 An account of the ceremony, in which the leading exponents of the Roman aristocracy all appeared, can be found in a letter of 19 June 1519, in *Carteggio inedito*, vol. I (1839), p. 408, and the question is taken up in Bruto Amante, *Giulia Gonzaga contessa di Fondi e il movimento religioso femminile nel sec. XVI* (Bologna: Zanichelli, 1896). The reference to ancient medals used as symbol of reputation is very representative of the distinguishing features of 'educated' elegance in Roman society at the time.

20 The lines are written in the margins of the letter that Giuliano Bugiardini sent him on Saturday, 5 October 1532, from Florence. In *Carteggio*, vol. III (1973), p. 434.

21 *Carteggio*, vol. III, p. 443. Michelangelo in Rome to Tommaso Cavalieri, late December 1532.

22 M. Hirst and G. Mayr, 'Michelangelo, Pontormo und das Noli me tangere für Vittoria Colonna', in *Vittoria Colonna Dichterin und Muse Michelangelos*, ed. by S. Ferino Pagden (Vienna: KHM, 1997), pp. 335–44.

Chapter 6 Michelangelo's glasses

1 An early reference to the painting of the *Last Judgement* appears to occur in the letter dated 17 July 1533 from Sebastiano del Piombo in Rome to Michelangelo in Florence, 'who has decided, before you return to Rome, to work as much for you as you have worked and will work for His Holiness, and give you a contract as you would never have dreamed of', *Carteggio*, vol. IV (1979), p. 18. In any event, the actual commencement of the work was in the spring of 1536, when they plastered the wall and bought the precious paints for the sky. See E. Steinmann, *Die sixtinische Kapelle*, p. 766, on the assembly of the scaffolding on 16 April 1535.

2 *Carteggio*, vol. IV (1979), p. 26. Michelangelo in Florence to Tommaso Cavalieri in Rome, dated 28 July 1533.

3 *Carteggio*, vol. IV, p. 63. Michelangelo in Florence to his brother Giovan Simone in Settignano, June–September 1534.

4 *Carteggio*, vol. IV, p. 65. Anonymous letter to Michelangelo in Florence sent before 23 September 1534.

5 *Carteggio*, vol. IV, p. 49. Tommaso Cavalieri in Rome to Michelangelo in Florence, dated 6 September 1533.

6 This precious piece of news, which helps put the story of their friendship in context, is found in a letter from Jacopo Meleghino to Michelangelo, dated 10 August (1537?), *Carteggio*, vol. IV, p. 81: 'Now, because His Holiness, finding himself on his own here and not having anyone to entertain him, would like to talk with you, if it is of no inconvenience to you, and if it please you, he would like to see the picture in the chapel.'

7 Letter from Gualteruzzi to Cosimo Gheri, dated 12 June 1536, in V. Colonna, *Sonetti in morte di Francesco Ferrante d'Avalos Marchese di Pescara*, ed. by T. R. Toscano (Milan: Mondadori, 1998), p. 25.

8 The unchallengeable judgement of the Church of Rome on the heresy of Reginald Pole, Vittoria Colonna and almost all the other members of the group is demonstrated by an impressive number of documents. These prove the enormous interest the spies for the Inquisition were showing in the group. In his monumental biography of Paul IV, Antonio Caracciolo collected the material for his own work a few years after the death of the persons involved and could rely upon not only official documents but also the personal accounts of many contemporaries of Pole and Vittoria Colonna. The resulting manuscript, *Vita di Paolo IV, di Antonio Caracciolo Chierico regolare*, is held in the Vatican Apostolic Library, Barb. Lat. 4961. The efforts of modern Catholic historiography have not achieved much in challenging that judgement; there have been recent attempts to rehabilitate the Viterbo group which was persecuted by the Church within the context of an orthodox culture that was only disputed by the 'intemperance' of boisterous Pope Paul IV. On this point, see the letter from Monsignor Giuseppe de Luca to the secretary of the Holy Office published in S. M. Pagano and C. Ranieri, *Nuovi documenti su Vittoria Colonna e Reginald Pole*

(Vatican City: Vatican Archive, 1989), p. 26, n. 8. Another important document for assessing the accusations of heresy against Pole and Vittoria Colonna is the 'Compendio dei processi del Santo Uffizio di Roma da Paolo III a Paolo IV', ed. by C. Corvisieri, *Archivio della Società romana di Storia Patria*, 3 (1880), pp. 261–90. Fundamental for an understanding of the relationship between Vittoria Colonna and Michelangelo is the work of E. Campi, *Michelangelo e Vittoria Colonna: Un dialogo artistico–teologico ispirato da Bernardino Ochino* (Turin: Claudiana Editrice, 1994).

9 Letter from Vittoria Colonna to Alvise Priuli, dated May–June 1543; in Pagano and Ranieri, *Nuovi documenti*, p. 150.

10 *Nuovi documenti*, pp. 127–30, in which the Inquisitorial censorship of Vittoria's letters is carefully examined. These letters express concepts that were restated many times in her correspondence with Michelangelo at the same time. The collection of Vittoria's letters is published in E. Ferrero and G. Muller, *Carteggio di Vittoria Colonna Marchesa di Pescara* (Turin: Ermanno Loescher, 1889).

11 For the pamphlet *Il beneficio di Cristo*, see S. Caponetto, *Il beneficio di Cristo* (Florence–Chicago: Sansoni–Newberry Library, 1972), and C. Ginzburg and A. Prosperi, *Giochi di pazienza. Un seminario sul 'Beneficio di Cristo'* (Turin: Einaudi, 1975). See also A. Prosperi, *L'eresia del Libro grande: storia di Giorgio Siculo e della sua setta* (Milan: Feltrinelli, 2000).

12 The receipt for the stonemason's rough work can be found in *I ricordi di Michelangelo*, p. 298: 'December 1537. I, Sanandro di Giovanni, have received from Michelangelo five *scudi* for the work on the Madonna that I carried out at the said Orenbino's. I declare myself satisfied with what I have had to do with him and with the said Michelangelo up to this December 1537.'

13 The comment is by Cardinal Ercole Gonzaga, in the Vatican Apostolic Library, Barb. Lat. 5790, c. 140r. Letter from Cardinal Ercole Gonzaga in Mantova to Don Ferrando in Rome, 10 March 1542 (also commented upon in Forcellino, *Michelangelo Buonarroti*, p. 246).

14 *Carteggio*, vol. IV (1979), p. 105. Letter from Vittoria Colonna to Michelangelo, without definite date. The editors of the correspondence place the letter in an approximate period between

1538 and 1541, but there is no evidence to show that it was not later. Unfortunately very few of Vittoria's many letters survive, even though Michelangelo told his nephew in a letter in 1552 that he was keeping them. This circumstance leads us to believe that Michelangelo was fully aware of how dangerous that correspondence was.

15 A strange coincidence links this allegory of Michelangelo to another allegory on charity from a place that was central in the spread of the ideas of Juan de Valdés. In the Church of San Giorgio Maggiore in Naples, there was and is an allegory of *Charity* with hair that transforms on the forehead into a flame that aspires to heaven, not far from the pulpit where Bernardino Ochino used to preach. The naif effect of this and other allegories, not all of which have survived unfortunately, could not have been adapted by Michelangelo, who studied the marvellous hairstyle that runs down to the lantern and symbolically feeds into its fire. The vocabulary of the 'Spirituals' is full of references to ardent thoughts on charity; see the letter from Paolo Sadoleto to Alvise Priuli, which was written in Carpentras on 4 July 1559 and comments upon the death of Reginald Pole, 'and that he has amassed on his head the burning coals of his great charity', P. Simoncelli, *Il caso Reginald Pole* (Rome: Edizioni di Storia e Letteratura, 1977), p. 201.

16 *Carteggio*, vol. IV (1979), p. 101. Vittoria Colonna to Michelangelo, n.d. (1541–4).

17 For a detailed account of the final work on the tomb, see Forcellino, *Michelangelo Buonarroti*, pp. 266–7.

18 The evidence of restoration to damage to the sculptures in the lower section of Julius II's tomb has been published in A. Forcellino, 'Le statue della Tomba di Giulio II', *Monumenti di Roma*, 1 (2003), p. 145.

19 Anonymous letter to Vasari, March 1564, in G. Vasari, *Der literarische Nachlaß*, vol. II (1930), p. 64. For the comment, see Forcellino, *Michelangelo Buonarroti*, p. 269.

Chapter 7 The Pauline Chapel

1 B. Cellini, *Opere*, ed. by B. Maier (Milan: Rizzoli, 1968), p. 552. Another precious personal account of Urbino's obscure character

emerges from the correspondence of the deputies of the Fabbrica di San Pietro, published by L. Bardeschi Ciulich, 'Documenti inediti su Michelangelo e l'incarico di San Pietro', *Rinascimento*, XVII (1977). The deputies, still loyal to the project and vested interests of the 'Sangallesque clique', submitted a complaint to the pope on 4 September 1548 concerning the mistreatment of one of their officials (p. 274): 'This maestro Michelangelo took hold of him to give him a light slap, which the official parried with his hand. From the other side, Urbino grabbed his arms tightly and told him he was a wretch and a glutton . . . but Urbino loudly added and said these words: If you come back here, you will not be leaving again.' This threat seems worthy of the arrogant scoundrel described by Cellini.

2 The inventory appears in C. Leonardi, *Michelangelo, l'Urbino, il Taruga* (Città di Castello: Petruzzi, 1995), p. 41.

3 *I Ricordi di Michelangelo*, ed. by L. Bardeschi Ciulich and P. Barocchi (Florence: SPES, 1970), p. 303: 'Let it be known publicly that I, Michelangelo Buonarroti, have given today, the twenty-seventh of February 1452 [*sic*], three larger than life-size marble figures rough-worked by my hand to Raffaello da Montelupo, sculptor here in Rome, to be finished for four hundred *scudi*.'

4 Steinmann, *Die sixtinische Kapelle*, p. 770; and in F. Baumgart and B. Biagetti, *Gli affreschi di Michelangelo e di L. Sabbatini e F. Zuccari nella Cappella Paolina in Vaticano* (Vatican City: Tipografia Poliglotta Vaticana, 1934), p. 69.

5 The technical information relating to the paintings was taken from Baumgart and Biagetti, *Gli affreschi*, which is still the fundamental reference work for the paintings. The diagram of the *giornate* is shown in *tavole* XLVII and L. For recent theories on the interpretation of the frescoes, see P. Hemmer, 'Michelangelos Fresken in der Cappella Paolina und das "Donum Justificationis"', *Capellae Apostolicae Sixtinae, Collectanea Acta Monumenta*, 9 (2003), pp. 131–52.

6 In Baumgart and Biagetti, *Gli affreschi*, p. 70.

7 A. Brucioli, *La Biblia quale contiene i sacri libri del Vecchio Testamento . . . Co' divini libri del Nuovo Testamento. . .* (Venice: Torresano e Zanetti, 1539), p. 56; see 'Fatti degli Apostoli', chapter IX. For the

history of this book, see Campi, *Michelangelo e Vittoria Colonna*, p. 156. From the Brucioli *Bible* to the Geneva *Bible*. 'Brucioli published a translation of the New Testament in Venice in 1530, just at the time when Michelangelo was staying with him. There can be no doubt therefore that from that date Michelangelo already knew the interpretation of that passage from gospels. Antonio Brucioli's *Bible* was banned by Paul IV in 1559.' G. Spini also argues that Michelangelo very probably owned one of Brucioli's Bibles in his *Michelangelo politico* (Milan: Unicopli, 1999), p. 30.

8 P. D'Achiardi, 'Gli affreschi di S. Pietro a Grado presso Pisa e quelli già esistenti nel portico della basilica Vaticana', in *Atti del congresso Internazionale di Scienze Storiche*, 1903, vol. VII (Rome: Tipografia della R. Accademia dei Lincei, 1905), p. 217, n. 1. On p. 243 there is a very illuminating examination of the iconography that associates these two saints with each other: 'The figure of Saint Paul has therefore always been of secondary importance in Christian medieval art, and the only events of his life that were generally depicted were those that in some way linked him to Saint Peter and were increasingly used to illustrate and exalt the actions of the latter.' For a more recent consideration of the iconography of the conversion of Saint Paul, see P. Rubin, 'The private Chapel of cardinal Alessandro Farnese in the Cancelleria', Rome, *Journal of the Warburg and Courtauld Institutes*, vol. L, 1987, pp. 82–112.

9 Jacopo da Varagine, *Leggenda Aurea*, edited and translated by C. Lisi (Florence: Libreria editrice fiorentina, 1985), p. 193.

10 *Archivio Segreto Vaticano, Lettere dei Principi e Titolati*, vol. XVI, f. 411. Published in Baumgart and Biagetti, *Gli affreschi*, p. 78.

11 For accounts of this conclave, see T. F. Mayer, *Cardinal Pole in European Context: a via media in the Reformation* (Aldershot: Ashgate Publishing, 2000), pp. 345–75, and Simoncelli, *Il caso Reginald Pole*.

12 For the very high valuation of the paintings owned by Urbino, see the letter to Michelangelo from the widow Cornelia Colonnelli in *Carteggio*, vol. V (1983), pp. 120–1, in which the widow from Urbino warns Michelangelo that 'the paintings were so beautiful that there was no price that could be paid for them, and one would have to go up to thousands of *scudi*, but she wanted the little children to enjoy

a hundred *scudi* for his sake'. Yet even Venusti only asked 21 ducats from Niccolò Gaddi in 1571 for an *Agony in the Garden* copied from a drawing by Michelangelo, but evidently he had not been able to make use of his cartoons. See Bottari-Ticozzi, *Raccolta di lettere sulla pittura*, vol. III (1822), p. 265.

Chapter 8 No more illusions

1 The Farnese inventory is in the Archivio Segreto Vaticano, Arm. LXI, vol. 14 (c. 177).

2 For the inventory of Urbino's assets, see C. Leonardi, *Michelangelo*, pp. 41–2: 'Similarly two paintings, in one a Christ and in the other an Annunciation.' For his servant's will drawn up in Michelangelo's house on 24 December 1555, see *Vita di Michelangelo narrata con l'aiuto di nuovi documenti*, ed. by A. Gotti, 2 vols (Florence: Gazzetta d'Italia, 1875), vol. II, p. 137.

3 Ercole Gonzaga's reply to the Bishop of Fano, who was offering him the picture on Pole's behalf, is dated 21 May 1546 and is in the Vatican Apostolic Library, Barb. Lat. 5793, c. 135.

4 *Carteggio*, vol. IV (1979), p. 183. Michelangelo to his nephew Leonardo, early July 1544.

5 Letter from Cosimo I de' Medici in Florence to Lorenzo Ridolfi in Rome, 12 January 1546, in *Carte michelangiolesche inedite* (Milan: G. Daelli, 1865), n. 22, c. 32: 'and given that this illness is dragging on and pernicious, to go there and see that his faculties are not fading, but brightening up and mark down as much as appears rational according to Michelangelo's mind. And because Luigi del Riccio, the agent of your in-laws, has been and is very familiar and interested in the said Michelangelo and secondly it is believed a certainty that he has been and is handling his furniture and can reasonably have news of whether others have been dealing in it . . .'

6 *Dialoghi di Donato Giannotti, de' giorni che Dante consumo nel cercare l'Inferno e 'l Purgatorio*, ed. by D. Redig de Campos (Florence: Sansoni, 1939), p. 68. The dialogue is dated between January and March of 1546.

7 The advice Michelangelo gives his nephew between 1547 and 1550 on his choice of a bride is clearly a catalogue of his misogynous sentiments. On the one hand he pushes his nephew into marriage

because he wants to have an heir at all costs, given that his family now has 'more property than people'; on the other hand he cannot hide his contempt for women even when he should be singing their praise. Here are some of the more significant passages. Letter dated 20 December 1550, *Carteggio*, vol. IV (1979), p. 357: 'You must only have an eye for her nobility, her health and particularly her goodness more than for anything else. As you're not being the most handsome young man in Florence, you should not attribute too much importance to her beauty, as long as she is not crippled or repugnant.' Letter dated 1 February 1549, *Carteggio*, vol. IV, p. 310: 'You need a woman who is loyal and whom you can command – one who does not want to put on airs and go everyday to banquets and weddings; because where there is a court, she will easily become a whore, particularly if she does not have family.' The most extreme statement appears in the letter dated 16 August 1550, *Carteggio*, vol. IV, p. 349: 'if I could find a servant girl who was good and clean, although this is difficult, because they are all whores and pigs.' For Michelangelo, winged thoughts and sentiments, like the eagle which he portrays for Tommaso Cavalieri as abducting the beautiful Ganymede, appear to be exclusively destined for handsome young men.

8 'Porque se ha hecho de Parma y Placencia en Pero Luyis, haviendo sydo nombrada S. Excellentia sempre para ello y tornandola por escendo del negozio y parar despues en el duque de Castro, aquien aborrisce todo el mundo por su vida y malas qualidades.' This judgement, which was widely shared in European courts, appears in G. Buschbell, 'Die Sendung des Pedro de Marquina an den Hof Kaiser Karls V im September/Dezember 1545 und September 1546', *Spanische Forschungen der Görresgesellschaft*, IV (1933), p. 333.

9 Letter from the ambassador Coppalati to Pierluigi Farnese on 17 November 1546, in A. Ronchini, 'Michelangelo e il porto del Po a Piacenza', *Atti e memorie delle RR. Deputazioni di storia patria per le Provincie modenesi e parmensi*, II (1864), pp. 33 ff.

10 Letter from Pierluigi Farnese to his Roman agent on 25 November 1546, *Atti e memorie delle RR*, p. 34. 'We are greatly displeased to hear that Michelagnolo has so little faith in us, and this is irritating

His Holiness beyond all measure. Find him and tell him in our name that we believe he does us a great wrong to trust so little in the affection we have always shown him. . . . In Parma on 25 November 1546.'

11 Letter from Fabio Coppalati to Pierluigi Farnese dated 17 November 1546, in Ronchini, 'Michelangelo e il porto', p. 33.

12 Meeting held on 25 February 1547, narrated in a letter written the day after by Antonio Arborino in Rome to Monsignor Archinto in Trento, in L. Bardeschi Ciulich, 'Documenti inediti su Michelangelo', p. 258. For the story of Saint Peter's, see also J. Ackerman, *The Architecture of Michelangelo* (London: Penguin Books, 1986), and G. C. Argan and B. Contardi, *Michelangelo Architetto* (Milan: Electa, 1990). From the documentation published by Ciulich it is pretty clear that Michelangelo was involved in the management of the building work on Saint Peter's as far back as November 1546.

13 *Carteggio*, vol. IV (1979), p. 251. Letter from Michelangelo to Bartolomeo Ferratino, late 1546–early 1547, p. 251: 'so that anyone who does not adhere to the said order of Bramante, as Sangallo did, has failed to adhere to the truth'.

14 Lorenzo Mariottini to Leonardo on 25 February 1553, in *Carteggio*, vol. II (1995), p. 43.

15 *Carteggio*, vol. V (1983), p. 89. Letter from Ludovico Beccadelli in Ragusa to Michelangelo in Rome, 28 March 1557.

16 Condivi, *Vita di Michelagnolo*, p. 48.

17 'Fifty gold *scudi* which was the sum he ordered for me . . . as part of the return of the revenue of one thousand two hundred gold *scudi* taken away from me by Pope Caraffa [Pope Paul IV], which was given to me by Pope Farnese [Pope Paul III]; it is true that the Piacenza toll was first taken away from me by the Emperor, and recently Pope Caraffa took away the office in Romagna from me on the first day he was made pope' (*I ricordi di Michelangelo*, p. 346).

18 *Carteggio*, vol. V (1983), p. 35. Michelangelo to Giorgio Vasari on 22 June 1555.

19 *Carteggio*, vol. V (1983), p. 55. Michelangelo in Rome to Giorgio Vasari in Florence, 23 February 1556.

20 'And I am quite certain, if it were to result in this pope failing

to return anything of his, he would forget about his thoughts of Urbino, for perhaps when you come back here another time, you will be very surprised', Sebastiano Malenotti to Leonardo Buonarroti on 21 March 1556, in *Carteggio*, vol. II (1995), p. 58.

21 For the composition of Vittoria Colonna, see E.-M. Jung, 'Il pianto della Marchesa di Pescara sopra la passione di Christo', *Archivio italiano per la storia della pietà*, X (1997), p. 115.

22 This is what Vasari mistakenly wrote on 18 March 1564 in a letter to Leonardo Buonarroti, in Vasari, *Der literarische Nachlaß*, p. 59: 'I have been considering that Michelangelo, as is also known by Daniele and Tomaso Cavalieri and many other friends of his, made his *pietà* with five figures [*sic*], which he broke, for his own tomb, and as his heir I would like to find out how it came into the possession of Bandino.' It is clear that in 1564 Vasari only had a very vague idea of what the sculpture was like and what had happened to it, because he thought it was made up of five and not four figures, and he did not know that it had come into Francesco Bandini's possession.

23 G. Vasari, *La vita di Michelangelo nelle redazioni*, vol. I, p. 97. The censorship of the nudes in the *Last Judgement* has obscured the equally important question of the censorship that continues to disfigure the angels in flight in the *Conversion of Saint Paul* in the Pauline Chapel. Baumgart and Biagetti, *Gli affreschi di Michelangelo e di L. Sabbatini* contains comments on the repainting. Biagetti noted that repainted areas on the *Conversion of Saint Paul* had been prudently left alone, whilst someone had thoughtlessly removed the repainting of the horse's head, which may actually have been done by Michelangelo. See C. de Tolnay, *Michelangelo, The Final Period* (Princeton: Princeton University Press, 1960), for a careful examination of the incisions into the frescoes in the Pauline Chapel before their censorship, which is not dated by the author. For the importance of the work carried out by Paul IV in the Pauline Chapel without consulting Michelangelo, and during which Michelangelo's paintings may have been censored, see K. Frey, 'Studien zu Michelangiolo, p. 164 ff. There were various craftsmen present in the chapel, including painters: 'On the ninth day of March 1556, to *messer* Adriano painter thirteen *s[cudi]* 64 *bol.* for several works and expenses on the display around the tomb in

the Pauline Chapel' (p. 164). The documents prove that Paul IV had important works carried out in the chapel and scaffolding was mounted which would have made it very easy to cover the angels and Saint Peter with drapes.

24 *Carteggio*, vol. V (1983), p. 324. Michelangelo in Rome to the deputies of the Fabbrica di San Pietro in Rome, 6 September 1563. This is Michelangelo's last letter and it had the desired effect because it thwarted the deputies' plot.

25 See n. 1 to the Introduction.

INDEX

Page numbers followed by 'f' refer to a figure – e,g. 25f; I.1, I.2, I.3, etc., are plates.